Immortal Comedy

Immortal Comedy

The Comic Phenomenon in Art, Literature, and Life

Agnes Heller

LEXINGTON BOOKS

A Division of
ROWMAN & LITTLEFIELD PUBLISHERS, INC.
Lanham • Boulder • New York • Toronto • Oxford

LEXINGTON BOOKS

A division of Rowman & Littlefield Publishers, Inc.
A wholly owned subsidary of The Rowman & Littlefield Publishing Group, Inc.
4501 Forbes Boulevard, Suite 200
Lanham, MD 20706

PO Box 317
Oxford
OX2 9RU, UK

British Library Cataloguing in Publication Information Available

Library of Congress Cataloging-in-Publication Data

Heller, Agnes.
 Immortal comedy : the comic phenomenon in art, literature, and life / Agnes Heller.
 p. cm.
 Includes bibliographical references and index.
 ISBN 0-7391-0919-7 (cloth : alk. paper) — ISBN 0-7391-1246-5 (pbk. : alk. paper)
 1. Comic, The. I. Heller, Agnes.

 BH301.C7 H45 2005
 700/.417 22 2005012375

Printed in the United States of America

♾™ The paper used in this publication meets the minimum requirements of American
National Standard for Information Sciences—Permanence of Paper for Printed Library
Materials, ANSI/NISO Z39.48–1992.

To Dick in friendship

". . . for it is only as an *aesthetic phenomenon* that existence and the world are eternally *justified*."

Nietzsche
The Birth of Tragedy

Contents

Preface

This book is to be read as an attempt to think philosophically about the comic phenomenon in general. As far as I know, this is the first attempt to do so; I have searched for something of its kind and found nothing, so I have taken a new path. My book is not meant to be a summary, but an overture. It is not provocative in character, though perhaps it is so in its form and message. I hope that it will be challenged, rejected, or ridiculed. For only in this case might I safely claim its success.

Very few things need to be said in advance. I never say a word about, or even indirectly refer to a novel, comedy, painting, or movie which I have not read or seen. I never rely on information borrowed from secondary literature. I have tried to omit secondary literature altogether and to offer my interpretation of each and every work discussed here while forgetting, or never getting to know, interpretations already offered by others. To be sure, I probably make claims which have been made, even many times, before, though in this case they have been made without my knowledge. I wanted to write this book without using crutches, and without refuting the interpretations of others. I wanted to write a slim book without incessant references. I wanted to think about comic phenomena instead of merely collecting data about them. There are almost no endnotes in this book, with only a few necessary exceptions. Endnotes are philosophically suspect anyhow, and now they spare the reader only a glance at the Internet.

But this was not quite the case when it came to the discussion of theories of comedy. In order to discuss theories, one must present them. Here again, though, I discuss only works of philosophy, literary theory, or art theory which I have read and found crucial, and do not refer to any pieces which were themselves relied upon or criticized in the works with which I dealt closely. Still, with a few

exceptions, I omitted endnotes in these sections as well. The reader will find a list of all the books I discuss or crucially rely upon after the concluding remarks.

The strategy which allowed me to write a slim book on a thick issue, and to present the reader with thoughts instead of lexical knowledge, has, to be sure, its own shortcomings. One can only read a limited number of books. I know that I have included a few works of literary and aesthetic theory that some critics will regard as insignificant, and that I have omitted several others which other appraisers will consider significant and important. The selection of readings is contingent on many things, and among others things, simply upon availability. I admit that perhaps I should have discussed a few books already suggested by my critics, making room by omitting certain others. But I can assert that I could not possibly have included all of them.

My actual choices of works for discussion can also be regarded as problematic. Perhaps not the choice of the comic genres, because, I hope, this method of division will soon be self-evidently comprehensible for readers, but my choice of comic dramas, novels, novellas, books, paintings, films, or even jokes discussed may bother some. I read and considered far more works than I could discuss in a short book, and I selected from them those works which I found most significant and/or most characteristic of the comic genre they represent. Some works I discuss in greater detail, to others I only refer. I often followed the judgment of tradition—for it was also mine—by considering and analyzing in the greatest detail those works which are beyond doubt the shining stars of the comic genre; works like *Don Quixote* among the novels, *As You Like It* and *Tartuffe* among comedies, and the works of Brueghel and Daumier among the painters.

There are several contingent elements in a selection like mine. First, I am guided by my taste. Perhaps others will judge certain works more significant on account of their different tastes. In my mind *Jacques the Fatalist* is a gorgeous comic novel, while others may find it less significant. Some will be annoyed that I merely mention the novels of Rabelais or the great *Tristram Shandy* without discussing these in detail. I can here give a reason why, even if some readers will not find my apology persuasive. The strategy of my book does not involve adding my voice to many. Since Bakhtin's book, Rabelais has become the favorite comic author of modernist literary theory, matched only by Lawrence Sterne as the other favorite. They have been discussed constantly since, discussed inside and out. In joining the bandwagon, I could not have spared myself or the reader references to that discussion. I could not have avoided voicing my agreement and disagreement with aspects of the debates; that is, I could not have escaped exactly what I most wanted to avoid. I ask the reader who is not already personally involved (as a literary theorist in the business) to just read for herself or himself the novels discussed and referenced, and only after having read them, to turn for advice to the many books already written on them. And finally, my selection was motivated, and indeed, I am afraid, I thus left some references inexcusably spare, not by my holistic inclinations, but by a yearning for several

writings that could not be omitted, writings that had to be included, even if only in brief mention, solely for love's sake.

At the close of the chapter on comic pictures, I refer to too many works. Perhaps my excuse is that most of them are contemporary works and that one of the things I wanted to show was just how favorably our contemporary world regards comic pictures. I wanted to describe how an attitude which used to be marginal has now become central. A further difficulty is that not everyone can visit the same exhibitions, find the same collections, or enjoy the same albums. A special problem might be that some of my favorite comic pictures are from private collections. I will of course provide the relevant reference information for such collections in the text, but this is not a substitute for seeing the pictures. Here, however, I hope that the reader's ambition will be to expand the list of significant comic pictures by adding several artists and pictures, rather than to take away even a few.

It is also problematic that in the chapter on comic films I discuss, in principle, only films in which the script writer, the director, and the chief "persona" are one and the same person. This choice in favor of a clearer authorship can be, of course, challenged. In addition, there are several holes in my knowledge of silent films as well as early talkies, and no video shop has yet been able to fill them.

I do not think, however, that any of the above objections, even if they are all valid, could or did change an iota of my theory, or rather theories, of comic genres. For the truth of a theory does not depend upon the number of its exemplifications. There is, however, a graver issue, which can be summed up in a single question: *which works are, in fact, comic?*

As I will mention several times in the main chapters of this book, certain things, characters, and happenings that are not considered at all comic at one time or by certain actors, can be perceived as comic in other times and by other actors. That is, "being" comic is not like being sugar or salt; it is unlike a chemical substance, for one has to have a sense for the comic, both a personal and an impersonal sense, in order to taste the comic, to sense it, to feel it, and to appreciate it. Since tradition, history and memory have already selected works which were read and seen as comic before us, these will also be regarded and read as comic today. But the opposite is not always the case. A few non-comic works are now appreciated only with the proviso that they be seen in a comic light. Kleist's melodrama "The Revenge," for example, does not work as a 'drama' on the stage, but as comic drama it does fine. Contemporary stage directors know this phenomenon very well and sometimes make splendid use of it, particularly in the opera. But if we are reading a contemporary novel or see a contemporary drama on stage, then history and memory have not yet made a decision of sorts as to whether it is to be read or seen as comic. The intention of the author, if it is made clear at all, is not entirely decisive, for the author after all is also just one recipient of his own work, among many.

Let me come to the point. Some of my friendly critics objected to my inclusion of a few novels by Beckett in the chapter on comic novels, and also to that

of a few of his dramas in the sections on comic dramas. They found objection-
able, for example, the classification of *Tin Drum* as a comic novel, for how, they
asked, could Nazi Germany be portrayed in a comic mood? They likewise took
issue with my detection of strongly comic features in Kafka's *Metamorphosis*.
But this is how I read these works, how I perceive them. I think those who do
not can still understand why I do. To make my case I wrote a separate chapter
on "existential comedy," without distinguishing dramas and novels, to show that
there is a kind of comedy which differs from the comic as it is traditionally
presented, and that it can be recognized as one of the representative contempo-
rary exemplifications of the immortal comic phenomena in literature.

Now, enough of the preamble, and let the curtain rise.

I thank my friends, Andras Kardos, Gergo Angyalosi, Otto Hevizi, Mari Zsam-
beki, and Tibor Pongracz, with whom I discussed the first chapters of the book
in their preliminary Hungarian version. I thank Bela Bacso, who, in addition,
also read later chapters and whose generous remarks I took into serious consid-
eration. I am grateful to Gyorgy and Maria Markus, who read almost the whole
book, very critically, and whose critical reading made me correct the composi-
tion of the joke chapter and drew my attention to the difficulties of my enter-
prise. I am also grateful to the students who participated in my class on "Com-
edy and Philosophy" at the New School Graduate Faculty in 2002, especially to
Robert Gero, from whose questions and remarks I grossly profited. I thank An-
drew Van Kempen for his help with the bibliographical information and his
preparation of the final manuscript. My warmest thanks, however, go to Katie
Terezakis, for her love of this book, for her constant help, for her interest and
support, and—last but not the least—for her conscientious editing.

This book is dedicated to my dear friend and colleague, the great lover of
philosophy, Richard Bernstein, whose seriousness and enthusiasm for all things
good, beautiful and true never interfered with his good sense of humor.

Chapter One

The Undeterminable Essence of the Comic

Both tragedy as a genre and the tragic as an event or phenomenon of life have been, from the beginning, favorite topics of philosophical inquiry. Aristotle, whose *Poetics* became the master narrative for every writer, interpreter, or frequent spectator of the theater, was interested in the essence of the drama, and made the strongest case for the brotherly ties between philosophy and tragedy. Both philosophy and tragedy, Aristotle says, portray things as they should be and not just as they are. Tragedy presents characters who stand above us, if not always ethically, then surely as far as grandeur is concerned. Philosophical thinking, as we know from writings of Aristotle that were later titled *Metaphysics*, stands two rungs higher than everyday thinking, and even stands above scientific thinking. In his hierarchically ordered space, tragedy, and philosophy are equals. This master narrative placed Plato's deeply problematic, conditional rejection of tragedy as a genre into shadow, and it also unfortunately marginalized Plato's distinction between the tragic as life-event, on the one hand, and tragedy as a genre on the other hand; Aristotle entirely sidestepped this distinction. Not every historical epoch has had a sense of what tragic drama is (Avicenna, e.g., did not understand the meaning of the words tragedy and comedy in the writings of Aristotle), but wherever it has become a respected genre, the ties of brotherhood between tragedy and philosophy have been renewed. This brotherhood was still celebrated into the nineteenth and twentieth centuries, by Hegel, Nietzsche, Lukacs, Heidegger, and Adorno to name a few.

The other master narrative of European philosophy, the Bible, does not know tragedy, nor does it know philosophy, at least not in the Greek sense of the

word. Certainly, tragic events are recited in the Bible, and tragic characters are presented. In fact, everything that, according to Aristotle, characterizes the plot and the heroes of the Greek tragedy, applies to several figures presented and stories told in the Jewish Bible. True, Christ is not a tragic figure, and neither are the apostles, yet we can easily refer to the stories of Jacob, Joseph, or Moses for tragic examples. Aristotle says that the tragic hero, who stands above us in grandeur, is by no means perfect, and that his imperfection contributes to his fall into the abyss, despair or some miserable condition, from which some tragic heroes can then reemerge (e.g., Orestes). It is also said that in a tragedy *dianoia*, the collision of thoughts and purposes, plays a central role; and Aristotle also puts special emphasis on scenes of recognition. The story of Joseph entails in fact all of the elements of tragedy enumerated by Aristotle, whereas other stories, such as those of Samson, Saul, Jonathan, or David, present most of them. Those tragic life-events are presented in narratives and not as drama. And since the tragic (or what Plato termed the tragedy of life) is identified by the Aristotelian master narrative as tragic drama, the biblical tragic heroes could not play the role of the main *interpretanda* in the philosophical discussions of tragedy. They could not do so in Jewish or in Christian philosophy, for more reasons than one, and they could not be so interpreted even by modern philosophy. In modern times, the tragic events and stories of the Jewish Bible do take the shape of tragic representation, first in musical genres like the opera and the oratorio, as in Handel, and later also on the theater stage. Still, philosophy has not taken up these tragic master narratives as foundational stories of the tragic genre.

In contrast to the tragedy, comedy, with the representative exception of the first philosopher, Plato, has not enjoyed any special attention from philosophy. To refer again to Aristotle's *Poetics*, comedy is said to be the *mimesis* of people and actions that are beneath us. Philosophy was always interested in the sublime, not in the ridiculous. I mentioned already that in the hierarchical metaphysical composition of the space of value in Aristotle, the tragic occupies pride of place on one of the highest rungs of the ladder, whereas the comic is placed on a very low rung, among the contemptible actors and actions of life. We all know Eco's lovely novel *The Name of the Rose*, yet we can hardly believe that in the lost chapter of his *Poetics* or any other work, Aristotle would have changed his mind about the low status of comedy. The tragic hero pleases sophisticated, noble spectators, who undergo a *catharsis*, whereas comedy is a kind of entertainment, and it pleases the common crowd. The spirit or soul occupies a place up there, on the highest rungs, whereas body is situated down here, at the lowest. In comedy, the body is a major player and it may also play—as in Aristophanes, the major comic playwright Aristotle knew—a filthy role, being vulgar and coarse. Catharsis is an internal spiritual experience, yet in laughter our whole body participates, and this is beyond the dignity of a *megalopsychos*, as we well know from the *Nicomachean Ethics*.

It is in Medieval and early Renaissance carnivalesque merrymaking that the comic comes to play an eminent role. We have Bakhtin to thank for his detailed discussion of the significance of the Day of Fools and of the different ways in

which the comic made headway everywhere from the marketplace to Rabelais's novels. Several of Bakhtin's interpretations and analyses have since been called into question, and his tint towards populism has been criticized, but this does not interest me. Bakhtin is still the very philosophical writer who put his finger on the neglected comic phenomenon, and on the relationship between the comic and the reversal of hierarchical order on the one hand, and the straight connection between the comic and the bodily functions on the other hand. Emphasis on bodily functions is also an expression of the reversal of hierarchy, of commandment and obedience. Scatological humor—which had already made its appearance in Aristophanes—returned to the marketplace, where the reversal of the command-obey relationship between mind and body became as important for comic presentation as the reversal of the command-obey relationship in social or political terms. According to Bakhtin, shitting, urinating, spitting, and the use of vulgar and coarse language was also meant as a celebration of life, of *zoe* or *bios*. It was Nietzsche, in his philosophical aphorisms and poems (in *The Gay Science* and in the last book of *Thus Spoke Zarathustra*), who first renewed the theme of the Day of Fools. Nietzsche also began the rehabilitation of the body, which was not easy considering thousands of years of philosophical neglect and hostility.

The picture has slowly, although not entirely, changed. Already with the deconstruction or destruction of metaphysical systems in philosophy, the way was cleared for intensive philosophical reflection on comedy. But if we believed that metaphysical thinking was the sole obstacle preventing as serious a reckoning with comedy as with tragedy, we would be disappointed. In German culture, for example, where the identification of ancient Greece and the German spirit became widespread after Winckelmann, we can hardly detect any essential change. I referred already to Lukacs and Heidegger, and I could also add Gadamer to the list of anti-metaphysical thinkers who still associate tragedy, not comedy, with truth (*aletheia*) and freedom. The sole exception to the list might be Aristophanes, who was actually a Greek.

Thus we cannot avoid first asking the question as to whether there is something in the phenomenon of the comic or in comedy itself that excludes philosophical reflection, or at least makes it tremendously difficult. And we cannot avoid asking still another question. It has frequently been argued that in modern times there are no more tragedies. If this were true, modern times could open the space not just for comic presentation, but also for philosophical reflection on comedies. Still, what about comic phenomena in modern times? Can there be comedies written in modern times? Or is the modern way of life itself comic to a degree that makes comic presentation impossible and transforms reflection on the comic phenomena from philosophical, to a low-level empirical exercise, such as rude humor? In some of his remarks, Kierkegaard was inclined to think exactly this. But if we accepted that modern life is through and through comic, then against what standard would we juxtapose it? Tragic? Serious? Catastrophic? Terrible? In Umberto Eco's just-mentioned historical thriller, *The Name of the Rose*, fanaticism appears as the "other," as the enemy of the comic, and the comic shines in the light of tolerance. So we should also ask the question

comic shines in the light of tolerance. So we should also ask the question as to whether in a world of widespread tolerance, comic genres would still be possible. Unfortunately, this potential danger to comedy is hardly impending, and in all probability it never will be. Nonetheless, the answer to this question will depend mainly on our perception of toleration, and on our understanding of the comic.

Thus philosophy has never been—until now—eminently interested in the phenomenon of the comic. This situation has, however, slowly changed. In recent years, or even the last few decades, several philosophical books have discussed various manifestations of the comic. There are a few books on laughter after Bergson and written in polemics with him, books on humor, irony, jokes, parody, palimpsest, etc. I will mention many of them in their proper place. But none of the works I know of (though perhaps I have missed some) discuss, the phenomenon of the comic in general. The manifestations of the phenomenon of the comic are manifestations of something. I want to find out what this something might be. Maybe this sounds like a Platonic theory of participation. Yet I am instead indebted to Wittgenstein's idea of *family resemblance*. When I say that parody is comic, and likewise irony, humor, or satire, I do not point at some common essence all of them share, but at their *family resemblance*. I prefer to speak about the phenomenon of the comic in general and not of humor, the grotesque and so on, because I am interested first and foremost in the family and not just in the single members of the family. My starting point is the discovery, or rather, the recovery of the comic as one of the main constituents of the human condition itself. This is what I refer to as the "comic" in general, and everything that I want to do here follows from it. I chose to call the family "the comic" not entirely by chance, although to some extent the choice was arbitrary. Among all the expressions we use to describe the comic phenomena in philosophical discourse, this one is the oldest. The word *grotesque* was coined during the Renaissance, the word *humor* was first used in its modern sense in the eighteenth century, and the term *irony* began its relatively great philosophical career with German Romanticism. And even these terms have changed their meanings significantly over time. As Manfred Frank has pointed out, we cannot understand irony in just the way that Schlegel interpreted it, not such a long time ago.

Yet there is a relevant objection against speaking of the phenomenon of the comic in general, namely that one cannot at all grasp this phenomenon, as it is, philosophically. There may have been, after all, good reasons, other than their metaphysical preoccupations, that the eminent philosophers of the canon avoided vesting any major interest in issues of comic presentation.

The phenomenon of the tragic, at least if we accept the Aristotelian "master narrative" that has erased from philosophical memory the Platonic distinction between tragedy of life and tragedy as a genre, is exceptional and rare. The tragic experience, both the experience of tragic heroes and of intelligent spectators, is homogeneous, for the genre called tragedy homogenizes all the heterogeneous phenomena. A tragedy is undividable, just like the perfect soul in Plato

or the individual substance in Aristotle. This warrants its superiority to other genres, which might tolerate heterogeneity. And this is a good description. Tragedy homogenizes, either in a narrower or in a broader sense, but all the same. Whether all kinds of tragic phenomena can be homogenized, and thus whether all kinds of tragic phenomena (the "tragedies of life", as Socrates puts it in *Philebus*) can be presented in tragedies, is a question one cannot answer. Because first, the answers to this question will depend on our understanding what a tragedy of life is, and, second, because in a philosophical discussion, traditional interpretations cannot be entirely forgotten and replaced by one long-since forgotten, abruptly and without further ado. Since I will make no effort to concentrate on the relation between the tragic events of life, whatever they might be, on the one hand, and tragedy as a genre on the other, I too need to walk further on the track of the tradition.

So, tragedy homogenizes the tragic event by melting together the tragic heroes and the tragic plot. This can be understood in a narrower or in a broader way. Lukacs, for example, interpreted it in a narrower way. In his mind, tragedy homogenizes the soul of tragic heroes, who are all possessed by one single passion and who all run towards a single destiny: their own death. Taken in a broader sense, tragedy homogenizes insofar as any of the characters of a tragedy exists, moves, and acts only in and with relation to the others. According to Hegel, tragedy stands for the totality (totalization) of actions. And even if those definitions basically fit for the interpretation of Greek tragedies and of the *tragédie classique*, it is not too forced to find the process of homogenization also in Shakespeare's tragedies. The author—just like a god—throws the characters of his tragedy into a shared situation, where they begin to act for or against one another, always mutually dependently, so that they all finally become and fulfill their shared destiny, unto death. And thus does their destiny become the destiny of the world into which they have been thrown. This tendency towards homogenization in a narrower or broader sense of the word relates tragedy indeed to traditional philosophy, yet it also makes it easy prey for a speculative comprehension, and for post-metaphysical, modern philosophers.

But when we speak about the comic, we face a mess.

How simple the relationship is between tragedy in life-events (whatever that means) and tragedy! Tragedy as a genre of drama homogenizes tragic experiences. This is clear and simple. The "tragic" cannot be seen, it cannot be heard, it does not directly address the senses, but only the intellect, spirit, or soul (depending on how a given thinker names it). Tragedy is not just rare because of the rarity of tragic heroes, but because of the rarity of tragic times. There were long historical epochs without tragedy at all, thus also without tragic experience, or at least without conscious tragic experience. And if the tragic experience is not conscious, then it is not a tragic experience at all, because unconscious tragic experience is nonsense, at least according to the founding father of the unconscious, Sigmund Freud.

How complicated everything becomes if we speak of comic experience.

In contrast, there are no periods in history without comic experiences. There is no human community known of which would not find certain things, gestures, and beings ridiculous or funny. There is no community without laughter and none which would not know practical jokes. There are things which are funny everywhere and any time, and there are things, acts, beings, that are ridiculous in one community and not in others; things that are comic at one time, but not another, in one human group, but not for others. Many comic phenomena directly hit our senses. There are comic sights and there are comic sounds, perceived without further ado and without reflection. There are comic gestures. The comic phenomenon may be a body, a text, an act, be it voluntary or involuntary, a position, a narrative, or the manner of speaking. It can also be a game. The comic is chaotic, like life itself; it imbues our everyday life, our entertainment, our human relations; it can be the manifestation of familiarity and strangeness, of love and disgust, of fear and shame—of practically everything. To put it simply: the comic is entirely, absolutely, hopelessly heterogeneous. Moreover, according to the philosophical tradition, it is also prosaic. Everyday life is, after all, prosaic. There is no poesy in the comic, no beauty, no sublimity. Is this not reason enough for philosophy to express a lack of interest in it?

I must confess that it seems impossible to address oneself to a "family" whose members are so different in kind, and so numerous, that one cannot even get to know them all personally. Still, I think that philosophy needs to address the family itself; it needs to address the comic, and not just the farcical or grotesque, or irony, or laughter, or jokes, or Shakespeare's comedies, or the art of Daumier, and so on. So I chose a detour, or rather a task, which I thought could be fulfilled, and I think that by fulfilling this easier task, we can also come to fulfill the primary task, that is, to finally offer an answer to the question of what the comic is.

To approach the task, I decided to neglect the philosophical tradition, which is not very illuminating in this regard, and to turn to the arts. Whereas philosophy still stands on bad terms with the comic, literature, painting, sculpture, and the theater have always been on the best of terms with it. The comic phenomena can boast not just of one single high genre, but of many (the enumeration of which I will return to later). Since things can be found funny visually, or to the ear, and since the body and its gestures and motions can be as ridiculous as text, language, story, or character, very different high genres can make use of the comic phenomenon. Accordingly, I here suggest a way to divide and grasp the comic in general, a way that seems to be plausible. I will separately discuss the different comic genres: jokes, comedies, the comic novel, the comic picture, existential comedy and the comic motion picture. All of these high genres together will give an answer to the question of what the comic is, and what the comic does. So this is what I undertake in the bulk of the book. What I am, however, bound to tell in advance concerns the limits, or rather the limitations, of my own enterprise.

The first problem I have encountered in my approach is the following: even if someone concentrates on the "high" comic genres alone, the heterogeneity of the world of the comic remains a problem. It is not on the same level, however, as the problem encountered if one tries to take on the experience of comic in everyday life. Genres themselves homogenize in more ways than one. Comic painting will, or rather must, concentrate on comic vision, and has to neglect comic language, text, sound, and even narrative, although the last not necessarily. A staged comedy can mobilize almost all of these elements, yet follows the restrictions of the genre (of which I will soon speak), relatively homogenizing most of them, since they must all be subordinated to the structure, to the characters and the plot, to a two- to three-hour-long duration, and thus to a closed frame. This I may describe as first-order homogenizing. It is perhaps due to this kind of first-order homogenizing that an interesting phenomenon we will soon face arises: comic genres, especially the comic drama, the comic novel, and the existential comedy, all have relatively fixed structures, which are constantly repeated, albeit with many variations, and they also accommodate steady character types. But in spite of this first-order homogeneity, heterogeneity reappears on another level and not just in one way. First, there are many comic genres, all of them are entirely different, and they all follow different structural patterns, even if each of them follows certain patterns of its own. One could even hold against the comic genres that each concerns only a relatively constant pattern, for this might remind the critic of the repetitiousness of everyday life. Yet not all kinds of repetitions are repetitious in the same way.

Furthermore, even if the phenomenon termed "comic" remains a general cluster, its dramas, novels, paintings, and films can be comic in very different ways. They can be satirical, humorous, ironical or grotesque. They can be parodies, jokes, caricatures and so on. No single world in the comic genre can be identified with one of them alone, but only with their ongoing combination. Is *Don Quixote* grotesque? Ironical? Satirical? Or is it humorous? Or is it a parody, a caricature, or all of these options? Very heterogeneous attitudes or elements of the comic are frequently introduced in one single comic work, and authors do not usually make an effort to fit them tightly together, for they cultivate just this heterogeneity.

So what is wrong with heterogeneity? I do not think that anything is "wrong" with it; still, it is important to transform the heterogeneity of life into the heterogeneity of the high comic genres, through the mediation of their primary homogeneity. As repetition in comic genres is different here from repetition in everyday life, so is their heterogeneity. And what of the other accusation, regarding the prosaic character of the comic, and its lack of beauty? The question is not whether one enjoys the beauty of the verses in Molière or in, for example, Brueghel's beautifully painted *The Peasant Wedding*. The question is rather whether beauty, if there is beauty, has anything to do with the comic character of the drama or the painting, or whether it is there in spite of the accompanying comic character. I think it is there "in spite of" and not "because of" it. The comic phenomenon is not "beautiful." And if I may, I will advance a con-

clusion as to why: laughter is rational, not emotional. Beauty is something we love, it elicits emotions or emotional dispositions directly. Also, comic genres can elicit emotions, yet they do it only indirectly, not spontaneously, in reflection. Moreover, there can be (although not necessarily) a *family resemblance* between the comic and the ugly, even if the ugly is by no means also always ridiculous. The ugly can be horrible, and sometimes is, but the ugly, if not dangerous, can be the object of laughter and good cheer.

The second-order heterogeneity and the second-order repetitiousness of the comic genres can also be understood as a reflective distance from the first order heterogeneity and first-order repetitiousness of everyday life. One could say, at first approach, that the comic genres make fun of everyday life and everyday characters, which they simultaneously present and represent. This theory looks promising. Some major types of the comic genre—especially film comedies and comic dramas—confront everyday common sense with everyday nonsense. The good sense makes fun of those who fall short of good common sense or who leave it far behind. This good common sense can represent different things or opinions. Once it was an affront to good sense to deny that Zeus causes lightning and thunder and that sons must obey their fathers. At other times it was considered below the standards of common sense to believe that sons must obey their fathers, or wives their husbands unconditionally. Some opinions and things, and their direct opposites, can be equally defended by good sense, depending on the times and the audiences in the broad sense of the words. Contents of the nonsensical opinions may differ, but rigidity and/or outlandishness are always ridiculous, since they offend the idea of justice represented by common sense.

This theory, however, is modeled mainly on comic drama, and especially on ancient comic drama. In almost all comic novels, and in certain modern comic dramas, however, comic rationality hardly takes the position of empirical common sense. Think for example of *Gulliver's Travels*. I will return to this question in the discussion of jokes.

The problem to be faced is not just the heterogeneity of the position taken by comic rationality, but also the heterogeneity of the butts of humor, although the two are intimately related. In his *Poetics*, as we know, Aristotle speaks of comedies as those works in which comic characters and actions stand below us. In such cases, good sense is the best guide for dividing the non-ridiculous from the ridiculous. Yet Aristotle paid no attention, at least not in his *Poetics*, to the possibility that characters or ideas can become ridiculous and funny also for the opposite reason, namely because they are far beyond and above everyday rationality. In his *Ethics*, when Aristotle makes mention of Socratic irony, which he calls mockery, he remotely stumbles onto the problem, but he does not follow up on it. But this problem cannot be avoided. For after the two, just briefly mentioned, sources of the heterogeneity of the comic (the heterogeneity of comic genres and the heterogeneity of comic attitudes), we encounter yet a third. Whereas characters or phenomena can be tragic exclusively if they are above us, they can be comic both if they are below us and if they are above us.

A person, a character, a judgment, a way of thinking or speaking which one cannot approach with rational means or tools of everyday common sense, can be, indeed, funny to us. Such a ridiculous person can be a noble dreamer, whose acts are unconceivable or absurd, not because he or she lacks something of intelligence, but because certain kinds of intellectual abundance can be perceived both as a lack and as an abundance, and as such, seem ridiculous. These kinds of people may be beyond the grasp of everyday good sense, but they would not, for that reason alone, also be found funny, for they might also elicit awe and mystical contemplation. To be really funny, they need to be alien or impotent in all pragmatic senses. The alien or stranger is often the butt of the kind of humor which hits those who stand below us, but especially those who try hard to behave as if they were not alien. There is also another kind of alien, who is alien in the world to which he nevertheless deeply, essentially belongs. Socrates—in Plato's *Apology*—calls himself a stranger. He is a stranger in his own city, because he says and believes things others find utterly nonsensical, and yet, he seduces others into believing and saying things which make their own habits and customs look funny and nonsensical. And this is funny in a double sense. The "impotent" person is also a typical target of laughter, and, again, he is normally perceived below the laughers. Now if the utterly impractical man is passionately involved in something he believes to be far more important than pragmatic life, then he can be ridiculous in another sense: ridiculous because he stands too far above everyday good sense to be finally understandable. A person possessed by such high passions is not necessarily also ridiculous; he only becomes ridiculous if he is trapped in the business of everyday life and fails there, where everyone acts normally, or if he lives only in dreams although he actually acts, or fails to act, exclusively on earth, like Don Quixote. And even the saint can be ridiculous. Prince Mishkin, from Dostoevsky's novel *The Idiot*, is also a little ridiculous, if not outright hilarious. He is absolutely good. What makes absolute goodness awkward to the degree of becoming comic? Is unconditional goodness itself the butt of laughter and amusement? Or do we see Mishkin also in a ridiculous light because of the impotency of his goodness, because, in all his goodness, he is unable to love according to the known standards of human beings, and not just sexually? What is so funny here? Is the absolutely good person funny according the standards of common sense, or the standards of a higher reason, or rather, are those who represent the standards of common sense funny alone? Answers will have to differ according to each person's emotional and intellectual predisposition. This is one of the most interesting aspects of the kind of comedy represented by the noble dreamers and saints: their being comical or not, and to what degree they are, depends a great deal on their recipients or interpreters. Sometimes, moralists among the interpreters take offense at the humorous presentation of noble souls. Rousseau strongly disapproved of the comic treatment of self-righteous Alceste in Moliere's *The Misanthrope*. This observation alone indicates that "high" comedy pertains only to certain cultures and is, contrary to "low" comedy in the sense Aristotle described it, not empirically universal.

As we know, we can say, if with some poetic exaggeration, that philosophy begins with a joke about philosophers: Thales tumbles into a ditch, because he does not watch where he is going, but gazes up at the sky. The Thracian maid in his company bursts out in laughter. The story—just like Socrates' self-identification as a stranger—is told about the philosopher and thus about philosophy. A philosopher is a stranger, for he lives in a different world than "normal" people do, and above all, because he also despises common sense, or the rationality that prevails in the world of his contemporaries. He believes instead in another kind of Reason, with a capital *R*. One can quote the Hegelian *bon mot*, "a philosopher walks on his head." He despises everything that "normal" people cherish, such as marriage, business and politics. Yet he is still ambitious enough to want to walk, like everybody else, on the earth. It is no wonder that he falls into ditches.

Hans Blumenberg, in his book *Das Lachen der Thakerin: eine Urgeschichte der Theorie* (*The Laughter of the Thracian Woman: A Prehistory of Theory*), beautifully analyses the ambiguity of the Thales story. Who is actually ridiculous in this story? The philosopher? Certainly yes. The Thracian woman too? Could it not also be that the Thracian woman, who can only see what is directly before her, appears just as ridiculous? Are not both of them together funny? Good common sense mocks the acts and ideas that lie beyond it, but while mocking them, it can also mock itself. Reason mocks common sense as narrow-minded, yet by mocking it, it also mocks itself. All combinations are possible and we can easily coin different names for the different combinations. Still, the phenomenon of the "comic" will not be determined thereby. It remains yet undeterminable.

The heterogeneity of the comic phenomenon will be also confirmed when we cast a glance at the effects and aftereffects of comic events or phenomena. To return first to Aristotle's *Poetics*, he says there that the effect of tragedy is cathartic. It elicits strong emotions of fear and pity (or empathy), which purify our souls of individualistic feelings of fear for ourselves and of self-pity. That is, tragedy has a therapeutic effect. If the spectator gets truly involved in the tragic drama, he gets shaken, and the experience can have restorative results, albeit not necessarily long-lasting ones. Whether this then leads to a real spiritual recovery is doubtful.

Now on the contrary, we cannot say that any spectator, reader or listener, in her confrontation with a comic phenomenon, will be shaken, whether she is listening to jokes, enjoying a comic novella or watching the antics of a clown. The listener/reader/spectator may burst out laughing, she may smile, yet she will not always laugh or necessarily smile, or she may react with an imperceptible internal smile. One can laugh or react with a smile or an internal smile at a general point; about certain characters or situations; about a funny remark, a pun, or a grimace, about some kind perceived resemblance; and about much else, and any number of incidental combinations. Yet whatever the cause of mirth, neither sentiments, affects, or emotions are involved in its enjoyment. Thus, comic

phenomena do not elicit sentiments or passions, and as a result they do not pu-
rify our souls cathartically. Unintentional laughter is actually incompatible with
emotions. Nietzsche once said that when laughing we drive a nail into the coffin
of emotions. That comic presentation can be motivated, and is in fact mostly
motivated by emotions or sentiments, is another story. Satire can be co-
motivated by hatred; humor can be co-motivated by musing with sympathy, yet
the reaction of laughter is still void of sentiments. While laughing, we are nei-
ther hating nor expressing our sympathy. Nonetheless, laughter is also therapeu-
tic. It may cure us of certain affects and emotions without eliciting such emo-
tions. Yet the therapeutic effect of the comic is not direct; it is mediated by
reflection, by understanding, by the work of the intellect.

One could object that laughter is not just laughter. It is the manifestation of
cheerfulness. And cheerfulness is a feeling, and moreover, a pleasant feeling. I
doubt, however, that cheerfulness is a spontaneous reaction to the comic. It is a
reaction to the situation where the comic appears. When I make funny faces to
my granddaughter, it is a familiar person who cheers her up by making faces. If
a stranger makes faces at her, she continues crying, yet in another mood. One
should not forget that even with the most spontaneous reaction, perceiving
something as comic implies a judgment. Judgment is mostly also spontaneous.
Moreover, although laughter is often a reaction to a comic experience, this is not
always so. Finally, cheerfulness as emotion needs to be distinguished from the
simple affect /reactive affect of "happy" as a contrary to "sad." Simple affects
are also exemplified in children's drawing of happy or sad faces. This kind of
"happy" affect is not yet a sentiment, it is not even an emotion, just a spontane-
ous reaction to a situation. It is transformed into an emotion or the sentiment of
"being happy" or "cheerful" in the direct aftermath of the experience, but can
also be transformed into an ambiguous or sad sentiment.

Both delayed and indirect emotional reactions to comic experience can be
long-lasting, precisely because they are grasped or mediated by the intellect.
When Belinskij first saw Gogol's comedy *Revizor* (or, *The Government Inspec-
tor*), he did not stop laughing during the entire performance, but, when the play
was over, he reflected: "How sad indeed, is our Russia." It is a common experi-
ence that the aftertaste of comedy is sadness. As Joachim Ritter writes, *laughter + melancholy*

> Man hat gesagt, daß das Nachdenken über das Lachen melankolisch macht. In-
> dem das, was im Lachen erscheint, das Lächerliche, als solches bedacht wird,
> verstummt das Lachen, und es treten diejenige Elemente des Lebens hervor, in
> denen es seine Brechungen, seine Zacken und Kanten, seine innerliche Zwei-
> deutigkeit hat.
> [It has been said that reflecting about laughter makes us melancholic. Insofar as
> what laughter makes apparent, the ridiculous, is considered as such, it silences
> laughter itself, and it brings into the foreground just those elements of life in
> which its refractions, its points and edges, its inner ambiguity, are contained.][1]

This observation, however, does not change the rational character of the
comic a bit, but rather confirms it. We laugh a lot, and then, after giving a

thought to the thing we were laughing at, we may feel sadness, or even despair, depending on the character of the butt of the humor. We can also feel delighted, merry, and free of prior resentments after reflection, after having given a thought to the thing about which we were laughing.

It is, though, entirely secondary whether the reflective or delayed aftereffect of the comic experience and its spontaneous laughter will be lasting sadness or a lasting good mood. When the comic has only a direct effect and no indirect one, which is the case in the simplest comic actions, then no adverse feeling will occur, for there is no reflection. If my grandchild is crying, I can console her by making funny faces. She will stop crying and smile at me. This is not only so in cases when we can speak with some simplification about a stimulus/reflex chain. For if I happen to listen to an innocent joke (the expression stems from Freud) in the company of friends, I will laugh without second thoughts and my laughter will contribute to the elevated cheerfulness of the whole company. In fact I can laugh (or smile internally) any time that I recall the joke and perhaps also the company in which it was told. But if I see a comic play like *Tartuffe* in the theater, and during the performance I get into a merry mood, then after awhile I cannot help but to reflect, to give a thought to the message of the playwright and to feel contempt or disgust or sadness or all of these. The frequently voiced estimation of the moralistic character of comic drama is due also to this delayed and mediated reaction. It is the immorality of certain comic characters which elicits the feeling of disgust and contempt. I will return to this question later.

The heterogeneity of the comic thus presents itself both in the effect and aftereffect. Generalization is in vain. Not just because the aftereffects of certain comic genres (mainly the so-called "high" genres) can be entirely different, sometimes sad, sometimes merry, sometimes elevating, other times depressing, but also because not all comic affects have such an aftereffect. The problem is even more involved, because, as I mentioned in the case of Rousseau, the reflective intellectual, moral and emotional attunement of the listeners or spectators will not only determine the degree to which the comic can be appreciated, but even whether it will be perceived as comic at all. This is so in everyday reactions to and perceptions of the comic, and it is even more true as regards our reaction to comic genres, given in which agreement and disagreement are also brought into play. Mostly one agrees with comic presentations, yet one can also rebel against them. And the situation is even further complicated, in that one can participate gleefully in a practical joke or laugh at a certain sort of joke, and later feel the pangs of conscience.

So far, all my attempts to determine what the "comic" is have failed; I have failed to find a way to pin down the common element among the members of the same comic family. I call these elements members of the same family, but I cannot yet justify or account for why they are so. First I tried to speak of all comic phenomena briefly, yet having found that task impossible, I tried to restrict my inquiry mainly, although not exclusively, to some common features of so-called "high" comic genres, that is to comic phenomena which have already

undergone the primary process of homogenization (homogenization by the concrete genre). Yet even this gross restriction did not allow me to demarcate the phenomenon of the comic. Thus I need to open another line of inquiry.

All kinds of comic experiences are experiences of, and about, absolute present time. This is obvious in everyday comic phenomena. One reacts with laughter at things. One sees, one hears, sometimes one even laughs at something one smells. The circus clown plays his tricks before our eyes, the fool whispers his truths into the ear of the king, the Thracian maid watches Thales fall down. One tells jokes in the company of fellows; written jokes are to told jokes just as scores are to music played. According to Borges, comic genres are oral genres. One can cry thinking of the past; indeed mourning is deeply involved in the past, as hope is vested in the future. One can, of course, recall past experiences of the comic, yet this is not the experience of the comic, but a pleasant or unpleasant memory. There is no feeling parallel to mourning in comic experience. And as we know, mourning is a central constituent of tragedy. There is no similar central and past-oriented emotion that can be called constitutive of comic experience. One cannot vest hope in future comic experiences, for the comic experience cannot be imagined. Authors of comic works, of course, employ their imaginations no less than authors of other works. But their works are not in themselves comic experiences; they are instead free constitutions of situations and characters which will or can elicit comic experiences, in the ever-present time of their listeners, watchers or readers.

Certainly, tragedy, like drama in general, is also experienced as an absolute present on the stage. Every drama unfolds before our eyes. Still, tragedy brings before us things we could not have seen or experienced ourselves. Both Greek and Roman tragedy comprise the tragic stories of mythological or semi-mythological characters of the past. What has happened in the past, playing on the stage, cannot happen now. And they could not have happened in the times of Sophocles, Euripides, or Seneca. Not only Shakespeare's historical plays present situations and characters of a heroic and terrible past; so also do all his tragedies. This is likewise true about Corneille and Racine. Some recent moderns tried to write tragedies about their present time, but they also indicated that most of their dramas are to be presented as tragicomedies, as did Ibsen and Chekhov. Moreover, in non-comic drama, and especially in tragedies, the illusion needs to be unconditional. We see the "others," but we do not participate; we cannot influence events nor can we interfere. The author or the player cannot step out of the drama. There is no *tragedia dell'arte* only *commedia dell'arte*; improvisation on the stage is the prerogative of comic actors. One cannot tell the audience that everything they see is just make-believe. *Parabasis*—this special tool of the comic drama—will be discussed later.

Similarly, there is no "historical comedy." A comedy can be placed into a fairytale milieu, but it cannot be placed into the past. Paraphrases, satires, parodies, and palimpsest mock genres, works, figures, and ideas of the past, in fact happen in the present. Spoofs of the *Mona Lisa* are not parodies of the lady who was sitting for Leonardo da Vinci; they are not even parodies of the painting by

Leonardo. They are parodies of the idolization of certain kinds of representations among the public of the times in which the spoofs were made. They differ from the common practice of making fun of a teacher or of a president or prime minister through exaggerated imitation, in that the latter is funny only for those who know the teacher, prime minister, or president, whereas the former is funny for those who know the painting of Leonardo and, in addition, who share in an ironical contempt for a hero-worshiping bourgeois public.

This is why the comic drama and novel, and eventually also the comic picture, are said to follow a moralistic or political purpose: they want to persuade or dissuade their contemporary audiences to do things or not to do things, to beware of something or trust something else. One can say similar things about tragedies: past missteps with tragic consequences should be avoided. It is said that Shakespeare intended *Richard II* to serve also as a warning for Queen Elizabeth. Yet one can hardly say that tragic drama "teaches" anything. In my mind, comic drama is not written in order to come up with a moral either. But the idea of comedy as a moralistic endeavor could occur and be maintained for a long time precisely because of the feature all comic genres indeed share: they speak of the present to the present; they present the present. This is what I meant when I said that the comic is always happening in the absolute present tense, and this is true about all comic genres and not just about everyday comic phenomena. As we shall see in chapter 4, this is also true about the comic novel. The novel is also said to always portray the past, since the omniscient narrator tells the story from the standpoint of its outcome. Yet we shall see that as far as the comic novel is concerned, this is not the case. It seems as if we have finally grasped the thing which is "common" to the whole family of the comic.

The sole, yet decisive problem with this theory is the following. Even if it were true (as I think it is) that comic phenomena are comic in the present and address the present, one still needs to add that they are not the sole phenomena to do so. Just here, in fact, are first and foremost the landmarks of religious practice. Religious landmarks (e.g., the liberation from slavery in Egypt or the birth of Christ) are not just occurrences which have happened in the remote past, once upon a time, like fairytales or secular histories; we remember them as having happened then and there, yet each and every year they are again present, repeated, and so they participate in the absolutely present time. Every Good Friday Christ is crucified, here and now.

There are more prosaic examples. Take, for example, the detective novel. The detective novel does not belong to the family of the comic, though it shares one important feature with the comic novel: it is a kind of picaresque novel. And it shares another feature with the comic in general, namely that it is an intellectual genre; the best of detective novels and thrillers require intellectual rather than emotional involvement. And there is also the aspect of problem solving. Problem-solving jokes belong to a very widespread kind of joke. We can add that laughter releases tension. In articulating jokes, the joker creates the tension from which the listener will be relieved. A very similar thing happens in detective stories. It is interesting to call Immanuel Kant as a witness here. He says

that in jokes, the self-created tension, the expectation of an outcome, finally gets released into nothing. In the detective novel, there is self-created tension, and the expectation is normally betrayed, yet (we may add) the tension is not released into nothing, but into something, namely into the solution of the riddle. Perhaps this is one reason why we do not laugh.

Thus my goal of pinning down the common feature of the family of the comic has again gotten into trouble. It is true that the comic is played out in the absolute present, but this cannot be the *"differentia specifica"* of the comic, since it is shared by other experiences and phenomena which do not belong to the comic family. The task of making some order out of the disorder, of suggesting guidance to mark the way of inquiry into the comic, of helping to generally grasp things that are absolutely heterogeneous with one another, has turned out just as jokes do: our expectation is released into nothing. The comic phenomenon cannot be defined or determined. It is unapproachable. It slips out from and escapes all nets. Has it, nevertheless, some foundational role in the human condition itself? For if it does, then it must be, by definition, unapproachable, indefinable and undeterminable. Is there a *telos* related to a presumed foundation, or is there none? Can one philosophically approach the comic without accepting defeat in advance? My hunch is that the answer to the last question will be affirmative. The impossible is always worth trying. Yet in what follows, I promise neither a good joke nor a good detective story.

Note

1. Joachim Ritter, *Subjektivität: Sechs Aufsätze* (Frankfurt am Main: Suhrkamp, 1974), 62.

Chapter Two

On Laughter

It would be good to speak about laughter without mentioning anything *about* which we laugh. Yet such an attempt fails if we try. Beyond a merely physiological description of the phenomenon of laughter, one cannot discuss laughter without reference to the ridiculous. If we discuss laughter as, for example, a merely physiological reaction to tickling, then we leave the very essence of laughter out of consideration. To formulate the issue at stake through a few negations, laughter as a physiological reaction has nothing to do with the ridiculous, with rationality or irrationality; it is neither therapeutic nor liberating, nor is it an answer to the experience of nothingness. In sum, merely physiological laughter has nothing to do with human life in general or individual life in particular. Hence, by isolating the question of laughter from that of the ridiculous, we are left with nothing important to say about laughter.

What then is "the ridiculous"? Now if we begin our discussion of laughter by trying to answer this question, we find ourselves again in a kind of jungle, or even worse, in a labyrinth. There are too many things which can make us laugh. We not only laugh at things that could be called "ridiculous": there is bitter laughter, too. We can laugh in despair, at the sudden recognition of our impotency. Children frequently laugh when learning about the death of somebody or a catastrophe. Although in such and similar cases we are not laughing at something ridiculous, bitter laughter is still an adequate answer to one essential feature of the comic phenomenon. The thing we are laughing at, or in conjunction with, is not understandable; it is obscure, irrational, or absurd. The child does not laugh at death because she finds it ridiculous, but because it is inconceivable or absurd for her. The laughter of an adult is frequently also an adequate answer to an irrational, incomprehensible, absurd experience he cannot treat otherwise.

I would say that all theories of laughter wrestle with an insoluble dilemma. If they want to say something important or essential about the phenomenon of laughter, they need to be highly selective and to exclude certain kinds of laughter from discussion. If they were to attempt to include everything at which we laugh, or all that occasions laughter, they would be faced with a practically infinite number of concrete cases. If they instead embarked on an experiment with typologies, they would bore readers with numerous and minute distinctions. And if they restricted themselves solely to the enumeration of some well-known aspects of the ridiculous, they would run the risk of neglecting the more difficult problems of the comic phenomenon, such as those entailed in existential comedy.

Thus philosophers refer to laughter mostly sporadically, or as an example in support of their philosophical (or political, ethical, or psychological) theories. For Hobbes (in *Leviathan*), laughter is the answer to the experience of victory, the sudden awareness of being in full power. The archetypal experience of laughter is the moment when, after a fight or battle, one steps on the shoulders of a kneeling, vanquished enemy. Observing another person's embarrassment can also be a source of laughter. In this case, the person of superior power (eminently the sovereign) can only burst out in laughter at the sight of his embarrassed subject, for a person in the position of superiority is never embarrassed himself. Sure, the Hobbesian version of the theory is more complex, but it remains sketchy. An embarrassed person may also laugh at his own embarrassment. Hobbes does present a few important occasions for laugher, but only a few. The most interesting theories of laughter are in fact not theories of laughter, but theories about jokes. Kant, Freud, and several contemporary authors are interested in laughter only insofar as laughter redeems jokes. A joke which does not result in the reaction of laughter remains unredeemed. This is certainly true, but it is also limited in scope. We do not laugh only at jokes, for the terrain of the phenomenon of laughter is far broader than the kind of laughter solicited by jokes. I am going to discuss those theories (such as the theory of incongruence, the theory of relief, and several linguistic theories) in chapter 6, which deals explicitly with jokes. It should be mentioned that all the above mentioned theories have been discussed elsewhere, including the discussion of special cases of the ridiculous. For example, Bakhtin, in handling the grotesque, mentions incongruence as one of the techniques used to produce the grotesque impression, as in the representation of a very old pregnant woman.

The first general theory of laughter was presented by Bergson. He exemplified his theory with quite different cases of the ridiculous. The cases Bergson discusses range from everyday experience to comic drama and jokes. Yet he too discusses the phenomenon of the comic not for its own sake, but for the exemplification of his philosophy of life. According to Bergson, laughter is a reaction to the mechanical, to an automation which stings us with its strangeness, such that we adhere to the organic, especially in cases of behavior and movement.

Laughter itself is thus a punishment. This also sounds true, at least in several cases. The mechanical imitation of others' sentences in Moliere's comedies, or in Chaplin's way of walking are cases in point. Yet if we laugh at Chaplin, it is hardly any kind of punishment, whereas if we laugh at Argan, it may also be a punishment. What is true about some kinds of laughter is not true about them all. Plessner rejects Bergson's theory since there are examples to the contrary. This is not good reason, for there always are examples to the contrary, in Plessner's book no less than in Bergson's. For my part, I will not critique either Plessner or Bergson, nor Freud or Hobbes or Kant, because I think that there is some truth in all of their theories. By this, I mean that the phenomenon of the comic is in fact illuminated by each of them, but by each only from one or another of their perspectives.

Still, I take as my starting point Plessner's book *Lachen und Weinen* (*Laughing and Crying*), because I do think that I can address the phenomenon of laughter—if only conditionally and provisionally—without speaking simultaneously about whatever phenomena occasions the laughter, namely by considering laughter, together with crying, as a kind of psychological constant. I would still maintain about Plessner's theory what I stated regarding the others. His view that the ridiculous rests upon a misidentification of *Leib* and *Korper* (taking organic body as if it were a body in general) is illuminating in certain cases, and not in others.

Plessner writes: "Lachen und Weinen sind weder Gesten noch Gebarden und haben doch Ausdruckscharakter. Ihre Undurchsichtigkeit und gewissermassen Sinnlosigkeit, d.h., ihre Ungeprägtheit und Unartikuliertheit, ist gerade ihrem Ausdruckssinn wesentlich." (89) [Laughter and crying are neither gestures nor gesticulations and they still have an expressive charater. Their opaqueness and meaninglessness, so to speak, that is, their very lack of form and their unarticulability, is precisely their essential, expressive meaning.] This could be used as a starting point. Thus, it is common to both laughing and crying that they are expressive, inarticulate, non-rational, and in a strict sense, senseless, and that all these and further qualifications do belong to the essence of their expressive quality.

Both crying and laughing are reactions, or more precisely answers, to a kind of provocation. For the time being, I will continue to neglect the issue of what such provocation might be. The reaction, the answer itself, seizes the whole person. While bursting out in laughter or tears, the body is entirely shaken, the facial expression gets distorted, and inarticulate noises are made. As long as one is laughing or crying, one is unable to speak in an articulate manner. Further, one cannot simultaneously perform any manipulative or spiritual task; for example, one cannot read, play tennis, or even drink, for laughing and crying lay

claim to all our capacities of concentration. In laughing and crying, body, soul, and spirit are entirely entangled. Bursting out in laughter or in crying (and these are just the purest forms of such expression) is a compulsion. Such an outburst cannot be withheld for long or regulated by willpower. Both laughing and crying are normally accompanied by bodily secretion. When we shed tears, we cannot help it. When laughing and crying are not of the elementary type, when we weep in silence or just smile, then these are not purely expressive reactions any longer, for a cognition that also considers the situation at hand (which is also of cognitive character) is built into the expression itself. In several cultures, adult men and women acquire the capacity for transforming their sheer expressions into emotions. The ritualization of laughing and crying, the creation of situations and of cultural objects which allow for the "bursting out" in laughter and crying for adults, and thereby also for the suspension of willpower, is an important feature of social life.

To avoid misunderstanding: not all kinds of smiling can be understood as controlled forms of laughter expression, although all kinds of smiling belong to the same family, a broad family of togetherness and recognition. Such is, e.g., the "contact initiating" smile. The mother smiles at her child, and the child smiles back at the mother. We meet friends on the street and we smile at each other. The social aspect of laughter and the contact-initiating smile have many things in common. They are answers to something or someone, and they are also expressive. But the child's smile is pre-cognitive, as is pure laughter, while the adult's smile usually is not.

Since laughing and crying are pure expressions, they are related to other kinds of expressive reactions. They are unlike gestures, since gestures are normally voluntary. I term the non-voluntary expressions which are characteristic of all healthy human beings 'affects.' Yet the name of the cluster is important only for the sake of a conceptual identification. For example, the Greek word *pathos* is sometimes translated as 'affect,' sometimes as 'emotion,' sometimes as 'feeling.' I translate it with the Latin word for affect (*affectus*). The most important affects are fear, anger, shame, and disgust. Among them, only shame is, if still arguably, a characteristic solely of the human species.

Thus if laughing and crying are expressions, they must belong to the family of affects. Affects are innate, yet all of their manifestations are reactions, answers to external stimuli, or provocations. We are always ashamed of *something*, afraid of something, disgusted by something, angry at or because of something. The external provocations can be very different; they may also alter according to cultures, times, and our age; they remain obscure to us. The elementary expressions of affects are, however, steady, unchanging, and evident, at least as regards the pure manifestations of those affects. In elementary manifestations, or expressions, one cannot disentangle spirit, soul, and body: in the case of pure shame, for example, affects manifest in blushing; in anger, we tremble and our faces change color, turning pale or reddening, and we say that we are shaking all

over or trembling with anger. In the case of disgust, we feel nausea, as if we were about to vomit, and in fear we also tremble, shudder, and pale or fade. In time, usually, cognition also gets built into elementary affects, and emotions thus come to occupy the place of pure affects, or better said, affects are transformed into several emotions. The same affect can be transformed into many different emotions. Emotions are therefore (contrary to affects) not innate but are specific to all healthy members of our species. They thus resemble the non-elementary expressions of crying and laughing. We can thus draw the conclusion that laughing and crying belong to the family of affect. Still, they are not affects as such.

Firstly, affects are by no means incomprehensible or mysterious. Even if we disregard interesting anthropological and philosophical theories such as those of Gehlen, who interprets affects as instinct remnants, qua consummatory behavior, resulting from the decomposition of instinct in higher animals and men, it will still be self-evident that affects must be regarded as functionally rational responses. A fear affect is a functionally rational response to the dangerous and the frightful, and this is so even if the fright reaction does not prove adequate in all concrete frightful situations. We can run away quickly in cases where it would be more useful to say rigidly put, or vice versa. We know that the force of a human being is multiplied in the state of rage; that the affect of shame is an ethical reaction to external authority; and that disgust can save us from death both physical and moral. All these affects are also means of socialization. The social world teaches people what they should be afraid of, what should carry them away with rage, what they should find disgusting and shameful, and what not.

In contrast, neither crying nor laughing has a special rational function, although both do remain reproductions of biological and social life. Neither of them is regularly used in the process of socialization. Although we can laugh when we see someone put to shame, it is the putting to shame and not the laughter which is the means of socialization; laughter is just a side-effect. Similarly, a person who has been put to shame can burst into tears; still, not crying but putting to shame is the means of socialization. Laughing and crying seem to be answers to the socialization process itself. And the reaction is not function specific. The person who has been put to shame can also laugh, and the person who sees someone else being put to shame can also cry. One cannot even try to explain laughing and crying as remnants of consummatory behavior, as reactions due to the decomposition of instincts, because neither of them replaces consummatory behavior or any other aspect of animal instinct which might have appeared in the process of human self-domestication. This is why I think that Plessner made an important and reasonable proposal when he emphasized that the vocabulary and the instruments of philosophical anthropology cannot reach the phenomena of laughing and crying, and that this is one reason why they need to be replaced by '*Dasein*' analysis.

I mention only to the side that some authors have now pointed out a difference between crying and laughing on this point. There is a debate going on

about the issue of whether higher mammals have the capacity to cry, or whether only human beings interpret the utterances and noises voiced in states of pain and distress as crying. After all, people also moan and whimper when in a state of pain or discomfort, yet we do not equate this with crying, but just like the affects, it is found to be a functionally rational expression, for it signals to others that something is out of order, and sometimes it even makes clear exactly what is out of order. We usually presuppose that only people have the capacity to laugh, and we do not take the grimaces of a gorilla to be laughter. There is, in my view, no such thing as functionally rational laughter. Yet all these are very much debatable issues. Dasein analysis, however, has nothing to do with these issues. Dasein analysis is the analysis of the human condition; it is not interested in genesis in the sense of origination, but only in the sense of *arche.*

As such, let us then begin with the *arche* and forget the question of origin. I will thus start my first approach to the many mysteries of laughing and crying with a purely phenomenological rendering, a bare description of the human condition.

Humans are thrown into the world by accident. We could as easily not be as be. "To be thrown" is, of course, a metaphor, and it is a fertile one. Every person is born with an entirely unique genetic code, being programmed as a genetically certain man or woman. The genetic code is prior to all personal experiencing, and in this sense we can speak of a genetic a priori. To make use of a traditional philosophical language, the genetic a priori is the unity of the singular and the universal. The newborn is a specimen of the human species and an unrepeatable singularity at the same time. The particular (*das Besondere*) is absent. The truth of the above sentence is one we all know from everyday empirical observation. Whenever we are sitting in a train or subway and we smile at an unknown infant, the child either smiles back or does not, yet the reaction of this 3-5 month-old will be the same whether white or brown or black, Chinese or Indian, American or German, and at the same time, it will be a very individual reaction. No sign of culture can yet be detected in the behavior of so young a child; this appears only later. In a one-year-old child, one can easily detect the signs of a particular culture. Now it is this particular cultural manifestation, this kind of mediation between the universal and the particular, that I am going to call the 'social a priori.'

The social space, the culture into which a newborn is thrown, is entirely contingent, insofar as it has nothing to do with the genetic a priori. It is entirely external at the time of birth and prior to all experience. This is why it can be termed a social a priori. The culture which is going to mediate between the singular and the universal is entirely accidental, in view of universality and singularity both. We shall see that this circumstance plays a very important role in

comedies, especially in unknotting the loops of the comic plot, e.g., in Lessing's *Nathan the Wise*, where it will turn out that the Jewish girl is born from Christian parents, and the Christian boy from Muslim parents, yet the girl became a Jew and the Crusader a faithful Christian. The accident of being thrown will thus be my starting point.

Some will object that it is God who throws, others that our previous life has determined us to be born this rather than that, here and not elsewhere. Even these theses would not change the next links in this chain of thought. That is to say, the cultural mediation between the genetic a priori and the social a priori happens in experiencing. The newborn is involved in a task of dovetailing its genetic a priori with the social a priori into which it is born. The environment, that is, the family, community and the natural habitat, have the task of introducing the newborn into the cultural, or the social a priori. Between the two a priories there is an abyss, termed by Gehlen the 'hiatus.' The constantly repeated and repeatable task is the dovetailing of the two a priories, the narrowing of the abyss into a gap. Take the first example of traditional logic, the Barbara syllogism, according to which all men are mortal, Socrates is a man, thus Socrates is mortal, which tells just this story. Socrates, who is mortal like all men, was a unique and unrepeatable man born in Athens at a concrete time from certain parents, and in a certain social milieu, and he became 'Socrates' only there and then. The newborn Socrates was mortal, yet he was not 'Socrates' as we know him, and Athens at the time of Socrates' birth was an Athens without Socrates. His task, the task of his parents, and of his city was a task common to all mortals: to dovetail his genetic a priori to the cultural a priori and vice versa, to bridge the hiatus.

Now here comes my hypothesis. The dovetailing between the social/cultural and the genetic a priori is never entirely completed. To some degree, dovetailing is usually a success. After all, the newborn is also coded for social life without qualification, since whenever dovetailing ends in a total failure, the newborn cannot grow up and cannot survive on its own in the social world into which he or she was thrown. On the contrary, if dovetailing ends in total success and no gap remains, then nothing short of a natural catastrophe could make the world (any world) change; there would be no ethics, history, or culture in its broader sense. Everything that qualifies Dasein is generated in the gap between the two a priories, in the ever-present tension between them.

In my view, both laughing and crying are the elementary answers to Dasein, for they are triggered by the experience of the hiatus, that gap or abyss. In the elementary outbursts of laughing and crying, the impossibility of the task of bridging the abyss is expressed. This hypothesis makes sense of everything philosophers, myself included, have said so far about crying and laughing.

We have learned that elementary laughing and crying are similar to affects. They are expressive, not gestures but spontaneous reactions, and they react to something from 'the outside'; and we have also learned that the expression itself is not culture specific, as many emotions are, but is species specific, innate, and universally human, just as affects are. Yet while all affects have a special ra-

Heller
Three on
laughter

tional function and can be understood as instinct remnants, this account makes no sense in the case of laughing and crying. If we accept my hypothesis, then all the pieces fall into place. If we assume that laughing and crying are answers to the gap, the abyss between two a prioris, a hiatus which cannot be entirely bridged, then it makes sense that they are expressive and spontaneous, involve body, soul, and spirit alike, and also that the readiness to laugh and to cry is innate. It is clear furthermore that they cannot be understood as instinct remnants, for the dovetailing of the two a prioris is an exquisitely human task, the task of Dasein alone; likewise the reaction to the impossibility of the task cannot be understood as a leftover from consummatory behavior. Thus it becomes clear too that laughing and crying have no specific rational function to play, since the answer to the human condition is not functional, but super-functional; it is all encompassing.

But why are two expressions triggered by the tension or hiatus, why not only one? Why laughing *and* crying, why not laughing *or* crying? There are many things which cannot be explained; still, I will try to formulate a second hypothesis as a tentative answer to this question.

I will again begin with elementary, everyday, empirical observations. There are two extremely difficult and critical periods in childhood (at least in our contemporary Occidental cultures), two points in the process of the dovetailing of the two a prioris during which the hiatus aggressively makes itself felt. The first starts from birth and ends with the mastery of language, and the second ranges from late childhood to early adulthood (now called the world of teenagers). As everyone knows, the first period is characterized by crying, the second by laughing. I cannot speak at this time about the differentiation of crying in childhood; I want here to remark only that whereas elementary spontaneous crying starts right from the beginning (birth), elementary laughter appears relatively late. It is a common experience that teenagers burst out in laughter at any possible or impossible situation, that they are constantly giggling and guffawing, while they normally cry far less frequently.

Let me go on a bit in establishing the support of common observation, now as regards adults. Elementary, spontaneous laughter is a collective, social phenomenon, whereas elementary crying is solitary. Crying remains solitary even in the society of others. The person who bursts into elementary crying is closed into herself; she does not notice others, not even, for example, in the cemetery. If a woman tells a man who is in love with her that she no longer loves him, he can burst into elementary crying, but his crying will be solitary; he will not be able to help it, and he may not even notice the reaction on others' faces, or he will not care. When someone cries in order to give a kind of impression, to influence another, then her crying is not spontaneous or elementary, because cognition and the awareness of the situation are already inbuilt. If we encounter a person on the street and see him crying, we know that he is alone and does not notice us at all. This is natural; we understand.

But laughter is, so to speak, collective. We laugh in the company of others; we laugh together. We laugh in the theater, and among friends. Laughter is not just solitary, it is also contagious; when one person starts to laugh, another often laughs at the sight of him, and then others, until everyone present bursts out in laughter, and no one can stop, even if they try. A person who is good at making others laugh is like someone who throws a burning match into a haystack. Soon the whole haystack is bound to burn. Yet if we see a person walking along the street who is just laughing to himself and for himself, we do find it odd. Perhaps he has told himself or just heard a joke; otherwise we think he has a screw loose.

Why these differences, if both crying and laughing are reactions to the impossibility of bridging the two a priories? No empirical observation reaches this question, not to mention a tentative answer. So let me try out another angle.

Crying is frequently associated with sentiments. Like spontaneous crying, elementary crying is triggered by a sentiment or a situation which generally evokes certain sentiments. Let me experiment with the following hypothesis. The crying person, although closed into herself, stands in relation to a sentiment. Let us imagine that this sentiment is empathy. One might say that in a broad sense crying is the expression of empathy with ourselves and with others. I have elementary empathy in mind. I could describe elementary crying as an empathy felt for myself, for the impossibility of leaping over the gap which divides me hopelessly from others. One can also burst out in elementary crying out of an empathy with others, who themselves despair about the impossibility of leaping into any state of total identification with others. Elementary crying is thus despairing over the hiatus, mourning the abyss one cannot understand, for one has no language and no concept to understand it. One just feels it. Elementary crying despairs over the absurdity of the human condition.

Elementary crying is also therapeutic. After 'crying ourselves out' we are again ready to establish contact with certain others. After the recognition that the hiatus cannot be swept away, even less wished away, one can enter into a relative compromise with the human condition. Indeed, one usually does.

As we know, we are far from being alone when laughing. We not solitary; we share the company of likeminded others. We laugh together and we also laugh at something or someone together. We make fun first of those who obviously fail to meet the requirements of the social a priori; second, we laugh at those who believe that they have jumped over the abyss but obviously have not; third, we make fun of those who do not notice the abyss at all; and fourth, we laugh at those who do not accept it. In the first case, we laugh at the stranger, at a person who uses the wrong cutlery in a banquet, or at a stammerer, who cannot keep up with the pace of conversation. In the second case we laugh at the self-righteous, the fanatic, the overly confident person, and so on. In the third case we laugh at the empty-headed conformist, who constantly and unthinkingly repeats banalities and who keeps rigidly to the rules. And in the fourth case, we laugh at the misanthrope, the person in a constant rage or full of unfounded hopes and ideas, and we also laugh at jealous people, and at all the chasers of the

unconditional. In the second and the third cases, we laugh solely at another or others; in the first and last case, one frequently laughs also at oneself.

So laughter is rational. But what does it mean? In the first approach it means that by laughing we keep a distance. We distance ourselves from others and may also distance ourselves from ourselves. Laughter is judgmental; with it, we pass a judgment. In this sense, laughter is the opposite of crying. There is no empathy in laughter. In the case of one type of laughter, bitter laughter, this contrast is symmetrical. Just as elementary crying expresses despair over the human condition as one of distance from the other, of the impossibility of really knowing the other or being one with the other—bitter, elementary laughter expresses a certain despair at our very inability to distance ourselves *enough* from the world, or from the other. Both are thus expressions of impotency. Yet laughter is, of course, not always bitter, indeed it usually is not. Normally, we associate crying with sadness and laughter with merriment and good cheer. In such 'normal' cases, the contrast between crying and laughing is not symmetrical. But in all cases, laughter means to keep a distance, to step back, to alienate rather than to identify with, and even to separate from the very desire for identification. Still, as I have implied, this distancing from our desire can be rather ridiculous. And we laugh at this ridiculousness—but the ridiculous is not that which laughs, except in the case of self-irony, which I will discuss later.

Keeping a distance is the first constituent of rationality in laugher. There is no sentimental laughter. As was said, laughter is, according to Nietzsche, the nail driven into the coffin of the sentiments. This is, however, only a negative description of a kind of rationality. In laughing, we do not identify ourselves with our solitary soul, nor with the solitary soul of another. Then with what do we identify, if anything? In fact, we identify either with the social a priori represented by the community of laughers, or with the gap I have described as arising between the natural and social. So somehow, we do identify ourselves with an eye, a gaze, a regard we perceive as present. But then what kind of rationality could this identification be?

To formulate an answer in positive terms, I will employ a category coined by Max Weber: *value rationality*. Laughter is, as we have seen, also a judgment. When laughing at something or someone, we devalue this very thing or person. If a person says something stupid or uses language in the wrong way unintentionally, we laugh, and we thereby devalue the person not as a whole person, but at least as a language user. We often apologize in making the required distinction: "I did not laugh at you but at what you said; you are not ridiculous, just what you said and how you said it." Or we can devalue the person and the thing done simultaneously, e.g., when someone overdoes obedience to an already discarded custom. Laughter can also revalue or even highly value an action. By laughing with a person who has a good sense of humor, we do indeed value her higher. Thus we are laughing from a value position, even if we are perfectly unaware of it. And we may also laugh for or against some other value, since

laughter is a judgment. Admittedly, in a great company of laughter, only the initiation of laughter is clearly judgmental, given that laughter is contagious and that those who follow suit are sometimes not only ignorant of the thing that first provoked laughter, but may never know and never even want to know of it. Yet this funny circumstance—that laughter is judgmental, that we usually laugh from a value position, and that we are frequently ignorant of the first cause of our communal laughter—by no means contradicts the thesis that laughter is value rational. For if we participate in a community of merrymakers, laughter itself becomes a value; it becomes an identity-constituting, cultural, and social value. In this capacity, laughter is, or can be, a value in itself; laughter can be an end in itself.

Although I cannot speak while actually laughing, I can always explain why I was laughing afterwards. I may mention a ridiculous object or act, or simply the heartfelt laughter of everyone around me. Naturally, I can also lie. I can lie when accounting for the causes of my crying, too. But as regards crying, I do not always know why I am overcome; moreover, I can only very rarely fully explain the cause of my tears. Laughter can also be founded or unfounded. This is also why laughter can be criticized, while crying hardly can be (with the exception of blackmail-style crying, or guilt-tripping). Crying has, for the most part, nothing to do with truth or falsity, goodness or badness, power or freedom. But laughter is intrinsically connected to all of these. Crying is neither moral nor political. Laughter is both. Since it is value rational and judgmental, I can kill with laughter; laughter annihilates and humiliates, yet it also recognizes, assents, protests, and negates. In sum, laughter always has meaning; it always means something. One can cry out in anxiety over nothing, yet one cannot laugh about nothing. Laughter is an unwilled, unmediated, and total expression, comprising body, mind, and spirit. It is the sole such expression which is not functionally rational (as disgust or rage are), but value rational.

The statement that original, spontaneous laughter is (unlike the affects) not functionally rational does not mean that it lacks any rational function, but that laughter itself is not just a function. Philosophical and psychological theories of laughter generally dwell on the functions of laughter, which are, as might be expected, not exactly specific. Laughter can kill, yet it can also have different therapeutic effects. For example, laughter can reassure someone (if we laugh together with him); it can alleviate sadness and grief; it can make people aware of their own foolishness and invite them to join the laughter; it can loosen tensions; it can function as a sanction, by lifting one's own internal censor (and to this issue I will come back in the chapter on jokes); and it can make us feel free in thought, although we are not free in fact.

When I associated laughter (among other things) with power or domination, I trod a well-known path, namely that of Hobbes' theory, which was mentioned. In Hobbes, the clever man laughs at the stupidity of the stupid from a position of superiority, and he strengthens his position of superiority through his laughter. A fool may also laugh at another fool, for laughter puts him in a relatively brighter position. One laughs too from a position of moral power; in laughing at a person

who holds much political and martial power, one can gain or practice moral power. The convicted can laugh in the face of his judge, the person awaiting execution, in the face of his executioner. A woman once told me that in a concentration camp, an SS soldier commanded her to kneel down, for he was going to shoot her. When, instead of pleading for her life, she started to laugh in the man's face, he became so embarrassed that he suddenly walked away. Permission to laugh used to be a kind of privilege. The slave could not laugh at a master without meeting hard social restrictions, even if sometimes punishment could be avoided. Equality among citizens abolishes, among other privileges, also the privilege of laughter (or laughter as a social privilege); this, however, does not prevent private cases of authorization and restriction.

In support of the rational character of laughter, I have associated it with truth and falsity, justice, and injustice. If someone just comes up with some nonsensical scientific theory, especially one supported by institutions, we laugh at the scientist as a scientist, at his theory and at the institutions senseless enough to support him. Conversely, if we see the public or the scientific community treating a promising new theory with spite and groundless disbelief, we laugh at their scientific prejudices. There is conformist laughter and also protest laughter; both are judgmental and both raise claims to truth or rightness.

Spontaneous, non-rational, pure, original laughter resembles (in the context just described) an unexpectedly rational communication or argumentation. We know that a statement can be both defended and rejected with rational arguments. Arguments and counterarguments can be good or bad alike; they can be equally right or wrong, valid or invalid to the same degree. Conformist laughter can marginalize and ridicule nonconformists, whereas nonconformist laughter can equally marginalize and ridicule conformists. Laughter is not a so-called 'objective' value judgment, yet its appropriateness can prove true; its judgment can prove to be right. Accordingly, it can be also an untrue, wrong, and unjust judgment.

Thus, laughter is value rational and, in this sense, it is judgmental and associated with power on the one hand, and is true or untrue, right or wrong, just or unjust, on the other hand. Even if laughter is not functionally rational in itself, several functions are normally attributed to its effects. Still, laughter cannot be described as a means to an end, or at least spontaneous laughter cannot be understood as such. We do not make decisions about laughter; we do not choose consciously between laughing and not laughing; we do not deliberate about laughter. That is, we cannot decide whether we are going to laugh or not, and as a result the category of instrumental or purposive rationality can hardly be attributed to laughter. But what about the different institutions and genres which make us laugh, from the king's fool or jester to a dramatic comedy or a joke? It is obvious that making people laugh is the purpose of all those institutions and genres. And it is said that those genres use laughter in a purposively rational way. They make us laugh in order to correct our morals, to teach us the use of

good common sense, to warn us of dangers, etc. I do not think that such is actually the purpose of comic genres, yet even if it were, we would still not speak about the purpose of laughter as such. We could hardly say that laughter itself is the means to a certain end, but just that the trigger of laughter (the comic play or joke) orients laughter in a way that should serve this or that noble or ignoble purpose.

Since laughter is social, cultural, and collective, and at the same time is judgmental, it does not surprise us that laughter may require permission. I have already mentioned that without such permission, laughter meets with social prohibitions. This means that spontaneous, original, unwilled laughter is also kept within limits. The 'how,' the 'with whom' or 'against whom,' the whole situation of laughter circumscribe. Here one sees an important difference between laughter and crying. Crying is either allowed or not allowed; to some it is allowed, to others not. For example, Pericles was reportedly highly esteemed because he did not cry at the news of the death of his sons. Men are men only if they do not cry, in certain cultures, while women can cry profusely. But the occasion for crying is indifferent as its trigger. In the case of laughter, precisely because of its social character, the situation is entirely different. During the time of acculturation, men and women learn about the relevant 'situations.' In this situation, one should not laugh, while in that situation, one may laugh, but only in a subdued way, and in other situations again, one can laugh freely and loudly. There are also situations in which laughter belongs to good manners or good taste. If one is addressed by people and genres specialized to make one laugh (a comic or a self-pronounced joker, or a comedy), it is in good taste to answer the address with laughter. Even in Aristotle's ethical ideal, the *megalopsuchos* (the big-souled or magnanimous person) should not laugh generally, but in the theater he gets permission to laugh, for here laughter can do no harm to his moral dignity.

Normally, one is not allowed to laugh during a church service. Nowadays, one is considered a barbaric or uncouth person for laughing at the sight of a hunchback, a dwarf, a Jew in a caftan, or even at a foreigner who uses unsuitable words and the wrong grammar. Indeed, one is supposed to act as though several deformities which were once free targets for laughter are not even of notice. These abnormalities were objects of laughter during times when people lacked permission to laugh at their parents.

Henri Bergson is right when he remarks that neither plants nor animals can be ridiculous per se; that is, they do not makes us laugh unless we recognize human features in them, as our own deformities. There never was, nor can there be, censorship in those quarters. We always have permission to laugh at monkeys, even when they were (and still are) sacred animals. Since I am ignorant of the role animal deities played in polytheistic religions and services, I will leave the question open as to their amenability to laughter. Still, I believe that if animals are taken as animals, they cannot be ridiculous, for not only the laughter, but also the laughed-at, must be confronted in some way with our distinctly human condition; both must cope with the abyss. Kant mentions a so-called

"instinct of reason." Now I advance the result of my entire inquiry: it is laughter that is the instinct of reason.

Laughter and crying, as the empirically universal expressions of the human condition, are registered in all sorts of cultural creations. There is of course a difference between theoretical and narrative registration, as there is between registration and triggering. I have mentioned that the philosophical tradition reflects only sporadically on the comic phenomenon, and (until the twentieth century) even more sporadically on laughter. I have also mentioned that narrative reference to laughter is already registered at the birthplace of philosophy, in the story about Thales and the Thracian maid. As I have said, this story points at the 'high' comic in contrast to the 'low' comic, at the funny position of philosophy and the philosopher, who is suspended between earth and heaven, just as Aristophanes presented Socrates in *The Clouds*. This story has a deeper message. It tells us that philosophy can make us laugh even if its task is by no means to trigger laughter. It can make us laugh just as Thales made the Thracian maid laugh. In this case, we laugh spontaneously and spontaneous laughter is then the laughter of common sense, which does not care about the abyss, or about ignorance; it does not even take notice of these. Yet philosophy can also trigger another kind of laughter, the laughter of understanding, of grasping the paradox. Philosophy can make us laugh at the human condition itself; that is, philosophy can replace laughter, since it can tell us something that otherwise is expressed in laughter. Philosophy can tell us in words what laughter cannot express in words, namely the unspeakable.

Laughter as an answer both to 'low' and 'high' comedy is registered from the beginning of our culture, that is, in our master narratives. Here I refer, of course, to Homer and to the Bible. With the term "Homeric laughter," one refers to the laughter of the Gods, as they are portrayed laughing heartily at each other in both the *Iliad* and the *Odyssey*. In both works, they laugh over Hephaestus, the ugly metalworking god with a limp. In the *Iliad*, they just laugh at his limping. In the *Odyssey*, the triggering scene of laughter is far more complicated. Hephaestus, who is being cheated on by his beautiful wife, the goddess of love, Aphrodite, invites the other gods to be witnesses to the injury inflicted upon him by his wife and her lover, the god of war, Ares. The gods arrive and thus become witnesses to Aphrodite's lovemaking; they find her caught with Ares in a secret net wrought and laid by Hephaestus. They burst out laughing. At whom are they laughing? At Hephaestus, of course. Now not just because of his ugliness and limping as in the *Iliad*, but because of his jealousy, his inability to control or satisfy his wife, and his stupidity in inviting witnesses to his shame. (Apollo and Hermes quickly agree that they would happily suffer the net in exchange for sharing the bed of Aphrodite. They neither laugh at nor judge Aphrodite or Ares with derision.) But in addition, the gods do laugh at the love-

making (and its interruption), which is generally ridiculous for uninvolved ob-
servers. In just this scene, we catch a few themes as structures which will come
to be typical in comic genres, especially in comedies. We will meet the same
theme and structure for example in Molière. In Homer's poems, it is not only the
gods, but sometimes also the heroes who laugh, and then the hero's laughter is
very 'Hobbesian,' since they laugh mostly when they succeed in victimizing or
humiliating their enemies.

In the Jewish Bible, laughter is first registered at the thought of the birth of
Isaac. The story begins when God promises Abraham that his wife, Sarah, will
give birth to a son. Upon hearing this news, Abraham falls on his face and
laughs. The laughter continues when three angels approach the tent of Abraham
and one of them promises that Sarah will bear a child in the next year. Here it is
Sarah who laughs, asking how, withered and old as she and her husband are,
they can still generate a child. The Lord asks Abraham why Sarah laughs; he
asks if the pair believes that there are things impossible for God. And Sarah
denies that she was laughing at God. Still, the name of her son is to be Isaac,
"the one who laughed." In this story, the humans (the man and the woman) are
laughing and not laughing at the gods. They do seem to laugh at God, or more
precisely not at God, but at the absurdity of God's promise. The relation be-
tween laughter and absurdity, impossibility and incomprehensibility, is here
indicated.

The two kinds of laughter, Homeric laughter and biblical laughter, are two
extremes (opposites) in the breadth of laughter. Homeric laughter humiliates the
inferior; biblical laughter expresses a lack of faith in the superior's promise. The
first is a merry laughter, the second a laughter of doubt and despair. Yet there is
an unmistakably common feature in them: their rationality.

In the case of the *Odyssey*, it is the irrational invitation of Hephaestus that is
utterly ridiculous. But in laughing at the open cuckoldry of Hephaestus and at
Aphrodite's lovemaking, the gods also laugh at themselves, for they are also
gendered, sexual creatures; they too want to make love, they too become jeal-
ous. Abraham and Sarah laugh at God's promise, which is by all human meas-
ures utterly irrational, yet they also laugh at themselves, at their own lack of
faith and lack of generative power. The absurd is irrational by definition, but
when what is irrational is an absolute faith, it is not absurd. For what is ridicu-
lous is a person's desire to know the reasons for and possibilities of the absurd
and impossible, not the person's faithful acceptance of incomprehensibility.

Yet to register laughter, to reflect upon laughter, to tell stories about laugh-
ter is one thing; to make people laugh on purpose is another thing still. Cer-
tainly, phenomena and works which were not meant to provoke laughter can
indeed trigger laughter if the observer or reader perceives them as ridiculous
(because stupid, pompous, etc.). In such cases, there is no difference in whether
we laugh at the Soviet philosophical Encyclopedia (as my friends and I did in
our youth), or at tasteless clothing or furniture. What has been received in utter
seriousness at one given time can become a laughing stock for another genera-
tion.

Philosophy can be ironical and experimental with humor, yet its aim is to make us think, not to make us laugh or cry. This is true even of post-metaphysical philosophy, like the philosophy of Nietzsche. Zarathustra himself is constantly laughing, and there are many parodies in Nietzsche's works, first and foremost in *Thus Spoke Zarathustra*. Moreover, the aphoristic genre is especially apt for triggering laughter, but still, we do not laugh at Nietzsche's text, nor do we cry. The substitute character of philosophy is not just preserved, but it is also made explicit here. The absurdity, the very impossibility of leaping over the abyss between the two a priories is expressed in thought—in the thought of philosophy.

The Christian religion developed an even more negative attitude to laughter. In the Middle Ages, scholars debated the issue of whether Christ laughed at all during his life on earth. The majority accepted the position that he never laughed. In the Christian tradition, it is Satan who does the laughing. He laughs at us, human creatures. It is the Enemy who laughs and who also makes us laugh. Laughter was not generally excluded from religious practice itself, though. I refer again to Bakhtin's discussion of the fool's day, the carnival, the parodies of the Last Supper and the grotesque handling of the saints' stories—all accepted supplements to everyday religious practice.

All kinds of activities and objects which we sum up with the word "art" have an entirely different relation to laughter than to crying. The two expressions do not at all occupy equally important positions in the artistic genres. Whereas all artistic genres have a comic or humorous version or language game, meant to provoke laughter, this is not true about crying. The so called 'high' arts, that is, the kind of arts which are open to practically infinite interpretations, all have comic versions, and do trigger laughter. None of them aims to incite crying. If crying does happen upon an encounter with such a work of art, it is an accidental side effect, as unintended as laughter would be in response to a work of philosophy or tragedy.

Yet crying is not the proper or intended answer to tragic drama either. Elementary crying is, as we know, solitary; there is no distance in it as such, but rather an intensity of feeling that I described as empathy. One who does burst out crying empathizes up to a degree of identification with herself or with someone else. Aristotle offers the hypothesis that tragedy purifies the watcher/listener from fear and pity. Through empathy with the tragic hero (which is far from being an act of identification), the watcher/listener distances himself from his earlier self, and this is how the affects are transformed into rational emotions. This is exactly what cannot happen in elementary crying. Certainly one does not need to accept Aristotle's hypothesis. I want only to indicate that catharsis does not imply crying. If one bursts out laughing when watching or reading a tragedy, then one receives the work as a kind of kitsch. Or, alternatively, if one cries, thinking of oneself, on the occasion of watching or reading a tragedy, this crying becomes a mere side-effect. I mention this problem in conjunction with the

example of tragedy, because here we have inherited a theory of purification from Aristotle. But what is true about tragedy as a drama is also true about poetry, music, film, painting, and much else. The horse of Achilles cried, but we are not supposed to cry about the crying of Achilles' horse. An actor burst out crying at the fate of Hecuba, but Hamlet did not; he began instead to ruminate on the crying of the actor. We do not cry when listening to the story of Little Red Riding Hood; not even children do. A musical expert would be nervous if his friend cried while listening to music. It is, indeed, an inadequate and certainly an unintended response to art. Still, there is no reason for being upset about or preaching against regressive listening, even if this kind of listening is in fact regressive. One cannot eliminate side effects from the reception of works of art.

There are, however, genres which are specialized for making people cry. In current English terminology, these are the "weepy" films, books, and plays. And this is a 'low' genre, belonging to the cluster of works of entertainment rather than to that of art. Genre may not even be an apt category for the weepies. For a weepy can be a melody, a drama, a television series, a play, a film, or a novel. Weepy is not simply entertainment, but neither is it simply kitsch. The entertainment industry prefers sitcoms at the moment, which are specialized to induce laughter. There is kitsch in painting and even in architecture, but there is no weepy in those genres.

Contrary to crying, laughter is elicited by a great variety of genres of 'high' art. Furthermore, high art can trigger laughter on many levels of the ridiculous, from the base to the most sublime. And sometimes the same artist presents both the basest and the most sublime text, story, act, language game, or pun as an occasion for laughter. Think, for example, of Beckett.

And why? Why is there no 'high' art which specializes in stirring crying, why only in arousing laughter? I can leave this question open, but my hypothesis is self-evident: high art excludes total identification with ourselves, with the world, and with someone near to us; it excludes the complete overcoming of distance; indeed the reception of high art presupposes distance. Distance from ourselves and from the world. Since laughter presupposes such distance, high art can, through its intrinsic character and value, elicit laughter but not crying, if the reception is adequate to the genre. Since in this book our subject is the comic, I will leave this question behind.

I have one last remark: artworks can neither laugh nor cry. Sometimes people say that music cries. But even if it did (which I doubt), this has nothing to do with elementary crying, only with the 'mimesis' of crying. The fact that fine arts neither cry nor laugh is obvious. It is less obvious that the presentation of pure laughter and crying is impossible in painting, sculpture, and architecture; of the visual genres, it is possible only with the medium of film. Only language can wholly evoke laughter and crying, but language, as we know, neither laughs nor cries, if for no other reason then that while crying or laughing we cannot speak. Diderot said something similar in his essay on the paradox of the actor. Yet language succeeds in transforming and transmuting laughter and crying. The

universality of the medium of language allows it to do something that it is not doing: it says it is crying, but it is not crying, just giving the illusion of crying. Language may say there is laughter, but it is not laughter, but the illusion or representation of laughter. Crying out "Oh! Ouch! Ah!" is not crying; shouting 'Ha-Ha' is not laughing.

High artistic genres can make us laugh. They offer not just the permission to laugh, although in certain ages and circumstances they do this too. They do not address their audiences with the words, 'you are now allowed to laugh', but more with an unspoken injunction: 'do laugh!' Do laugh not in general, but at this or that; do laugh at these shortcomings and those vices, stupidities, and paradoxes. Comic genres do not intend moral betterment, but they can carry a moral message as much as political message.

The greatest powers and assets of comic genres (like every power) can be misused. One can use comedy for purely political purposes, be they noble, less noble, or even ignoble. In the Austrian/German stage of the nineteenth century, the Jew was generally presented as a comic figure, whereas the Negro was the typical comic character in America at the same time. One might say that this happens in 'low' rather than 'high' art, and that these works will be fast forgotten, and this is generally true, but it is by no means entirely true.

The political ambiguity of the comic artwork can also imply moral ambiguity. Indeed, in a comedy the evil character will be the loser, the good victorious. The wicked puppet will be beaten and cry 'ouch!' But who is really good and who wicked, in such a show? This ambiguity, however, has nothing to do with comic artworks, but with the status of morality itself. But to discuss this issue further is beyond the scope of this book.

Making people laugh is an institution, or better said, it implies a whole family of institutions, from the king's fool through the circus clown, up to the writer of comedies, comic novelists, stand-up comedians, and so forth. Maybe the one who makes others laugh does not laugh, but perhaps he does; perhaps the relation is reciprocal (as in telling jokes), though it need not be. In any case, whenever we laugh, expressing merriment or despair, happily or ironically, it is the hiatus between the genetic and the social and the cultural a priori that cannot be eliminated. Merry laughter gives assent, bitter laughter mourns; one says yes, the other no, but they speak without speaking about the same experience. As Wittgenstein said twice, the world of a happy man is entirely different from the world of the unhappy man. And so is their laughter.

Chapter Three

The Comic Drama

I begin the discussion of the various comic genres with that of the comic drama because, at least in our Western culture, this is the genre with the longest history. I would not say that this comic history is entirely continuous, since there are long historical periods without comedy, but it is a continuous history in its patterns, for some basic structures of the comic drama have not changed in roughly two thousand years. I will speak about the comic drama in three steps. First, I will explore the specificity of comedy within the wider family of comic genres; second, I will inquire whether there is a historical or perhaps even an ontological connection between comedy and tragedy; and finally, I will discuss the common substantive and formal features of comedies, independently of the times of their conception. Before jumping into deep waters, I should sum up first a few things already said about laughing and making others laugh.

1. We can laugh at someone or something without anyone making us laugh. Such was the case of the Thracian woman. This kind of laughter does not require a sense of humor.

2. When someone makes us laugh, we laugh at the character who makes us laugh, e.g., a clown. In this case we laugh about him yet also together with him.

3. Someone can make us laugh about someone or something else. Here, the person who makes us laugh is not the butt of our laughter. This happens when someone tells a good joke. We laugh at the joke's punch line, not at the joke-teller. We also laugh together with him, as a kind of appreciation of his narration.

4. The person who makes us laugh is witty, has a good sense of humor, entertains us with puns and remarks, and otherwise induces a merry mood. In such

a case, we laugh together with the person who makes us laugh, and such laughter generally has no concrete target.

The comic drama combines each of 1-4 in its ways of making people laugh. Appreciation of the presentation of the ridiculous itself requires the presence of a kind of sense of humor. And who is the one who makes us laugh in a comic drama? Suppose it is the author of the comedy. This is a sensible presupposition, if for no other reason than the important function of parabasis in comedies since Aristophanes. An actor, in the name of all actors and of the author, steps out of the plot, directly addresses the audience, and asks for its applause. With this gesture, the author or the actor (and they can be the same person) claims for himself the role of a successful humorist or clown, one who has invented, modified, or varied the plot. The acknowledgment of his merit lies in having a good time.

But in fact it is not the author of the comedy who makes us laugh, because it is not together with him that we laugh, and he certainly is not the butt or target of our laughter. Generally, we laugh together with certain characters of the play, and we laugh at certain other characters. The author of the comedy plays an entirely different role than the teller of the joke. He is not the one who speaks (except in a parabasis and perhaps in the prologue and the epilogue); rather, his characters, the actors, do the speaking. And there is normally not one single character who makes us laugh, but several. Moreover, making us laugh and being the butt of laughter are not two strictly divided roles. The same character that makes others laugh can also become the target of laughter in another situation.

There is also a point in a comedy, namely the happy ending. A happy ending is not, strictly, a punch line. Rather, the point satisfies us in the end, injecting in us a happy mood, but the comedy needs to be funny from the beginning until the end to be successful as a pure comedy. A kind of point, or several points, are needed in every dialogue or verbal riposte within the wider whole. In a comic drama, there are always witty men or women, good at verbal duels or punning, who offer many an occasion to the audience to react with laughter or at least with an appreciative smile. In Shakespeare, this is so even in cases when at the moment in question, the main plot is still tilting between tragedy and comedy.

There are also clowns in comic dramas. Some of them play the fool, entertaining us with the tricks of clowning. Yet the most ridiculous clowns of comic dramas are those who misinterpret themselves entirely, who take themselves completely seriously. All words they utter sincerely are humorous for their listeners or recipients. The recipient is not quite identical with the audience, for since the Renaissance, comic players can also assume the position of a quasi-audience. Laughter takes place not only in the theater, but also on the stage itself. Players can make fun of each other for us and for themselves.

The combination of all the varieties of laughter is what makes comedy suitable for development into a "high" genre. Certainly not all comic plays belong to this "high" type. In order to really develop into a high comic genre, a comedy

needs first of all to become the carrier of a kind of moral taste. In putting stress on moral taste, I do not want to tackle the frequently discussed issue of whether comedy is, or need to be (whether wittingly or unwittingly), instructive in a moral and political sense, either by showing the "right" thing or unmasking the "wrong" one. The laughter of a vulgar person is also vulgar. But laughing at vulgarity is not vulgar. The vulgar person will guffaw when some character gets trashed by another. In almost all "Latin" comedies (I include here Italian and Spanish comedies) someone gets a trashing. The audience laughs. But vulgar laughter is transmuted into aesthetic laughter within particular situations that contextualize who gets trashed and why. One can laugh at the punishment of a villain, yet one can also laugh together with (or in favor of) the person who gets trashed. This happens when, e.g., Scapin is trashed. We sympathize with him, we laugh, yet we also wish him well, because he is the kind of shrewd fellow who helps young people in love. To stay with examples from Molière, the stuttering doctor (in *Love as Doctor*) is not ridiculous because he stutters, but because he is a blockhead swelled with self-importance; his stuttering just enforces the absurdity of what he says. One could object that in Aristophanes this kind of ethical taste is not yet discernible. Indeed, in Aristophanic comedies there are vulgar, grotesque scenes aplenty. But they inevitably serve the developing political rhetoric, and in addition, those scenes are bounded by refined lyric poetry sung by the chorus.

At the end of Plato's *Symposium*, Socrates remarks to Aristophanes and Agathon, or the comic poet and the tragic poet, that the same person could write both tragedies and comedies. For the present time we can take this remark in its literal sense and add that Plato had to wait almost two thousand years to see his wish fulfilled. Some might object that a few dramas by Plautus can also be interpreted as tragedies. It is beyond doubt, though, that since the time of the Renaissance (perhaps from Shakespeare onwards), a tragedy writer will also frequently create significant works in the genre of comedy. And so it is later with Lope de Vega, Calderon, Diderot, Lessing, Kleist, or G. B. Shaw. Even Molière is the author of at least one tragedy.

But this is perhaps only a symptom of a more interesting connection. It is well known (or widely agreed) that great tragedies are rare. After the three great Greek tragic poets (the works of other ancient Greeks being lost), we had to wait until the Renaissance for any continuation of the tragic drama. After the Renaissance, though, the chain was not entirely broken until the twentieth century, not until after Ibsen. It looks to us as if the same could be said about comedies, whether the same person creates both or not. Aristophanes, the best-known inventor of the comic theater, lived close to the times of Euripides, who he loathed. I mention only as an aside that the position of Aristophanes as a latecomer made several philosophers, from Hegel to Marx and Lukacs, believe that comedy must come after tragedy in a historical sequence. But this is by no means the case in modern times, nor is it true about Roman dramatic art. Both

Plautus and Terence lived in the last century of the Roman Republic, and they were followed by Seneca, the greatest Roman tragic poet (although he cannot be measured with the Greek yardstick). The later times under Imperial regimes did not produce comedies, nor did the Middle Ages. The rejuvenation of comic art instead happened simultaneously with the rejuvenation of tragic art. In fact, it was on these waves of simultaneous rejuvenation that a new genre, the opera, was born. It should come as no surprise that at roughly the same time the story of the opera *seria* and the opera *buffa* begin, and that—just as in the genre of the drama—the same composer frequently wrote comic and serious operas alike.

So what is the reason for the shared fate of comedy and tragedy? One could answer this question simply by pointing out that comedy and tragedy are both dramatic genres. Comedy appeared simultaneously with tragedy in times advantageous for drama in general. I would not reject this explanation. But I would give a second thought to the phenomenon of the conspicuously regular presentation of the comic during the Middle Ages, and the total absence of any presentation of the tragic at the same time. Although no new comic dramas were created in Medieval Europe, the comic presentation still played a socially and culturally significant role. Let me again refer the reader to Bakhtin. Surely not just tragic drama but the tragic as a phenomenon of life remained unthematized in the Christian universe, where the concept of Fate was roundly replaced by the concept of divine Providence. Absolute faith in redemption excludes tragic life experience. The saint cannot be a tragic hero. Walter Benjamin says something similar about the non-tragic character of the Baroque *Trauerspiel*. The slaughter of kings and princes does not transform a drama into a tragic play. The concept of drama is broader than both tragedy and comedy together. Accordingly, there is still drama after the demise of both tragedy and comedy in the traditional sense.

Thus one can simply accept as a brute fact, or a truth without any explanation, that times favorable to both comedies and tragedies are rare, and in which tragedies and comedies appear simultaneously. But let us go one step further and raise the question of whether there is something held in common between the times wherein tragedies and comedies flourish simultaneously. As a follow-up question, let us ask why the same poets did not write tragedies and comedies in ancient Greece, why this possibility had to be first raised by Plato, and, finally, why this changed from the Renaissance onwards.

Let me advance a hypothesis. Both tragedy and comedy are born in times when the order or hierarchy of values gets shaken or severely questioned; both arts come about during periods of turbulence in which previously held beliefs and ideals become uncertain, unstable, and labile. Yet while in tragedies the clash of at least two sets of values (or the presentation of one set of values and the denial of all others values) is displayed by significant individuals, who go to the extremes in their conflicts and are usually thus destroyed—in comedies it is the noble and ignoble conceptions of the lives of average men and women that collide. And the very same conflict is peacefully solved, even giving satisfaction to the carriers of the nobler ideas. Aristotle almost, even if not quite, distin-

guished between tragedy and comedy in this very way. In view of modern drama
though, a few corrections are warranted, and will be raised in due course. For
the moment, we must return to our comparison.

Tragedy confronts us with death, it presents living towards death—whereas
comedy confronts us with life, it presents living towards life. It is obvious at a
glance that death does not even exist in most comedies. Comedies are written
against death. The first great comic writer, Aristophanes, was a propagandist of
peace. In a comedy, war is not heroic, and the warrior is not a hero. There are no
heroic conquerors. The sole glorious war in comedies is the war of the sexes,
which can end in pleasure. Among the key players in a comedy, no one dies.
When someone does die, it has a comic or good upshot in the play itself, as
when the main characters of a comedy, its lovers, inherit a big sum of money
(take, e.g., Shaw's *The Arms and the Man*). To fake dying or death and to come
to life "miraculously" is a frequent, favorite motif of comedies. Moreover,
among the comic characters no one is sick, yet they often fake illness or are
hypochondriacs (*Le malade imaginaire*; *Too Good to Be True*). Whenever the
heroes of comedies suffer, they suffer either from love, which will be later re-
quited, or from a paternal or marital tyranny, which will later be shamed or
corrected, or they undergo a misunderstanding which will be clarified, such that
all get what they deserve. In tragedies great and noble causes are generally de-
feated; in comedies small, very human causes will win the day. In this manner,
comedies "compensate" for the tragic worldview. Tragedy and comedy are two
perspectives, two positions from which we can take a good look at our world. To
paraphrase Hegel: in just the way we look at the world, the world will look back
at us.

Indeed, comedy presents being toward life, being against death. Fans of
Heidegger would immediately tell us that the main characters of comedies are
therefore inauthentic beings. Indeed, some of them are, but others are not.
Comedies are played out in the world of finitude, not of infinitude, in the world
of limits and not in that of the unlimited. There are compromises in comedies,
not absolutes, conditionals and not one unconditional. The heroes and heroines
of comedies do not care much for power; they covet happiness and some
money—as one, if not the most important condition of happiness. One could
even add that comedy is a sad genre, since being satisfied with compromise and
the conditional may look sad in comparison with the challenge of the absolute
and the unconditional. True enough, that is also sad, but it is also merry and
funny in both respects. We laugh, with such comedy, at ourselves, at our occa-
sional pettiness, our loves and jealousies, our pleasures and pains. While in a
tragedy we take pleasure at the experience of the sublime, in a comedy we mark
the experience of human frailty. When in Terence's comedy *The Self-Torturer*
the main character, the spirited epicurean Chremes, remarks to his brother
"homo sum: humani nil me alienum puto" he offers us the first key that opens an
access to the treasure trove of comedies. And we are offered the second key in
Shakespeare's *As You Like It*, when in the forest the gay company of exiles sings
in the voice of Amiens: "Heigh-ho! Sing heigh-ho! Unto the green holly–Most

friendship is feigning, most loving mere folly: Then, high-ho, the holly!–This life is most jolly."

Comedy knows no contradiction between reason (good sense) and sensuality; when it portrays characters experiencing such a conflict, it does so critically. There is nothing intrinsically wrong with sensual gratification or desire, with lovemaking or with drinking. All these very human pleasures can become the object of laughter, as can their opposites, such as frugality or asceticism. But the objects of the most laughter are surely those characters who take pride in their contempt of earthly delights, particularly if they are hypocrites, but even if they are not.

However, although comedies ridicule human beings in our virtues and petty vices, Aristotle's assertion that comedies portray men and women inferior to us would not do justice to Roman or modern comedies. From Terence to G. B. Shaw, we often encounter in comedies men and women of grandeur, although their grandeur makes its presence felt in daily conflicts and not on the stage of a world theater. Morally, they can be more blameless than most tragic characters. Comic drama can be subdivided in different categories, and the character of the heroes and heroines can be one of the criterions of subdivision. Diderot once distinguished three kinds of comedies. In Lessing's translation, they are: the *Possenspiel, lustige Komodie* and *traurige Komodie* (*comedie seriouse*). (The farce, the funny comedy and the sad or serious comedy.) In the first type (here Diderot mentions Aristophanes) there are no noble characters, whereas in the other two there are. Terence was Diderot's favorite comedy writer; his works are put into both the second and the third cluster. (The reader may see Lessing's *Das Theater des Herrn Diderot* for an elaboration.)

In one respect I am inclined to accept Diderot's subdivision. There are certain comedies in which the sheer appearance of certain characters is hysterical. When men enter the scene with gigantic erect (artificial) phalluses or with huge buttocks, we immediately burst out laughing. If someone appears in a jester's cap, we are supposed to laugh, because he plays the role of the jester. We begin to laugh before even one word is uttered. The comedies of Aristophanes, in spite of their complexity and their lyric poetry, are of this type. In the Renaissance and in Baroque comedy, the "jester's" appearance is not fixed by convention; the actors themselves decide whether they want to put their cards on the table for the sake of laughter at their very first appearance. The first appearance of Falstaff in *The Merry Wives of Windsor* can be clownish, but this can also be avoided. Nowadays the actors' gestures and the modulation of their voices carry the first comic effect, unless the text directly indicates a certain comic appearance.

Diderot offers another noteworthy division, that of drama into three subgenres: historical drama, tragedy, and comedy. Whereas in a historical drama, historical facts must be honored; in a tragedy, the poet can add things that, however essential, stem from fantasy; while in a comedy, everything, Diderot writes, is entirely invented. In the case of historical drama, we can perhaps agree with Diderot, but only up to a point (e.g., Shakespeare could not have invented ficti-

tious noblemen as the protagonists of the War of the Roses). But can we assent to Diderot's distinction between tragedy and comedy? Shakespeare, again, used as raw material stories that were already circulating for both his comedies and tragedies. Still, I think that Diderot puts his finger on something important. Comedy, as a genre, was born whole. The poet Aristophanes fully invented his stories. Indeed, in ancient Athens it was Aristophanes alone who invented his own stories. For a long time, including during Roman antiquity and later, tragedy writers never ceased to work on myths, and most comedy writers either invented their stories (Molière for one) or used the stories of other comedy writers (such as Plautus or Terence used Menander), but worked neither on historical stories nor myths.

Shakespeare did not invent the basic raw material of his tragic plots, yet at least one comic drama, *Love's Labors Lost*, he did invent from scratch. As is frequently observed, the very ending of this comedy differs from the endings of all other comedies by Shakespeare. We might now add that the opposite of Diderot's conception is true. Among tragedies conceived during different epochs one can hardly even detect structural similarities. Critics tried for a long while to superimpose upon tragedy a so-called "triple unity" (the unity of time, place, and action), but in the end even the most ardent defender of the continuity of tragedy forgot about that concept. Yet, there are identical structural elements in comedies. This is why comic writers (take Molière again), even if they invented their plots themselves, lavishly borrowed characteristic motifs, fragments of plots, and even characters from earlier comic dramas. What was a mistake in the analysis of tragedies proves true about comedies. For here we can indeed point to structural continuity.

After what has been said about the everydayness and human frailty of comic characters, it may come as a surprise that I now want to argue that comedy is an aristocratic genre. While the comic *phenomenon* proves to be (in contrast to the tragic phenomenon) universal, or omnipresent in all human cultures in which people laugh, the comic *drama* or the comedy as a "high" genre is no less or more aristocratic than is tragedy. One can laugh at others, and oneself, only from up high, only from the top. When I say 'aristocratic,' I do not mean a social, but rather a poetic position. In order to perceive human comedy as ridiculous, but still to treat it with understanding, even love, one has to take a position above the world of human comedy. Not in the sense that one who takes such a position is better or nobler than any of the characters in comedies, but because in both laughing and understanding we occupy the position of the *raisonneur*. In several comedies, *raisonneurs* or reasonable thinkers appear on the scene, although they do not participate in the plot. On other occasions, they remain offstage, but they conduct the play. The attitude of the comedy writer (the *raisonneur*) is not cynical, but it is always skeptical. In fact, this attitude belongs to the happy ending, to the victory of a justice that we need not weigh with particularly high stakes. Justice wins the day when lovers embrace one another; when the jealous, vain, or the envious are punished with an appropriate trick; when youth wins over age (comedy, after all, speaks of life); when stupidities are pardoned;

when a practical jokes causes no anger; when the characters and the audience are ready and able to embrace life with joy. The therapeutic effect of a comedy succeeds entirely differently from that of the tragedy. The comic effect is no purification from fear or pity, no indirect catharsis; it works directly. Comedy cheers people up; it drives out depression and melancholy. As the Servant says in the outset of Shakespeare's *The Taming of the Shrew*: "You honor's players, hearing your amendment / Are come to play a pleasant comedy / For so your doctors hold it very meet / Seeing too much sadness hath congeal'd your blood / And melancholy is the nurse of frenzy. / Therefore they thought it good you hear a play / And frame your mind to mirth and merriment / which bars a thousand harms and lengthens life." The Servant, that is, the poet and the actor, formulates succinctly. Comedy frames the mind to mirth and merriment also insofar as it mentally prepares us to accept imperfections, our own imperfections included.

Writing comedies requires freedom, but a kind of heavy freedom which is constantly endangered and put at stake. Comedy requires freedom, for without freedom there is no distance, and without distance, the average and conventional cannot be ridiculed. It is a dangerous freedom with which comedy writers risk making fun of common vices and uncommon stupidities. Thus in times that allow citizens to affirm or deny all things according to our personal taste, comedy, as we know it from Plautus to Shaw, will lose its bite and thereby also its social importance and therapeutic effect, for such comedy requires both freedom and danger. The banalization of comedy began in the nineteenth century and is still in full swing. It is, however, not my aim to relate even a brief history of the genre. What needs to be analyzed here is the way in which the character of comic humor in "high" comedies underwent certain qualitative changes. Irony, for example, gained significant momentum after the Romantic movement. To this I will return later.

The change in the character of the comic attitude, however, does not necessarily alter the traditional structure of the comedy. But the structure of comedy does undergo drastic changes in the twentieth century, namely in the so-called "comedy of existence." Many things which characterized most all comedies prior to the twentieth century disappear or are changed radically in existential comedy. I said earlier, for example, that there is neither death nor illness in the comic tradition. Yet there is both death and sickness, indeed, there is also murder, in the comedy of existence. Moreover, dangerous freedom, the very lifeline of comedy, began to openly manifest in the social and moral concreteness of modern existential comedies, whether intentionally or unintentionally. In existential comedy, socio-political determinations are often entirely gone, plays take place in "no man's land" or in an abstract space, and they are frequently timeless or constitute their own time. There is of course biting irony here too, but within a new comic structure. I will discuss several consequences of this change in chapter 5.

The birth of existential comedy and the banalization of the traditional comic structure and themes happened simultaneously. This current state is certainly not a "final state," for in comic genres, as with art in general, there are no final

stages. One has to stop, however, in the present, or rather with the genealogy of the present, since prophecy is alien not just to comic genres, but to the philosophy of comedy as well. Anyone who attempted such forecasting would become ridiculous herself.

I want first to present a brief catalogue of the stable structural features of the comic drama. Most of these features can already be found in the work of Aristophanes; they are a matter of course in the works of Plautus and Terence. Since the Roman period, no comedy writer has added to the stable structural features of comedy, and perhaps not since the Greek "new-comedy," though the fact that we have only fragments from this earlier age prevents any final judgment about its characteristic features.

Aristophanes is, at least in one of the most important features of his oeuvre, still an exception. Namely, he is the sole significant comedy writer (and not just satirist) who puts on stage and makes fun of several political characters of his time. The characters—such as Kleon or Socrates—appear in masks and garb that are to be recognized immediately. This kind of direct political intervention is alien to the art of comedy since. Not even in plays full of direct political allusions, such as Shaw's *Caesar and Cleopatra*, where a critical judgment of British colonization appears in the guise of a quasi-historical play; Shaw's allusions are thus made indirectly. Some forms of politics and direct political allusions do continue to play an important role in several kinds of comic genres, such as in the cabaret, in newspaper feuilletons and cartoons, or in political jokes. Yet where they try the same sort of direct reference in the genre of "high" comedy, comedy itself is transformed into a witty cabaret piece. This happens for example in Tom Stoppard's farce, *Dirty Linen and Newfoundland*.

There is a kind of relation between Aristophanes and comedy on the one hand, and Aristophanes and the cabaret on the other hand. In the first case, it is the structure and the development of the plot that is held in common; in the second case it is the "content"—if one can refer to content with only quotes—that is decisive. Aristophanes employs two motifs to trigger laughter: political satire and dirty allusions, words, or stories. All of his other designs hardly make us laugh; rather, they tend to elevate us to a poetic and contemplative mood. I have already mentioned Aristophanes' famous parabasis, and I will return to this again soon.

The specific position occupied by Aristophanes can be best characterized with the central place parody occupies in his plays. In order to really laugh at a parody, one needs to know the "original," the de facto butt of the parody. One does not need to talk about "genres" to be aware of the connection. We laugh heartily whenever someone imitates a politician well—and all imitations are simple parodies—if we know the politician, have seen him and heard him speak. The same is true about the imitation of a teacher. Aristophanes introduces well-known, actual figures into his plays, and they appear onstage with their own names, as Kleon, Socrates, or Euripides. Yet Aristophanes' parodies are far from being simply imitations of some kind of mannerism. Aristophanes' target is the

philosophy of Socrates, the politics of Kleon, the dramatic art of Euripides. In one of his plays (the *Acharnians*), Aristophanes directly parodies one of Euripides' tragic dramas, *Telemachos*.

A direct parody of real people is hardly characteristic in comedy after Plautus. Obviously Athenian democracy presented a unique condition for this kind of parody, which has never been repeated. Yet something was substituted for direct parody, and I would call this something *parodistic presentation*. Parodistic presentation is not a parody of well-known historical figures or recognizable artistic or philosophical works; it is rather a parody of types, of something typical. For example, Molière is rich in the parodistic presentation of professional types such as the doctor and the lawyer, and Shaw in the parodistic presentation of the English upper classes. These authors keep winking at the audience with their presentations of certain types, and the audience understands and laughs. We can laugh at the parodistic presentation of a type, even if we have never personally met, for example, a self-important, asinine music teacher.

Now I want to enumerate the common structural elements of the comic drama, each of which I will later discuss in more detail. They are: the practice of wit; of punning; of clowning (between two or more typical figures); the use of intrigue (either with one typical figure of the intriguer or schemer or without one); of deception; of reversal or inversion; the making of mistakes; losing and finding something or someone; the conflicts and misunderstandings between opposing pairs or duos such as old-young, parent-child, or master-servant; and finally, the battle of the sexes with its own love stories, hurdles, and happy outcomes. The ten main vices, the ridiculous vices of comic drama, are the following: stupidity, vanity, cowardice, tyranny, jealousy, hypocrisy, envy, greed or avarice, conceit, and pedantry. One or several of these is to be found in every comedy. Two of the core Christian vices, covetousness and gluttony, are conspicuously missing. Surely, we do laugh at the covetous person, if he happens to be an old man who desires young flesh and tries to buy it; or at the glutton if she is, for example, a servant who satisfies an already fat belly by tasting all the plates first offered to her employers. Yet we laugh even more heartily at men and women who despise and reject the pleasures of the body with disgust. Amanda in Molière's *Femmes Savants* is not ridiculous because she is a woman in love with scholarship, but because she fakes this love, and because she expresses contempt for love's other delights from a position of false superiority. In comedy, of course, *omnia vincit amor*: love conquers all. Those who make fun of Eros and those who try to force Eros will both come to grief.

Although it does not belong to the main structural elements of the comic drama, the over-identification with a social role can also trigger laughter. It is on account of such an over-identification that doctors, lawyers, courtiers, or philosophers can be portrayed with parody. Also typical of parodistic presentation are the so-called "talking names," which refer either to a person's occupation, social space, or character, such as Bottom, Puck, Titania, Dogberry, and Malvolio (all from Shakespeare). In a so-called "comedy of manners," as found in Scribe, Sardou, Wilde, or Shaw, it is the mannerism of both the "upstairs" and

the "downstairs" which manifests itself in a rigidity of language and behavior, and this is what elicits laughter.

One of the oldest maxims in the philosophy of art is that in a drama each word and every single sentence must advance the action of the whole work. This aesthetic commonplace refuses to notice, however, that in comic drama several scenes serve one purpose alone: to entertain the public. Dialogue presented as a duel of wit can serve only this function. Yet in comedy there is singing and dancing; one can also stage a parody of rituals, just as in the marketplace. In one play of Aristophanes', the chorus leaves the stage dancing. The comedies of Shakespeare and Molière, and the Baroque in general, are inexhaustible in presenting pastoral plays, the recital of poems, and singing and dancing. The "ceremonie burlesque" of a doctor's initiation in Molière's *Le Malade Imaginaire* cannot advance the action, since it follows it, and the Hell scene in Shaw's *Man and Superman*, although positioned in the middle of the play, as a dream should be, still makes no advance in the action of the play. These and similar insertions instead conjure up the spirit of the carnival.

But to return to an earlier problem, parabasis does not advance a work's action either. An actor, speaking in his own name or in the name of the author, talks, in parabasis "out" of his role; he turns directly to the audience and relates things about the play or the performance; he asks for applause and praises the play at the same time. Romantic philosophers and writers (Schlegel, Tieck) saw in parabasis something modern, since it is a kind of de-illusioning; with parabasis the distance between stage and audience becomes relative and these two roles can even be swapped. This happens in Aristophanes and Plautus, in all the comedies of Terence, and occasionally also in Shakespeare and Molière. Dicanopolis, for example, asks the Athenian audience to forgive the fact that although a mendicant, he dares to make fun of Athenian citizens. In several plays by Molière, the author is named or referred to, and in Calderon's play *The Wonder Magician* a servant remarks that "this is not a theater farce" which reminds us of Magritte's visual joke *This is not a pipe*.

There is no parabasis in tragedies and there cannot be. Shakespeare, with good humor, presents in *Midsummer Night's Dream* the transformation of the tragedy of *Pyramus and Thisbe* into a comedy, as the artisans of Athens, already at their first rehearsal, decide to introduce a parabasis. In order not to scare the ladies, the group decides, the boy who plays the lion will address the ladies directly, in order to put their minds at ease, and will assure them that he is but an actor and not a real lion.

Such and similar insertions into the comic drama do not "waste time"; nor do they advance the action of the work. To this one should add that action in a comedy has a different character than action in a tragedy or in a romance (a nontragic drama). Let me propose a thesis: every comedy is a comedy of errors, although these errors can be entirely different or of an entirely different weight. This is also why the "agon" of verbal riposte can be an end in itself, or may aim

solely at making the audience laugh; this is also why it can slow down the development of the plot, instead of speeding it up. I mention as an aside that there is a history play in Shakespeare's *Henry IV* which resembles comedies in this respect. Witty exchanges of puns and all kids of semantic, humorous remarks do not carry the action further and are, in the above sense, ends in themselves, although they also serve to characterize the central character of the drama, Prince Hal. For this reason alone I would resist calling *Henry IV* a pure tragedy.

Agon in comedy usually manifests as a verbal duel. It belongs to the essence of comedy that the verbal duel amuses and entertains. Perhaps this is because the arguments are funny, perhaps it is because the use of language or the pronunciation is funny, or perhaps all of these combined make for the humor of the exchange. In certain cases, such a verbal duel is in fact fought in order to please the audience, and the entertainers are clowns. But there are also verbal duels in which the duelers mean every word seriously, and it is just herein that they become utterly ridiculous. In Roman comedies and in Shakespeare and Molière both types of verbal duel are frequent, but from Baumarchais to Shaw only the latter are prevalent. As another aside, when comedy turns into an opera libretto, as in Mozart's *Figaro* or in Verdi's *Falstaff*, one leaves out first and foremost the entertaining witty lingual duel and ceremony. For simplicity's sake, I will now proceed from the most primitive to the most sophisticated versions of our comic structural elements.

In the *Frogs* of Aristophanes, a gentleman pronounces the word "Artemisia" as "Hartomixes"; the mispronounced word also means something else. Bad pronunciation is always hilarious when the mispronounced word is vulgar or can at least be easily understood as sexual allusion. If a lady says instead of "I am thirsty," "I am dirty," or if, as in *Much Ado about Nothing*, Beatrice utters the name of the gentleman with whom she fights the lingual duel of lovers–Benedick–we burst out of laughing, if we dare. The text can spell out the sexual meaning directly, or can leave the actor to so interpret it. This is the preferred method of Oscar Wilde and G. B. Shaw. Almost the whole plot of Shaw's *Pygmalion* centers around bad or good verbalization. It is here that we meet the most sublime version of the game of mispronunciation, for the "class related" comedy of pronunciation cuts both ways. Not only is the uncouth pronunciation ridiculous, but so is the snobbery of the upper classes, whose dignity seems to hinge upon some fixed elocution.

Humor gets more complicated when the misuse of words has a carnivalesque function, insofar as it reverses or confuses the sense of a sentence. The artisans' discourses, e.g., in Shakespeare, are hilarious whenever they discuss issues about which they normally do not speak, and when they use expressions to which they are unaccustomed, the meaning of which they do not understand—which is why they employ them in the wrong context. Yet the nonsense talkers can also be urban dandies, provided that they are stupid enough not to understand the words they use. Shakespeare and Molière are practically inexhaustible in inventing these kinds of nonsense discourses, which requires great talent, for it is remarkably difficult to invent entirely nonsensical sentences that

still hit the jackpot. All of the sentences of police officer Dogberry are jewels of this art. Take for example: "Come hither, neighbor Seacoal: God has blessed you with a good name; to be a well-favored man is the gift of fortune; but to write and read comes by nature." Three jokes in a small space. Seacoal is a talking name; it refers to stupidity and can also have an obscene connotation, yet Dogberry does not understand this. The first reversal is the name is with God's blessing, which is followed by its reinforcement, the second reversal between art and nature. Dogberry uses for the first time the word "well-favored," without understanding what it means. This is how Shakespeare makes fun of natural law theory and its misconstruction. The same Dogberry says a little later: "You shall also make no noise in the streets, for . . . to babble and talk is most tolerable and not to be endured." I do not need to say that if one babbles one also talks, and hence the "and" is funny, whereas in the continuation of the sentence "and" connects two contradictory injunctions, which is why it is funny. If we read the scene to the end, we find several further illustrations. Feste (in *Twelfth Night*) remarks "Nothing that is so is so"—a hit as far as the logic of identity is concerned.

Trisottin (in Molière's *Ecole de Femmes*) composes poems from nonexistent words. This in itself would not necessarily be funny. What makes the poem hilarious is the rhymester's strict belief that alliterations and rhyming alone make his verses poetic, not the puffed-up content of his verses. In Trisottin's case we see lingual parody that is also a parodistic presentation. Perhaps Molière did have a model he disliked and ridiculed. But the character Dogberry is not a parody. His is a grotesque presentation with an absurd text, yet Shakespeare's humor here is not biting; it is understanding.

The poet and the philosopher, and surely bad logic itself, are the oldest targets of comedies. I already mentioned Aristophanes' parody of the tragedy of Euripides, yet he invented also the agon of the logics, wherein Right Logic and Wrong Logic measure their reciprocally warring strengths. In Aristophanes, parody is always the dominating theme, as in *The Clouds* when he makes Socrates, the great teacher, say to the oafish Strepsiades: "Whatever you learn you forget at once." This is no pun, but it is a biting and sarcastic comment on the effects of Socrates' way of teaching.

In Aristophanes, the contest of the two logics also serves a moral and political purpose, yet in modern European comedies from the Renaissance onwards, verbal duels are like games or play, even if they ridicule someone or something well known by the audience. They make us laugh, but they do not instruct us, at least not directly.

Jokes appear in comedies as ingredients of witty talk. The characters of a comedy tell jokes, comic stories, and anecdotes, sometimes with the intention of creating a merry mood, bringing about laughter in which the other characters may share. This kind of joke-telling is a version of storytelling and has nothing to do with making fun of others, especially not of those who share one's company. Practical jokes belong to the category of intrigue, joke-telling does not. Aristophanes' *Frogs* opens with the question Xanthias addresses to Dionysus:

"Boss, would you mind if I started off / With a good old gag that always gets a laugh?" and then it turns out that Dionysus has almost messed his pants already on account of too much laughter. In *Miles Gloriosus* (by Plautus), Periplecto-menus cracks a joke, the structure and the message of which remained almost unaltered through centuries. It survived as a *Satchen* (Jewish marriage broker) joke and was quoted a few times by Freud. The versions go something like: Why is it good that I do not have a child? Because if I had one, I would always be anxious. If he had a fever, I would be afraid that he was going to die; if he were a drunk or favored riding horses, I would constantly be in a panic that he was going to break his leg or head. So if I have no child, I will spare myself all of these worries. Similar aphorisms, puns, and paradoxes of both Wilde and Shaw, which manifest as exchanges of wit, are in fact such jokes.

Yet comic agon can assume the pure form of a contest of wit. The stakes are then clear: the winner of the contest is the quicker person, better at riposting, a harder and higher hitter. Servants—in Terence the slaves—can also conduct a contest of "smart talking," which is usually presented as clowning. Wit can hit its mark without being a contest of wits, as when a person of common sense makes fun of phony arguments, like the just and witty Toinette or Dorine in two comedies of Molière. This kind of witty riposting is at its peak in the war of sexes. This is an innovation in modern comedies. The war of sexes is not a nov-elty, for this plays a significant role in ancient comedies, but the presentation of this war through a verbal contest, in the witty agon between the lovers, the tussle of words, is a more modern invention. Girls could not appear on the Roman stage (only matrons and women of pleasure could); they were hidden inside the house. When boys talked to them they had to turn their back to the audience and talk instead in the direction of the girls' houses. But the boys could not receive an answer from there, though sometimes a play staged the wailing of a girl in labor. In modern comedy from Shakespeare onwards there are rarely more fas-cinating scenes than the ones where boy and girl or man and woman become entangled in a verbal battle. Indeed, the verbal battle between man and woman is not specific to comedy. In tragedies, we meet such scenes with the Greeks, first and foremost in Euripides (see *Medea*, for example). This tradition continues with Shakespeare and also in the tragedie classique. Yet there is no exchange of wit here; there is rather an exchange of recrimination, of hatred or sadness, of vows and farewells. In tragedies such a contest happens over issues of life and death; in comedies they are solely about life, love, sex, and frequently also about money. Shakespeare is rich in such love battles and the whole of Spanish com-edy turns around its verbal duels, which are frequently versified in Lope de Vega or Tirso da Molina. Is it still worthwhile to point to their later continua-tion, as in the comedies of Beaumarchais or Shaw?

Quod erat demonstrandum: in a comedy not all scenes need to advance the ac-tion. But there is action, frequently very adventurous action, and a thick plot. Without an adventurous plot there can be no "happy ending," because things end happily only after defeating the obstacles created by the plot. To be sure, the

romance or the non-tragic drama also ends in a satisfying mood. This genre has
some structural elements which bring it into the vicinity of the tragedy, and
others which bring it close to the comedy. I cannot think of Shakespeare's *The
Tempest* or of Lessing's *Nathan the Wise* as comic plays, although in some re-
spects they do resemble comedies. Yet some fairytale-like features play a far
more important role in romances than in comedies; the stories of romance often
take place in different times and places, whereas comedies do tend to follow the
triple unity scheme.

Every comedy is a comedy of errors. But its take-off point, its initial posi-
tion, is not an error; it is, I believe, something "social." As always, there are
exceptions to this case too: first comedies based on myths, such as all the vari-
ants of Amphytrion, and at least in part the direct political comedies and paro-
dies. The kind of comedies in which the plot is triggered by a mere accident do
not entirely follow this scheme either. Still, in this case the key "social" motives
make their appearance, if not right at the beginning, then in the further develop-
ment of the plot. So what is this initial social position?

What is "given" in such comedies is a tyrant or a few tyrants: whether a fa-
ther or a stepfather, perhaps one that is money-hungry or a fortune hunter, or
less frequently a mother, a son, a jealous husband, an old man desiring a young
body, or a man harassing a woman who does not want him. There is a pair of
young lovers, or sometimes there are two pairs, or two young boys and two
young girls. The tyrant wants to prevent the young lovers' happiness because
he/she has other plans, perhaps including the prospect of money. In such a situa-
tion even an otherwise good person (such as the mother of Ann Page) can be-
have as a tyrant. Intrigue starts at this point, whether it comes at the beginning of
the comedy or in the midst of it.

The initial position is important for understanding the comic drama alto-
gether. As I mentioned, the golden ages of comedy and the golden ages of trag-
edy roughly coincide. Comedy appears on the stage just as tragedy does, when
"time is out of joint"; when things which used to be natural do not seem to be
natural anymore. And vice versa. It may no longer seem natural that a father
should decide the fate of his son; that unconditional obedience and respect is
owed to the ruler of the state and of the house; that the servant should silently
serve the master, never talking back; that women should subject themselves
entirely to the wishes and whims of men, be they fathers or husbands. When
belief in those absolutes has been shaken, the comedy writer (just like the tragic
poet) confronts us with this gain or loss. From this standpoint it is irrelevant
whether the comedy writer judges it to be a gain or a loss that rather than the
father beating up the son, the son now beats the father (*The Clouds*), or that the
slave, the servant or the maid shame their betters. Aristophanes, the conservative
aristocrat, may hate this development. Terence, the liberated slave, may enjoy at
least part of the transformation, but both portray it. I need only add that comedy
has a more intimate relation to this 'time out of joint,' because it builds its cas-
tles on the upturned soil of change. Let me again hint at the analysis of Bakhtin,
regarding the carnival play, where women order men around, slaves command

their masters, subjects rule the king, and laymen dominate priests. True, this is only for one day.

The plot of a comedy resembles a game of chess. It opens with the chess figures occupying their initial positions. The game or plot must develop in order to end happily, in order for lovers to find each other, for tyrants and other villains to come to grief, and all others to reap what they have sown. Every comic writer solves this task and guides the audience from the initial position through to the merry, satisfying conclusion. The quality of a comic drama depends among other things on the way in which the writer succeeds in performing this task, for example if he succeeds in creating for future comic writers a model of plot development. *Amphytrion* by Plautus and *Phormio* by Terence became such models. This is one characteristic of a great comedy. Another is the poetic skill to shape verbal duels, to maintain an interesting exchange and to keep witticisms alive in such as way as to make the audience laugh at subtle jokes. The third and perhaps most important characteristic of great comedy is the creation of comic characters, who are not just carriers of a role or a function, but very much alive, both inexhaustible and well formed. In modern times, Terence became more highly appreciated than Plautus for this reason. He created not just concrete and authentic characters, but also characters with a philosophical message; characters that nevertheless did not become mere mouthpieces of ideas, such as tolerance or intolerance. It requires a kind of genius if, in addition to the above, a writer is to succeed in creating a comic character that can assume a symbolic position. The name of this character will then stand for the symbolic position. Such symbolic characters are, among others, Falstaff, Tartuffe, and Figaro. Finally, not necessarily laughter, but the quality of the happy mood created by a comedy depends upon the poetic dimension of the play. Pleasing verses, suggestion of a beautiful environment (garden, forest) enhance the therapeutic effect of comedies. Roman comedy was not really interested in beauty; neither were Molière or Shaw. Yet in several comedies by Shakespeare, certainly in the Spanish Baroque comic drama, and especially in the comic opera at its peak, that is, in Mozart, merrymaking and beauty merge into one.

After this short detour, I will return briefly to the comic plot. The error motif is necessary to the fundamental structure of the comic plot. The error can be due to accident, and it can also be induced. One person or a few people may deceive or mislead others, in the second case either consciously or unconsciously. The knot caused by this error can be undone by chance because it is tied in such a way that it can be easily disentangled. The different threads, the thread of calculated deception on the one hand, and the thread of chance or mistake, normally get entangled in several ways. If one analyzes this combination one can still isolate three components: the intrigue, the mistaken or misinterpreted identity, and a narrative concerning losing/finding. In order not to continue an enumeration of generalities, I will very briefly interpret Shakespeare's *Twelfth Night* from this narrow but important aspect.

The beginning as well as the end of this comedy is built on the shipwreck motif. The shipwreck was employed several times by both Plautus and Terence

and plays the role of the contingent event. The scheme is the following: two brothers or sisters or one brother and sister, always twins, lose each other at sea during a tempest, both believe the other dead, and in the end, they finally find and recognize each other. The design of losing/finding and the twin theme (both are also separately employed) are here united. Viola (the female twin) comes to play the role of a boy. This is the deception theme. Here deception is also combined with the theme of a metamorphosis of identity, and it is the deceiving, metamorphosed identity which puts the plot into motion. Identity-metamorphosis as an element of 'intrigue without intrigue' also appears in Plautus' *Amphytrion*. In Shakespeare, the second complication, or the parallel plot, begins with the appearance of the twin brother, and this is a parallel plot which appeared in Terence's story about the girl of Andros (*Andria*) as well. In Shakespeare, with the beginning of the second plot, we are already dealing with two pairs of lovers, who, however, are entirely unaware of this connection, even while we, the audience, are aware of it and are hoping that both pairs will find happiness. Together with the thread of the second love story, Shakespeare weaves into the fiber of the play a second intrigue; this time it is a planned one. The second intrigue follows the well-known scheme of "he who sows wind reaps a whirlwind"; and it gives plenty of occasions for witty jests, hilarious scenes in which the players laugh and make one another laugh. To put it concisely: in this comedy Shakespeare brought together all of the traditional elements and schemes of comedy. And I have not even mentioned that Olivia's clown also plays the typical role of the king's fool. Moreover, there are also exchanges or dialogues in which the interlocutors agree, or at least believe that they agree in everything—and about which it much later becomes clear that they were all the while misunderstanding one another: where one spoke about a girl, another referred to money. A dialogue of misunderstanding in the guise of mutual understanding is also typical in comedies from Plautus to Molière.

There are well-intentioned intrigues and malicious intrigues. Malicious intrigue also appears frequently in tragedies and in romances, e.g., in the intrigue of Iago against Othello. In a comedy, malevolent intrigue is rare, although it is possible first and foremost in plays where one of the chief characters is a comic daemon. Tartuffe, the comic daemon, plots to rob Orgon of his property. This kind of malicious intrigue is, however, never successful in a comedy. In the end, the evil plotter loses his game. But well-intended intrigues and aimless plotting normally do succeed. In some comedies (as also in some tragedies) the intriguer himself invents the intrigue and also sets the stage for its development. Phormio in Terence and Scapin in Molière play this kind of "professional," benevolent intriguer. They are in fact comic authors, co-authors who knit their own comedies into the text of a comedy written by someone else. They enjoy writing comedies; they love the art of plotting and take pleasure in a plot's success. But they also take care that the complicated knot woven by their plot can still be unknotted, with their help, so that justice can finally be done and the lovers can find one another in the happy ending. In *The Merry Wives of Windsor*, Mrs. Quickly, who is an intriguer by profession, decides that she will honor her art by

helping lovers rather than harming them. Puck, of *A Midsummer Night's Dream*, is perhaps the loveliest of all professional intriguers, and he also belongs to the family of benevolent intriguers or intriguers who just enjoy seeing the effects of their plots. Surely no one believes Puck when he pretends that he mistook one of the Athenian youths for the other because of the similarity of their garments! This was purposefully done and enjoyed. Not to speak of the jovial moment when he conjures the head of an ass onto poor Bottom's male body. Puck loves the hurly-burly; he takes pleasure in the mess and he finds his joy in the happy ending.

The inventors of most benevolent intrigues in comedies are not professional intriguers, but part-time intriguers, like the maids and the servants who help their weaker young mistresses and masters when they find themselves in a fix, as in Terence, Molière, Goldoni, and the Spanish Baroque theater. But anyone can invent, if a situation requires it, an intrigue, even the priest (with the cooperation of Beatrice and Benedick) in *Much Ado About Nothing*.

Since every comedy is a comedy of errors, there is no comedy without delusion. Delusion does not need to be deceit, but it must be continuous; it must last through a few scenes at least. There are also kinds of deceit which do not form a chain, yet which still become decisive, as, for example, when Jupiter and Mercury take on the figures of Amphytrion and Sosio respectively, or when Raina, in *Arms and the Man* (by Shaw), keeps secret from her family that she is hiding an officer of the enemy army in her bedroom. In these and similar partial intrigues, the sexual allusion contributes also to our amusement. A typical element of intrigue, from Plautus to Molière, is to lock the master out of his own house, and from Aristophanes to Shaw he is locked in. In this case, comedy loves to present the sight of a master climbing a rope out of or into his own house. It is also common to find the part-time intriguer playing on the credulousness of a target, producing "miracles," or making phantoms walk across the house, as in Plautus's *Mostellaria* or Calderon's *The Impish Ghost*. There is also a kind of self-defeating intrigue, such as in Plautus's *Alularia*, in which Euclio is so scared of being robbed of his gold that he hides it in ever different places and keeps lying about its whereabouts—until his son's slave sees him dig it into a hole and takes it, not in order to steal it for himself but to secure his young master's happiness. It is well known that Molière—*roman L'avare*—takes over almost everything from the structure of Plautus's play, with one essential difference. Euclio is not a daemonic character, but Harpagon is one. This changes not just the message of the story but also its ending. While Euclio, in the end, laughs together with us and at himself, Harpagon remains the slave of his daemonic avarice.

These kinds of intrigues can have entirely different functions in a comic drama. There is unmasking intrigue, "playing for time" intrigue, plot-complicating intrigue, plot-solving intrigue, etc. Several kinds of intrigue can play a role in one single drama. For example, in *Miles Gloriosus*, Plautus builds on two different intrigues. The first is the twin-sister intrigue, the second the pseudo-wife intrigue. The first intrigue aims at gaining time, the second at com-

plicating the plot. Both in *Le Malade Imaginaire* and in *Tartuffe* of Molière, the unmasking intrigue plays a decisive role. Orgon hides under the table, Argan pretends to be dead. Orgon hides under the table in order to get proof of Tartuffe's hypocricy; Argan pretends to be dead in order to unmask his second wife as a hypocrite. But while in *Le Malade Imaginaire* this intrigue is also a plot-solving one, this is not so in *Tartuffe*, where a vicious counter-intrigue by the villain Tartuffe follows the unmasking intrigue—and this final knot cannot be untangled, only cut by *deus ex machina*.

Just as in tragedies, the identity of main characters in a comedy can become shaken or unstable. The fist tragic identity crisis in the world of drama is undoubtedly that presented in Sophocles' *Oedipus the King*; this is followed by several similar crises in the works of Euripides, for example in *Medea, Elektra, The Bacchae*, and others. Who am I? Am I what I once believed myself to be? Am I what others believe I am? The character in crisis seeks herself, yet she can also change herself in the process. She may get outside of herself, but she can also re-conquer herself. In a tragedy, a character loses himself, reformulates or rewrites himself, actualizes himself, gets outside himself, and may also return to himself, if only in death, like Othello.

The misinterpretation or misidentification of the self seems a tragic theme, and indeed, the idea that one has to become different in order to remain oneself does not seem the stuff of buoyant stories. But comedy may also exhibit the misidentification and misinterpretation of the self and its metamorphoses in a decidedly comic light. This magic trick is achieved simply. Misidentification and misinterpretation of the self turn out to be based on error, while metamorphoses and the loss or exchange of one's traditional role is portrayed as resulting from an intrigue.

The oldest fundamental situation of the uncanny loss of self in a comedy is the one in which the following two questions are asked: "Am I what I am?" and "Why don't they believe that I am what I am?" The simplest scenario of this type is the scenario of *Amphytrion*. Yet it is simple only in the eyes of the audience, not for the players. Consider: Alkmene goes to bed with a man she believes to be her husband because he is exactly like her husband, but he is not her husband. The god Jupiter thereby takes a woman he desires, but he can only have her while in disguise, namely as her husband. The latter motif is played out by Molière more strongly than in Plautus. In Molière's scenario, the aim of Jupiter is the impossible: that Alkmene, who he embraces by playing her husband, should embrace him in return as her lover. It is a god—Mercury—who plays the slave in the disguise of Sosio, while Sosio the actual slave thus meets himself on the street. "He" is "me" and even has my name. One of the pairs (Jupiter and Mercury) has a good time in disguise, whereas Amphytrion and Sosio are entirely confused; they lose orientation. The world they took for granted becomes uncanny; their good common sense is cheated out of any possibility of understanding. True, we can also read the story in reverse. The cheat-

ing and betraying god betrays and cheats himself and not Amphytrion, because he is but a god in vain, if, after all, Alkmene loves Amphytrion and not him. Mercury gets into a more comic situation than Sosio. A god who appears as if he were a slave and assures the slave that he is indeed a slave is more ridiculous than an entirely disoriented slave, who knows himself as a slave.

This fundamental scheme also gets repeated in the twin stories, albeit with some modifications, as in Plautus's *The Menachmi Twins*, in Shakespeare's *A Comedy of Errors*, or in Goldoni's *I due gemelli Veneziani*. There is only one pair of twins in Plautus (although the name of the two boys is the same) whereas in Shakespeare and Goldoni we have two twin pairs. The doubling of twins into two twin masters and two twin servants enables the two modern writers to repeat the scenario of *Ampytrion*. The repetition of the scheme will, however, produce a different, more farcical play, because while in *Amphytrion* there is planned deceit, in the above-mentioned plays of Shakespeare and Goldoni, all error stems from ignorance alone.

To return to the original model: Mercury accuses Sosio of lying when he says that he is Sosio, and asserts that he, Mercury, is Sosio. When Sosia clings to his identity, he gets a trashing. Beaten, Sosio shouts: "You will never make me other than myself'—to which Mercury retorts: "You are mad." Mercury then begins to reason with Sosio. Sosio gets here to a certain point in rumination: "He wins in argument, and I must seek another name myself. . . . Then, if not Sosio, who the deuce am I?" At the end of this scene Sosio turns to the gods praying: "Ye gods immortal, give me help! Were did I lose myself? Where was I changed?" (In Molière's version Sosio asks himself: "Is it possible for me not to be me?") This is not funny! Nor is it funny when Hermia wakes up during the night (*In Midsummer Night's Dream*) only to see that her beloved, Lysander, chases Helena with his love, and turns away from her, from his true beloved, with disgust. No, it is not funny, and we still laugh. We see fun, since we are initiated in the plot, we know that the victims are only apparent victims of a benevolent intrigue and we know that everything will end well. Sosio will regain himself and his name, Amphytrion will learn that he remained Amphytrion and that Jupiter has begotten a child in his shape, Hermia will wake up again to see that she is still loved by Lysander, and Titania will believe that it was but a dream that she seemed enamored with an ass. A comedy takes the characters of the play into the labyrinth of identity loss, misinterpretation, and misidentification, just as does a tragedy, but the comic poet offers the thread of Ariadne to the audience and to a few actors of the play; thus we know all the time that there will be a path leading out of the labyrinth. The borderline situation can be hilarious if one knows for certain that those who happen to suffer it are in error and that they will soon see the balance of the world restored. Men and women will become again what they are.

Up to this point I have discussed loaded questions such as "who am I?" in one sweep. But this one question contains many questions. Indeed, the question of shattered identity is the most dramatic, at least potentially, when personal identity as constituted by individual memory is really at stake. Yet in comedies,

the uncertainty of social identity is also a source of error and of fun. In a typical scenario, the social identity of a young man or woman changes when they turn out to be children of other parents than the ones they thought to be theirs. This is most often played out with poor boys and girls who find that their lost, real parents are actually wealthy and noble. It can also turn out (as in Figaro's case) that the woman he is coerced to marry is in fact his mother, or as in Shaw when the virtuous youth who despises his father-in-law for being a usurer and making a fortune on the ownership of decrepit houses for the poor, finds out that he himself has always lived on income made from the paupers living in those same houses.

The suspicion that one is the child of different, unknown parents is quite common at a certain age. It can be a source of uncontrollable anxiety and also of hope. Tragedy may express this anxiety, as in the story of Oedipus the king; comedy, however, brackets out anxiety, putting all stakes on hope. The theme of "finally" finding long-lost parents, parents even unknown, is a motif of wish fulfillment, a strong psychological drive. When a child, at the end of a comedy, finally finds his or her real parents, and when parents see again children they believed lost for good, there is a typical happy ending. As was mentioned, the "real" parents are usually rich and noble; a similar twist happens when it turns out that a character's true beloved is exactly the person that her or his "real" parents have chosen to be their child's legal spouse. The "unreal parents" are tyrants, the "real" parents loving. This is, indeed, wish fulfillment. In a comedy, all *is* well that ends well.

We know of several variants of this wish-fulfilling schema from the long history of comic drama. Only in the nineteenth and twentieth centuries are we sometimes robbed of this satisfaction. Vivie Warren, for one, never knows for sure who her father is, although her mother's entourage wants her to believe that he is in fact also her lover's father.

Plautus and Terence vary several prototypes. With them, we get the first story of the kidnapped girl. In Roman comedies, a kidnapped girl is often sold to slave traders who either keep her or re-sell her for good money. In *Rudens* by Plautus, the slave traders promise to hand over the girl for money at a pre-arranged place, but they do not intend to keep their promise. Due, though, to tempest, shipwreck, and so on, they come ashore on the same island that they were supposed to be. (In this play, there are a lot of similarities with Shakespeare's *The Tempest*.) In Terence's *The Self-Torturer*, a mother abandons her child at birth, for she believes that her husband is disgusted by girls. She will come to regret her action. In the end, when the young lady by chance reappears, the father is the happiest of all men. Here, it happens that the girl is the offspring of a secret matrimony and disappears in a tempest, only to reappear later. (Since these Roman comedies take place in Greece, it is a great asset that the foundling is a child of Athenian citizens—a great asset, but not a sufficient one—for money is also needed.) In Molière's version, it turns out that little Agnes is also the child of a secret matrimony; her father returns home to acknowledge her at the very moment when she is in the greatest trouble. Even more, the father has

chosen a husband for his daughter, and, as the comedy has it, this gentleman inadvertently happens to be the same young man with whom the girl is already in love. In *L'avare* (also by Molière), the recognition motifs are multiplied. The tempest story is repeated; here the rich Anselm has lost his wife and two children at sea. He mourns them constantly, and alas, in the end, they are reunited: father, mother, son, and daughter.

Comedy portrays the fulfillment of another dream wish as well. The thought of a lost sister or brother plays a significant role in the fantasy world of children. One can easily detect wish fulfillment where the comic author tells the story of twin sisters and brothers (another self) being lost and found. This kind of wish fulfillment is combined with the motif of error, specifically of identity confusion. The eventual scene of mutual recognition is of the greatest poetic importance. Aristotle identified exactly the scene of recognition in tragedies as the crucial setting for distinguishing the superior from the inferior artist. His example is a comparison of the recognition scenes between Elektra and Orestes, and Orestes and Iphigenia in different tragedies.

But this distinction is not at play in a comedy. The comic artist does not exert much effort inventing a subtle recognition scene. In comedies, nothing really depends upon the recognition scene, or at least nothing which would indicate the sophistication or artistic quality of the play. The most brilliant comedies can make use of exactly the same recognition scenes as the worst. Think of *Twelfth Night*, *L'avare*, or *Figaro's Wedding*, which are among the most splendid comedies ever written. We encounter no more than three variants of the scene. First, there is still a living witness who can tell the story, whose person warrants confidence and who, in addition, can identify a few marks on the lost child's body. Second, the child's layette, preserved for years as a keepsake and a token of identity, is recognizable. And finally there will be a special token the child has kept, often a ring with an inscription. The ring is, of course, another symbolic image: it symbolizes the place of birth or origin, but also wealth, and later promise, commitment, and finally happiness. One of the above three is sufficient in a scene of recognition, yet writers regularly combine them, using two and sometimes all three possibilities. In the case of lost and found identical (or semi-identical) twins, of course, none of these tokens are necessary. In their recognition scenes, they, and we, see with our own eyes. In the very moment that one knows one is not seeing double, not the victim of a conspiracy or of the tricks of phantoms, the thing itself is already clear and settled. In order to clarify their identities, the twins need only appear at the same time in the same place. The comic author's skill is practiced in his postponement of this meeting or his placement of it at the very end of the drama.

The above models were described in brief and look quite simple; indeed, they may look simplistic. And still, they speak the language of unconscious desires, the desire for real, loving parents, for brothers and sisters lost at sea (and who has not lost brothers and sisters to the sea?); they speak the language of fulfillment, of promises kept. This is the language of a low-level salvation, but still, a language of salvation. The lost brothers and sisters find their homes; they

return home. For them, the promise of Eden, of happiness, is carried out. After experiencing tyranny, cruelty, conspiracy, hatred, jealousy, and resentment, after having been cheated and betrayed, they are returned to a sensible reality, brought back into a rational world order. The world out of joint is put right. In a sensible world, parents bring up their children and do not tyrannize them; money is important, but not more important than love and empathy; and freedom allows human beings to exercise their self-control and forbearance. In this world, trust is stronger than suspicion, loyalty is stronger than disloyalty, and openness to understanding trumps the refusal to understand. In a sensible world order, there are no great heroes, nor are there great tragedies. It is into this world that the lost children return in the final consummation of the comic drama. This is why I think that the configuration of losing and finding is not just one schema among many, but that it definitively reveals something essential about the ontological, existential message of the comic drama. We seek, in comedy, the relief and repose of rediscovering contentment with ourselves and our world.

Almost all analysts of the comic drama believe that incongruence is one of the main sources of the comic effect—starting from the simplest cases of incongruence, as when one puts one's underwear on one's head, and up to the complex cases, such as a joke in which the punch line is incongruent to the whole story leading up to it. The comic drama draws from several sources of incongruence. The most general type of incongruence belonging to the fundamental structure of comedies can be described as the confounding of identity. With the comic confounding of identity, a character begins the play in a role which is not hers, but someone else's; she becomes different from the person who she in fact is. In a comedy, swapping the appearance of a certain personality is closely related to the identity crisis or the problematization of identity. But in this case it is not the character who is in crisis about her identity, but her interlocutor, either because he does not notice the incongruence (because he is deceived) or because although he notices something awry, does not understand it, and becomes anxious and confused.

One encounters in the repertoire of almost every comic poet one or several "swaps" of personality. The girl who dresses as a boy plays too the role of a boy, the master of the servant, the mistress of the maid; an intriguer will instruct a character to dress as a doctor or as a priest in order to support his intrigue, or to spy on the "enemy." If one can skillfully weave such and similar sorts of incongruence into a play, a comic effect is as much as guaranteed. We, the audience, know of the cause of the incongruence, and we begin to laugh, while the actor, cognizant of our knowledge and of the source of the comic effect, proceeds to milk his scene, making us laugh even more. The comic drama as a genre (and like some other genres) operates with moral sublimation. When Viola and Rosalind forget for a minute that they are disguised as boys and begin to behave like girls, we are amused, but our laughter is far from hostile. When, though, in *The Merry Wives of Windsor*, the old and conceited womanizer Falstaff is dressed in female clothes in order to really pull the wool over his eyes, we laugh at him, for this is a kind of justice. And when Eliza forgets her assumed role for a moment

and falls back into her cockney, we laugh both at her and at the superciliousness of the upper classes.

The first comic story of cross-dressing is found in the *Thesmophoriazuae* by Aristophanes. There, Euripides asks Mnesilochus to join the woman's assembly disguised as a woman, in order to spy out the evil rumors circulating about him (Euripides). The women, though, notice Mnesilochus' flat chest and guess the ruse. In the comedy *Eunuch* (by Terence), a woman-crazy teenager disguises himself as a eunuch in order to get into the bedchamber of a girl, intending to impregnate her in a very non-eunuchlike manner. *Charea* served as the model for both Baumarchais's and Mozart's *Cherubin*. To be sure, sexual arousal and action were considered far more natural in Terence's time than even in the enlightened eighteenth century, but being natural did not spare them from ridicule. Stories of girls dressing as boys and of the swapping of costumes and identities between mistresses and maids are, however, unknown to ancient comedy. As was mentioned, a respectable girl could not even appear on the Roman stage— nor could a boy playing a girl. Although, if the plot really required it, a courtesan might be dressed to play a wife.

On the Shakespearian stage, as we know, all female roles were played by males. Thus, when a Shakespearean girl gets dressed as a boy, the actor is in fact dressed "straight." Because the actor is playing a girl, such cross-dressing is doubly erotic. The boy plays a girl, but she plays a girl in a boy's garment; thus while changing his sexual identity as a girl, he returns to his sexual identity as a boy—but will be returned again to feminity. Sexual identity thus becomes doubly labile, and questionable. Girls fall in love with other girls, believing them to be boys. Though a girl is deceived, her deception is unintentional; it is the consequence of incongruence. Moreover, the confusion of sexual roles itself throws into question the rigidity of those roles. Is a sexual role, after all, just make-believe, or as assumed as social roles are? What proportion belongs to the imagination in the concoction that is sexual identity?

In the development of the crisis following from the cross-dressing, one encounters the same general questioning of identity found in *Amphytrion*. In *Twelfth Night* (III.1), for example, Viola thus turns to Olivia with: "you think that you are not what you are" and "I am not what I am." Sebastian formulates something similar (at IV.3): "I am mad, or else the lady's mad."

In Tirso de Molina's *Knight of Green Pants*, Dona Juana appears dressed as a boy from the outset. Her metamorphosis has an entirely different motivation than that of Viola or Rosalind. (There are stories similar to Dona Juana's in Shakespeare, as found in *The Two Gentleman of Verona* or *All's Well That Ends Well*. The latter is, however, not a comedy but a romance.) Dona Juana's motive is neither escape nor a game of hide and seek; she dresses as a boy for a very female reason: chasing her unfaithful lover, just like Mozart's Elvira. While the characters of Rosalind and Viola are a little "boyish," Dona Juana exhibits only a wounded femininity in undertaking her desperate adventure. But, as the play develops, she begins to enjoy her role. It pleases her to turn the head of Dona Ines, and she increases her enjoyment by taking up the name of a real person

who appears in the drama, Don Gil. There are a few carnivalesque moments when there are three Don Gils on the scene. Tirso de Molina combines three comic motifs here. The first is the identity of the names (here 'Don Gil'); the second is the identity of faces, as in every twin story, but here the original Don Gil and the supposed Elvira are one and the same person. The third comic motif is the exchange of sexual appearance and roles; as a result of this exchange, we get the incongruence of sexual attraction. Dona Juana uses her own cross-dressing to make others insecure and confused about their identity, sexual, and social. In so doing, she only intends to regain the love of Don Martin; this is her purpose from the beginning. In other plays, twins are thought to be one and the same person, but here one single person is thought to be a pair of twins, male and female. When we finally arrive at the happy ending, a triple wedding, as suits a comedy, even her own valet does not know until the last minute who Dona Juana actually is.

The fixed hierarchical relation between master and slave (servant, valet) was already turned upside down in ancient comedies. Still, there the master never dresses as a slave (or the mistress as slave girl), or vice versa. In the tragedies of Shakespeare, it frequently happens that a nobleman or king, in order to save his life or the life of his lord, dresses himself in rags or in a common garment, but these characters never swap clothes and identities with someone else. The swapping of clothes is social cross-dressing and differs significantly from the reversal of superiority found in verbal repartee. In a verbal exchange it can turn out that the slave is smarter than the master, but no one therefore takes the slave for a master or the master for a slave. Social cross-dressing, on the contrary, aims at the misidentification of people through undermining the rigid identification of social roles. Writers of comedy must create the make-believe: that if a man merely wears a lady's dress, he will become a lady in the eyes of others. This is one of the fundamental schemas of modern comedies. In Calderon's *The Lady and the Maid*, Lisardo takes on a peasant's garments and immediately a peasant woman, Gileta, falls in love with him. The same Gileta is then dressed by Diana, the main character of the play, as a countess. In this guise, not even the garlicky smell of her hands checks the dandy's perception of her as a highborn lady.

Baumarchais employs the same effect in both his Figaro comedies. In *The Marriage of Figaro*, Susanna plays the role of the countess and the countess the role of Susanna. Metamorphosis through cross-dressing is still typical in comedies of the late nineteenth century, for example in Hoffmanstahl and in two of the operas composed by Richard Strauss on the libretto of Hoffmanstahl. There is, however a difference between these. The sexual, piquant message of social cross-dressing will be preserved in the latter, but the trick loses its function as an action furthering the plot or as a reconciling device. In Shaw, it will serve as but a signal: the swapping of roles is going to be developed psychologically, on the inside rather than the outside, at an invisible level, through the transformation of character, though the gaining of self-knowledge. As a result, the reversal, problematization, or change of identity will, in a comedy, not substantially differ

from the same reversal in a tragedy. We witness, herewith, the birth of tragicomedy. Take for example Shaw's play, *The Devil's Disciple*, which is identified by its author as a "melodrama"; or take the plays by Chekhov. (Peter Eotvos's opera, based on Chekhov's *Three Sisters*, is rather melodramatic, or if it is comic, then it is closer to absurd or existential comedy.)

Both in tragedies and comedies, the family is the epicenter of conflict. In tragedies the family is usually royal, or of high nobility. Conflicts in such families can change the times, or push time out of joint. In comedies the family can be noble or bourgeois, but the conflict remains within the family, even when it is framed by a fairy tale or myth, in the form of prelude or epilogue. There is no standing model to guide the character and the outcome of family conflict in tragedies, although frequently brothers fight against one another (the Cain-Abel, Romulus-Remus pattern). There are, however, a few prototypical schemes in comedies: a tyrannical father who wants to prevent the marriage of his son/daughter to his/her chosen lover, usually because he prefers a rich person; a young person or people who follow, or struggle with following, their heart's desire; and finally, there is a valet, a slave or maid who helps the young ones achieve happiness. The parent is old, the lovers are young. The conflict between a tyrannical father and his son or daughter becomes a battle of old ways against the new; it is a generation conflict. The father commands power, his children are dependent, so the conflict between the tyrannical father and his children is also a power struggle, or a struggle between the power of money and the power of love. Yet an arch-narrative also hides behind the seemingly merely social plot: the story of a patriarchal Abraham who is ready to sacrifice his son, but with whom the angel of God, or God, intervenes. At the end of comedies, a divine messenger often does appear, in the shape of contingency, or what we rightly call a *deus ex machina*. Here, the *deus ex machina* replaces and performs the act of divine justice, without the divine interference. At this point, the comedy again presents a kind of wish fulfillment: it reverses the Oedipal theme. Rather than the son killing the father, the son and daughter are the ones the father stands ready to kill—by being ready to kill their souls, their promise of happiness, and their future. As was said, the father's main motive tends to be avarice or greed, but frequently sexual forces also play first fiddle. If one listens to Freud, ultimately greed is also a libidinal motive. The father wants to "take" the beloved of his son. Even if this sexual notion is not spelled out directly (it usually is not) and does not complicate the plot, it remains omnipresent. It is not the "penis envy" of women but the old men's envy of the potency of youth that adds the spice to comedy. We laugh at the old dick who gets jealous of his own children and who has to be cured of such foolishness, for otherwise he will deservedly come to grief. In a comedy we always laugh at the greedy, jealous old man, who substitutes domination for potency, and who stands for everyone who substitutes domination for potency in general.

As far as I know, the model of the tyrannical parent was not extended to the mother prior to the Spanish Baroque drama. Nor do I know of mother-in-law

jokes among the ancient comedy writers. But in Lope de Vega's comedy *La Discreta Enamorada*, the mother takes over the traditional father's role. She is a widow who tyrannizes her daughter in the same way that fathers do in other comedies. There is sexual envy here as well; moreover, this is the main motive. The mother is eager to seduce her daughter's young lover; this is why she wants her daughter to marry the boy's elderly father—whose relation to his own son is indeed characterized by the traditional potency envy. Both the elderly woman and the elderly man spell out their sexual intentions explicitly. The captain ruminates (at least in English): "I look old, but she will soon discover that I am still a young and hard boy. . . . Give your daughter me to marry. If she believes me too old and treats me with distaste, she will soon discover how youthful my body is." The daughter, Fenisa, weaves her own intrigues, promising her hand to the old man, and sleeping, in the meanwhile, with his young son. Thus she achieves a *fait accompli*. Her mother finally marries the old man, for (III.2): "Any saddle will do for such an old hack."

Although we do not meet the character of the tyrannical and sex/envy besotted old woman before the Baroque theater, there are several typical comic female roles in ancient comedies. An old woman trying to seduce young boys appears in a Bacchanalia parody in Aristophanes. The fundamental comic female type is the ever-grumbling and nagging wife, well known at least since the legendary character of Socrates' wife Xanthippe. Later, even when marriage to the beloved is the clear and desired goal of lovers, comedies never cease joking about the institution of marriage. For women marriage is a catastrophe, for men, a comedy. Marriage is desirable as long as it has not yet happened; it becomes a burden only after it is actualized. And marriage, the nagging wife, and the niggling mother-in-law are emblematic butts of jokes to the present day.

While in generation conflicts greed plays as important a part as that of potency envy, in the comic conflicts between married couples, jealousy always plays the leading role. Whereas the jealous husband is always suspicious, credulous, and stupid, the jealous father is not necessarily any of these. Whereas the husband is in a state of constant anxiety about being cuckolded, the jealous father relies on his money, power, and tradition to feel secure. Yet there is something they share: both behave like tyrants. They are both confident in one thing, namely, that their wife or child is their property, and thus that they can do with these females whatever they want, forbidding the women whatever they want to forbid.

The denouement of the comedy does not just bring lovers together; it does not just shame jealous tyrants and does not just have a liberating effect by making fun of tyranny, violence, and constraints. First and foremost, the comedy presents and represents the triumph of reason and good sense. Tyranny, jealousy, the treatment of wives and children like personal property—all this is not just bad and harmful—it is also senseless; it precisely defeats its own purpose, becoming not just defeating but self-defeating. The rationality of laughter or comic logic is splendidly presented in the conclusion of comedies. Evil is shown to be ridiculous and stupid, but also irrational, a kind of madness. Comedy is

thus an extraordinarily optimistic, even utopian genre. Where *"omnia vincit amor"* is close to a fairy tale, *"omnia vincit bon sense"* is closer to a utopian vision. But the utopia does not sound utopian because of the skillful weaving of the plot, the absurd blindness of its characters, and the complications of intrigue and accidents. Remember the comedy *Hecyra* of Terence. Here, a man turns out to be jealous of himself for having raped his own wife when she was still a virgin. Without this utterly absurd scenario, no happy ending could be made believable. The complication of such a plot makes the utopia found with the final triumph of good sense believable. (One must mention that raping a girl or woman did not have the same negative moral connotations or consequences in ancient Rome as it does today. If the raped girl was a daughter of free citizens, the rapist had to marry her. Only raping a free married woman was considered a grave sin, a crime, in effect, against her husband and family.)

At the end of the comedy, in any case, we are satisfied and in good cheer. We are pleased that the lovers are united and the tyrants and wicked intriguers have come to grief; that normalcy and good sense got the upper hand. Yet it would be a mistake to believe that we—our laughter and our sense of reason or liberty—are presented or represented by the young people who sought and found their happiness. We do not identify ourselves with them, nor do we laugh together with them, although we laugh for them. Rather we identify and laugh together with the very people who promote, without self interest, the happiness of others. Beside servants, slaves, and maids, there is almost always a friend of the family who helps the main characters. He or she is liberal minded, tolerant, and sensible. And he or she also represents a philosophy, often a kind of stoic, but sometimes an epicurean philosophy. This is the character or function we earlier identified as the *raisonneur*. The *raisonner* participates in the play, insofar as he constantly unmasks the irrationality of family tyrants, but he does not weave intrigues or participate in scheming. He reflects on the characters, on their choices and their folly, and he advises and criticizes them. His philosophy is not speculative but practical; he embodies rationality in the shape of understanding and tolerance. His enemies are fanaticism and cruelty. In his person, the two aspects of the happy ending are combined; he represents liberty and happiness from the beginning. In his eyes, tyranny is folly and jealousy is madness. This character has a common wisdom: the more someone bullies others, the less will he be able to keep hold of the things and people dear to him. The *raisonneur* of a comedy discloses to us the essence of his wisdom: tolerance is more reasonable than intolerance. And moreover, tolerance brings us far closer to our real goals. As in the comedy *The Brothers* by Terence, the two brothers Micio and Demea constantly argue about the principles of education. Demea is a strict disciplinarian who abuses his son. Micio treats with care and understanding even the errors of his stepson. As Micio formulates his principle at the outset of the play: "It is beyond all right reason, and it is quite wrong . . . that there is more weight and stability in authority imposed by force that in one which rests on affection. . . . A father's duty is to train his son to choose the right course of his own free will, not from fear of another. This marks the difference between a

father and a tyrant in the home." Later he says: "Dear Demea, you must realize that in every other respect we grow wiser with increasing years, but the besetting fault of old age is simply this: we all think too much of money." Micio treats potency, envy and greed with humor and self-irony, and he equates them.

Comedies favor the toleration model also in marriage. A husband who trusts his wife fares better than one who tries to keep her under his control. A distrusted and controlled woman will lie and will always outsmart a suspicious male. In his comedy *The School of Husbands*, Molière follows the logic of argumentation in Terence's *Brothers*. Skeptical rationality manifests itself in toleration of human frailty; good sense, and good moral sense are held alike in Molière's plays. And since we are in the world of comic drama, they also pay dividends, as in *The School of Woman*, in *Tartuffe*, or in *The Misanthrope*. The scenario of *The Misanthrope* is the most complex, yet here too, we side with good common sense and moral sense against well-intentioned, self-righteous intolerance, although here, as in a few plays by Terence, our judgment may vacillate.

In addition to the usual "pairs" of father-son, father-daughter, and husband-wife, the "duet" of master-slave or master-servant plays an almost obligatory role in all comedies, the mistress-maid role appearing in several modern comedies. These "pairs" are major agents in the development of the plot and are splendidly fitted to fighting verbal duels. Although the relationship between master and servant is in principle more asymmetrical than the relationship between husband and wife or father and son, in the world of comedy this is not the case. It is usually not the slave who is finally liberated (although this can happen too at the end of a Roman comedy), but the slave, servant or maid is there to help others liberate themselves from oppression and tyranny. Servants most often so aid their young masters or mistresses. It happens sometimes that a servant gets beaten, verbally or physically, without any reason, but she or he can take the hits, never feeling too humiliated, but continuing on in his tricks. In the Roman comedies, as sometimes also in Shakespeare, the witty characters of the lower class entertain us and the other characters of the play with their perhaps rude, but always funny jokes. Still, a deeper sense of justice and nobility is presented in certain of these servants and commoners than in their masters. And they are absolutely necessary to the structural expansion of many plays, for the young master and mistress has to confide in someone; this someone is usually the trusted servant or valet. Thus the valet becomes the confidant of the master, or the maid the confidant of the mistress. Servants are also go-betweens; they keep secrets and deliver messages, playing the role of Hermes. And they are "translators"—a rich source of humor and complication, for on occasion they mistranslate their messages.

Confidential talks are certainly not restricted to the master-valet, mistress-maid relation. In all of the plays that develop two parallel plots, there are normally two pair of lovers, or two young men and two young women. Tricks of confidence are easily taken care of when the two young men are friends and/or the two young women sisters (the latter, e.g., in Mozart's comic opera *Cosi fan*

tutte, and the former in one if his earlier comic operas, *Abduction from the Seraglio*). In Shakespeare, the said girls are sisters, cousins, or friends, and the play ends with a double wedding. Yet even the double plot and the girl-girl, boy-boy duet does not make the mistress-maid or master-servant relation superfluous. Among equals jealousy can cause dissent, distrust, and even enmity, but this cannot happen (it seems) between mistress and maid, and it happens quite rarely in the relationship of master and servant. Friends can betray each other, but one cannot doubt the loyalty and fidelity of the maid.

After the modern world comfortably settled into bourgeois life, the character and role of the servant underwent several metamorphoses. The metamorphosis begins with Beaumarchais's *Figaro*. At the outset he constructs his intrigues in the interest of his master, though he is no longer really a servant, and is both cleverer and more accomplished than his so-called master. In Shaw, the "new man" as the chauffeur in *Man and Superman* or as the waiter in *One Can Never Tell*, are comic in a different respect than their traditional ancestors. The new men are comic because, although they are in fact not servants, but equals, they do not feel at ease in the role of equality. The son of the waiter is a lawyer rolling in riches. But the son is not ashamed of his waiter father; rather the father is ashamed of his lawyer son. This is, of course, still the old comic motif played out in a new orchestration; there are role-reversals and problematic identities, tricks which have characterized the genre of comedy since its birth.

The battle of the sexes has also comic variants. Many things forbidden in a tragic play are allowed in a comic one, especially the use of vulgar, even dirty language. As was mentioned, in Aristophanes' *Lysistrata*, where the women conspire not to go to bed with their husbands, lovers, or clients until the men of Sparta and Athens make peace, the men appear onstage hung with huge and erect artificial phalluses, and the bawdy jokes only begin there. The Shakespearean translators of the nineteenth century made a grand effort to replace expressions for body parts and functions with euphemisms still acceptable in Victorian society. It was at this time that the so-called indecent scenes and dirty language moved into a new venue or institution, the cabaret, just as the clownish scenes found a new home in the newly established institution of the circus.

Yet even if the comic genre did offer broader space, in the medium of language, for a presentation of both the battle of the sexes and of sexual desire altogether, the particular schemas of the comic drama discussed above also set a limit to that presentation. A comedy *must* have a happy ending; in the case of a battle of the sexes between the unmarried, this is almost always defined as a wedding, and in the case of married couples this involves their reconciliation. The philanderer husband will return to his wife, the jealous youth will ask the young woman he loves for her forgiveness, the unfaithful will discover that love is more important than money, and the intriguer will be unmasked. In spite of these limitations, there remains a large playground for the portrayal of characters and complication of plots, even for one comedy writer alone. But common to all

variations is the verbal battle between characters. Verbal battles must be spirited, funny and real; there must be hits and counter-hits, points seized and scored. We laugh at every hit, tasting it, taking pleasure in it, and sympathizing with its position. The wittier, the merrier. To mention just a few better-known examples, take *Much Ado about Nothing*, *The Taming of the Shrew*, *The Gardener's Dog*, *The Misanthrope*, or *Man and Superman*. Verbal battle characterizes the battle of the sexes even when the happy ending has an unusual twist, as in *George Dandin*, in which Angela makes a fool of her stupid, brutish, and jealous husband and goes to bed with an attractive young man. As Angela says at II.2: "Did you ask, before our wedding, for my consent? Did you ask whether I wanted you? You were only interested in the judgment of my father and mother; you are in fact married to them. I never said with one single word that I chose you as my husband. No one can oblige me to obey your wishes like a slave; I absolutely protest. I want to taste the freedom which is due to my age." (*My translation.*)

At first glance, of the five comedies I just mentioned, the battle of the sexes definitively increases sexual tension in four of them. The taming of Kate can be interpreted in many ways, including sexually. This is certainly the case in the story of the taming of Tanner Jog, which presents the reverse of the Shakespearian story. Here the man protests against love and marriage and Ann tames him into wedding her; yet in the very midst of their verbal battle, an erotic childhood experience surfaces. The sexual battle between Benedick and Beatrice and that between Teodoro and Diana (in *The Gardener's Dog*) represent the two schematic extremes of verbal erotic play. As we know, at the beginning of the play Beatrice and Benedick only rib and mock one another, all until their company decides to make them believe that each is secretly in love with the other. As a result, they do fall in love with one another, or at least they become aware of their love. Due to the trick, though not because of the trick, their love is made manifest, for these two were destined for each other without being aware of it. The bottom line is that the story follows the schema: when we feel ourselves to be loved, we are inclined to fall in love; when we are sure that another is in love with us, we have the courage to declare our own love.

But Teodoro and Diana play another typical love game, that of the merry-go-round. The moment that Teodoro admits his infatuation to Diana, she feels estranged from him; when in turn Teodoro becomes estranged from Diana, she becomes infatuated and interested. The merry-go-round goes on and on. It is even more vicious, and more sexually explicit, because Teodoro is a servant and Diana a mistress, a kind of early Lady Chatterley. At the peal of the sexual battle, Diana slaps Teodoro in the face. This slap has nothing to do with the well-known comic beating; it is rather an erotic gesture, a case of erotic violence. Sure enough, after going though the familiar lost and found plot, this battle too ends with a wedding.

Among the ten main vices of comedy enumerated above some are also tragic sins. We need only think of the jealous Othello, the envious Edmund, Kreon the

tyrant, or the hypocrite Richard III. Sins emblematic of tragedy, such as the passion of hatred, vengefulness, the thirst for power or fame, betrayal, and disloyalty are also found in many comedies. Yet the tragic hero cannot be stupid, only naïve; he cannot be a coward, only cautious; he cannot be a snob, just hungry for recognition and honor; and he cannot be vain, merely overconfident. In a tragedy, one also represents the social position one holds. Simply representing cannot be ridiculous; what is ridiculous is identifying oneself with a position or a profession while striving to embody it. One becomes funny in overplaying a role, in behaving as though one is epitomizing a part that one in fact just attempts to realize. A king who is every inch a king cannot be funny, but a doctor, lawyer, or courtier who in every situation (party, bedroom) plays the role of doctor, lawyer or courtier can indeed cut a comic figure.

The philosopher is often a comic character (especially, e.g., in Molière, who was well versed in philosophy), because the practical affairs of life seem entirely lost on him; he even seems to despise the sort of common sense he lacks. Whereas what we hate is rarely funny, what we disparage and look down upon with contempt or scorn is often amusing. This follows (as the language of "looking down on" spells out) directly from the "spatial" position of the regard. The comic writer and recipient look down upon the comedy of life from the higher plateau of a position of judgment. They have the loftiness and clear-sightedness that allow for judgment. Characters that embody merely petty vices can be treated with contempt if they are not dangerous, and receive a more severe scorn if they are. We laugh at, not with them, in either case.

It is at just this point that I see my preliminary description of laughter as the instinct of reason most justified. "High art" is the type of art which is open to practically infinite interpretations. Comic drama does not belong to the category of high art because of its plot structure; indeed, there is often not much to interpret in comic plots alone. But comedy is a high genre because comic drama, just as it stands, is itself an act of interpretation. Comedy interprets the essence of laughter even while it triggers it, through translating the instinct of reason into a presentation. Comedy, that is, presents everyday life from the standpoint of reason. I have already pointed out the elements of this presentation. The starting point of the plot is an irrational or unreasonable decision, and the source of the unreasonable decision is a character or a few characters who are themselves irrational or unreasonable. These characters are unreasonable because they are obsessed with something; obsession is the guiding thread in comedy, trailing a path that also signifies, in negative comparison, the instinct of reason. Obsession is something formal. One person is obsessed by one thing, another by something else; both are as fanatically devoted to the object of their obsession. But in its fixated pursuit, obsession contradicts both common sense and enlightened reason. Some obsessions are tragic, pointing beyond the possibilities of a limited life, in which case they are not ridiculous. But obsession with some low and petty thing does not point beyond the normalcy or confines of daily life, as a tragic obsession might; a petty obsession is a deficit; it is a subtraction from life. Whereas all obsessions are fanatical, the petty obsession is mean and wretched.

Obsessed comic characters usually "suffer" from one of the above enumerated comic vices. They are in fact obsessed by those vices. I use the verb "suffer," for sometimes reasonable people are able to purge irrationality from the spirit of an obsessed person, who is then cured and returns to a kind of rational, non-obsessive, non-fanatical behavior. I already mentioned a comedy by Plautus, *The Pot of Gold*, in which Euclio is cured of his miserliness by the end of the play. In Molière, however, Harpagon turns out to be incurable and is demonically comic. And the vain old Periplectomeus (of *Miles Gloriosus*) sums up his own story thus: "What a confounded fool I am!—Well, I believe I deserved it. . . . Give us your applause."

There is still a comic vice from which no one can be cured. This is stupidity. The foolish ones are usually not chief characters, but sometimes more than one fool together play secondary parts in a comedy. Stupidity alone does not a good comic figure make. The comic writer takes it that the real fool is the repository of at least one other vice. So the fool of a comedy is by and large not just simpleminded, but adamant and unaware of his foolishness. Such are the hilariously stupid doctors and lawyers in Molière's *Monsieur Pourceaugnac* (another talking name). In the last citation, we hear Periplectomeus (yet another talking name) adopting the position of the instinct of reason at the end of the play, referring to his obsessions as foolishness.

Merely silly, stupid, and foolish characters can aggravate the situation for lovers and characters of good sense, but they do not mastermind vicious intrigues. One cannot be obsessed by silliness, just by greed, jealousy, envy, covetousness, miserliness, self-righteousness, and the like. Yet when the instinct of reason sits in judgment, all of these obsessions are seen as just different varieties of foolishness.

Terence, Shakespeare, Molière, Shaw—to mention only the comic writers I personally love best—create characters who, although obsessed, cannot be described with reference to one single obsession. They are far more complex than that. Most such characters appear in a new light in each and every scene. Our sympathy may vacillate, especially when their obsession is far from being petty. This is the case with *The Eunuch* of Terence, wherein the errors (and every comedy is a comedy of errors) are just errors and nothing more, for they do not originate in any character's vicious or foul obsession. This is especially true of the controversial *The Misanthrope*, where the comic hero is a dignified person, and he is right in quite a few things.

If not everyone is "cured" of foolish obsessions at the end of comedy, at least some successful obsession-exorcism (even if not a final escape from silliness), is generally not excluded in the happy ending. For the obsessed characters this is a painful cure. They are not laughing; they are hurt and devastated. But then, what is a cure? When is an obsession exorcised? The comic drama gives us good advice: obsession is exorcised when the person who used to be obsessed can laugh at his own obsession. Rationality also requires distancing ourselves from ourselves. The identity crisis, so central in almost all comedies, should be

overcome, yet the total identification with ourselves, an over-identification which is the folly of all comic figures, must also be left behind.

The daemonic comic character is, however, beyond redemption. The daemonic comic character is not only a tyrant, although he can be one; he is not just a hypocrite, although he can be one; and he is not just a miser, although he can be one. The daemonic figure is the embodiment of radical evil in the comic drama.

The affinity of radical evil to the comic has long been discussed. But its role in the comic drama has gone unnoticed. People have always experienced the fusion of the comic and the evil at the marketplace. Both death and the devil, two absolute evils in the popular mind, were made fun of during the Carnival several centuries ago. The most daemonic evil character of Shakespeare, Richard III, is both a hypocrite and a clown. Yet he is the main character of a tragedy, not a comedy. We encounter similar incarnations of radically evil clowns in novels, e.g., in Thomas Mann's Joseph tetralogy, or in Dudu the wicked dwarf. Chaplin's role as a 'great dictator' presents the daemonic as comic in film. It may sound paradoxical, but in fact the comic daemonic is most difficult to portray precisely in a comic drama. For in comic drama, by definition, the plot must lead to a happy ending, without which it would not be a comedy, yet the main comic character, if he is daemonic, must remain fixed in his vicious obduracy, for without it he would not be daemonic. And if he does not remain daemonic, then he never was. Daemonic evil sometimes makes a guest performance in Shakespeare's comedies, like Don John the bastard in *Much Ado about Nothing*, an Iago-type, but only in two comedies by Molière will the comic daemon play a chief role. Of course I am referring to *Tartuffe* and *L'avare*.

The dominant feature of the daemonic characters of Tartuffe and Harpagon is the total closure of their worlds. In *The Concept of Anxiety*, Kierkegaard says that the daemonic man is unable to communicate. Although he can talk without ceasing, he will never establish a relation, or even a contact, between himself and others. Only thoughts and convictions that can be comfortably fitted into their closed universe exist for daemonic figures; everything else is criminal or nonsensical. To employ modern terms, the daemonic man is "ideological" and "fundamentalist" in a very private sense. No one can call his world or anything belonging to it into question; he never pays attention to anyone who contradicts him or interprets something differently that he does. The daemon is obsessed, and he is obsessed absolutely. This kind of total closure is, to repeat, daemonic, yet not necessarily evil or wicked. The evil daemon does not just dwell in his closed world, rejecting communication and reviling everything which enters from outside of it; but he also hates those he rejects, and he desires to destroy them. He indeed plans their destruction. The daemons who cannot reach out from a closed universe are irrational; the daemons who do their utmost to destroy those they exclude are both irrational and wicked. To put it simply, daemonic evil is "totalitarian" and treats others as would any totalitarian despot. The constant repetition of the same sentence, as in the case of Harpagon's "without dowry!" could be the sign of a mental disorder. But there is no com-

mon metal disorder in the case of Harpagon, although some might say that total closure is a kind of madness. Even if it is, this is not a medical but a moral situation. For Hapagon, the obsessive repetition of the same sentence is the manifestation of absolute self-identification and self-assertion.

The two daemonic evil characters in Molière, Harpagon, and Tartuffe, represent the two fundamental types of daemonic wickedness. No objection can reach the "inside" of Harpagon; all are automatically rebounded. He fences himself in, yet he does not fascinate others—on the contrary, he repels them. He is immovable but without charisma. Tartuffe is also immovable, yet in another way. He is not obstinate in the affirmation of the certainty of his system of beliefs, like Harpagon, but he is unbending in his manipulations and his certainty of their success. Tartuffe is charismatic, and as a result his obsession works like a contagious disease. Both Orgon and Mme. Pernell contract the disease. As with the supporters of Hitler or Stalin centuries later, they cease to believe their own eyes and ears; they believe only Tartuffe. They become themselves like Tartuffe, and their world becomes daemonic, closed; yet still, they are not transformed into wicked daemons. Tartuffe is more horrifying than Harpagon, for while Harpagon commands absolute obedience, Tartuffe commands not only obedience but also absolute faith; Orgon and Mme. Pernelle believe in Tartuffe and they also love him. The wicked commands love: this makes *Tartuffe* a frightful comedy. In the breathtaking scene when Orgon, returning home, inquires about the happenings in his absence, and turns out to be disinterested in the sickness of his wife, and in his children, worrying only about the well-being of Tartuffe; when after receiving the news about his family, he impatiently repeats the same question "And Tartuffe?" finally getting the answer that Tartuffe is well, he cries out in refrain "the poor one!"—he is both frightening and ridiculous. Not only is the repetition ridiculous, as in the case of Harpagon's "without dowry!" so is the irrational credulity. The credulity of Orgon verges on foolishness, and Mme. Pernelle is in fact a fool. We are used to laughing at folly in a comedy, but we are horrified by Tartuffe. All the same, we do laugh at the silly disciples of a daemonic figure who have fallen for his wickedness. We, the audience, are not fooled; we are in a position of superiority, because we laugh together with Dorine, the maid, at Orgon. In the end, of course, the fools who have been possessed by the daemon will be cured, although smart they never will be.

It is easy to understand why Orgon and Mme. Pernelle are comic figures. But why do we find Tartuffe, the daemonic evil character, the dangerous daemon, also comic? And why do we laugh at Harpagon? After all, it was by a very close miss that they did not destroy the lives of the young lovers and of a whole family. When Harpagon finds his money stolen, he insists that a policeman "arrest the whole city together with the suburbs!" Of course, we laugh upon hearing this absurd sentence, but then we are already at the end of the story and know that Harpagon will come to grief. But when, in the case of Tartuffe, he suggests Orgon's arrest to the policeman with reference to Orgon being "already a prisoner"—even we, the audience, are ignorant, for we do not know that the

tables will be turned in the following minute. Yet I disagree with interpreters who believe that it is a *deus ex machina* alone which transmutes this potential tragedy into a comedy. We know that Molière, as do so many playwrights, sometimes employs a *deus ex machina* to end a play. But in a comedy, this does not matter at all. Both in *Tartuffe* and in *L'avare*, Molière prepares the happy end of his drama far earlier. So when and how?

We meet two wicked daemons. The world of each is entirely closed; they do not listen to others; they hate and destroy. Yet there is something, some frailty, some weakness which cannot be accommodated in their closed world. This is carnal desire. Harpagon lusts after marriage to the young virgin, beloved of his own son; Tartuffe desires the wife of Orgon, his closest follower and devoted subject. Their obsessions do not put limits on their lust. Harpagon and Tartuffe live in closed worlds, but their bodies each desire the touch of another body. The daemon is unreachable; he is moved neither by pity nor love, and he is deaf to the claims of justice. But the body is something else again, going its own way, lusting, following a different obsession. The two most distrustful monsters become gullible when they are carried away by lust. Harpagon and Tartuffe are comic characters because their writer built a decisive incongruence into their characters. And this is why we are able to laugh, and why they come to grief. As a counterexample, think of Richard III, the self-made clown of a tragic drama. He laughs at others, but we cannot laugh at him. He seduces, but without feeling desire. He is in complete control of his body, however wretched, and he frequently uses it for manipulating others.

Comic daemons live at the time of the slow metamorphosis of traditional comedies into existential comedies. It suffices now to refer to Durrenmatt's play *Besuch Einer Alten Dame* (*Visit of an Old Lady*). I will talk more about this transformation in chapter 6. Herewith, we gradually say good-bye to traditional comedies, one of the representative high genres for the presentation of the comic phenomenon. These kinds of plays are no longer written. There are no more comically tyrannical fathers, who only as victims of righteous intrigues consent to the marriage of their children; there are no more witty valets, more sophisticated than their masters; maid and mistress do not swap garments anymore; children are not lost during a tempest at sea and found again by happy parents; neither are twins sources of laughter; nor is it funny that someone gets beaten. Error is no longer ridiculous; *bon sense* does not win out against silly prejudices. Yet we still enjoy the staging of old dramas and operas; we still laugh and empathize; and we still continue, and will yet carry on, the work of interpretation—which is and remains inexhaustible. There is still redeeming laughter.

Chapter Four

The Comic Novel

The next "high" comic genre, the comic novel, belongs to a more general cluster, namely that of comic prose. Even if I were quite lax in my original aim of determining or making explicit the phenomenon of the comic by means of a discussion and an analytical discernment of the main comic genres, I would here encounter greater difficulties than in the case of the comic drama. In handling comic drama, it suffices to neglect so-called "light genres" and to rigidly divide periods within the history of such drama. These "abstractions" must also be constructed for a discussion of comic epic prose. The comic drama, however, is regulated by its theatrical performance; because it is written for the stage, it is subject to very specific temporal and spatial limitations. There are no such limitations in epic prose. This is why, solely on the grounds of their length (which is to say by a merely formal or seemingly formal criterion), it is customary to distinguish three comic epic genres: the novel, the short story, or novella, and the joke. But this distinction is not, in fact, just formal. Just as the size and surface of a canvas is not unrelated to the proportion and message of a painting or a fresco, or perhaps even more so, size matters in epic prose. In a comic novel, the character of the comic and its effect is different, sometimes essentially so, from the comic in a novella or in a joke.

Since I am not engaged in writing a history of any one genre, I will not circumnavigate the line of reasoning I mean to follow by turning now to Greek or Roman comic epic prose—rich as they are. This is not just a pragmatic decision, but should alert the reader to a strategy guiding this book: a certain reception or, more precisely, a hermeneutic reworking of the comic phenomena directs my inquiries. Between the comedies of Aristophanes, Plautus, and Terence on the one hand, and the comedies of the modern authors from the sixteenth century

onwards, there is an incessantly active lifeline: the moderns follow in the foot-steps of the Romans, picking up their themes and appropriating and modifying the earlier comic structures. In contrast, the new comic novelist goes back, for the most part, no farther than Rabelais. Though we might refer to Homer and Virgil as founding fathers of the epic genre, it would be wrong to trace comic epic genres to them.

I will not begin my story at quite this point either, for I want to stretch it to a very particular limit, found paradigmatically in the works of Samuel Beckett, from which I believe the comic epic genre can be best considered. It is true that both as regards plays and novels, Beckett's works also lie outside of the border-line I will draw; and it is also true that these borders themselves, like those of the new European Union, can be crossed without a passport, without asking for permission, and sometimes without our noticing that we have done so. But I do want to point to a specific boundary line, and I will argue that, once it is crossed, we definitively enter the world of the comedy of existence. This world will be the subject of the next chapter. For the time being, I will advance only one crite-rion necessary for distinguishing existential comedy and for proceeding with our discussion of the novel: in existential comedy, the function of rationality has absolutely changed. In a traditional comic work, both in comic epic prose and in comic drama, the ridiculous is also irrational. As we have seen, the measure or yardstick of "reason" is always present, irrespective of whether the irrational is portrayed as base or noble, as petty or magnificent, or—as it usually happens—as all of these things. In the world of existential comedy, however, no "reason" exists for the narrator or main character to provide any kind of fixed measure. As a result, existence itself, the very human condition, appears in a comic light. The ridiculous and funny do not just point at something serious, bringing it into relief; rather, it becomes impossible to distinguish between the comic and the serious.

In comic literature there is also irony and humor. From here on I am going to distinguish in a borrowed, if uninvited, Kantian manner, between *regulative* irony and humor on the one hand, and *constitutive* irony and humor on the other. What I call constitutive irony and humor was first discussed, discovered and perhaps even invented in German Romanticism, particularly by Friedrich Schlegel; Kierkegaard later elaborated upon Schlegel's concept of irony. With constitutive irony, there is no distance between the ironist or humorist and the world which is treated with humor or irony. Or (in what amounts to the same), the distance between writer and topic gets built into the world/work itself; the very work becomes ironic and humorous in just the way that the world it de-scribes is supposed to be.

Regulative irony or humor (as I apply the term) characterizes an attitude or perspective from which another person, a statement, or an idea are made to ap-pear in a comic light, such that the very distance between the ironist or humorist and the butt of his humor is made manifest. Shaw says once that every English-man is a joke. This is regulative irony; it delivers the message of a comic drama across the distance from the topic at hand to the perspective of its witness. In an

existential comedy, where irony and humor become constitutive, every man is a joke, and this is not a joke. I find it unhelpful to characterize existential comedy as simply the "grotesque" or "absurd," since not just traditional comedy, but the comic novel, novella, and joke can be grotesque and absurd, as can various kinds of pictorial representations, without being existential. This characterization would be more illuminating with a specification: in an existential comic work nothing is untouched by the grotesque or the absurd, but this always includes both the narrator and the reader.

Milan Kundera distinguishes three periods of the novel. The chief representative work of the first period is Sterne's *Tristram Shandy*; the second period is marked by the classic works of Balzac, Dickens, and Tolstoy; and in the third period there is a return to elements of the style of the first, found in novels like Rushdie's *Midnight's Children* or in Garcia Marquez's *Love in the Time of Cholera*. I would like a slightly different story of the adventure of the novel. I will not insist that my story is "truer"—only that it does greater justice to the comic genre.

For in the case of the comic novel we can hardly distinguish three periods. The history of the comic novel is in fact surprisingly continuous. It goes on without interruption from Rabelais or Cervantes, through Fielding, Diderot, Gogol, to *The Pickwick Papers* and straight to Svejk, to *Ulysses*, *The Tin Drum*, *Felix Krull*, and *Love in the Time of Cholera*. It is easy to guess why I began my list with author's names and continued with the names of "heroes" and titles. The further we proceed in the history of the comic novel, the more frequently we encounter authors who do not only write comic novels, but many sorts of novels; indeed, we find authors who wrote comedies rarely or only just once. One comic novel can be a writer's sole masterpiece, as in the case of Cervantes; or it can be their best-known work, as in the case of Swift; or it can be but one novel among several, better known than others, as in the cases of Dickens and Mann. The name of "Hasek" does not sound familiar outside the Czech border, but the name of the good soldier Svejk is recognizable further and wider.

From the times of the Renaissance to the present moment, comic novels have been consistently written and read. These novels share certain features that set them apart from other novels. We may call all "other" novels, for simplicity's sake, "socio-historical," "realistic," or "bourgeois" novels. Such novels also contain comic figures, they can be rich in comic situations, and they can also be ironical. It is not because of a lack of humor that they differ from comic novels, but because their structure, manner of presentation, and narrative strategy are different from those of the comic. One may say that the comic novel and the socio-historical novel are born simultaneously, at least in England, with *Tristram Shandy* on the one hand, and Richardson's *Clarissa* on the other. Both were great favorites of their time's readers, including Immanuel Kant.

In contrast to comic novels, in which main characters or comic "heroes" are all men, the first chief characters of the socio-historical or bourgeois novels are heroines, irrespective of their author's gender. And from Jane Austen on,

women occupy a pride of place in the development and shaping of the character and structure of this new kind of novel, just as women are their first enthusiastic readers. This interesting specificity does not follow from the character of the comic phenomenon in general—in the comic novella women are frequently portrayed as main characters—but from the narrative strategy and the structure of the comic novel in particular.

Let me for a moment return to the theory of the "three periods" in the development of the novel. I suggest that this division does not apply to the comic novel. The history of the bourgeois novel since Richardson and the history of the comic novel run parallel to each other. Or more precisely, the bourgeois novel has a history, whereas the comic novel, which began at the same time, has none. Expressly because the bourgeois novel is realistic, it is widely exposed to changes in the times. When one avenue of imagery or portrayal becomes untimely, the novelist crafts new, timelier scenes on which he can safely, if not unproblematically, tread. Dickens and Balzac did so, as did Flaubert, Dostoevsky, and Proust.

But the story of the comic novel is a quasi-story, and our comic novelist can tread on the same avenue his predecessors did. Some would think that this difference results from comedy's relation to the "referent," the socio-political "reality." The situation is more complex that that. An outstanding feature of the comic novel is that it constantly puts its finger on contemporary social and political incidents and actors; it makes constant allusions even to concrete political events and abuses of the day—whereas its bourgeois counterpart is imbued with the spirit of the times, even while its contemporary allusions are presented indirectly rather than directly. It is not reference to existing affairs that accounts for the difference between comic and bourgeois novels, but the character of the adventures they present. Adventure in a realistic novel is largely internal, although internal adventures may be related to world experiences. The outstanding importance of internal adventure (a tendency which peaks in Proust's work) makes the bourgeois novel sensitive, to an extreme degree, to the turning points of social experience and historical consciousness. Whenever historical consciousness, or people's basic perception of their world, is undergoing marked transformation, then the relation between portrayed internal and external events and characters' relations to their world will change—and so too, then, does the style and the organization of the novel that renders them. Not only the novels, but the characters they portray are themselves age-oriented, especially in the nineteenth century. Due to the power of their internal experiences, characters in novels constantly change within the novel, whether they win or lose, succeed in their ambitions or become disillusioned. In contrast, the main figures of a comic novel do not change within the novel. Their character remains steady throughout the series of adventures and even during the transformation of their world or situation in it. This is true about Don Quixote, Gulliver, Huck Finn, Svejk, and Krull, to mention only a few comic characters from different centuries and historical ages.

The spontaneous reaction of readers to these two kinds of novels is also different. In a "realistic" novel, there is only a slight difference between its reception by sophisticated and unsophisticated readers. We all become captives of the story; all soon enough come to identify with the main character and begin to dislike his or her enemies; we all hope for our character's success; we are all happy if the character does well and sad when he or she gets into trouble; and we all alike follow with excitement the development of the plot. Most can resist only with great difficulty the temptation to take just a cursory glance at the ending of the novel, because we are curious and feel we need to know in advance how the story will end. I have, however, never met a reader who fought or felt any temptation to look into the last chapter of a comic novel to satisfy her curiosity. Who really cares how Gulliver's travels will end? The comic novel frequently does not "end" at all. Hasek's novel about the good soldier Svejk and Thomas Mann's novel about the adventures of Felix Krull in fact remain unfinished, but so what?

The non-ending or the artificial ending characterizes the comic novel through and through. Diderot "finishes" his book *Jaques the Fatalist*, allegedly the memoirs of Jaques himself, with three chapters which he did not (again allegedly) "find" in the memoirs, and he also "judges" one those chapters to be inauthentic. In the second part of *Don Quixote*, Cervantes abruptly makes the Don die, in order to prevent plagiarizers from continuing the story of "Don Quixote" in a faked third part. Although the ending he then wrote was not artificial, Cervantes could have postponed it if he wanted. Most comic novels could be continued *ad infinitum*, if the author did not put an arbitrary end to the story. There are exceptions, as there always are. For example, when a comic novel is a straightforward parody, the writer needs to follow the text he parodies, as in the case of Mann's *Der Erwählte*, or in combinations of comic and realistic genres, such as in Fielding's *Tom Jones*. Sure, Fielding could have continued with further adventures for Tom in another volume, but in the end, Sophie and Tom had to meet and become a couple, in the spirit of the then-new bourgeois novel. The same can be said about *Love in the Time of Cholera*, wherein Garcia Marquez parodies the sentimental Latin-American belletristic, with humor and love.

Let me briefly return to us, the readers. The recipients of the bourgeois novel, sophisticated and unsophisticated, differ from one other in one respect, and that is in the depth of their reception. All share an essential aspect of their reception: all are captured by the characters and the story; all laugh and cry, sharing sorrow, fear, and hope with the heroes. But of the comic novel (as also of comic film) the naïve and the sophisticated reception will still be essentially different, though both kinds of readers enjoy the work. The naïve reader follows the adventures and is amused by the funny situations, while their metaphysical message bursts in upon the sophisticated reader. A comic novel can have entirely different messages for unsophisticated and sophisticated readers. Though it is amusing for all, for some it is intellectually complex, demanding, and dense with meaning. Interpretation of a comic novel involves deciphering ciphers; it is itself an intellectual adventure, a philosophical exercise.

Up to this point I have looked at the comic novel from the perspective of the novel, now I will briefly scrutinize it from the perspective of the comic phenomena. How is the comic novel possible?

Watching or reading a comic drama takes up roughly two to three hours. During this limited time span, two or three interwoven plots develop before our eyes. Most characters, or at least several of them, are themselves comic (they can be, for example, embodiments of comic vices), and they tend to become the victims of tricks or errors. The intrigues around them constantly produce comic situations, and the ending of their story will be reassuring or "happy." We are ourselves amused continuously during these few hours; we may burst out laughing just preparing ourselves for the next gag, pun, or funny encounter. We assume the attitude, the readiness for amusement and laughter, and our expectations will be met if the comedy is any good.

In comic epic prose, the shortness of the genres do not pose additional difficulties. Consider a joke or a comic anecdote. (The comic anecdote differs from the joke, in that the anecdote's characters are not just familiar people, but the situations they present have actually happened, or at least could have really happened. The listener does not suspend her sense of reality to appreciate the anecdote.) The joke—just like the comic novella or anecdote—ends with a punch line; its ending, or the point that finally makes it comic, concludes the joke. The recipient (the listener) pays attention to every sentence in a state of interest and tension, because she awaits the punch line, or the "end." One can maintain such a state of tension or attention only for a relatively short time. The tension must be reduced; it must dissolve in the redeeming laughter. (In the comic novella, I must add, laughter is fed by other sources as well, usually by erotic situations, as in Boccaccio, but I cannot address the specificities of all sub-genres here.)

Comic novels, however, are long, sometimes very long. It might take a few days or weeks or even months to finish reading them, depending on what one has to do in the meanwhile. A few comic novels were written in installments, while others were written over an extended time; sometimes the writer was interrupted in writing them, and continued working only much later (this happened to Dickens, Joyce, and Cervantes). So how can one maintain the comic effect for such a long time? Neither the writer nor the reader can burst out laughing continuously for months or years, or even prepare oneself to do so, incessantly waiting for amusement. And in addition, as I have already indicated, there is no punch line in a comic novel.

The specificities of the structure of the comic novel have in all probability to do with the task of coping with this enormous difficulty, and perhaps this accounts too for the structural similarity of all comic novels (existential comedy included), in contrast to the great divergence among the "realistic" novels. To put it succinctly, every comic novel is a novel of adventure, a kind of picaresque novel. This is why, contrary to the bourgeois novel, the heroes of comic novels are always men. Women could not have had the adventures narrated in these

novels unless they were disguised as men. External (as opposed to internal) adventures were the prerogative of men. Of course, not all novels of adventure are comic novels (see *Robinson Caruso*), but all comic novels, I repeat, are picaresque novels. The remote ancestors of comic novels are not just earlier comedies, but also epic adventure poems. The writers of comic novels frequently refer to Homer's *Odyssey*, or to *Orlando Furioso*, sometimes they are paraphrased, in the manner of parody. The hero of the adventure novel is always "underway." Hasek speak about Svejk's anabasis. Trips follow each other in waves, as in the case of Gulliver, or in Don Quixote's three journeys, Pickwick's three journeys, Tschitsherin's travels, and the two journeys taken by Gogol's dead souls. In all these novels, the main character leaves for an adventure, returns homes, leaves again, and returns home again. There are little journeys, like the one Huck Finn takes on the Mississippi, and grand journeys, like the one of Candide and company between Europe and the Americas. There are adventures of "high" characters (Don Quixote, Pickwick) and of average characters (Candide, Krull), and even of "low" characters (Tshitsherin). There are comic journeys which can be read as parodies of "serious" and fashionable travel books (Gulliver's); there are also books that follow the irrational "adventures" of a horrifying reality, which takes its characters into an absurd comic dimension, as with Oscar in the *Tin Drum*. Still, the structure of the novels remains almost the same.

Since comic novels are always picaresque, one might think that the development of the plot plays a greater role in them than in socio-political novels. But nothing could be further from the truth. There is no unified plot in a comic novel, or only an extremely loose one, as found in Pickwick's court case. One could always add a few adventures to the slackly laced narrative, just as one could omit several of them; this would make no essential difference. The author can leave a story hanging for one hundred pages, and return to it only when it has been almost completely forgotten (*Tristram Shandy*). Such is the spray that makes for the fine aroma of the comic novel. Think of Diderot's *Jaques the Fatalist*. Almost at the start, Jacques begins to tell his master the great love story of his life, but he is interrupted; later on he begins to tell it again, then again and again, never finishing it. Only at the end of the novel does the presumed editor of the book tell us the whole story, in order to finish the novel. The comic novelist does not fulfill the basic requirement of a good realistic novel. He does not firmly guide us from the beginning to the end. He does not guide us at all, and he certainly does not guide us in one or the other direction. We must guide ourselves if we want to start somewhere and arrive at some point. Self-guidance does not orient us within the plot, but rather in our interpretation. The comic novelist, instead of guiding readers, keeps us constantly in a state of postponement. He keeps us from arriving, not at the point, since there is not one, but at a final interpretation. Through his tactics—of hesitation, repetition, playing hide and seek—the comic novel becomes what it is: an encyclopedia of all comic phenomena.

In order to support my thesis that the comic novel becomes an encyclopedia of comic phenomena in and through the employment of its creative strategy, I must address a few special elements of this strategy.

The comic novel is philosophical. Authors of several comic novels were philosophers; others were publicists or pamphlet writers; others art or literary critics. None of them were "naïve" or merely spontaneous, instinctive geniuses; they were thinkers, people used to reflection. The butt of their parodies and jokes are often metaphysics, logic, ethics, religion, and the fools who champion them. To pull off such parody, one need not be a philosopher. However, in a comic novel the parody of philosophy is also philosophical; the parody of ethics is ethical; the parody of logic is logical; and, indeed, the parody of religion is also religious-philosophical. Philosophical parody abuts philosophy itself. Of the typical forms of this game, the questioning of all identities (the principle of identity), which we have seen at work in so many comedies, is paramount. First and foremost, the identity of the "author" is put to the test and questioned in almost every comic novel. "The death of the author" occurs for the first time. The author steps outside of the plot (this also happens in the comic drama, in the oft-discussed parabasis), yet here, he simultaneously questions his own authorship and truthfulness.

"Authorship" in Kierkegaard's sense, that is, an author's masked appearance or appearance incognito, is a rather traditional trick in comic presentation. Do we know who the author really is? How do we know what we know? Who has authorized whom to describe these things as though they really happened? Who writes the writing? Jacques, for example, insists that everything has already "been written." When his master denies this, asserting that he will now do something quite different, Jacques answers without hesitation that this different thing too "has been written." When Don Quixote reads, in the second volume written by an "impostor," that during his adventures he went to Toledo, he accepts that the novel must be lying, since he will not go to Toledo.

The onto-teleological antagonism between free will and predestination, as well as the metaphysical dilemma between accident and necessity, follow the comic novel from Cervantes through Joyce, Grass, and Garcia Marquez. Who can have any certain knowledge about God/the Master? Or about man? Or about the universe? We, the authors? Authors of what? Not even of the novel or the chief character of a novel? But then is an author somebody or nobody?

One somebody who, perhaps, writes, tells us in *Jacques the Fatalist*: "It is obvious that I am not writing a novel, for I do not do the things all novelists do. Yet those who maintain that what I write is true are perhaps less mistaken than those who would take everything I write as a fairytale." Diderot's readers, well versed in philosophy, were surely amused by such a sentence, mimicking philosophers' and other writers' claims to omniscience. But not only is the author's identity problematic, so too is the identity of his chief characters. The heroes of the comic novel are marginal, and most of them also suffer from identity confusion, because they do not know who they are, or mistake their identity, or just claim to be someone else. Yirmiyahu Yovel's hypothesis (in his next, now forth-

coming work) that the first Spanish picaresque novels were born out of the Mar-
rano experience deserves serious consideration. After all, Sancho Panza empha-
sizes several times that he is an "old Christian," and as it is well known, the
christened Moors and Jews were called "new Christians." The alleged author of
Cervantes' book is also suspected of being a "new Christian." The root of iden-
tity confusion and the circumstance of a main character's marginality may be
unique in each and every comic novel, but identity confusion itself is omnipres-
ent. The heroes of Rabelais are giants; Gulliver is at times a giant, at others a
dwarf; Oscar (of *Tin Drum*) is a dwarf who, when he begins to grow a bit, be-
comes hunchbacked. Pangloss is a metaphysician alien to the world; Jacques's
Master is a nobody and a somebody—perhaps God himself. Tom Jones believes
himself to be a foundling; Bloom (in *Ulysses*) is a baptized Jew; the members of
the Pickwick Club are eccentrics; Huckleberry Finn is a vagrant; Gregorius (in
Der Erwahlte) stands, due to his disorderly begetting, "outside the human race,"
in his own words.

In one way or another, one of the main characters of a comic novel always
lives in another world; he dwells not in a pragmatic world, but in a dream, an
illusion, in his own phantasm or phantasmagoria. One of the most important
aspects of the presentation of the comic novel—the element of the absurd—is
deeply, tightly connected to this structural feature. We have encountered the
portrayal of identity confusion in comic drama, and can grasp that it endures as
an important common denominator of all comic phenomena. Yet, as we know,
in a comic drama the identity problem gets "resolved" in the happy ending. Not
so in the comic novel, which is, as already indicated (and in a manner of speak-
ing), a never-ending story.

The drifting of reality, and the truth-claim concerning authorship on the one
hand and the uncertain identity of the comic novel's heroes on the other, are
structurally intertwined. And this is the characteristic feature of the comic novel.
Since authorship is uncertain, we generally do not know who speaks and who
serves as a mere mouthpiece. The transition between possible and impossible
hovers, as do so many other prospects contained therein. Since there is no om-
niscient author, there is no reality; nor is there truth beyond doubt. There can be,
in the comic novel, no final solution. Paradoxes, games, plays, puzzles, and
mysteries fill the pages of comic novels and need not be entirely resolved.

Let me illustrate all this with the single example of *Don Quixote*. Borges
preferred the second volume of *Don Quixote* because it is there that the Don
reads and comments on the book written about him, and listens in on the conver-
sation of his neighbors at the inn, discussing his adventures taken from the unau-
thorized version of his life story. In the introduction to the first volume, the
author appears before us as self-legitimated, though he speaks about himself, his
readers (and also about Aristotle), with not just a little irony. "Idle reader! You
can believe me, whether or nor I take an oath, in that I wish that this book, the
offspring of my mind, would be so perfect and amusing that a greater perfection
could not even be imagined. Still, I can do nothing against the laws of nature,
according to which everyone begets someone like himself. . . ." In the first chap-

ter, he (the author) immediately promises that "during our narration we will never deviate even a hair's breadth from truth." Still, as we read at the end of the eighth chapter: "Unfortunately, the writer of this story interrupts the battle exactly here at this point, with the excuse that he has found nothing else recorded about the heroic deeds of Don Quixote." According to this note, it is not the "I" who authored the story, but someone else, and even this someone else did not invent it, but relied upon the records of someone else again, records which he cannot now revise with fictions. In II.24, we encounter the author of the novel, or rather the recorder of the story: the sage Cide Hamete Benengeli. We learn that he is a Catholic Arab, that is, a new Christian fighting with his identity problem. We learn further that the author of the book is not in fact an author, but just a translator, rendering the tale from Arabic into Spanish, and having dire troubles finding the suitable words. The same Cide Hamete Benengeli will also *be* described (by whom? Cervantes perhaps?) as a precise and considerate historian, while in the twenty-fourth chapter some author (but who?) makes the following remark: "Cide Hamete Benengeli, the Arab writer de la Mancha, thus continues his important, sublime, circumspect, charming, and fictitious story. . ." Aha, we say, so then it is a fiction! But, we could rightly ask, how is it that an Arabic writer hails from the Castilian district of Mancha? And then, the twenty-eighth chapter begins: "Happy and lucky were the times when the most brave knight, Don Quixote de la Mancha, was born, because it is due only to his respected endeavor to resurrect in our world the almost entirely disappeared order of knight-errant; because we have only him to thank for our enjoyment, in a world much in need of entertaining narrations, for the sweetness of his true stories, and also for the narratives and tales inserted into his stories, which are sometimes not less amusing, witty, and true, than is the chief tale itself." Who has invented whom and what? What is true and what is a fiction? Who wrote what? Everything can be questioned. And this is just the fun of the work; for the game, the joke, the play, and the puzzle are all sources of merriment and of philosophical pondering alike.

In II.5, we learn from the "translator" of the book that he does not consider this chapter to be authentic. Yet what makes a chapter authentic? That the things it narrates have really happened? Or does authenticity lie where an "original," first fake or fiction is related? The twenty-third chapter is introduced by someone (who?) with the following remarks: "Whoever translated this chapter from the original chronicle by Cide Hamete Benengeli has added that he found . . . some words added, written by the hand of Benengeli, but that he could not make anything out of them." So, now the story we read is not even the version of our translator, since he quotes an earlier translator who, on his part, read some remarks written on the margins of the work by the author, which could not be deciphered. In the fifty-ninth chapter, Don Quixote eavesdrops on a conversation from the neighboring room. One man asks another: "Please, before they bring up the dinner, let us read a further chapter from the second part of Don Quixote." As we know by then, this second part of the supposed novel, which plays a role in the second part of our novel, is not the real second part but the

forged second part. In the sixty-first chapter, we read the following as Don Quixote and Sancho Panza are leaving the scene: "This was really a very noble, elegant house, where we say goodbye to them, because Cide Hamete Benengeli wanted it so." Should we thank Don Quixote for the story, then, or Cide Hamete Benengeli, or if Benengeli is not identical with the translator, then who? To whom does Don Quixote owe his brilliant life? To himself, to the translator, the chronicler, or the author, if there is an author at all? One encounters several similarly confusing, if not as sophisticated, games in almost all comic novels. For example in *Tin Drum's* "Buried in Saspe": "Yet I want to stick to the truth and behind the pen of Oscar correct a few things." In all probability Oscar and the writer are identical. Yet who can be sure? Dickens, in the *Pickwick Papers*, says that he borrowed his hide-and-seek tactics directly from Cervantes.

At the very end of his novel, Cervantes, the author, mediator, and translator, finally puts all his cards on the table. Cervantes steps before us and says: "Don Quixote came into the world only for me and I for him. He was potent in acting, I in writing; we two were born for each other." Proud words and humble as befits a creator; we hear in them that it is always the artist and demiurge who writes.

In his palimpsest "The Life of Don Quixote and Sancho Panza," de Unanumo asserts, among things, that it was indeed someone else, whether Cide Hamete Benengeli or another, who wrote *Don Quixote* with the hand of Cervantes. For with the exception of this absolutely major work, all other books by Cervantes were just mediocre, as though not written by the same person. One can, of course, speak of divine inspiration, or angels dictating the text, and in this sense Cervantes' game with Cide Hamete Benengeli discloses the truth. But this is too simple and too prosaic. What is worse, Unanumo would strip the novel of its supreme grandeur: the shining irony and humor that unifies beauty, the sublime, the comic, and all the games. Cervantes said, and it is true, that he invented Don Quixote and that Don Quixote invented him. The two together lifted the comic novel genre onto the level of high, noble art. This novel is not one picaresque story among many. It is fate and destiny, ultimate and unrepeatable, inimitable yet a model for so many to come. In this sense, it is a modern work.

After this long way around, it is time to return to our unanswered question: how can a novelist maintain humor, fun, entertainment, hilariousness, and the spirit of merriment in a long or very long book? The ironical and self-ironical game of masking and unmasking is but one trick among many, though a philosophically important one.

One of the questions presented earlier suggests another structural element of the comic novel. The author or translator, as some of our above quotations reflect, weaves into the main narrative several smaller, auxiliary tales. Indeed, there are smaller tales, jokes, or anecdotes laced into the canvas of every comic novel; in some novels there are many, in others only a few. Svejk the good sol-

dier usually introduces his numerous comic anecdotes with a preamble such as: "I knew once in X a person named Y"—and follows with an extremely funny story. Although Hasek's book consists of a chain of Svejk's adventures in World War I, without those inserted tales the book would not be what it is. Yet the incorporated comic novellas, short stories, anecdotes, comedies, and jokes do not transform a comic novel into a collection of comic novellas or anecdotes. Sometimes the opposite is suggested. Kundera thinks that the *Decameron* should be rather read as a novel consisting of novellas. I do not agree, both for structural and for substantial reasons. Without main characters whose external adventures stand in the center of the novel, there is no comic novel, even if funny tales, jokes, and novellas frequently interrupt the flow of their adventures. The philosophical and sometimes metaphysical message of comic novels is not concentrated in the inserted novellas or tales, but in the adventures of the main characters.

Still and all, there is no comic novel without inserted comic stories. Let me name a few randomly as examples. Think of the story of the goat shepherd in *Don Quixote* (chapter 12), from which Shakespeare drew in his *As You Like It*; or of the story of the ragamuffin (of chapter 24) or of Princess Micomicoa (in chapters 36 and 37) or especially of the story of the foolish, curious man, fitted to Boccaccio's pen, to which the author refers back in the second part of the novel. Or, remember the funny and absurd story told by the "hero of the Oceans" in Joyce's *Ulysses*, or the story of the old man in *Candide*, or the story of the scars in *Tin Drum*. We laugh merrily or bitterly at the inserted stories, and this is also a way for the writer to maintain a light or dark, but always a comic, mood.

Not only comic tales or novellas can be inserted into comic novels; so can comic dramatic scenes and jokes. Mr. Deasy tells, for example, a well-known Jewish joke to Stephen (*Ulysses*), whereas in *Tom Jones*, Fielding steps outside of his own story to support the indignation of the character Humour with a well-known footman-joke. Contrary to the inserted comic tales, which are often unconnected to the main adventures, jokes usually comment directly on events or characters of the main story. We frequently encounter lyric insertions as well, and these too are generally parodies or at least of a parodistic nature. Thus in a comic novel, various kinds of comic effects strike us in waves, and we are entertained continuously. But the main sources of amusement remain the adventures of the chief characters, whether or not those adventures are injected with the spirit of the supporting tales.

Comic novels play with all varieties of the comic, and whatever their supplementary stories and elements, they do so also in their "main" stories. In the prime trajectory of a comic novel, one can encounter satire, both ironic and malicious in kind, friendly humor as well as sarcastic humor, mocking, joking, the absurd, the burlesque, parodies, caricatures, puns, and so on. Both the situation and the hero can be ridiculous, as can both together. There are comic vices here too, mostly the same vices that exist in comic drama. Both intrigues and

accidental encounters play a role here as well. For example, the vicissitudes of
Tom Jones are almost completely the result of intrigues and accidental encoun-
ters. Only contrary to comic drama, here no time element limits the number of
the resulting adventures.

Gerard Genette, in his book *Palimpsest*, distinguishes parody from travesty,
and distinguishes several kinds of parody, such as minimal parody and satirical
parody, from pastiche. As far as the comic attitude is concerned, the most impor-
tant of his recommendations for a theory of humor are perhaps the contrast be-
tween the playful and polemical attitude, and their further specifications into
ironic and satirical, humoristic and serious attitudes. All these types, attitudes,
and comic formations can be found in every comic novel, the "serious" element
included. But the fundamental attitude or emotional coloring of comic novels
can be very different.

Chief comic characters can be comic in very different ways. But in all ways,
they must be stylized. They must be stylized not just in comparison to the realis-
tic heroes of the socio-historical novel, but also in comparison to the best of
comic drama. The stylization of the characters does not entail simplification;
rather, it is connected to an already mentioned fact, namely that they do not
change within the novel. This is why they lend themselves so well to illustration.
When we utter names like Sancho Panza, Pangloss, Pickwick, or Svejk, we
already see them. At one point, Fielding begins to describe Miss Bridget, but he
stops the description and rather refers to a lady portrayed by Hogarth in one of
his prints. Just look at Hogarth's *Winter Travel*, and you will immediately see
Miss Bridget, writes Fielding.

So comic characters are stylized, but not simplified. Their complexity, inso-
far as they are complex, results from their philosophy or their philosophical
significance. It is their philosophy, their logic, the logic of their dreams (phan-
tasmagoria and illusions included), which lends them complexity. This is why
one cannot draw a "lesson" or "moral" from the best comic novels. And where
they still do include lessons or morals, as in *Candide*, we are dealing with a
combination of the comic novel and the fairy tale: the novel has a "happy" end-
ing, as comedy must, while that ending makes clear some lesson or moral of the
story, as must fairy tales.

In a comic novel, just as in comedic drama, there can be "high" and "low"
comic characters. The good and noble can also cut a comic figure. Don Quixote
is the greatest instance of the "high comic," not because he happens to be a
hidalgo, but because his dreams, visions, and phantasmagoria are gallant, digni-
fied, and aristocratic. In the same way, the characters of Tom Jones and Pick-
wick are noble; their dreams are noble dreams. Huckleberry Finn, and to a lesser
degree, even Tom Sawyer, live in a dream world; they change the prosaic world
into a dream world with the magic of their imaginations. (Such novels are less
radical because the heroes are children, and it is more normal for children to live
in the magical world of fairy tales.) Another famous novel whose heroine drops
into a dream world is, of course, *Alice in Wonderland*. Needless to say, there are
no fewer political allusions here than in any typical comic novels. This book was

expressly written for a little girl and became the favorite of grown-ups who could appreciate it from a more philosophical perspective. Still, the noble, good, or charming people at the center of these novels do not become comic just in being accidentally thrown into comic situations, but because they carry comic features in their character which predestine them to stumble upon comic situations, and to behave as they do once they are in them.

The "pairing" of comic figures is as general a practice in comic novels as it is in comic drama. The master-servant combination is frequent here too, also recurrent is the servant playing as important a comic role as the master, or even a more comic role—though the slave and master prove funny in different ways. Such roles are played by Patrick beside Tom Jones or Sam Weller beside Pickwick. It is perhaps not surprising that this kind of character-doubling remains important in early detective stories, and sometimes in later ones, for they are also stories of adventure and they always take place in the present time. In some versions of the comic novel there are also independent comic figures that are somehow still related (see Candide and Pangloss), and in another version the "servant" of the pair plays the role of the main hero (Svejk and Lukas).

The comic portrayal of a noble person is in itself a complicated and difficult task. It cannot be said that Don Quixote is right, or that he is wrong, that he is wise or that he is a fool, that he is a visionary or that he is blind. Don Quixote is clearly all this, simultaneously. Something similar can be said about the servant who remains critically loyal to his master, although his comic character will be different from the Don's. One tracks this difference in the dissimilarity of his dreams and phantasmagoria. Sancho Panza knows that the inn is not a castle, yet he believes in specters and is afraid of them. Sometimes servants reverse the phantasmagoria of their masters; they do not take reality to be poetry, but they do understand poetry as reality, like Patridge in the theater. The main difference, however, is that the language of the servant differs from the language of the master. Lingual humor plays as important a role in comic novels as it does in comic dramas. Logically faulty sentences and the erratic use of words are always a source of good fun. Sancho Panza, as we know, constantly inserts popular proverbs into his speech, yet he always inserts them incorrectly and unsuitably. Don Quixote is amused by him, and so are we.

We feel ready to laugh freely at the foolish, base, and revengeful person if he or she comes to grief. The comic novel is, however, not as keen on retributive justice as the comic drama. Sometimes a wicked person comes to grief, at other times he or she simply drops out of the novel, and in some case, the character changes ways, like Jingle in *The Pickwick Papers*. But none of this depends on the degree to which the character is portrayed as comic or ridiculous. Our laughter is also discriminating, since, as we should not forget, laughter is also an act of judgment. We laugh in a different manner at the base and at the foolish; at the revengeful and the wicked; at the egoist and the vain but not wicked person.

Yet in the comic novel, in contrast to comic drama, the daemon or the daemonic comic is out of place. I would say that the comic novel as a genre has its own "anthropology." This anthropology has a family resemblance to Kantian

anthropology. In the comic novel, good and noble people are rare, but they exist. The majority of people are, however, egoistic, money hungry, power hungry, vain, envious, cowardly, and hungry for intrigue. And yet there is none among them who would be wicked without interest, or just for the sake of a game. Even Blifil is guided by his interest. The heroes of comic novels are confronted with men and women who are guided and informed, in all their deeds and actions, by their own 'dearest Ego'; people who do not care for others unless they stand to draw some profit from it. The comic novel relates that we need to learn to live together with these kinds of people, and that something of such people is also found hidden in our innermost souls. This "anthropology" provides, however, neither a "moral" nor a "lesson."

While speaking briefly about Genette's *Palimpsest*, I made mention of the fundamental atmosphere, mood, and coloring of comic novels. The fundamental mood of a comic novel depends above all on the way its writer treats the general 'image of man'; whether he smiles or snarls at common human vices and what kind of position he occupies between philanthropy and misanthropy. The attitude of the writer determines whether the fundamental mood of the novel will be playful or polemical, ironically polemical or satirically polemical, sarcastic, humorous, playfully humorous, and so on. Let me refer to the attitudes of two characters in Moliere's *The Misanthrope*: Alceste and Philinte. One can look at the world with the eyes of Alceste or with the eyes of Philinte, and the world, populated by the kinds of people seen by such eyes, will look ridiculous in quite disparate ways. Two regards, two words. Gulliver or Don Quixote, Jonathan Wild or Tom Jones. It is not the 'image of man' that is different, but the judgment of it. And the difference in judgment is constitutive of the fundamental mood of the work. I am describing only the fundamental coloring or mood of a comic novel. But I still want to insist that, whatever its essential mood, the comic novel is the encyclopedia of all comic phenomena. Indeed, I want to continue to defend the claim that all comic novels play this encyclopedic role, and that all well-written and structured comic novels play the encyclopedic role to an equal degree. Swift is bitingly satirical and polemical, but Gulliver is still full of humorous scenes, puns, and ironic presentations.

 The anthropology of the comic novel is not "existential," for in it pettiness, egoism, vanity, and possessiveness become ridiculous in their very irrationality. Even if not all comic novels have the same measure of rationality, they can all be so measured by a yardstick of rationality; such a yardstick really exists for the comic novel. Characters of the comic novel push us, however gently, into a position from which we can laugh on the side of a superior kind of reason. In contrast, the "existential" comedy is bereft of any rational yardstick, which is how laughter itself can become uncanny (*unheimlich*)—for we do not understand at what we laugh or from which perspective we laugh. The comic novel makes us laugh at pettiness, selfishness, cowardice, stupidity, credulity, and flattery (and so on), and allows us to measure these vices with a kind of 'yard-

stick of rationality.' Yet the comic novel, I maintain, is not therefore "existential," for it does not confront us directly with the "human condition" as such. With what does it confront us then? What does it present at all, if not the human condition altogether? The answer is simple: it confronts us with human relations, and above all with the "bourgeois" modern world. The comic novel presents to us a world which has forged the yardstick of reason in place of "tradition," but which does not live up to the ideals of its own self-created rational yardstick. This is the common denominator between comic drama from the Renaissance onwards and the comic novel.

Let me return to the contrast between the socio-political (realistic) novel and the comic novel. I said that the realistic novel changed in character a few times, whereas the comic novel has remained generally constant. I added that in the realistic novel, ever-changing historical events get embedded into the characters of the heroes, whereas in comic novels the author and the stylized characters alike constantly and directly refer to their "present age." Comic novels refer to and make fun of concrete institutions such as the parliament or governing bodies, elections, courts of justice, the state of education, political parties, academies of sciences or schools, literary salons, literature and philosophy, judges, ministers, elegant ladies and dandies, whores, the police and the army, the institution of marriage, family, nations, minorities, lawyers, doctors, priests, ministers and rabbis, courtiers and nobility, courts, kings, emperors, and war and peace. All of which is to say that they make fun of the "state of the modern world." Some of these "themes" are also to be found in comic drama and in other genres born together with the bourgeois world epoch, such as *The Beggar's Opera*.

The comic novel is not interested in the genesis of the modern world epoch, which is one of the foremost concerns of social-historical novels; it is interested exclusively in an ever-present presence. The comic novel, with almost unlimited possibilities, may serve as a representative distorting mirror of the absolute present time. The comic novel has enough time and space to let thrive all the critical passions, ironical inclinations, and sarcastic instincts it stores. It does not need to stage real mafia to give a good taste of the similar doings of social mafia. This remains an outstanding feature of the comic novel from the beginning to end. Think for example of the parody of Irish nationalistic politics in Dublin by Joyce. It is no wonder that comic novels constantly refer to each other, as to real predecessors. Fielding writes that Tom Jones routed out the enemy flank just as Don Quixote or any other knight errant would have done before returning to Molly. Needless to say, Mrs. Bloom is also called Molly, and Miss Bloom is Milly.

The two central themes of jokes, as will be discussed in 6, are politics and sex. It might be noteworthy that in comic novels sex does not play an eminent role, or at least no more eminent than other kinds of 'secretion' processes. Even where sex comes into focus, the act itself becomes entirely stylized. The role played by politics, though, is significant, and far greater than in realistic novels. It is due to their sexual or even erotic indifference that some comic novels be-

came very early favorites for children. (*Don Quixote*, *Gulliver's Travels*, not to speak of *The Adventures of Huckleberry Finn*, which was believed to be a children's book.) The child reader has access to only one layer of a novel; and she has less access to the deeper layers that bear philosophical messages in comic novels than she does to the deep layers of realistic novels. In contrast to the comic novel, though, the comic novella is frequently erotic and seldom political. It is interesting that even the novellas inserted into comic novels are rarely erotic. Surely there are countertendencies as well, as Diderot's novel *Les Bijoux Indiscretes* may attest, but in my mind that work is more of a collection of loosely related novellas than a comic novel proper.

I must return to the fundamental mood of comic novels for the last time. I contrasted above the Alceste position or regard to that of Philinte, and alleged that the world they each portray cannot be the same world. Now I must clarify that it is still not the same world even if each presents a broken, distorting mirror of exactly the same moment. If we decided to describe Swift's England and Fielding's England (in *Tom Jones*) in prosaic sociological language, it would turn out that each writes of, indeed, the same England. I am referring here only to *Tom Jones* and not to Fielding's work in general. For Fielding wrote a parody (*Shamela*, the parody of Richardson's *Pamela*), a satirical novel (*Jonathan Wild*) and a comic novel which approximates our contemporary genre (*Joseph Andrews*)—but his real comic masterpiece is *Tom Jones*. I make this claim not just because this particular novel suits my taste, but because this is the novel in which Fielding himself discusses on a theoretical level the difference between the two 'regards' in the comic novel. And he does so not only once. For example, in the introduction to the sixth chapter, Fielding expresses his hope that his readers do not belong to the abstruse sect mentioned with great respect by Mr. Swift, people who have terrified the world with the idea that such things as virtue and goodness do not exist at all in human nature. He adds that these truth-seeking sages remind him of gold diggers searching for gold in dirty places; these truth-seekers search for their gold in the dirtiest of all places, namely in the rotten soul. Fielding knew that moralists are typically also misanthropes.

As was already mentioned, Swift's novel is also rich in humorous scenes, especially when Gulliver describes his first travels in Lilliput among the giants. Here he draws inspiration from the already rich tradition of comic novels, especially from Rabelais, working with the distortion of bodily proportions and, with them, stature. We laugh when (in the kingdom of the dwarfs) Gulliver extinguishes a fire by urinating on it, just as we laugh when (in the kingdom of Giants) Gulliver tries unsuccessfully to jump over horseshit, instead landing deep in it. Also on the island of the Laputa, where Swift makes fun of philosophers and scientists, we can join in the laughter. Yet the more we proceed in the book, the more spiteful the satirical presentation becomes. After Swift the humorist, the bitter hatred of Swift the pamphleteer appears more and more in the foreground. Laughter dies out the moment our author's hatred is no longer aimed at institutions, but at human creatures themselves. His words and sentences propa-

gate a secularized version of the dogma of inherited or original sin. Here man, the "yehu," is inferior to all animal creatures.

When Gulliver returns home for the last time and his wife and children greet him with great joy, he sincerely admits that the sight of his family fills him with nothing but disgust, hatred and contempt. When his wife kisses him, he faints and lays unconscious for a whole hour, all from the touch of this repulsive animal. But is this true for the reader? Can Gulliver/Swift inject us with his disgust? Or do we not, rather, laugh reading the report of poor Gulliver, the man who faints from disgust when his loving wife happily embraces him? We witness here, once again, that the comic novel hides many secrets. Fielding judges Swift, the satirical writer and pamphleteer, to be a repulsed misanthrope. But can we read without irony the polemical sentences of his hero and mouthpiece, Gulliver? We cannot. We cannot help an outburst of healthy laughter at reading or hearing such stupid and irrational—yes, utterly irrational—moralizing. At whom do we laugh, though? Swift is not Gulliver. It is Gulliver who writes the memoirs of his travels; Swift just edits and publishes them. Perhaps even Swift secretly laughed at the fool who after long and dangerous journeying finally returned home, unable to draw more than this one conclusion from all he saw and experienced, namely to hate those who love him. Gulliver is shown to be disgusted by everything that used to be his home and habitat. Let us consider his case again. Gulliver faints from the touch of his wife, not because he has stopped loving her, but because she belongs to the rotten race of the yehu, to the human species. This is an exaggeration, and a hyperbolic exaggeration at that; as such it is a caricature. The scene can be read as a confirmation of Gulliver's marginality (after all, the heroes of the comic novels are and remain marginal), yet it is a confirmation in the form of a caricature. Gulliver's confession is a distorted mirror which reflects another distorted mirror; it is a second-order distorted mirror, caricaturing not only of Gulliver, but also the structure of mirroring the mirror—in much the way that Foucault analyzed Velasquez's painting *Las Meninas*. In this case, Swift would be commenting ironically both on Gulliver's transformation and on his own staging of it. Gulliver read in this way brings Swift's novel to its finish without a proper ending and leaves more questions behind than it removes. But is this really a good reason not to accept the reading?

It seems as if I have taken as many liberties as an author of a comic novel, proceeding from detour to detour in this chapter, and without even spicing them with humor—all to now return to the thesis that comic novels include all forms of the comic and can thus be regarded as the encyclopedia of the comic phenomenon. And I want to take one last detour in support of this modest proposal, since the basic coloring or affect of the comic novel is also a manifestation of the comic phenomenon that is our quarry here. In Gulliver's case, the fundamental mood is that of polemical, satirical irony. One also encounters polemical,

satirical irony in Gogol's *Dead Souls* or in the *Pickwick Papers* or in *Ulysses*, but in none of these others is it the most fundamental mood.

Furthermore, satire is not necessarily directly polemical. In the comic novel, at least, an indirect, ironical satirical presentation or a satire in the form of a caricature is more common. Political parties and the partisans of those parties are constant targets in the world of satirical caricature. Thus does Gulliver recite to the knife the tale of the war between parties of high-heels and low-heels or the war waged between the Lilliput states over the issue of on which side of the egg one must break the shell. And thus does Pickwick tell of his experience with the unending strife between yellow and blue and their respective newspapers. Or listen to Mr. Deasy asking Stephen, the journalist in *Ulysses*, to get a letter he has written into print—when Stephen replies that his paper is called "The Evening Telegraphy" Deasy responds, "That will do."

In *Jonathan Wild*, Fielding mainly practices satirical irony. This form of irony is the first kind of irony according to Kierkegaard's classification in *The Concept of Irony*. One speaks ironically, according to this definition, if one says something quite seriously, although one means it in jest. The intended meaning of sentences is just the opposite of the direct meaning. This form of irony is not always satirical, but in the case of *Jonathan Wild* it is, for Fielding wanted to annihilate a political adversary (according to historians it was Walpole) by exposing him to laughter. Satirical caricature can also be practiced with political or moral motivations, and it is frequently employed in parodies of works of literature, philosophy, and science and of particular tastes. I already mentioned that caricatures distort proportions; this is also why they are well suited to satirical, ironical presentation. But not all parodies are caricatures, as I will briefly document in the following. For example, palimpsests are not caricatures. It is very problematic to speak of *Don Quixote* as the parody of picaresque romances, but even if it were a parody of those novels, it could still not be read as their caricature. Joyce's *Ulysses*, a palimpsest, is certainly not the caricature of Homer's *Odyssey*. And even the parodies frequently inserted into comic novels can be ironically playful and not at all like caricatures.

One could safely say that the irony of the comic novel belongs mainly to the first classification of satirical irony, but in its playful manifestation. This kind of playful irony characterizes almost all novels by Garcia Marquez. As frequently happens, the alleged author asserts something about someone and we find the assertion itself funny; or, and this is even more frequent, one of the characters utters a 'wisdom' which is in fact ridiculous. If the second kind of irony gets multiplied, irony can end in a kind of comic blah-blah. This type of irony can also be a playful parody and also happens in comedies. In *Ulysses* someone makes the serious remark "not every Hungarian is responsible for being Hungarian"; or we read in *Candide* that "Plato already said a long time ago that the best stomach is the stomach that throws up all food."

It is rare in comic novels to come across the second form of irony in Kierkegaard's classification. This is the reverse of the above: something said in jest is meant seriously. This is so-called "bitter irony." The second kind of irony

appears more frequently in the twentieth century, usually in comic novels written about the lives of average men and women in totalitarian regimes. (As an aside, a whole recent film, *Life is Beautiful*, is constructed around this kind of irony.) In *Tin Drum*, a grotesque chronicle of the history of Nazi Germany, Gunter Grass frequently lets his characters speak with bitter irony. As Jan Bronski says: "I have always maintained that the castle in the air is the sole abode worthy of man." Here we encounter deeper kinds of bitter irony as well, as when a banal sentence refers to something horrible, 'noticed' only by the reader. For example, Maria recommends, as the final solution of the "Oscar problem," registering him in the Nazi euthanasia program. At the vehement protest of her husband, she thus apologizes: "But Alfred, do not make such a fuss about this. . . . If they say that nowadays this is the way to deal with it, I really do not know what else to do." The double reversal of bitter irony counts as great bravado. To exemplify the case of double reversal, let me quote from a letter written by a general to his wife in Hasek's novel (from the chapter on "Svejk in the Russian transport of prisoners of war"): "You cannot even imagine, my darling, what happened the other day, when I convicted a teacher for spying. I have a well trained man who generally hangs them. He has a great practice; he is a corporal and does it for sport. I was resting in my quarters when the corporal comes up to see me and asks where he should hang the teacher. I answered him, on the next tree. And, please, imagine the comedy of the situation. We were in the midst of a huge steppe. Yet a command is a command, so the corporal takes the teacher and they both depart to find a tree. . . . You see, my darling, we are not a bit bored here, and please, tell our little Willie that his Daddy will soon send him a real Russian, and that little Willie can then ride on him just like a real horse."

I return briefly to the two fundamental attitudes of the authors of comic novels, which constitute the fundamental coloring or atmosphere or mood of the novel. Both the polemical and the playful mood are vectors of a variety of comic presentations; the dominant of them, though, becomes the dominant overall color or mood of the work. I described the two dominant moods as in effect an Alceste-type and Philinte-type. The tendency of the first is satirical; the tendency of the second humorous. But they are just tendencies. And the reading of the dominant mood can also be modified in time. We can perhaps laugh lightly at a presentation which in its own time triggered rather bitter laughter, just as we find many things ridiculous now which were once presented as serious. Whenever an interpretation changes, not even drastically, the kind of mood the comic novel injects in us will change as well. Moreover, the reception of the fundamental mood does not depend only or even primarily on the interpretation (and not even on the philosophical interpretation) of the work, but on the character of its recipients. There are Alceste-like recipients, and Philinte-like recipients, though most recipients stand somewhere between these two types. Still, there are limits to interpretation, and those limits are not set by "the comic phenomenon" in general, but by the concrete sub-genres within comic genres. This is eminently true about the comic novel, the encyclopedia of all the comic phenomena.

There are jokes in comic novels, also dramatic fragments and dialogues, but, in contrast to realistic novels, the epic character of the novel does not become more dramatic with their addition. Their dialogues are theoretical or pseudo-theoretical rather than dramatic; they involve no dramatic turning points, and their style remains basically narrative, as befits an adventure story. Comic novels are full of what may be called burlesque scenes, scenes that work well in film, though they were first written long before the invention of film or movie pictures. Think for example of the scene where Mr. Pickwick chases his hat. They are also rich in surrealist, macabre, or absurd scenes. The grotesque absurd is, for example, the penitence of Gregorius on the rock, as is the whole story of Candide and of Oscar, stock and barrel. Likewise is Svejk's rumination about the problem presented by a man devoured by his own dogs: "how he will be put together for the Last Judgment?" The organic humor of publicly urinating, spitting, stuffing one's face and anything else that crosses the line of acceptable behavior can play a role here—incidentally, although infrequently, also sex in public. Yet a play with language remains one of the chief sources of humor even in the most lewd or grotesque comic novels. Whatever the action at hand, irrational associations, the wrong uses of words and expressions and misquotations are of constant interest.

Lingual and logical humor are not parodies in themselves. They can work to implement the intended effect of a comic novel, to keep readers in a good mood, preventing even momentary boredom. As such, lingual and logical comicalness functions like jokes do. But lingual and logical humor also serve as one of the best vehicles of characterization. When a writer characterizes heroes and heroines by their expressions, their employment of words, their styles, their relative lingual sophistication or rudeness, their typical slips of tongue, their proper or improper use of idioms, their typical addresses, their lingual circumspection or its absence, the elegance or inelegance of their wording, their uses and abuses of figures of speech, their lingual wit, their understanding of puns and their capacity for punning—that is, when language serves as the presentation of uniqueness—it can serve the purpose of representation or rather representation as a kind of parody.

Parody is fed by all kinds of manifestations of the comic phenomenon, and in reverse, it can fertilize all of them. Parodies can be written in both fundamental comic moods: they can be playful and polemical, satirical and ironical, grotesque and moralistic. Parody can make its appearance in any and every situation, especially where least expected. There are parodies in every comic novel, and a few comic novels can be interpreted as parodies in their entirety.

In the first chapter, a distinction between parody proper and parodistic presentation was made. Parody proper is concrete; it is like a distorting mirror in which one can recognize the undistorted in the distorted as distorted. If its proportions are likewise distorted, the parody also becomes a caricature. Most parodies, though, are not caricatures. One recognizes parodied politicians or institutions in parodies of them. Such recognition is the pleasure of a work's contemporaries, but not of the latecomers who are entirely unfamiliar with the

original or context of the parody. This is also why and how the perception of its recipients codetermines the character of the comic. Not only public figures and institutions can be presented in distorting mirrors, but also works of literature and philosophy, or at least the styles and mannerisms of certain writers, poets, philosophers, and painters. The more that instead of single, concrete works, certain styles and mannerisms are made the target of parody, the more we must speak of 'parodistic presentation' rather than of parody proper.

In novels, indirect parody is the most frequent form of parody. It is not usually the author, writing in his or her own name, who presents a parody, but one of the novel's characters, who writes or otherwise presents a parody for the amusement of his fellow characters. This is just what usually happens in daily life, in a company of the likeminded. But indirect parody is always parody of individual characters or representative characters, works, or styles; that is, parody is of something unique and individual. One can parody a minister indirectly, but not the institution of ministry; one can indirectly parody a judge, but not the courts. The parody of institutions, which is one of the main ambitions of comic novels altogether, is always of a more direct, first order; institutional parody is complex and relies upon the rendering of several interactions.

The simplest kind of parody practiced in everyday life, and here alone, is the "minimal parody," as Genette calls it. In a minimal-parody one just imitates, or rather repeats, something another person has said, without adding a word or taking any away. The modulation of the voice in the simple repetition can have a parodying effect. Several sentences which are not comic in context can have a hilarious effect if taken out of context and repeated. Their repetition can be accompanied by gestures and grimaces, but these just reinforce the actual text, acting as mere addenda. This is how teachers or religious leaders are usually parodied. The success of this parody depends upon a preliminary knowledge. The audience will react with laughter if the butt of the parody is personally familiar (whether from some 'live' interaction or from television).

In a novel there is no such a thing as a modulation of voice, only the description of it; likewise gestures can be described but not seen. The parody of a poem, a philosophical work or a short story must be a very good one to have a funny effect. Parody of works of art plays as important a role in the comic novel as does parody of political actors or institutions. There is one thing both kinds of parody share: criticism. Parody is one of the most important modes of criticism. Parody is critical insofar as it is a kind of unmasking. It has been said that translation unmasks its original unintentionally, for it makes plain whether or not the original made sense at all. Just this effect is intentional in the comic novel. The parody means to unmask its original as senseless and as such to expose it to laughter. Since the comic novel, as all comic genres, critiques from the position of rationality, it is by no means certain that the criticism of the original will be "just" or "right." It is even less clear that the parody should be considered artistically "higher" than the original. This can be the case, but it is not frequently the case. Richardson's *Pamela* is a far better novel than Fielding's *Shamela*. Still, *Shamela* rightly ridicules the kind of sentimentalism that characterized

Pamela's enthusiastic reading audience. A parody is in fact a parody because it harbors no ambition of being "better" than the original. Comic novels parody, though, first and foremost kitsch, trashy artistic presentations, blunders, ephemeral fashions, dilettantism, undeservedly popular writers who have been blown out of their true and modest proportions, flatterers, and officially sanctioned poets. Comic novels are thus also critiques of taste. In *The Pickwick Papers*, the weepy to-do about the female village teacher is a parody of third-rank "women's literature"; the supposed manuscript of the old pastor is a parody of melodrama; Mrs. Hunter's poem on the dying frog is a parody of the dilettantish poet; the whole twenty-first chapter is a parody of *Monte Christo* or a novel like it; the forty-ninth chapter is a parody of *Don Quixote* or at least of a novel of similar aspirations. The novel of Dickens exemplifies that comic parodies of comic novels can also be written. Joyce does it too. In matters of literary parody, Joyce's *Ulysses* is simply inexhaustible. Think only of "The Honey of Sin," the hilarious parody of the "romantic" novels read by Bloom as erotic, forbidden pleasures; or think of verses like "Bound thee forth, my booklet, quick / To greet the callous public. / Writ, I ween, 'twas not my wish / In lean unlovely English." One could quote one like this from almost every page of *Ulysses*, where parody only follows upon parody.

Parody is not just one comic possibility among many that comic drama utilizes. Rather, parody or parodistic presentation is the very heart of the comic novel. The novel does not need to parody works of art, whether good or bad; it does rely upon spoofing political institutions, politicians, or familiar figures; it is not dependent upon the masters or the masses. Whether a parody is polemical or playful, only the situation at hand, whatever it may be, and its repetition, suffice to make a scene into a parody. This happens in *Svejk*, where the sadistic captain Dubb, every time he addresses one of his subordinates, begins: "You do not yet know me, but you will get to know me." The constant imitation of these threatening words by Svejk is in itself a minimal-parody. Or, in his palimpsest *Der Erwahlte*, Thomas Mann inserts into his text fragments or quasi-fragments from the original, which sound comic without further comment. Simply quoting the old "style" within the new "style," without quotes, is a parody of sorts. One can in fact parody anything in a comic novel. Yet it is not quite because of its character as a kind of container of all kinds of parodies, or because it is sometimes altogether a parody itself, that parody is the very heart of the comic novel.

Why is it then that parodistic presentation can be called the very heart of the comic novel? The main characters or heroes of the comic novel are marginal. Their identity is more than problematic, and so is the identity of their authors. The main characters of comic novels are fools, madmen, dwarfs, eccentrics, giants, vagrants, anarchists, and bastards; their social standing is undefined and insecure; they are constantly journeying and never at home; they have no homes or family; they live in another world; they live in fantasies, phantasmagoria, dreams, ideas, and their own idiosyncrasies. Comic heroes are not what they seem to be, they are not what they are. And parody is about doubling; it is about the exploration of the identity of non-identity. Parody and its 'model' are identi-

cal, insofar as the original *can* be recognized in its distorted mirror; yet they are also non-identical, not just because there is a mirror or that it is a distorting mirror, but also because the mirror makes something explicit about the original which is otherwise hidden: its non-rationality. Parody is the presentation of the very occurrence of comic characters and the comic novel. The comic novel, whether it parodies a concrete, socio-historical novel or institution or not, is always a distorted mirror, reflecting something in "reality" which in reality does not show up: the lack of rationality in the phenomenon at hand. In the comic novel it is the anarchist, the fool, the bastard, the eccentric, the dwarf, or the giant who unmasks the irrationality of normalcy, or of pragmatics, or of the habits of his day. Whether this is done with understanding, light humor or with biting sarcasm does not make a real difference in this regard. The distorting mirror tells the truth about the world it unmasks and ridicules. And just as parodies of works of art are not necessarily or often better than the originals they make fun of, so is the distortion of "reality" not necessarily truer or better than what it distorts. The comic novel does not aim to replace the "real," but to keep alive and let thrive its double identity. Two worlds flourish in the comic novel which cannot otherwise be united, except in Hegel's mind: irrational reality and unreal rationality. The comic novel stages the possibility of making fun of and laughing at things about which we may be more likely to feel anger or anguish. And then, when we are almost ready to reconcile ourselves with this reality, they can again bring us to rage and tears.

I refer one last time to the tradition which maintains that the essence of comedies can be grasped by first grasping the world they parody. This tradition maintains, for example, that *Gulliver's Travels* is the parody of travel adventures like *Robinson Crusoe*; that *Don Quixote* parodies the romances; that *Candide* is a mockery of Leibniz's philosophy; that *Svejk* parodies the Hapsburg monarchy and the First World War; that *Ulysses* spoofs the *Odyssey*; and that *Tin Drum* lampoons Nazi Germany. I think this a gross oversimplification. These "models," if they are models at all, are no more than trampolines. The comic novelist jumps with his feet or fools on the trampoline, establishing a castle in the air. In the bound, the writer creates a world that differs from all other worlds, and even from the trampoline without which it could not have sprung. But a world is thus created, and if we enter it, we might dwell for weeks, even months, in the comic dominion.

Chapter Five

Existential Comedy

First, I apologize for the title. The authors I am about to discuss under this heading would surely protest against the expression "existential." Especially Beckett and Ionesco, who lived when the popularity of so-called existentialist philosophy was at its peak. I could have chosen "absurd," "black," or other epithets instead of "existential"; Jaquart speaks, for example, variably about a "theater of paradox," a "metaphysical farce," and "genre dérisoire." I find none of these versions fitting, or more fitting. Still, I need to determine, at least roughly, what I mean by "existential comedy." I will speak of comedies that stage characters, or tell stories of characters, which do not play historically or socially known or understandable roles, of comedies and comic stories where the conflicts are stylized to the degree that they present or represent "the human condition." Not generalization or idealization, but the presentation of significant marginality as the carrier of the human condition characterizes the existential comedies. The force of the message has little to do with the "concreteness" or "abstractness" of the presentation. Many an existential/absurd drama has a very loud social message. The existential comedy is, indeed, absurd, but absurdity is not an end in itself; neither is it a game.

Of course, all comic genres present the "human condition." They do it though mediations, indirectly, not with the kind of directness of the "existential" absurd comedy, which is almost naked. Existential/absurd comedy confronts us with existence, with the human condition face to face, suddenly, directly, whatever the "topic" may be (if there is a topic at all). Existence, the human condition itself, appears in a comic light.

Up until this point, I have taken care to distinguish between the comic genres. Yet for the kind of comic vision I will call "existential," although it admits of genre differences, these differences are of little relevance for its comic mes-

sage. Not just because some of the representative inventors of this comic form (e.g., Beckett) wrote epic prose, short stories, novels, dramas, radio plays, television plays, and puppet theater—successively and also simultaneously—but because the questions they raise and the world they present are not genre specific. We can detect typical schemes here too, mostly in the dramas and epics, even irrespective of the length of the work.

My selection of works (and authors) for the discussion of the comedy of existence may seem far more arbitrary than in the previous chapters, with the exception of that on jokes and films. In the cases of the comic drama and the novel, there exists a kind of canon, and I only rarely deviated, essentially, from this canon. Here, however, I will follow my instinct and taste, and also the logic of my inquiry: I am going to discuss Kafka, Beckett, Ionesco, and Borges.

The reader may shake her head and ask: why did I start my inquiry in the early twentieth century and not later? How can I introduce three short stories of Kafka into the discussion of existential comic genres when I presented Joyce's *Ulysses* in an earlier chapter, among comic novels? Why have I in fact ended my main inquiry into the comic drama in the first half of the twentieth century? Why would I finish my discussion of existential comedy in the sixties of the same century? Am I thereby suggesting the demise of the comic genre? Or, one may also ask: Is Kafka a comic writer at all? Why do I not discuss Pirandello instead? And so on and so forth. All these questions are relevant, and I will offer my apologies and give also some minor reasons for my choices.

First, there is a historical sequence here, yet there is also none. The kind of existential comic/absurd works which occupied a central role in the self-understanding of European intellectuals in the mid-twentieth century were as innovative and as surprising as surrealistic painting or abstract expressionism. Even more so, for their way of representation shed a new light on several phenomena, and specifically on that phenomenon called the "comic." In my view, this innovation can be traced back to Kafka, yet after Ionesco and after Borges, at least in my mind, and at least seen from our angle, there are no more radical innovations. I may be mistaken. This, however, does not mean that the comic genres are withering. In fact, among the old comic genres, the comic novel has made a comeback. That is why I introduced, within the canon of comic novels, *Tin Drum, Felix Krull,* and *Love in the Time of Cholera.* I have not observed a similar comeback of comic plays, only the watering down of existential comedy (Pinter, Albee). There is an important exception, however: the comic opera. I neglected contemporary comic opera because I have disregarded, unfortunately, music in general in my discussion of the comic, mainly due to my professional incompetence.

All in all, I do not believe that existential comedy is the *dernier cri*, nor that someone who returns to an earlier kind of humor must be denounced as a "conservative" or worse, as a bad artist. I will limit the following discussion to the great contribution of existential comedy to our understanding of the comic phenomenon. "Understanding" is perhaps the wrong expression. Works of existential comedy have expanded the phenomenon of the comic to territories from

which they have been formerly excluded, because they sharpened our perception
for a broader sense of the comic. This is, perhaps, already an answer to the
comment that Kafka should not be treated as a comic artist.

Kafka, just as Beckett, Ionesco, and Borges, in fact expanded our perception
of the comic through his fantastic, absurd presentation. Absurd, fantastic presen-
tations are the most frequently employed artistic ploys in the service of the ex-
pansion of the comic space of presentation. From this it does not follow that all
Kafka's writings are comic or can be read in a comic light. Although it does
depend on the readers or listeners, on how far they should or could go in the
expansion of their own perceptions. This makes for an important difference
between comic novels on the one hand, and existential comic writings on the
other. The absurd or the fantastic does not expand the existing space of percep-
tion of the comic in a comic novel; rather, the comic novel just utilizes the exist-
ing space in full, whereas for the existential comedy, the expansion of the comic
space is one of its greatest characteristic achievements. This is true not just of
Kafka, but also of Borges. With Ionesco or Beckett, we need not rely on our
own intuitions, for they themselves call many of their works comedies or tragi-
comedies.

For my part, I do not find it fitting to call certain existential plays "tragi-
comedies." Beckett, for example, calls his *Waiting for Godot* a "Tragicomedy in
Two Acts." But seriousness does not transform a play into tragedy, and neither
does death. Even less does the desire for salvation or mystic imagination. There
is a kind of drama, which is neither comic nor tragic, as we know from Shake-
speare. Lukacs called such drama "non-tragic drama" or "romance-tragedy," for
at least according to the traditional philosophical understanding of the genre,
these are not just serious or sad plays. Such dramas need to stage a few heroic
characters who carry their destiny through to the bitter end. In an existential
comedy, such and similar characters are absent.

If it makes sense to speak of tragicomedy at all, then it is only regarding a
few dramas by Ibsen and all of Chekhov's dramas. These dramas are tragic or
comic depending upon the regard, the approach, and the perception of their
recipients. All the constituents of a tragedy are present, thus the drama is a trag-
edy if, and only if, the spectators believe in the heroism of the main characters;
that is, if they see the characters in a tragic light. Yet if one distances oneself
from the same characters because one judges them, consciously or instinctively,
as petty figures who are puffed up with false pride, precisely in playing he-
roic/tragic roles unsuited to them, then their audience will perceive the same
drama as a comedy. There is no paradox in such a tragicomedy, as there is in the
case of *Waiting for Godot*, only a difference in perspective. The seeming para-
dox will be dissolved if it is noticed—if it exists at all.

There are some features of existential comedies which remind us of jokes;
features such as constant repetition, the logic of *non sequitur*, the dreamlike
development of plot, and frequently also minimalism. Just as everything can be
the butt of a joke, so everything can be comic in an existential comedy: God,
death, life, love, etc. Yet although jokes are frequently philosophical, they are

never metaphysical. Jokes make fun of metaphysics, idealism, in fact of every "ism," mysticism included; they ridicule the desire for redemption, they ridicule family, old age, and handicaps, as well as all kinds of sentimentality. All of these "themes" are also conspicuously central in existential comedies, sometimes termed "tragicomedies." But even if the term "tragicomedy" is a misnomer, it still points to the specificity of existential comedy. Whereas paradoxes are dissolved in a joke, and this is why it is a joke, they remain unresolved in the existential comic novel or drama. Whatever is ridiculed is also mourned; the thing which has been lost is mocked, but the loss still hurts. An aura of mysticism can surround the absurd drama.

Moreover, the absurd drama is sometimes also sentimental in an upside-down way. Emotions of all kinds play an important role in existential works (both as they are ridiculed and mourned), but not in jokes. Jokes can be serious; good jokes *are* serious, but they are not deep in the manner that existential comedies are. In an existential drama or story there is no point, sometimes they do not even have a happy or unhappy ending in the way that traditional dramas do, not to mention jokes. Yet the depth of existential comedies has to do with something other than the absence of a proper ending. Vladimir, in Beckett's *Waiting for Godot*, opens the second act by singing a popular old song about a dog who has stolen a bone from the kitchen and is beaten to death by the cook. The other dogs will then tell their fellow's sad story, and thus the song is repeated again and again, ad nauseam, in the circular text. Such devices are frequently significant in the way that existential comedies work, even if not in all of them.

So why did I say that existential comedies expand the territory of the comic, if all their moves can already be observed in jokes?

Because this is not quite true about jokes, for at least two reasons I have already mentioned. First, there is an absence of metaphysics, mysticism, and emotion in jokes. And second, the expansion of the territory of the comic in existential comic works is not exhausted by the inclusion of a few new topics, but also comprises the transformation of the internal structure of the comic presentation.

Death, love, God, sin, confession, guilt, redemption, and charity are central topics in existential comic works, yet they also include the well-known, traditional themes, such as the commonplaces of daily conversation, marriage, lies, and other vices, political control, authority, and so on. The question is not *what* these works are about but *how*. How are these comic plays, novels, and short stories constituted? How do they work? What is the secret of the absurd *commedia humana*?

One can hardly speak of comic presentation without mentioning irony and humor. In the preceding chapters, whether the matter in question was comedy, the comic novel, jokes, or comic images, I always pointed to the difference between irony and humor. Yet irony and humor also have their history, as they are also, to a degree, genre-specific. The existential comic cannot be understood, in my mind at least, without taking into account the essential change in the philosophi-

cal perception of irony and humor from romanticism onwards. The new philosophical conceptions presented with the romantics answered on their part to historical challenges, and they also influenced comic presentation. I would not maintain that absurd comedies were strongly "influenced" by the change of philosophical perception, yet given the close relation between comic genres and philosophy in general, if there is no influence, then there is certainly a confluence.

Schlegel, Tieck, and other major figures of the romantic movement associated irony with modernity. By then, it was already a commonplace that Socrates was to be considered an ironist, and that ironical speech was practiced prior to modern times. I also mentioned "irony" frequently without reflecting on the difference between ancient and modern irony. What then is the difference between Socratic irony and the kind of modern irony discovered and promoted by the philosophers of Romanticism?

As I mentioned, *humor* is a new expression, invented by Scottish/English men of the Enlightenment in the eighteenth century. A person who understands jokes, who is witty, who contributes with social grace to a "joke culture," as to a "conversation culture," was said to have a "sense of humor." Later on practical jokers would also be called men of good humor, and the contemplative joker would be termed a humorist. The term expanded further, as sons of the leading nation of the civilizing process and of rational skepticism, Englishmen, were said to have a good sense of humor, whereas Frenchmen became rather famous for their *esprit*. But everyday and philosophical meanings of terms like *irony* and *humor* by no means coincided.

In the following discussion I will rely heavily on Kierkegaard, who analyzes irony in several of his books, among them in *The Concept of Irony* and the *Concluding Unscientific Postscript*. It is in this latter work that he also ventures into the most extensive discussion of the specific case of humor. I will not here develop an "orthodox" Kierkegaardian exposition; I wish rather to exploit the rich Kierkegaardian conception for my limited purpose.

The "comic" is also the so-called *genus proximum* in Kierkegaard. Comic is everywhere, since contradiction is everywhere. Comic is the painless contradiction, whereas tragic is the painful contradiction. I already mentioned that such and similar an understanding of tragedy is unusual in philosophy and, as regards tragic drama, I do not think that it is even fruitful. But Kierkegaard does not speak about tragedy as a drama, but about tragic events in everyday life. His thought might have been inspired by Plato's *Philebus*, where Socrates mentions and discusses "the tragedy and comedy of life." Irony and humor are aspects of the comic:

> The comic is in general present everywhere, and every type of existence may at once be determined and relegated to its specific sphere, by showing how it stands to the comical. [. . .] Hence it is true without exception that the more thoroughly and substantially a human being exists, the more he will discover the comical.[1]

There is a type of the comic that one can call the *immediately comic*. Such are the kinds of contradictions which are painless, at least for the observer, such as the picture of the well-dressed gigolo who, while walking on his toes, suddenly stumbles over a stone and finds himself in the mud. Yet there is a kind of comic which is not immediately obvious. This is the comic which appears from a different perspective for specific individuals. It is a post-reflective, mediated kind of comic. Irony and humor belong to this second kind of comic. A person who bursts out in laughter at the sight of the gigolo tumbling into the mud is neither an ironist nor a humorist, or at least there is no connection between his roaring laughter and his being incidentally also a humorist or an ironist. Both ironists and humorists are people who query truths that have been taken for granted, facts, ways of thinking and life altogether, and who reflect upon the discrepancy between semblance and essence (truth) in a form of comic remark, joke, or jest.

Irony and humor are thus two kinds of *reflective* comic attitudes. Neither irony nor humor is a genre, or a sub-genre, but we can find them in all sub-genres, such as parody or caricature or even satirical presentation. They are perspectives, attitudes or positions. One can also say with Kierkegaard that they are bound to subjectivity, in the sense that both the ironist and the humorist are "singular" beings. Kierkegaard says that irony is a determination of subjectivity.[2] While the comic inheres in the human condition, being empirically universal, the same cannot be said about irony or humor. As individual, singular, and subjective attitudes or perspectives, they can be found only in sophisticated cultures which have opened some free space for individuality and subjectivity. All in all it can be said that irony and humor, as individual attitudes, appear in worlds where the individual attitude in relation to norms and rules (and especially to ethical norms and rules) generally appears and can become to a degree accepted. They appear during times in which the single person enjoys some freedom of judgment, not necessarily political freedom, but a certain freedom of the mind, a free space, even a small one, where one person can play around with thoughts and ideas, and can look at things in a different way than others do.

There is also irony and humor in the Bible, but there is no single representative ironist or humorist. Although Harold Bloom's theory about the author of the "Book of J," who must have been an ironist and a humorist, could be supported by the text (e.g., with the passage in which God inquires how Adam discovered his nakedness in a conspicuously ironical manner), still, the first representative ironist in our culture is and remains Socrates. Socrates sits for the portrait of the ironist for Kierkegaard, as he does for all of us.

On Kierkegaard's philosophical map (I do not dare to talk about a system in the case of an author who denied his own authorship and who despised systems), both irony and humor occupy a place. Irony is placed between the aesthetic and the ethical spheres, whereas humor rests between the ethical and religious spheres. This mapping is more relevant as regards irony, for as far as humor is concerned, it would work better if we placed it between the aesthetic and the religious spheres. This difference is of no importance if one speaks of executive

irony and humor, of the ironical or humorous attitudes in face-to-face personal encounters or in live dialogues, but it becomes important with contemplative irony and humor, given that they appear in poetry. I do not want to disregard the problematic character of this distinction. Socrates does not aim at being understood, yet he desires to be understood. This is, in fact, the description of his incognito appearance. He practiced executive irony, yet we perceive it in a contemplative stance, through the poetry of Plato. We do not encounter Socrates "live." The case with Kierkegaard's favorite humorist, namely Lessing, is very similar. Lessing excelled in executive humor in his conversations with Jacobi, yet his executive humor as reported and commented on by Jacobi is transformed into contemplative humor for us, who are not conversing with Lessing.

In speaking of ironists and humorists, Kierkegaard has in mind spheres of existence:

> Irony is an existential determination, and nothing is more ridiculous than to suppose that it consists in the use of certain phraseology. [. . .] Whoever has essential irony has it all day long, not bound to any specific form, because it is the infinite within him.
> Irony is a specific culture of the spirit, and therefore follows next after immediacy; then comes the ethicist, then the humorist, and finally the religious individual (CUP p. 450).

Yet obviously ironic or humorous attitudes are not always manifestations of "kinds of existence." In all genres, jokes, and comic images included, we may encounter irony or humor, or, accidentally, both. The existential ironist and humorist radicalize irony and humor in the infinitude of their subjectivity. If I may express myself in everyday terms, they cannot but be ironists and humorists respectively, because this is what constitutes the essence of their existence.

It is difficult in the case of occasional jests to generally distinguish between irony and humor, yet one can easily do so in concrete cases, i.e., irony can be biting, even cynical, while humor is more understanding, emotional, and also more skeptical. But this description looks fairly haphazard, I admit.

In the *Concept of Irony*, Kierkegaard also mentions the kinds of irony which are, or can be, non-existential. One may say something in earnest but mean it in jest; or, alternatively, one may say something in jest, yet mean it in earnest. This is a game, and it has an individual character insofar as the speaker invents this game. But there must be present in his company a few people, or at the very least just one, who understand what the speaker means them to understand, someone who catches the ball, for otherwise the joke or the jest would not come off; it would not be perceived at all. These ironical techniques both break the rules of communication and reinstall them.

Socrates was the first existential ironist. Irony constituted the core of his existence (See, e.g., CI p. 50ff, p. 236ff, p. 260ff). He was masquerading, deterring, and seducing; he operated with casual suggestions and argued without conclusion; he lived incognito. The incognito of an ironist, in this case of Socrates, was all-encompassing. Socrates found an absurdity in life altogether. He did

not want to be understood, hence the incognito, and yet he desired to be understood, hence indirect communication. Still, Socrates stood on firm ground, on moral ground. It was this certainty, the certainty of his moral subjectivity, that warranted his superiority as an ironist, a jester, and a fool.

It is obvious from this brief summary that Kierkegaard will have as much unease about romantic irony as did Hegel. Romantic irony is anti-Socratic. The Romantics do not stand firmly on a ground; they are not ethicists; their irony dissolves into nothing. At the same time, Kierkegaard's opposition to romantic irony is less persuasive than that of Hegel. After all, Kierkegaard speaks about the absurdity of the entire world, and this is not a far cry from the Romantic perception.

And what is the existential essence of the humorist?

> Since according to the forgoing dialectic of the religious sphere itself forbids direct expression [. . .] The humorist constantly [. . .] sets the God-idea into conjunction with other things and evokes the contradiction [. . .] he transforms himself into a jesting and yet profound exchange-center [. . .] but he does not himself stand related to God (CUP p. 451).

Briefly, the humorist treats every earthly striving as comic, measured against something he believes to be higher, yet to which or whom (God) he does not stand in relation. He is in a sense—this is my point—standing between the poetic and the religious. My point is, of course, not original. This is also "the point of view of the author," one of Kierkegaard's own points, as one who speaks of himself as a humorist, a religious man, and a poet.

I keep wondering about the portrayal of Socrates by Plato.

Ficino said that Plato was possessed by poetic madness. In his spirit I would add that Plato, just like Kierkegaard two and a half thousand years after him, communicated indirectly, through the characters of his dialogues. Socrates was not simply his mouthpiece, but only his most representative character mask. Plato himself was, and remained, undercover. Socrates—in Plato's presentation—frequently appears as a complete fool, as a clown. The tradition ascribes this to Socratic irony, as a kind of self-irony. I would recommend another interpretation. I think that Plato was a humorist in the Kierkegaardian understanding of that notion. He lingered in the sphere between the religious and the poetical. He was not a metaphysician, but a man related to transcendence, and this relation could not manifest itself in direct communication. He was a man of disguise; he put on different masks, and we will never know who he in fact was. His essence never appeared directly, only indirectly.

I just briefly introduce my Plato interpretation, which I elaborate upon elsewhere, for one reason alone. I want to indicate that existential humor is as old as existential irony. In fact, they have long appeared together. Both require a relatively free space for the play of thoughts, which remains thoroughly personal. The very existence of ironists and humorists is vested in this earnest play, and is infinitely subjective in the Kierkegaardian sense.

Yet even if, in Kierkegaard, irony and humor are not spoken of as ways of playing with words, as eminent rhetorical devices, but as existential spheres, irony and humor still remain an approach or an attitude of the subject, an outlook of an individual to the world, and to the immanent and transcendent world alike. This irony and humor tests and suspends everyday and scientific certainties; it volatilizes them. But the act of volatilization is always performed by the individual, from the perspective of the ironical and humorous individual.

The Romantic movement, and especially Schlegel, make a few strenuous efforts to speak about irony in other terms, but they are not consistent. Schlegel frequently talks about irony in a Socratic way, e.g., when he exalts the breaking of narrative illusion in a story, as when the author himself steps outside of his developing work. This is how Schlegel interprets (and lionizes) the parabasis in Aristophanes' work. As was seen in the chapters on comic drama and the comic novel, parabasis is a typical device in some comic genres. If we accept parabasis as the main vehicle of irony, then irony would be even less modern than the Socratic spirit.

In his *Critical Fragments*, Schlegel in fact regards ironic communication very much as Kierkegaard later did. But Schlegel also experiments with the general idea of non-identity. Non-identity does not inhere in the perspective of the masked man, but the world itself is non-identical. Poetic thinking suspends, in Schlegel's mind, the laws of rational thinking and rational concepts, placing us back in the original chaos of human nature and the world. This thought might seem to us obscure (Schlegel, after all, wrote a complimentary essay on incomprehensibility). And it is obscure in a way, because Schlegel speaks of poetic language, myths, and the absurd in one breath, yet (in my view) it is precisely his conflation of these different aspects which make his the first attempt to formulate the message of the existential comedy of the absurd. Poetic language, Schlegel says, makes it "natural" to suspend rationalities; it places us into an absurd world. That is, the world (in this case the world of myth) is absurd, yet to enter into the world is natural. One accepts the chaotic, the absurd as natural. And the modern world, as it is, is in fact non-identical.

The non-identity of the single individual, what allows for his masquerade and his indirect communication, is not an "attitude," a position, or a perspective, but the manifestation of the modern condition which is also the human condition. Non-identity, the absence of logic, chaos, is here, in the modern world, as natural as in the world of myths. Parabasis inheres in the world itself. The world itself steps constantly outside of itself, and this can happen anytime, without forewarning. We expect something in the world, but the world performs its parabasis, commenting on itself, getting out of the plot, fumigating its own plot—while here we are, single existers, and must yet do something with the world. Irony is not on the side of the ironist, but on the side of the world. The world embodies irony; that is, the human condition is the ironical condition. The single individual who steps into the ironical world has to cope with it. And he will never understand it. Not Socrates and Plato now, but the world itself is incognito. Both the immanent and the transcendent worlds are. Standing on the

unfirm ground of everywhere and nowhere, it seems to make no difference whether one speaks of irony or of humor in Kierkegaard's terms.

I do not mean to present the theory of Romantic irony as a prolegomenon to modern absurd comedy, but just to point out that some intuitions of the early Romantics were already shifting perceptions of irony and of the comic in general, and precisely in the direction of existential/absurd comedy.

The irony or the humor of existential comedy is the reversal of the ironical and humorous approach, attitude, or perspective. Indeed with it, the world itself is incognito; it manifests itself as absurd, chaotic, non-rational, and non-identical. The source of the comic is, however, not the non-identical, absurd world itself, but the relation of the individual subject to the world. This relation is natural. In an upside-down manner, the single individual of the existential comedy takes the world for granted; he takes absurdity for granted, and likewise chaos. The young Gregor Samsa in Kafka's *Metamorphosis* is not at all surprised when he wakes up one day to discover that he has been transformed into a gigantic insect. The way in which absurdity is taken for granted sometimes reminds the reader of detective stories, or mystical detective stories, such as Borges' *Death and the Compass*.

I will term the irony and humor of the modern, absurd, existential comic *constitutive irony* or *constitutive humor*. I will also distinguish two further kinds within both general terms. In one kind of constitutive irony or humor, the absurd world is fantastic; it is presented as dreamlike, myth-like, metaphorical, or allegorical, as in Kafka's *The Metamorphosis* or in most stories by Borges, in several dramas by Beckett and Ionesco, by Dürrenmatt, and in some of Eco's novels. In the second kind of the absurd found in constitutive irony or humor, the fantastic or unbelievable appears as embodied in the real world, as does Auschwitz in the film *Life is Beautiful*, or in Kertesz' novelo *Fateless*, or as the Stalinist world does in the Hungarian novel *The Sinistra District*.

I will not discuss this latter, second kind, only the first. Just one last remark first. Perhaps it is the appearance of precisely this second kind of constitutive irony or constitutive surrealism that has put an end to the "golden age" of the existential comedy. For when fantasy cannot reach the horror of the real, it will finally give up the effort to present a personal nightmare, and thus give up on the necessary elements of existential comedy.

Structurally, the reversal of the ironic or humorous attitude characterizes the existential/absurd comedy. But why do we speak of comedy? The absurdity, the non-identity, the non-rationality, the inconceivableness of the immanent and transcendent world is in itself everything but comic. Surely, it is the "human," the personal attitude to this world which is portrayed as comic. But why? Why is this relation comic at all?

First, it is not always comic. Sometimes we can hardly read it as comic, e.g., in Kafka's *The Trial*. Normally, however, it is the reader's or spectator's eye which places the relation also in a comic light. I mentioned earlier in my brief discussion of tragicomedies that tragicomedies have two different readings.

They are accomplished tragedies, yet they are also accomplished comedies. Whether we read them as tragedies or comedies depends on our understanding of the main characters, of whether we see them as heroic or as petty, insignificant characters blown out of proper proportion. I mentioned also that this is not so with the reception of existential comic works.

But whether one perceives the dramas by Beckett and Ionesco as comedies or tragedies does not only depend upon the character of Clov or of Amedee. Normally, one perceives them simultaneously as comic and non-comic (not tragic, but horrible or sad!). Whether the comic or the non-comic aspect strikes a person more forcefully depends first and foremost on the importance of the comical vehicles—the carriers of comic message—in the story or the play.

All kinds of comic devices can be the carriers of the message in an existential comedy. There are semantic and phonetic jokes aplenty. There are parodies and satires. There is wit and clowning, as much as there are more typical comic characters. There are comedies of error; there is deception and self-deception. We encounter again the traditional comic pairs, like husbands and wives, parents and children, teachers and students, maids and manservants, tyrants and their puppets. There appear, of course, the wars of the sexes, of the generations, and so on. All the paraphernalia of traditional comedies are, however, transformed by being fitted into the reversal of the "original position," to the presentation of an absurd world in which one behaves "naturally." This is the sole existing world; there is no other one, since the "other world," in Nietzsche's terms, is there only as the other of the first world, and this world is just as inaccessible and incomprehensible. The comic presentation makes fun of those of us who behave naturally in an absurd world. Yet here there is, I repeat, no other presentable world. Whether this deadlock accounts also for the touch of sentimentalism and nostalgia that surprises the reader in several existential comic works, is a standing question. One can detect it even in the stories of the least sentimental of the absurd comic writers, Borges. Just think of the comic sentimentality in the portrayal of the memory of Beatriz in *Aleph*.

As I said, I will base my discussion of existential comedy first and foremost on the analysis of works of Beckett and the comedies and farces of Ionesco. I will not include in the discussion Pirandello, who, although writing earlier than Beckett, stands closer to our contemporary comic authors than to Beckett or Ionesco. I refer interested parties instead to Umberto Eco's discussion of Pirandello. All kinds of artworks have their "classics," by which I mean their most perfect and most radical embodiments. As I see it, the "golden age" of absurd comedy is, at least for the time being, over. Beckett, and in the second place, Ionesco, are the most perfect and extreme (radical) embodiments of this artistic vision. Since absurd or existential comedy flourishes—contrary to comic drama, the comic novel, and even the comic image—for a relatively short historical time, I must proceed here as I will proceed later in the discussion of the comic motion picture, and concentrate on a few authors and their works rather than on the common structural features or themes of a genre.

Still, I want to cast first a cursory glance at Borges and Kafka.

As one last introductory remark I would like to return to issues discussed in chapters 3 and 4. In the comic drama the identity of the main characters is frequently obscure or questionable. They are not the kind of people they believe they are. The main characters of comic novels find themselves in a similar impediment. They are frequently marginal. In the story of comic novels an additional identity problem arises. The identity of the author and authorship itself will be questioned. The writers (Cervantes, Swift, Diderot, Dickens, and others) play their hide-and-seek games around the puzzle of authorship. The existential comedy, in contrast, does not just play with authorship, but here the identity of the "real" authors is itself flawed. Beckett is an Irishman who writes in English and French and lives in Paris. Ionesco is a Romanian who writes in French; Kafka is a Jew who writes in German and lives in Prague. It makes sense, perhaps, to ask the question as to whether the non-identity of the world and of the human condition becomes funnier if portrayed by authors who suffer themselves from the condition of non-identity.

Kafka's comic vision does not embrace jokes. Borges, however, frequently applies the kind of technique which characterizes some condensed philosophical jokes. Take, e.g., *Tlön, Uqbar, Orbis Tertius*. As far as genre is concerned, it is a complex parody, and among other things, a parody of philosophy. The narrator enumerates a few philosophical positions and paradoxes which are constantly discussed in the fictitious country of Tlön. Among others, the paradox of losing and finding nine copper coins, or the Eleatic aporia of Tlön, is significant. This paradox is (for us) not even a puzzle. It can be solved by a child in elementary school. But in Tlön the problem refers to something absurd. Thus different philosophical schools address the "paradox" from different angles. The scholars of the commonsense school deny its veracity: "They claimed it was a verbal fallacy based on the reckless employment of two neologisms [. . .] the two verbs 'find' and 'lose,' which, since they presuppose the identity of the nine first coins and the nine latter ones, entail a petitio principii." This story makes fun of philosophical logic, yet it also makes fun of the "counter world" and the "counter book," to parody, among other things, our understanding of anti-world and anti-matter, and it makes fun of the aporias and the paradoxes of logic. The story makes fun of self-evidence, and it also makes fun of the absurd. Borges is playing, as he also does in *Zahir*, although not in all of his parodies or parodistic presentations of the world, in pseudo-dreams, pseudo-phantasms, mystical experiences, and detective stories.

Among Kafka's short stories I will briefly discuss three. Each of the three represents a different version of existential comedy and mobilizes different traditions of the comic genres.

The setting of *The Metamorphosis* is similar to the setting of a typical comic drama: the family. We have the egoistic father, the subservient mother, the exploited son, and the lively little sister. There is also the typical ploy of comic drama: the change of identity. But here it is not the sexual or social identity that gets abruptly changed, like in stories of cross-dressing, shipwreck, etc., in a

comedy; and it is not just that human size is suddenly altered, as does frequently happen in comic novels. Rather, a metaphor itself turns into metamorphosis: a human is changed into an animal, or more specifically, a bug. This kind of metamorphosis is also well known from fairy tales: as the effect of a curse the prince has been turned into a frog. That the soul and the psyche of a man remains identical after taking on the form of an animal can also be seen as a natural device in fairy tales. The animal is usually an ugly one, as the frog exemplifies. So what makes *The Metamorphosis* an existential, comic short story instead of a fairy tale? What is the trick? I think there are three. First, the metamorphosis happens in a family that is portrayed naturally (the typical comic drama setting); second, the fact that the insect is portrayed as not only ugly, but also disgusting and useless; and third, following from the first two reasons, the story ends, as do so many works of existential comedy, with death and not with the reversal of the "curse." For the trick is that there is no curse. Life itself, Gregor's life in his family, the silent acceptance of being used as a mere means, is itself absurd. The metamorphosis in Kafka's story has an entirely different function than it would in a fairy tale. It blows the absurdity of a life out of all its everyday proportions. This makes an everyday destiny appear in an existential light. One becomes what one is. In being treated like an insect and accepting such treatment, one becomes an insect. Life itself is portrayed as the curse. But this curse is also comic, for Gregor Samsa's life has been comic, and his death will be too. The description of the sad fate of Gregor by Kafka is in fact comic.

Gregor's family members are not even surprised that he has become a monster; taking the absurd as if it were natural is a common element of fairy tales, jokes, and existential comedy. The description of the change in Gregor's appetite and diet, of the way he learns to crawl properly and perfects his technique in order to accommodate himself to his new life, are all extremely funny. For example:

> No one was likely to visit him, not until the morning, that was certain; so he had plenty of time to meditate at his leisure on how he was to arrange his life afresh. [. . .] he scuttled under the sofa, where he felt comfortable at once, although his back was a little cramped and he could not lift his head up, and his only regret was that his body was too broad to get the whole of it under the sofa.[3]

In *Josephine the Singer, or the Mouse Folk*, there is no need for metamorphosis because we find ourselves immediately in a comic fairy-tale milieu, among mice. The race of mouse, according to the story, is a music-loving race. Whether Kafka made fun here also of Jewish self-interpretation and irony is a question which I will leave open. However, it should be mentioned that Jews are portrayed as mouse folk in *Maus*, the well-known comic cartoon about the Holocaust.

As far as I know, this short story is the first case in literature, perhaps the first case altogether, of the comic presentation of the religion of art. Yet the religion of art stands here also for religion. It is not a satirical, but a humorous

presentation. It is a beautiful example of constitutive humor. The story states its case just as directly as *The Metamorphosis* did, in its first two sentences. "Our singer is called Josephine. Anyone who has not heard her does not know the power of song." After this introduction it comes as a surprise that the unknown author of the report is a skeptic:

Is it singing at all? Is it not perhaps just a piping? And piping is something we all know about. [. . .] We all pipe. [. . .]
Yet if you sit down before her, it is not merely a piping [. . .] here is someone making a ceremonial performance out of doing the usual thing [. . .] we admire in her what we do not all admire in ourselves [. . .]. At any rate she denies any connection between her art and ordinary piping [. . .] Josephine does not want mere admiration, she wants to be admired in exactly in the way she prescribes, mere admiration leaves her cold. And when you take a seat before her, you understand her; opposition is possible only at a distance; when you sit before her, you know: this piping of hers in no piping.
[Our people] would not be capable of laughing at Josephine.
Josephine believes [. . .] it is she who protects the people. When we are in a bad way politically or economically, her singing is supposed to save us, nothing less than that, and if it does not drive away evil, it at least gives us the strength to bear it. [. . .] True, she does not save us and she gives us no strength; it is easy to stage oneself as the savior of our people [. . .] who have always somehow managed to save themselves. [. . .] The menaces that loom over us make us quieter, more humble, more submissive to Josephine's domination (pp. 129-35).

Josephine one day disappears. Is God dead? Is religion dead? Is art dead? All these Hegelian questions get raised in the comic mode. Are they funny questions? True, in the end, the comic presentation turns into a kind of pathetic sentimentalism cum ironical skepticism, as so frequently happens in existential comedies.

She is a small episode in the eternal history of our people. [. . .] Was her actual piping notably louder and more alive than the memory of it will be? Was it even in her lifetime more than a simple memory? [. . .] Josephine, redeemed from the earthly sorrows which to her thinking lay in wait for all chosen spirits, will happily lose herself in the numberless throng of the heroes of our people, and [. . .] will rise to the heights of redemption and be forgotten like all her brothers (p. 145).

The short story *A Hunger Artist* follows a third comic tradition, that also of Beckett's plays and of some of Ionesco's. There is no fantastic presentation here, there are no metamorphoses, no fairy-tale reminiscences, and no motives of comic drama either. The venue is the circus. We are in the marketplace where the folk gather to witness a fabulous performance, a trick, a spectacle, a show, a stunt, a feat. We are among the rope dancers of Nietzsche's *Zarathustra*, in the company of tamed beasts, clowns, and their managers. The stunt in question is, however, not a usual one. The stuntman is not a jongleur, not a conjurer or a

magician; he is a hunger artist. He starves his body, goes almost to the extreme
in the exercise of asceticism. Asceticism as an art, exposed under pressure to the
eye of curious spectators, because asceticism is also a way to earn money: this
contradiction fuels the constitutive irony of the story. Kafka read and loved
Kierkegaard. *The Hunger Artist* can also be read as a poetic presentation of
Kierkegaard's concept of the comic, of the Kierkegaardian vision of existen-
tial/absurd comedy.

The contradiction presented by Kafka is neither painfully tragic nor pain-
lessly comic, as Kierkegaard suggested, but both painful and not painful, sad
and ridiculous, just as in an existential comedy. The uncanny yet funny story,
like *The Metamorphosis*, ends with the death of the anti-hero. And, interestingly,
unlike the other comic Kafka stories, and very much like the non-comic *Before
the Law*, there is a punch line here. And it is due to this punch line that *A Hun-
ger Artist* can also be read as a parody of the Nietzschean ascetic priest. The
dying hunger artist thus whispers, in answer to the overseer's question of why
they should not admire the artist's fasting, a last confession into the overseer's
ear. It cannot be fully understood: "Because I have to fast, I can't help it. [. . .]
Because I couldn't find the food I liked. If I had found it, believe me, I should
have made no fuss and stuffed myself like you or anyone else" (pp. 89-90). This
parodying point is stressed by the fact that a young panther has been put into the
hunger artist's cage. Something very similar happens without a punch line in
The Metamorphosis: the young sister becomes a beautiful woman. The neurotic
Kafka held as much admiration for life as the neurotic Nietzsche. Perhaps Io-
nesco did too. But not Beckett. All three kinds of comic presentations were
brought to perfection in the works of Beckett.

Pigeonholing is a stupid business. Still, I cannot help but remark that Beckett's
first great novel, *Murphy*, is both still a traditionally comic novel and already an
existentially comic novel, standing closer to Joyce's *Ulysses* than to Beckett's
own *Mercier and Camier*. Still, Murphy dies, and his death is "logical," unlike
the death of Don Quixote; Murphy's death, although entirely accidental, is also
in character. That his ashes end up incidentally on the floor of a pub is also in
character. He is the typical anti-hero, just like almost all of the other later heroes
of Beckett will be. We meet him lying naked in the rocking chair to which he
has tied himself, in order not to move. As an anti-hero, he is also a grotesque
hero, for his aim to do absolutely nothing is as unattainable as doing everything
(e.g., he flies kites with Kelly). When he is pressed to become employed he must
die, for he thus becomes an existential failure. As he says at one point of the
novel: "In the chess-game between man and his stars there is no return match."

The cosmic egocentrism of Murphy is as ridiculous as egocentrism nor-
mally is, but it becomes absurd through Murphy's own ambition to raise his
egocentrism to cosmic heights. The author's paraphrases of Spinoza and his
parody "Amor intellectualis qua Murphy ipsum amat" tell the whole story.

In this new setting, all the tricks, ironies, parodies, and puns of the old
comic novel reappear (and even the expression *volte-face*). It is a picaresque

novel. True, the adventure, the "anabasis" of its anti-hero, turns into the opposite of the anabasis of traditional picaresque heroes. He does not test himself, for testing in his case would already mean the loss of "existence." Yet the other characters of the story are full-blown comic novel figures. Beckett makes direct references to Don Quixote and Gulliver, and Ulysses characters like Professor Neary and Comboun are directly borrowed from the *The Pickwick Papers*. The story of Celia is a parody of the then popular Perdita novels. Cooper, the detective, is a parody of the hero of the then-popular detective stories. ("I got it! I got it not!") Indeed, one grotesque scene follows the other, from Kelly and his kites to Miss Dew, who "feeds" pigeons with carefully prepared lettuce that they never eat.

Murphy is a philosophical novel; it parodies philosophies with gusto. Among others, it lampoons the philosophies of Spinoza, Leibniz, Berkeley, and Schopenhauer. Murphy is the windowless monad, and also the embodiment of Berkeley's solipsism. About psychophysical parallelism we read the following reflection: "He had not thought about punch because he got it, and when he thought about it, he had not felt it." There are newly created words like "eleuthermomania," which refers, allegedly, to an Irish neurotic reaction.

Watt is no "turning point," but an extension of the aspects of an existential/absurd comic inclination already present in *Murphy*. The "socially concrete" descriptions of the traditional comic genres evaporate. The space and the time of happening is undetermined. We are in the no man's land of conversation among naked souls. Yet they are also funny souls, and their conversations are grotesque and senseless. The puns stress fun as an essential ingredient. This is indicated already in the title, a phonetic pun: *Watt*: what is watt? Here irony and humor become for the first time essentially constitutive. This is noticed by Richard W. Seaver, who writes (in *I Can't Go On, I'll Go On: A Selection from Samuel Beckett's Works*): "Watt is a logical positivist in an illogical environment." The dialogues can become nonsensical, because the environment is illogical.

The dialogues in this novel remind us more of those of Ionesco's *The Bald Soprano* then of the dialogues in Beckett's comic dramas, with one important difference. Ionesco generally makes fun of small talk, whereas Beckett generally makes fun of bad logic, as in his philosophical jokes. Remember this example, regarding the tram stop:

Why he [Watt, A.H.] should not have requested the tram stop, if he wished to do so? –There is no reason, my dear [. . .] no earthly reason, why he should not have requested the tram to stop, as he undoubtedly did. But the fact of having requested the tram to stop proves that he did not mistake the stop, as you suggest. For if he had mistaken the stop, and thought himself already at the railway station, he would not have requested the stop at the station.—Perhaps he is off his head. Perhaps he wished to annoy the conductor. Perhaps he suddenly made up his mind not to leave the town after all. Perhaps he is going home the roundabout way. Then his going on onwards to the station proves nothing.

In the same novel we encounter several times the description of everyday occurrences with verbal humor, e.g., "The lady's tongue was in the gentleman's mouth. The lady now removing her tongue from the gentleman s mouth, he put his into hers." Beckett's humor frequently follows such a pattern, namely by simply describing what in fact happens; he also avoids the use of words which normally refer to whatever is happening.

I will exemplify the presentation of the existential comic situation in Beckett's prose works with the following stories and novels: *First Love, The Calmative, Mercier and Camier*, and *The Expelled*. I will exclude from the discussion the trilogy *Molloy, Malone Dies*, and *The Unnamable*, because in these works the comic element is subdued.

A common feature of all the novels and stories to be discussed has often been pointed out and should not be neglected. All of these stories and novels, with the exception of *Mercier and Camier*, are written in first person singular. Sometimes there are more narrators then one (*Molloy*), but in none of those cases do we know who is speaking. Although *Mercier and Camier* is written in the third person singular, the supposed author remarks at once that he has always been together with the people discussed. Thus even the first sentence puts a question mark after the identity of the "author." The unresolvable character of authorship so well known from comic novels returns here and becomes constitutive. The work's identity becomes elusive, and not just its chronicler's identity.

There is an abstraction from time and place, a kind of fluctuation. It is not a Bergsonian time of internal experience that replaces so-called objective time, for the subjective time (if there is any) is as elusive as that so-called objective time. *The Calmative* begins with the absurd statement, spelled out "naturally," that the anti-hero does not know when he died. *First Love* begins in the cemetery, where the anti-hero "associates" his marriage with his father's death, rightly or wrongly, as he says. The "I" of *The Expelled* has forgotten his age. We are always in no man's land; the characters are put into several situations (all of which resemble one another) in this no man's land, although there are certain roles or things which offer indications for the "where" and the "when," like a bike, who (yes, *who*) plays a central role in *Mercier and Camier*, or the stable, the bed, the furniture (important all of them), or the taxi, likewise the policeman, the detective, the ranger, or the prostitute, all constantly recurring figures in Beckett. Beckett's policemen remind me sometimes of well-known jokes about policemen.

I call the heroes of these stories anti-heroes, for all the "heroes" of Beckett are tramps, or in the present parlance, "homeless people." They are also clowns, or in Seaver's terminology, music-hall figures, like the Marx brothers. They play, they move, and they talk like clowns. And they are wonderfully funny. Yet although they are clowns, they do not play a role like circus clowns or court fools do, because they play themselves. They are independent clowns, free in their sense of independence. They are stubborn and extremely egocentric (like Murphy). They are incapable of love. In the life of these clowns, the greatest threat is not the policemen, the rangers, or other "officials" (if worse comes to

worse they take the bicycle) but the love of a prostitute. And not because such love is of a prostitute, but because it is love. They all want to escape from any situation of bonding. They also stink; they are all dirty, and never wash. This is a metaphorical presentation, the symbol of uncleanness, yet it also "naturalistic," if one portrays tramps.

The first-person narratives begin with the literal rendering of the metaphoric act of "being-thrown," after "having been thrown out of the home." The narrators are lonely, yet they do not suffer from loneliness, at least not directly and openly; they rather enjoy it. If one needs the modern exemplification of the Aristotelian "*autochephalos*," these tramps fit the bill. They are the caricatures of *autochephalos*, portrayed with humor. For these novels are representative works of constitutive humor.

To this I must add a remark in a Kierkegaardian spirit. Just as irony is the middle ground between the aesthetic and the ethical, humor is the gray zone between the aesthetic and the religious. Beckett is a writer who presents us mostly, at least after World War II (if not yet in *Murphy*), with the most marvelous works of constitutive humor. The gray zone between the religious and the aesthetic is represented by the novels and stories themselves. They present sinners in an unredeemed world, yet there is a strong tie between this unredeemed world and redemption. Or at least there is a negative tie. One cannot portray an unredeemed world and guilt, just as one cannot portray unconditionally good people, without having an undefined relation to redemption. This relatedness will be even clearer in Beckett's dramas, but it is present already in his stories and novels. There is nothing funny about redemption. Yet the relation of a unredeemed world to redemption (a kind of practical negative theology), if presented aesthetically through indirect communication, is (also) funny. And—I do not think that I overstrain my interpretation here—if the practical relation of an unredeemed world to redemption is funny, then the human condition itself is funny.

We learn in *First Love*, immediately, in the cemetery, that the young man who just visited his father's tomb has written a few things already, but that among all his poems he best loves his own epitaph, which sounds: "Hereunder lies the above who up below/So hourly died that he survived till now." This epitaph is, of course, a joke.

In *Mercier and Camier* we read in the first chapter: "Every now and then the sky lightened and the rain abated. Then they would halt before the door. This was the signal for the sky to darken again and the rain to redouble in fury." This is also a joke (a logical joke), just like those that will be quoted in the chapter on jokes. In *The Expelled* we encounter some Kafkaesque motives, but the point is borrowed from the circus of Chaplin movies or from Bergson. The anti-hero, after having been thrown out of "home," tries to walk "with my feet in front of one another, for I had at least five or six, but it always ended in the same way. I mean with the loss of equilibrium, followed by a fall." Beckett presents us here with the most archaic laughter situation, the fall of a person who walks very attentively, in a studied way.

Puns, sophistic logic, and senseless *bavardage* are just some of the sources of the comic in Beckett. The main source is, however, his technique. As I already mentioned in the short reference to *Watt*, the description of developments in the way they happen, while carefully avoiding any use of the words which usually refer to events, and instead making use of the language of things, is Beckett's method. This "method" is used when rendering sexually loaded situations; in cases of scatological humor, such as the descriptions of diarrhea, constipation, urinating, etc.; or in portraying dream logic. For example, in *First Love* the "I" thus ruminates:

> But man is still today, at the age of twenty-five, at the mercy of an erection, physically too, from time to time. It's the common lot, even I was not immune, if that may be called an erection. It did not escape her naturally, women smell a rigid phallus ten miles away and wonder.

Is this sin or guilt comic?

The anti-hero of *First Love* abandons the prostitute when she gives birth to his child. The end of the story is not comic. The "I" speaks to himself:

> But what does it matter, faint or loud, cry is cry, and all that matters is that it should cease. For years I thought they would cease. Now I don't think so any more. I could have done with other loves perhaps. But there it is, either you love or you don't.

Formal logic is restored in the consciousness of sin.

Mercier and Camier and *The Expelled* end not with the consciousness of sin but with an indirect communication of the relation to transcendence. Among all the prosaic works, *The Expelled* is perhaps the most dreamlike. Everything that happens here follows a dream logic. The anti-hero of the story is as poor in love and human bonding as the "I "of *First Love*. And he is also tempted to set fire at the stable (the temptation). But there is a horse there (a reminiscence on Nietzsche?). The horse has not taken his eyes off of the narrator. The horse remains standing at the window.

> I left the matches, they were not mine. Dawn was just breaking. I did not know where I was. I made towards the rising sun, towards where I thought it should rise. I don't know why I told this story. Perhaps some other time I'll be able to tell another. Living souls, you will see, how alike they are.

With the last few quotations I wanted just to render perceptible the constitutive humor in Beckett's prose works. Among these prose works, *Mercier and Camier* is almost a drama. Both wit and humor manifest themselves above all in the dialogues of the two clowns. These clown figures never leave Beckett, the dramatist.

In the nineteenth century, the so-called "*comédie larmoyante*" became very popular. These are sentimental comedies, comedies which make one laugh and

cry simultaneously. As the prosaic works of Beckett relate to the traditional comic novel, so do his plays (or most of his plays) relate to the *comédie larmoyante*. In a Beckett theater piece you need your handkerchief for two reasons. But the comic elements in Beckett have nothing to do with the light social farce, and the sentimental streak is not consummated in a happy ending after a sad and emotionally intense misunderstanding. The Kierkegaardian humor in these plays is the sole constitutive element. Love is, and remains, the center-point, but the kind of love which is central here is not love as desire, but love as goodness. In constitutive humor, the sentiments (and sentimentality) will also become constitutive; that is, they must be indirectly communicated.

I will discuss the following comic dramas or plays with a comic touch: *Waiting for Godot, Endgame, Happy Days, Play, The Old Tune,* and *When Where.* I will not consider the non-comic plays (like *Krapp's Last Tape*) or some of the comic ones, in order to avoid repetition.

One cannot find more fitting characters for indirect communication about salvation than clowns. In *Waiting for Godot,* Beckett hit the jackpot, yet he was dissatisfied with his work. Although for me *Godot* is and remains the most perfect modern comic drama, I still understand Beckett's misgivings. In comparison to *Endgame* (which was considered alright by the author), *Godot* is a bit too sentimental and sometimes even too direct. But perhaps exactly those *comédie larmoyante* features open the way for practically infinite interpretations. Mine is just one of them. And it will be less than an interpretation, for I will but concentrate on the characteristics of *Godot* which secure it a place of honor in the world of the comic genre.

Estragon and Vladimir, just like Mercier and Camier, are typical circus clowns, named Gogo and Didi. But they are no longer young. They used to be circus acrobats: "Hand in hand from the top of Eiffel tower, among the first." (This is also a parody of Ibsen's *Baumeister Solness*.) They behave as clowns normally do. For example, they play the old trick of being unable to take off their boots, the joke of looking into the boot, and they constantly repeat themselves, e.g., in their play with the hat, their pretending to have just met, their pretending to go (while they remain) and so on. They also tell (or try to tell) old and dirty jokes; they unbutton their flies publicly: "I never neglect the little things in life." We encounter also the recurring motive of the comic hero "hanging himself," just like Papageno in *The Magic Flute.* In addition, the trick of prohibiting laugher, and further the practical joke of offering a choice between, e.g., a turnip and a carrot, though one only ever receives the opposite of that chosen, continue to reoccur.

Yet those clowns are waiting for Godot. More precisely, Vladimir is. Estragon just follows Vladimir's steps, skeptically and reluctantly. The relationship between Vladimir and Estragon is like that between Don Quixote and Sancho Panza, although at some points they may change their fixed roles.

The play enters the twilight zone between the comic and the mystic as soon as the themes of sin and redemption are orchestrated. That is, when Vladimir remarks—while taking off his hat again,

> There's a man all over for you, blaming on his boots the faults of his feet. One
> of the thieves was saved. It's a reasonable percentage, Gogo.
> Estragon: What?
> Vladimir: Suppose we repented.
> Estragon: Repented what?
> Vladimir: Oh. [. . .] We would not have to go into the details.
> Estragon: Our being born?

A quasi-theological discussion is going on. Vladimir talks about the Savior.
But there is an uncertainty about the "what." From what may we be saved?
From hell? From death? Estragon's final judgment sounds: "People are bloody
ignorant apes." This is a Sancho Panza remark. Vladimir, the Don Quixote of
Beckett's play, does not share this sentiment. He will wait for Godot today, and
if he does not come today, then tomorrow, and the day after tomorrow. I may
add that the boy, Godot's messenger, who resembles an angel from a Christmas
play, does not strike us as a dream figure, but as an unskilled child actor. Yet he
is still the "real messenger of Godot" for Vladimir.

> Boy: What I am to tell Godot, Sir?
> Vladimir: Tell him (he hesitates) . . . tell him you saw us. . . .

This is humor in Kierkegaard's sense.
The other pair of the comedy, Pozzo and Lucky, are also comic characters
from the circus. What happens here is the reversal of one of the comic and fairy-
tale traditions, wherein animals play human roles. Pozzo is an animal tamer, and
he behaves like an animal tamer. Lucky is an animal, perhaps a bear, perhaps a
tiger presented as a man. Pozzo speaks to him, treats him, and speaks about him
as an animal tamer usually speaks to a bear, a tiger, or a panther. Yet then, satis-
fying the curiosity of Didi and Gogo, the "animal" is transformed into a "think-
ing machine," offering the opportunity for Beckett to break speech (sentences
and words) down, to make fun of "thinking loudly." One of the funniest scenes
of the play hits us, however, also as a nightmare. Lucky is neither an animal nor
a talking machine, but a human person. A rope around the neck of a bear is an
unpleasant sight, but not uncanny. The same done to a man is uncanny and hor-
rifying. If one looks at the play from the mystic aspect, this scene could also be
perceived as a trial. Vladimir does not only defend Lucky, but he also volunteers
to wipe away his tears. But when Estragon tries it, Lucky kicks him violently.
Then Vladimir volunteers to carry Estragon.
Vladimir is the "good man." The four of five leaves which spring forth from
a barren tree during one single night—between the first and the second act—can
be read as the message, as the "sign" of salvation," . . . things have changed here
since yesterday" remarks Vladimir, yet also as the comic presentation of the idea
of a message.
The second act begins with an allusion to Kierkegaard. Vladimir sings "The
dog came in the kitchen," a song which is to constantly repeat itself. The second

act looks as if it were a repetition of the first. Yet there is never in fact a repetition. Vladimir offers radish instead of carrot. Didi and Gogo are playing mama/child. They change hats (clowning), they abuse each other (clowning again), Pozzo and Lucky reappear, this time in a parody of Cain and Abel, yet now Pozzo is blind and the rope is shorter. What is and remains repetition is only the "eternal repetition:" waiting for Godot. Vladimir:

> But at this place, at this moment of time, all mankind is us, whether we like it or not. What are we doing here, that is the question. And we are blessed in this that we happen to know the answer. Yes, in this immense confusion one thing alone is clear. We are waiting for Godot to come.

The boy-messenger asks again what he should tell Godot. The answer is the repetition of the answer in the first act. This will be the answer tomorrow and the day after tomorrow, "And if he comes [. . .] We will be saved."

The yearning for salvation could, perhaps, also be understood as a parody. But something prevents me from accepting this interpretation. I referred earlier to Beckett's sentimentalism. The play *Waiting for Godot*—if it is "about" anything at all—is about friendship. It is a play about two old clowns, one a believer, the other a skeptic; a fool of philosophy and a fool of common sense, who will never abandon one another. The friendship theme is also repetitious, but this is another kind of repetition than "waiting for Godot." It has no parody, because it prevails as the truth in a parody.

Endgame, in contrast, "a play in one act," is hard and biting. There is no goodness here, and no human relation stands on trial. No one waits for Godot or for anyone else. Still, Clov is leaving, the old Clov is liberating himself. From what? From eternal punishment. Interestingly, *Endgame*, Beckett's most uncanny play, also mobilizes the characters and the situations of traditional comedies: mother, father, son, slave. Beckett stylizes them (their speech, character, and situation) to such an extreme that we hardly recognize them. Father and mother are both in an ashbin covered by a sheet. A metaphor ("throwing someone into the bin") appears in its literal sense, presented on the stage. We will encounter a similar technique—metaphors or similes presented in literal sense as "real"—in modern painting from Picasso to surrealism. Constitutive humor frequently appears in literature also as constitutive surrealism.

Clov and Hamm are clowns. Their appearance, their movements are clownish. Clov's walk, e.g., is stiff. They perform clownish movements or acts, e.g., in the play with the ladder. Communication among the characters is frequently the kind of miscommunication we know so well from jokes. For example: "What time is it?—The same as usual." (Whence the joke: Do you know the time?—I do.) Or: "Why do you keep me?—"There is no one else." (Whence the joke: Eve to Adam: "Why do you love me?" Adam to Eve: There is no one else.") Hamm is the absurd version of Molière's miser: "Lick your neighbor like yourself," as he says. He is an almost blind tyrant with one undefined sin in his past life, which has something to do with a boy, perhaps his son or perhaps Clov's son; that is, with the redeeming future. Is he supposed to be the devil?

Nagg and Nell (Hamm's parents) are just an old husband and an old wife fed up with each other, and still tied to each other. They may scratch each other on the back, they may threaten to leave the other, they even try to kiss, but they are unable to do so. They have warm reminiscences of their engagement and they also tell some jokes (badly), to entertain one another. If they were not in a bin, their conversation would sound like small talk and common quarreling. And it is small talk and common quarreling; nonsensical and funny. Nagg, the father, wants his sugar plum. Hamm, the son, answers that there is no more sugar plum. Nagg: "It's natural. After all, I am your father. It's true if it had not been me it would have been someone else."

The end of the world, the "endgame," is also metaphor in reverse. We say that the world dies with us, and the metaphor is played out again in its literal sense. Three of the anti-heroes of the play will die, Nell first, and the dog, too.

In *Happy Days*, a play in two acts, Beckett continues to do what he began in his prose works. He empties the stage, placing only two characters on it, and even these two can hardly be seen. Voice becomes more important than movement. The voice itself begins to "move," from the conversational tone to the rhetorical, from a tone rich in modulation to monotonous blah-blah, from loud demonstration to whispers, from a fast to a slow tempo and back again. The comedy of the play is ever more carried by the music of speech. The performatives seem to carry independent power.

Winnie, a woman of fifty, is covered by mould, first up to her waist, and later to her neck. The technique of combining (here again) sentimentality and dramatic cruelty is beautifully developed. Winnie talks to Willie, who is sixty and is unseen by us; she talks to him and talks to him, always without receiving an answer. Willie just reads the sports pages. When Winnie does receive some answer it will be short and out of context, like: "Eggs" ; "Formication" (sic!) ; "Wanted bright boy," etc. The desperate longing for communication and for love, the hopeless attempts at establishing contact, the silly small talk, and the often nonsensical chatter used to restore communications, on the one hand, and on the other hand, finally, Willie's main preoccupations: looking in the mirror, putting on makeup, paying attention to her glasses, her toothbrush, etc., together bring out the essence of existential comedy. Monotonous repetition serves both purposes here: the desperate hunger for communication and the hopeless chaos of things communicated. For example, Winnie's "Marvelous gift. Wish I had it"; "No pain, hard; any"; "This is going another happy day"; "I can say no more" (while she continues to talk); or "Great mercies."

But in the end (before the End) Willie appears on all fours, sinking his head to the ground, and crawling towards Winnie. He says in a just audible voice: "Win." And then Winnie sings, "He loves me so." This is redemption through love and not through laughter. It is similar to the ending of the short play *Come and Go*. The three women in hats (they are nameless) "hold hands in the old way."

In *Play*, which might be described as a farce, humor is carried out almost entirely in monotonous and often nonsensical speech. In this play irony, not

humor, becomes constitutive. Two women and a man are standing in gray urns; we see only their heads. The story which develops from the mouths of the three is that of a very common and commonplace love triangle. It becomes extravagant because of the extreme egocentrism of the three storytellers. They tell us what they themselves believe; they are not considering any listeners (for there are none), so they do not pretend to be objective. Thus they can be sincerely and absolutely egocentric. Theirs are three truths which have nothing in common. This is the source of the comic.

The Old Tune is also a farce. Here Beckett once again puts on the stage music-hall comedians, making fun of old people and their phony reminiscences. In the Acts without words, the body language carries the comic element, as in Chaplin's early silent films.

At the end of the third chapter I finished the discussion of comedy with the rhetorical question: 'What happened to redeeming laughter?" One can hardly speak of redeeming laughter as an answer to existential comedies about sin, guilt, and redemption. True, there is laughter, and spontaneous, light, and playful laughter too. But the redemptive power of laughter does not depend solely on its spontaneity, but also on the "what" of laughter. When the tyrant, the miser or the religious hypocrite is ridiculed, then laughter can be redemptive, if, and only if, we also learn to laugh at ourselves. The comic work as a whole brings relief (like a joke) and it makes us feel our power to accept ridicule, to avoid ego trips, to be more understanding and liberal minded, to be critical and also loving. The laughter that accompanies existential comedies is, however, rarely redemptive in the above sense, and the kind of absurd comedies which are characterized by constitutive humor are not so at all. Laughter in this case leaves an ambiguous, embarrassed aftertaste. We think perhaps that we should not have laughed, although laughter was the proper answer, the answer for which the constitutive humor called. Death, slavery, and the end of the world can become matters for the comic, yet not in the same way as marriage or cross-dressing. Not ridiculing something in itself, but the character of the mockery, the way in which it is ridiculed, makes the difference. This question is going to accompany us also in what follows, but less radically. For, if I may repeat myself, most of Beckett's prose stories and dramas are prototypes of existential, constitutive humor, whereas most of Ionesco's works are prototypes of constitutive irony. There is more relief and less ambiguity there. Ionesco is a reckless ironist without inhibitions.

Many plays by Ionesco advertise their comic character. *The Chairs* is called "a tragic farce," *The Lesson* a "comic drama," *The Bald Soprano* an "anti play," *Ammedee* a "comedy," etc. Ionesco uses traditional comic tricks, although mostly in the way that characterizes existential comedy in general. For example, in "*Maid to Marry*," it turns out that the maid is a man (not a cross-dresser!), and he loves and frequently employs phonetic puns (e.g., "Nicolas d'Eu"); he makes us laugh by disorganizing language. Ionesco makes frequent fun of philosophers and literary critics. In *Improvisation*, e.g., he stages three men (each of the three

is called Bartholomew) who inform Ionesco about the meaning of his own plays. One is a Marxist, the other an essentialist, the third a phenomenologist. All the three are, just like the scholars in Molière, learned or ignorant fools. One of his "critics" attributes an idea of Ionesco to Aristotle, and the other intervenes, "No, Adamov said it first." Still, Ionesco also reverses the signs. For the foolishness of the three critics proves also one "truth" in the spirit of the voguish philosophers of his time, namely "that the work does not exist, only what is said about it." Yet at the end of the play, the poet's monologue about poetry, performed before Marie (as his audience), reminds us of a pedantic kind of preaching. Irony is also self-irony.

I might also appear a little pedantic with my insistence on distinguishing Beckett's constitutive humor from Ionesco's constitutive irony. Still, I will insist on the distinction and attempt to spell out why. I can only repeat that there is no redeeming laughter in Beckett, since love and goodness alone have redemptive power. There is almost no redeeming laughter in Ionesco either, but neither is there redeeming love or goodness. Still, the comedies of Ionesco are not darker than those by Beckett; indeed they seem even more playful, lighter. Why? Because we feel the touch of some redeeming power here too. The power felt is that of *reason*, in the Enlightenment sense of the word. Not in all of Ionesco's plays, but in some of them, there is a character called Berenger, who is a hero, not an anti-hero, insofar as he represents sound reason in a totally senseless and mad world. Not first and foremost in his arguments (although in them too), but in his actions and his practical reason, rationality and sensibility are signified. (The name Berenger can easily be associated with Bergeret, the name of the rational man in a few novels by Anatole France.)

Berenger is the hero of *Rhinoceros*, *The Killer*, *A Stroll in the Air*, and *Exit the King*. Three of these plays have a directly political message. Since Aristophanes, it is only in the twentieth century that the political comedy again reconquered the stage. Even before Ionesco, some farces and comedies of Bertold Brecht (e.g., *Arturo Ui*) indicated the revival of the oldest comic tradition in the genre of comic drama. Men and women of common sense (and of reason) appear also in a few of Brecht's political comedies. This opens up the possibility for constitutive irony. Yet it is only one possibility among many.

Not religious, but ethical pathos appears in Ionesco: halfway as a measure, halfway as impotence, and since it is both, the pathos is also inherently ironical. The ambiguity is internal. Think only of the maid's constant intervention in *The Lesson*. Politics is as ambiguous in Ionesco's comic works as is ethics, although less so in the only formally, not essentially, comic dramas such as *Rhinoceros*. Ionesco's political comedies also employ a few tricks we know from Aristophanes (people roar like animals and fly like birds), and they are normally quite direct in their political allusions. There are also direct parodies or caricatures of famous people and of fashions in the literary world and in philosophy, just as in Aristophanes. But Ionesco's comedies would not work so well without the fictitious and sometimes also traditional comic characters, like the detective, the "English family," the Logician, the Proprietor, and the Concierge, or without

some new parodies and caricatures like that of the "Stranger from the Anti-world." The absurd theater of Ionesco is penetrated by parodies, but it does not parody "reality," since the world, that is "reality" itself, is presented as a parody.

In contrast to Beckett's minimalism, staging is an important contributor to the comic effect of Ionesco's plays: the stage does not only situate the players, but it also plays. Moreover, the stage and the arrangement/rearrangement of it can be essential in creating an uncanny atmosphere. Sometimes the play would not become either uncanny or comic without the active participation of the "things" on stage. In *Amedee*, one of Ionesco's most hilarious comedies, which has two alternative endings, mushrooms grow and multiply in one room, while a dead body is constantly growing in the other room until it crashes through the window. Later, before a brothel, American soldiers help the couple with the body. In *The New Tenant*, where, among other things, the hiccup of Plato's Aristophanes (at *Symposium* 185c) is repeated ironically, it is the Caretaker (who volunteers to look after the Gentleman, the new tenant, who does not need her service) who will hiccup. In this work, the nightmarish, absurd character of the comedy hinges entirely on the arrangement of the furniture. A new tenant moves into an apartment after the suspicious death of the former tenant. Two furniture movers come and go constantly to furnish the empty rooms. They bring ever more new furniture into the room; wardrobes, stools, a radio that does not work, until the new tenant is entirely surrounded by furniture. And there is still more to come. Already the staircase is jammed, then the street is jammed. The tube is jammed too. The Thames stops flowing. They have to open the ceiling. Here the hyperbolic character of the uncanny gets ridiculous. At the end of the play, the furniture movers address the Tenant, who cannot move anymore: "You are really at home now! Is there anything you want? Put out the light. Thank you."

The absurdity, the nightmare is not difficult to decipher. It works, as we have seen many times in existential comedies and will see again in the discussion of modern comic painting, through the presentation of metaphors in their literal meaning, such as "satiated with life" or "overpowered by memory," etc. Yet here the memory appears onstage. The memories are presented and represented by the furniture. One desires to furnish one's memory; one yearns for experiences. And after the room gets fully furnished there is a point at which there is no room left for more. The light has to be put out. The externalization of the internal, the presentation of thoughts, and memories as objects, triggers a hilarious, yet uncanny effect.

I have already mentioned how repetition, this well-known comic trick, becomes constitutive in the comedies of existence (only remember the role of the "dog in the kitchen" story/song in *Godot*). Ionesco uses the repetition technique quite frequently, as he also uses another device of comic novels: offering two alterative endings. The former tenant moved out, the next tenant moves in, the new tenant will be an old tenant, and, again, a new tenant will move in. Everyone furnishes his apartment ad nauseam, and then the light goes off. Something very similar happens in *The Lesson*. The middle-aged professor gives lessons,

and his young female student gets killed. The maid knows ahead of time that this will happen, for it has already happened thirty-nine times!

The girl gets killed indeed, and immediately the next student rings the doorbell. Thus will the victims number forty-one. Needless to say, this comedy is also playing with metaphors, like "dressed to kill," by presenting them in their literal sense. Instead of making fun of a womanizer, as happens in traditional comedies (and even in a hyperbolic way with Don Juan, with his 10,003 female victims), and portraying a middle-aged professor who "steals the hearts" of all his young, attractive, and stupid students, here the professor really pulls out a knife and the girl really dies. And this is exactly what is made fun of in such an existential comedy. As I mentioned, portraying a metaphor in a literal sense or a fairy tale in a "realistic" sense are typical comic vehicles, both in existential humor and in existential irony. The forty coffins that must be ordered one after the other, the assistance of the maid's friend, Father August; the fact that the maid herself orders the wreaths, makes the grotesque ending hilarious. Bartok's *Bluebeard's Castle* employs the same technique, yet it is not comic, because he does not translate the metaphor into the language of common daily life but into the language of the fairy tale.

Let me return to the stage and to the things that actively participate in Ionesco's comic plays. What is true about things is also true about noises. Naturalistic noises play a part as much as things in causing a comic effect. They are also active theatrical ingredients. This is certainly the case in the drama *The Chairs*, and although we get the faint impression of sentimentality (in the relation between old man and woman) this is also overdetermined by the farcical and the grotesque.

The play opens in an atmosphere of loneliness. An old couple lives alone on a deserted island surrounded by the sea. (I should not need to repeat that a metaphor is presented here too in its literal sense.) They are sure that guests will arrive this evening. As the old woman (called Semiramis by her husband) says: "All is not lost, all is not spoiled, you will tell them everything, you will explain, you have a message. You must live, you have to struggle for your message." Then the invisible guests keep arriving through several doors and sit down (invisibly) on the visible chairs. They all wait for the Orator, who appears but does not speak. He is deaf and dumb. He can utter only inarticulate sounds. Just at the end of the play, he succeeds, with great effort, at writing a few senseless words on a blackboard.

The Emperor, however, is present, but is, and remains, invisible. The couple throws confetti on the chair of the invisible Emperor; they cry "Long live the Emperor!" and then they throw themselves out of the window. Let me return to my point. The chairs and the blackboard also play roles; indeed without them there is no comedy, since without them no one could address anyone, let alone the invisible Emperor. And in the end we hear the sound of an invisible audience.

The most frequently employed comic device in Ionesco is dream logic, and the most general vehicle of making fun is language. Both together imprint on us

the image of a disintegrated world housing only the absence of sense. In dream logic a person changes into another person and back again, while the dreamer is not at all astonished. In dream logic there is no causality, only post hoc without proper hoc. We have encountered dream techniques in several philosophical jokes. They have been developed with gusto in the temporality of "long *durée*" in several Ionesco plays: dream logic can go on for three full acts. There are dreams of pleasure, and there are also nightmares, and dreams where pleasure suddenly turns into a nightmare and vice-versa. Dead people are alive in dreams and so are the unborn. We can be murdered in a dream, and we can also fly. All of these things may happen in an Ionesco comedy.

However, dream logic is not always comic. Take *The Killer*, for example, where a beautiful spot, a paradisiacal dreamland, metamorphoses into a nightmare (as in totalitarian states). This darkest of the Berenger dramas would not touch us as comic despite its dreamlike character. The dream is filled with well-known elements of phobic experiences, like seeking but not finding (the beloved or even a briefcase); it is accompanied by anxiety and dread. True, this drama is also full of humorous and grotesque scenes and figures, like the discussion about philosophy or the discussion between the voices of clowns, e.g., "Who was the gentleman?—A national hero. Harold Hastings de Hobson.—How did he manage to catch the same train again?—He did a shortcutting." Or: "They didn't serve any *coq au vin*?—They did.—But they did not tell me it was *coq au vin*, so it did not taste right." But comic scenes do not make a comic drama. Only remember Shakespeare's *Macbeth*. Berenger argues (indeed) rationally for both reason and unreason, in order to stop the killer from killing: "Agreed? You kill without reason in that case, I beg you, without reason I implore you, yes, please, stop. There is no reason why you should, naturally, but please stop, because there is no reason to kill or not to kill." (The killer just chuckles.) Berenger aims at the killer with his gun, then drops his "old-fashioned pistols" and stammers: "Oh God! There's nothing we can do. What can we do. . . . What can we do. . . ." It is left open whether Berenger will be killed. In all probability he is killed, but we are not sure. The uncertainty of the end is very close to the ploy of alternative endings: you choose.

In this brief reference to *The Killer*, I do not want merely to demonstrate that the dreamlike character of the plot does not change a play into a comedy, or that even grotesque elements do not do so either. I want to demonstrate Ionesco's constitutive irony. The play is written in the spirit of constitutive irony, because Ionesco's stories are played out in the gray zone between the ethical and the aesthetic, in the sphere of irony. Needless to say, Berenger's argument (there is no reason to kill, and also no reason not to kill) is an open reference to the unavoidability of the existential choice (the leap) as presented by Kierkegaard. And Berenger, the man of Enlightenment, here treats his own rationality ironically, by admitting its pragmatic impotency. He does not shoot; he drops his "old-fashioned" guns.

In *A Stroll in the Air*, where Berenger is presented as the Heavenly Hiker, the comic touch gets the upper hand. The dreamlike play is full of comic en-

counters, characters, and dialogues, yet, also here, Berenger the rationalist finds
no solace. After returning from his heavenly hiking, he says: "The nothing is but
abysmal space." His negative utopia is not funny, but Berenger's apocalyptic
vision still has a little comic touch. It is too apocalyptic, if I may say so. It re-
minds me of the worst futuristic nightmares of contemporary ecologists. But
why the comic touch? The lady has her cup of tea; the journalist goes to the pub,
which is still open; and Marthe still clings to her "perhaps."

Language is the inexhaustible source of jokes and fun in Ionesco. He makes
his characters misuse language in all possible ways. He does so first in the pres-
entation of ordinary small talk as nonsensical. It is well known that in Ionesco's
first successful comedy, *The Bald Soprano*, the conversation between Mr. and
Mrs. Smith is simply taken, with slight variation, from an English language
reader. The English family in *A Stroll in the Air* also speaks grammar-book
English. The small talk is silly; it sounds silly, e.g., "Yogurt is excellent for the
stomach, the kidneys, the appendicitis, and apotheosis." The silliness of the
sentence reminds me of the talk of the ignorant craftsmen in Shakespeare.
Common jokes appear in the nonsensical conversation like "In the newspaper
they always give the age of the deceased persons but never the age of the newly
born. That does not make sense.—I never thought of that." In *Amadee*, our anti-
hero asks the man who rings the bell: "Are you really the postman? Then you
can't possibly have a letter for us." (The "then" is lovely.) When the policeman
is looking for Amadee Buccinioni, he answers "I am not the only Amadee Buc-
cinioni in Paris! Nearly half the people of Paris have the same name!" And so
on.

So all the traditional comic elements return in Ionesco (more so than in
Beckett), but they assume a different significance because the structure of the
plays are different.

The misuse of language by the craftsmen in Shakespeare's comedies was a
laughing stock for the players. The audience laughs together with them. The
misuse of language, however, is "natural" for the co-players in existential come-
dies; deconstructed language is the language for them. This is sense for them;
they do not know anything else. We are perhaps laughing at a world where no
one is laughing. Traditional comic novels played games with men's size. Gul-
liver was once a giant, and at other times, a dwarf. Alice could grow and shrink
depending on the food she swallowed. In *Amadee*, it is a dead man who is con-
stantly growing; mushrooms are literally sprouting from the floor, and this is
unusual, but not at all surprising. Moreover, no one knows who the dead man is;
no one even knows whether he died of natural causes or was killed. Amadee
thinks that maybe he himself was the one who killed him. The stupid, everyday
quarrel of a married couple (a game frequently presented by Beckett), takes
place before this background. They have to decide what to do with a constantly
growing corpse.

> Madelaine: If you do not get rid of him, I'll get a divorce.
> Amadee: What will people say!

Madelaine: You should have gone to the police and said you killed him by accident.
Amadee: Did I really kill him?

Perhaps Amadee killed not the young man, but the baby, or perhaps both died a natural death; perhaps he only let a woman be drowned. There is guilt here, yet it is not only we who do not know the character of Amadee's guilt, for Amadee forgot it himself. We participate, we should not forget, in the world of constitutive irony, where it is taken for granted that everyone forgets what is not in his interest to recall.

It is maybe only an accident or a coincidence that in both Beckett's and Ionesco's world policemen and detectives (and in Beckett also rangers) occupy a suspiciously central place. They also play an important role in the short stories of Borges and in Kafka's novels. I mentioned in an earlier chapter that we usually distinguish between narrative jokes and puzzle jokes. A puzzle can become a joke, or a joke can become a puzzle. Moreover, the absurd and the puzzle have some affinities. The senselessness of existence can also be presented as a puzzle, an unsolvable puzzle, but still a puzzle. That the existential comedy ridicules (or can ridicule) death brings it also into the vicinity of a puzzle. This is the puzzle of life and death. We may think of Borges' story *The Immortal*. When someone dies, is there always someone who killed him or her? Garcia Marquez turns to this puzzle not only once. But if there is a killer among us, and moreover, within us, then there is guilt, and this guilt can be ridiculed or at least tackled with serious humor and an unpardoning irony. The biblical story of Adam and Eve and the expulsion from Eden looks as if it were the master narrative of at least the Western world. Detective novels sometimes get close to existential comedy, and several novels in the mood of existential comedy are also detective stories. So are, as I mentioned, Borges' mystical stories and a few novels by Umberto Eco and others.

We have seen many a traditional comic figure taken up by existential comedies. There are also constantly recurring comic topics: love, sex, marriage. They are general, and perhaps also "eternal" in the sense that they are taken up everywhere and in all comic genres. Marriage as a joke appears perhaps first in the legend about Socrates and Xantippe, and continues to play its part in Roman comedies and some comedies of Shakespeare and Molière, until we arrive at Beckett and Ionesco. In Beckett and Ionesco the comic presentation of the emptiness of marriage becomes as important as the comic presentation of love and making love. Kierkegaard once said that marriage is in itself a joke, yet a joke that one takes (or must take?) seriously. Genres are divided. In tragedies and several non-tragic dramas, marriage is taken seriously; in comedies it is taken with jest. The same can be said about love and sex. In existential comedies, they are presented as a joke and also taken seriously. Only existential comedy adds to them death, guilt, and redemption. Since existence is itself a puzzle that cannot be solved, salvation and damnation, identity and non-identity, blessing and

curse, bonding and solitude, desire and disgust, meaning and meaninglessness, sense and senselessness, are all presented together, for us, spectators, who are ready for a non-redeeming laughter. We do laugh, for we do not take the world as it appears in the existential comedy "for granted." Yet the characters in an existential drama do, if not always, whether they are rational or silly, men of faith or of despair. We are just interpreters, disorganized Leibnizean monads using our telescopes as Clov used his. But Clov was not laughing, and we, his spectators or readers, are. We enjoy the fun that sprouts from below the equilibrium between hope and despair.

Notes ·

1. Søren Kierkegaard, *Concluding Unscientific Postscript*, trans. David F. Swenson and Walter Lowrie (Princeton, NJ: Princeton University Press, 1944), 413. Hereafter "CUP."

2. Søren Kierkegaard, *The Concept of Irony with Constant Reference to Socrates*, trans. Lee M. Capel (New York: Harper & Row, 1965), 260. (Hereafter "CI."), (See also the section "The Concept Made Possible: Aristophanes.")

3. For all Kafka translations, I use *The Basic Kafka*, (New York: Pocket Books/Simon & Schuster, 1971).

Chapter Six

The Joke or the Third Kind of Narrative Prose

It seemed reasonable to begin the discussion of comic epic prose with the case of the comic novel, perhaps because it is rarely considered in its own right, or perhaps because the comic novel could serve as the paradigm of the combination of almost all comic attitudes, styles, and modes. Since the "longest" comic prose was discussed at the beginning, it would have been logical to follow with a discussion of shorter comic prose, the comic short story, or novella.

The two would have deserved separate sections. In contrast to the typical comic novel, which can be, as we have seen, utterly unerotic, the comic novella is concentrated around erotic adventures. Again, in contrast to the comic novel, in which the heroes are almost without exception men, the heroes of the comic novella are frequently heroines. Female eroticism and sexuality are normally portrayed with understanding and humor. I could have discussed stories from the *Arabian Nights*, from Chaucer's *The Canterbury Tales*, Boccaccio's *The Decameron,* or Balzac's *Funny Stories with Gusto.* I resisted the temptation to speak of the comic novella because I do not wish to draw a full map of all the comic genres in this short book. The reader may also miss the discussion of aphorism, feuilleton, cartoons, and sitcoms. But I am already a little impatient to turn my attention to the most frequently discussed and most exceptional genre of all comic genres: the joke.

Joke is the only comic genre which is, by definition, only comic. One could even say that joke is *the* essential comic genre. There are jokes in comic dramas and in comic novels, and jokes are frequently cracked in the works of existential, dark comedy. Clowns are also (among other things) jokesters. The joke crosses the dividing line between "low" and "high" comic arts. There are subtle jokes,

yet there are also rude jokes; there are sophisticated and refined jokes, yet also brutal ones. There are transcultural jokes and local ones; jokes of the saloons and of the gutter. Yet all jokes, whether sophisticated or not, refined or brutal, induce laughter. Jokes are made to woo laugher. The proper answer to a proper joke is laughter. This is one of the reasons why laughter is so frequently (although not always) analyzed in books discussing jokes. True laughter is the answer to the phenomenon of the comic, to all the comic challenges. All comic genres carry this challenge. Needless to say, comic genres employ as their raw material the typically ridiculous or funny situations of everyday life which normally elicit spontaneous laughter themselves. Yet laughter can also be less direct; it can also be replaced by a smile, or by "internal" laughter. Since laughter is the public expressive affect par excellence, one cannot burst out laughing in the same way while reading a book in the corner of a library, as one can while listening to a funny story in the company of others. One has to be tuned in to laugher, and the readiness to laugh together with others is the elementary form of attunement.

Joke is a public genre, just like comic drama; thus laughter as the adequate response to good jokes can be taken for granted. (The well-known circumstance that sometimes an audience dare not laugh, because of embarrassment or other reasons, belongs to the problem of normative or social restrictions of comic expression, and will be discussed later.) Yet there is something that distinguishes joke as a genre from all the other genres: it is perhaps the only representative genre, at least in modern times, which is orally transmitted. Joke culture remains an oral culture; it is the last genre of oral cultures to have survived the Gutenberg galaxies and even the world of multimedia. Sure, books on jokes may appear (they have even become fashionable), and one can learn a lot about jokes by studying joke encyclopedias. Yet the jokes one reads are no longer jokes proper. Even if one tells jokes in public in order to provide information about them or to exemplify something, they lose an important aspect of their joke character. In my lecture course on the theory of the comic, I read a few jokes in class. In this situation, the jokes had already lost their authentic joke character. Of course, sometimes students did laugh, but laughter was not the aim and purpose of my reading; understanding, interpreting and scrutinizing jokes was. Laughter became the side effect, then, instead of the main effect of telling jokes. A joke is a real one if it is told in the company of people who are attuned to listening to the joke. The proper response is spontaneous laughter, even if the side effect or aftereffect includes interpretation or reflective understanding. Even information gathering from jokes is possible, but it is by no means the necessary result or the required effect of listening to jokes.

The public and oral character of joke-telling creates a kind of silent conspiracy among the listeners. The readiness to laugh, like laughter itself, creates a bond of quasi-companionship among a group. This is why the narrator of a joke has to presuppose the relative homogeneity of the company attuned to mirth. One tells certain jokes to certain people from whom one expects the ability to grasp certain hints, background information, and the hidden message of the joke. One

cannot tell jokes with footnotes. They would no longer be jokes. It may even be sufficient in a homogeneous group of a certain joke-culture for someone to utter only the first sentence, or perhaps the punch line, or—according to a well known anecdote—the number of a joke, and everyone will burst out laughing, because they have heard the joke several times already, and one single word or even a number may work as a trigger to bring the joke back into the conscious mind and to simultaneously provoke the expression of laughter.

Joke, I repeat, is the last remaining genre of oral culture. Myths, fairy tales, and epic poetry also belonged for a long historical time to the oral genre, yet, at least in more or less modern cultures, they have already lost their oral character. As representations of oral culture, they soon become museum pieces, like folk art or *Volkslieder*. This is why it became so important to collect them and to record them from the nineteenth century onwards. We tell our children fairy tales because they cannot yet read; we do not usually narrate them from memory, but often read the stories from collections of fairy tales. Joke culture, on the contrary, is alive and kicking.

Jokes are not only orally transmitted, but they are also constantly modified; there are frequently several variations of the same joke. One could even dare to say that the same joke is never told twice. The joke lives, that is, in its delivery. Not every joke-teller is equally good at delivery. The personality of the joke-teller, his ability to keep a poker face before arriving at the punch line, his gestures, the modulation of his voice, all contribute to the pleasure of listening to the joke. A joke which sounds flat when read can be superbly enjoyable if told by a good joke-teller.

Yet all oral genres share some basic features. I will enumerate those of them which are especially relevant to the case of jokes. Similarly to the tellers of fairy tales, joke-tellers are not professionals, even if telling jokes can be one skill among many in the cache of professional comedians. Whenever a group gathers and becomes attuned to listening to jokes, several participants—even if not all of them—tell jokes in turn, some better, others worse. Yet joke-telling ceases to be a living genre if there is but one entertainer in the group and all the others are just listeners or recipients. One should not forget that a joke needs to be retold, in another group, for another generation, etc. One learns how to tell a joke properly by telling jokes. There is a silent competition in a group where jokes are told; many participants desire to have their turn. Desire is important, for telling a joke well, at least in my perception, generally comes with major psychological gratification. But again, just as in the case of fairy tales, there are certain people, well known in their own circles, who tell jokes far better than others. They have a talent for telling jokes, and that is why they are in demand. Yet they rarely become professional.

A professional teller of jokes was, once upon a time, the fool; nowadays he is known as a humorist, a comedian, or a clown, depending upon the institution in which he practices his profession. The professional teller of jokes is a public performer. Anyone can have access to his performance who pays the entrance

fee (e.g., to the circus, the cabaret) whereas for a non-professional, the joke-teller's art is exercised at the crossroads between public and private life, from the pub to the salon. Here the oral genre of joke-telling and the oral genre of telling fairy tales part ways. It is my guess, although I cannot prove it, that the oral culture of joke-telling is an urban culture, whereas telling fairy tales is predominantly a peasant culture. Of course, oral genres (like genres in general) cannot be mechanically separated on the sole ground that they are orally transmitted. There are also orally transmitted anecdotes. The structure of an anecdote differs from both the structure of the fairy tale and of the joke. Further, there are several important constituents which bind jokes and fairy tales (and myths) together, in contrast to anecdotes. They are, however, not directly related to the person of the narrator or the performance of the narrative. To mention only the most obvious difference: the best-known, traditional narrators of fairy tales are older people, especially older women, whereas the typical joke-teller is not usually some certain age, but is usually a male. Women generally told fairy tales in the past; they did not tell jokes. During the last fifty years this "division of roles" has begun to change: women have been telling jokes too. Although the so-called joke material plays a secondary role to the technique of jokes, it still needs to be stressed that traditional joke material normally reflects man's vision of the world. For example, mother-in-law jokes usually ridicule only the mother of the wife.

The venue of joke-telling is located, as I mentioned, along the juncture between the public and private senses of life. The joke-space is not formally institutional, yet jokes told are frequently political. More precisely, as far as the butts of jokes are concerned, the joke-world does not make the distinction between political, private, and intimate spheres; no sphere is shielded from being exposed to laughter. True, jokes are older than the emergence of the modern world, and we inherited the skeletons of many traditional jokes. Comic dramas in Athens and in Rome are the treasure troves of jokes, yet here we are also dealing with urban cultures which allowed for some continuously critical attitudes. The demise of comedy during the Roman Empire supports the hypothesis of a connection between at least a limited liberty and a culture of jokes.

The practical jokes of the Carnival, to which so many references have already been made, normally make fun of authorities. But, to emphasize one important aspect of jokes, carnivalesque practical jokes make fun of external, not internal authorities, and in addition permission has already been given, in the Carnival, to upset the traditional hierarchy for just a few days. The emergence, or perhaps the re-emergence or renaissance of the joke world, which for a few centuries flourished continuously, unrestricted to certain days of the year, has something to do with the kind of development Habermas described in his *The Structural Transformation of the Public Sphere*. That the possibility was opened up for the uninterrupted critique of authorities in salons, pubs, and cafes on the one hand, and the emergence of a joke-world as such on the other, are, in all probability, closely connected phenomena.

As I have indicated, the butt of jokes can be anything and everything, yet not everywhere and anytime, and not without certain restrictions. There exists a kind of informal institutionalization of joke-telling, which has to do with morals, social position, and also with the circumstances of given events. In fact, the informal institutionalization of jokes has to do with all three of these factors together.

The moral restriction can be general or specific. The general restriction normally has to do with convention; we may call it an ethical, rather than a moral restriction, for it has nothing to do with the moral judgment of the storyteller. For example, it has been understood that there are jokes not to be told in the presence of children or of ladies. This specific restriction can be called moral, for it is inbuilt in the moral character of the storyteller. He may understand, as a case in point, that he should not tell the joke about impotency in the presence of an impotent man, or should not crack a joke about God in the presence of deeply religious people. The restriction is not universal, for it depends upon the tact of the storyteller and his personal judgment concerning the situation or the personal sensitivity of certain members of the joking group. The joker will decide whether, for example, the religious person will feel hurt upon hearing a joke about God, or whether he will "understand" that it is only a joke and should not be taken personally. To exemplify the character of the restriction, take the following German joke: "Tell me, how many Jews can fit in a Volkswagen?—Thirty two.—How come so many?—Two in the seats and thirty in the ashtray." I gather that a German joke-teller would take care not to crack this (in fact rude) joke in the presence of a survivor of the Holocaust.

The general social (not moral) restrictions are even more informal. They remind us of the distinction between high and low culture; in fact, they can be inserted into this distinction. As we know, there are refined jokes and rude ones, indirect and direct ones, sophisticated and simplistic ones. There are circles of people who circulate only sophisticated, complicated and subtle jokes, and other circles of people who circulate simplistic, rude and sometimes brutal jokes. People who make a display of their commitment to high culture will not allow rude and brutal or insipidly dirty jokes to be told in their company, or if they do, they will certainly not laugh at them, and this embarrasses the joke-teller. But the culture of sophisticated jokes is not necessarily class specific. I was very surprised when I compared Jewish jokes from eighteenth- and nineteenth-century Poland and Russia with Jewish jokes in America. Whereas the Eastern European Jewish jokes are over sophisticated and deeply philosophical, the jokes of the American Jewry, especially those born during the twentieth century, are often rude and simplistic. This does not indicate the total decay of the sophisticated wealth of jokes (Woody Allen uses them in his films), but indicates the transformation of the joke-culture itself. In the twentieth century, due to the general tendency of de-sublimation, all social strata cultivated rude jokes. The social restriction which informally ostracized brutality and oversimplification was lifted.

Particular social restrictions—like particular moral restrictions—normally rely on the taste and tact of the joke-tellers, as in the case of ethnic jokes. Nowa-

days, those special restrictions are incidentally transformed into general restrictions, e.g., in the United States, where it is politically incorrect, and not just unwelcome, to crack jokes about homosexuals or ethnic minorities, even in their absence, given that they are present in society although not in the group of joke-tellers. This development is dysfunctional in the joke world, from the perspective of the joke world.

There are places where it is in bad taste to tell jokes at all, e.g., the cemetery, especially during a funeral, and not just because joking could be perceived as sacrilegious, but also because others cannot listen and cannot laugh. In such and similar situations (e.g., in a church), a joke does not serve the same purpose as in a company of people attuned to jokes. Cracking a joke (just like bursting out in laughter) can be a neurotic reaction, an expression of embarrassment, and also a gesture of subversion. Now, the subversion of social rules can be a practical joke, yet joke-telling is not a practical joke; it instead implies the suspension of the practical or pragmatic attitude. One can speak about the subversion of the rules or standards of jokes when comic disinterestedness gets lifted. For example, if, in telling a joke, the joker aims at causing general embarrassment or making someone ashamed or angry, his comic disinterestedness has given way to disrespect for customary interpersonal boundaries.

The readiness for an attunement to jokes often requires loosening some personal and social inhibitions (alcohol can and does, up to a degree, contribute to achieving this lighter state of mind), but such relaxation is possible only on the condition of trust: one must be confident and not feel threatened with personal exposure. Direct allusions to one of the company betray the basic trust and make the society of jokers uncomfortable. This kind of breach of the jokers' confidence in the innocence of the jokes and their playfulness can break up the company of jokers. Sometimes this may be well advised on moral grounds, but this specific, concrete issue cannot be dealt with in this context.

The optimal time for joke-telling is similar to the optimal time for telling fairy tales or anecdotes. One needs leisure, the time for relaxation, respite. Kant believed that the best time to tell jokes was after a good dinner and good wine, while drinking coffee. One cannot tell jokes while working, or during strenuous hiking, dancing, or concentration on something else. Telling jokes or listening to jokes requires the person as a whole; it demands his full attention.

Kant enumerates telling jokes and listening to jokes among the acts of play. There are three kinds of such play: music, games, and jokes. Joke is a play of thoughts, and moreover a free play of thoughts, and in this way it is a judgment, an aesthetic judgment.

I will return to this connection shortly. First, I would like to take up again, if only briefly, the problem of oral cultures, this time on seemingly formal grounds.

Oral cultures employ schematic repetitions. In fairy tales about three brothers or three sisters, it is always the youngest who hits the mark, gets lucky, and becomes happy. There is normally a good witch and a wicked one, and so on. Similar schematic repetition characterizes jokes. Later on, I will discuss a few of

them. There are also wandering motifs both in the world of fairytales and in the world of jokes. The same joke can be told with quite different characters, if the characters perform the same joke-function. The jokes I heard as a child about Hitler were repeated in my youth about Stalin, and perhaps they were already told about Caligula–who knows. Jokes, just like fairy tales, wander from genre to genre. Here is an example of a famous egg joke:

> A middle-aged man goes to see a psychiatrist. Doctor, he says, I am afraid that my wife has a problem.—What kind of problem?—She thinks she is a hen.—How long has she thought so?—A year now.—Why didn't you come sooner?—We needed the eggs.

Woody Allen tells essentially the same joke at the end of his movie *Annie Hall*. In this specific context, the joke sums up the "lesson" of the whole story. Ionesco, in his farce, *The Future Is in Eggs*, plays with the joke: Jacques and Roberta do their patriotic duty by laying eggs for the multiplication of the white race.

Yet perhaps the most important shared feature of oral genres like myths, fairy tales and jokes is their indifference to reality, possibility, and probability. They are indifferent to accepted beliefs. To enjoy the sense of a joke has nothing to do with the belief that the thing happened, could have happened or might have happened. The grotesque, fantastic, and the absurd perhaps surprise us in a novel or a drama, but not in a joke or a fairy tale. Contrary to fairy tales, there are jokes that lack any fantastic or absurd features, and there are also jokes that abound in them. This is why I would not say that there are no "realistic" jokes, but only that jokes are indifferent to reality. There is nothing absurd or fantastic in the joke told by Plato and Diogenes Laertius about Thales and the Thracian maid, yet there is in that joke about the wife laying eggs.

According to Freud, some verbal and almost all conceptual jokes are characterized by an indifference to belief and reality, and this is why they can be best compared to dreams. He says that in conceptual jokes, the jokes make use of 'displacement, faulty reasoning, absurdity, and indirect representation by the opposite—which reappear one and all in the dream-work.' (See Sigmund Freud's *Jokes and Their Relation to the Unconscious*, and especially the section "The Relation of Jokes to Dreams and to the Unconscious.")

What does a joke do to the joker and/or to its listeners? Why do we enjoy jokes? What kind of conscious or unconscious wishes or desires are satisfied by telling a joke or by listening to one? Three major theories give different answers to these questions: the power or domination theory, the relief or liberation theory, and the incongruity theory. The first theory was most radically, although not exclusively, formulated by Hobbes, the second by Freud, the third by Kant. All three theories combine the explication of jokes with the explanation of laughter. In fact, Hobbes speaks about laughter in general and not about the kind of laugh-

ter prompted by telling jokes, whereas Kant and Freud are interested in laughter as the answer to jokes.

According to the first theory, laughter is a manifestation of superiority, of the "sudden glory" felt by victory, the pleasure accompanying the feeling of one's own power and domination. It is—to use a Nietzschean expression—the moment the will to power is satisfied. If jokes or comic anecdotes provoke laughter, they must manifest the superiority of the joke-teller's, and his listeners', intellectual, political, social, or personal superiority. So we crack jokes about our political enemies, about the inferior sex, about stupid people, other nations or races, madmen, and servants. Joking is basically a kind of ego-trip. Both the teller of jokes and the listeners (at least those who laugh at the jokes) are boosting their egos; they feel themselves to be even more superior to those they are cracking jokes about than they did before joking.

There are jokes which fit this bill, but most jokes do not. From this one could conclude, perhaps too soon, that no particular conscious or unconscious desire which gets satisfied in telling jokes or in listening to them can be found.

Or one could approach the Hobbesian theory from a different angle. One does not need to ask whether all jokes (or most of them) express the superiority of those who tell the jokes or are listening to them. One may simply ask whether the joke-situation itself, the situation created between the teller of the joke and the listeners, results in the shared experience of a kind of "sudden glory," of being in control. If this is the case, then one could disregard the content of the joke (whatever that means) as well as the technique, the character, and the type of the joke told.

The question as to whether the general aesthetic distinction between author, recipient and work is applicable to jokes remains. If it is applicable, then one can speak of jokes from the position of the joke-teller (the author's position), and then from the position of the listener (the recipient's position), and finally from the position of the character, technique, and type of joke itself, that is, from the position of the "work."

To speak of jokes as if they were works of art is, perhaps, not quite adequate, for more reasons than one. First, there is no authorship in the sense appropriate to a work of art. Jokes are rarely created by one single joker; they are normally handed down, even if strongly altered. When a joke is attributed to a renowned author, as the famous absurd joke about twins is to Mark Twain (Do you have a brother?—I do not know.—How come?—I and my twin brother were taking a bath in a tub when we were three months old and one of us drowned. I do not know whether it was him or me.), it is better to be cautious. Famous authors, as in this case Mark Twain, are normally just repeating old, wandering jokes. True, it can also happen the other way around. A few jokes created by Heinrich Heine continued to live an anonymous life as wandering jokes. In addition, the position of authorship is temporary and relative, since all recipients can become joke-tellers, and some of them usually do. But the changing of positions between teller and recipient does not entirely annul the distinction itself.

According to Freud, the storyteller is an exhibitionist. Although this conception is neatly connected to Freud's relief theory, it also makes sense if one accepts instead the Hobbesian power or ego-trip theory. The joke-teller occupies the position of power and superiority. He already knows the joke he is about to tell; he knows the punch line ahead of his listeners; he is in command. He also chooses the jokes he tells; this privilege belongs to his power position. Moreover, his exhibitionism is not only permitted, but required. It is in an exhibitionist performance that the joke-teller suspends his inhibitions, sidestepping and escaping censorship. Finally, the joke-teller can allow himself the privilege that he otherwise could not enjoy, namely the monopolization of the speaker's position. Even if others duly follow him, those who actually speak will all occupy a monopolized position as against the others. In this respect, joke-telling is an exercise of power, even if the joke-teller does not boost his ego with his jokes. Yet in a good joke performance, the joker boosts his ego, and he can even double this boost by being additionally self-ironical. If the others laugh at the jokes, the joker's feeling of superiority increases; his power is confirmed and reconfirmed. (And if they do not laugh, the storyteller loses face, so he takes a risk in telling a joke, but so does everyone who aspires to power and its preservation). However, the "sudden glory" is not the joke-teller's bonus; this gift is collected by the recipients of the joke. The joker is the giver of the gift; the recipients are the receivers of the gift. And as Aristotle said, the giver of the gift is in a position superior to the receiver of the gift. But one could add that in this case the "sudden glory," the experience and the laughter, that is, the received gift, is also a gift of power, since shared laughter is likewise the manifestation of superiority.

I would say that the power theory describes the joke situation from the perspective of the joke-teller (the author) well, but that its explanatory force is insufficient and conditional from the perspective of the joke's recipients (the listeners), and that it is not at all illuminating from the overarching perspective of the joke, or the "work" itself, so to speak.

We can turn for help to Freud's theory, the theory of liberation or relief as the satisfaction of unconscious wishes and desires. Freud says very interesting things also about the techniques and strategies of jokes, mainly in the spirit of incongruity theories, and I will frequently use his descriptions and examples. Yet his foremost original contribution to the theories of jokes is his relief theory, and the comparison between the dream-work and the work of producing jokes. It is obvious that, in his theory, Freud speaks from the perspective of the recipients of jokes. Relief comes in and through the sudden event, the point, the punch line. Since the joke-teller knows the point in advance, only the recipients experience this pleasure. The joke presents us with the sudden glory of relief, yet the joker, the exhibitionist, does not experience relief. Telling the joke, having the privilege of exhibitionism, lifting social and especially psychological orders of censorship, of inhibitions, of the barriers of shame, is in itself a relief, but this is the relief of the "before" and not of the "after." The relief felt by telling the joke story is not the relief felt as a result of the story. It cannot express itself in laugh-

ter. The storyteller is not allowed to laugh while guiding the recipient towards the punch line. But laughter is the manifestation of comic relief; laughter is the pleasure, satisfaction and wish fulfillment. This is the kind of relief of which the joke-teller is divested. And it is precisely the kind of laughter which can be interpreted quite well by the relief theory.

Relief is liberation. It is liberation from authority. Authority can be external and internal. If the joke makes fun of external authority (political authority, the father, the church), it elicits laughter and thereby relief, but relief is deeper and far more significant if the authority lifted or suddenly circumvented or suspended is an internal authority, including our own judgments, beliefs, norms, or prejudices; our internalized vision of the world, of the right order of things. And most significantly, the silent subversion of internal authority gives free way to aggression, which, however, is not expressed in an aggressive act, but solely in laughter. Laughter is or can be the kind of aggression which liberates our unconscious or conscious psyche from deep-seated hatred and grudges, from desires which are kept under strict control in our daily lives. Desires and erotic and aggressive wishes are satisfied by the laughter triggered by the punch line of a joke.

As indicated, relief theory is in fact not such a far cry from power theory; it is rather a complementary theory. Relief is possible not only by lifting barriers set by internal authority, which has censored the psyche, but also when the power of external authority is suspended. Although those under the boot of some external authority and who laugh at a joke about it do not laugh from any position of power or de facto superiority, still, those downtrodden, exploited, and oppressed might feel themselves, if not de facto, then at least in spirit superior to their oppressors. There is no ego-trip here, but revolt, opposition, and protest. Superiority dwells in the mind, not in the external position. Gallows' humor is also of this kind.

The third theory, the incongruity theory, was first formulated by Kant in the already cited and famous passages of the third *Critique*. There, he says that something unreasonable is presented by jokes, and adds that laughter is an affect which occurs when a tense expectation suddenly empties itself into nothing. He also stresses that a critique of convention is hidden in the texture of all jokes.

Kant is mainly interested in reception, which is in full agreement with his philosophy of reflective judgment, and which is why he puts such great emphasis on the subjective effects of jokes. He adds that the effects of jokes inhere in the structure of the joke itself. The structure requires that there should be some unreasonableness in the joke. And the structure furthermore requires that the semblance, and not the real thing, should finally turn into nothing, that is, should prove itself to be nothing after all. The joke must contain incongruities, since it is incongruity which is dissolved into nothingness. Thus, although Kant's *Critique of Judgment* puts forth a reception theory of the beautiful and of artwork, the description of the structure of jokes also occupies a central position in the inquiry.

Other, later incongruity theories concentrate entirely on the structure and the technique of jokes, that is, on the body of the joke or the "work." They abstract as far as possible from the position of the storyteller on the one hand, and from the position of the recipients on the other. Laughter is not important in these later incongruity theories, likewise not the psychological status of the joker and the listener, but only the joke itself is considered.

The Kantian incongruity theory is, as I already mentioned, closely associated with the Kantian idea of playfulness. Joking is like playing. It is without interest; it is an end in itself. This Kantian idea can illuminate two separate issues frequently raised in reflections on jokes. The first addresses the question of seriousness. Jokes are 'merely' jokes; they are not serious, one might say. But this summary statement runs counter to our experience of jokes. Jokes are serious, since there must be sense in senselessness. We laugh at senselessness, but it is the sense of the senseless that gives us pleasure, and this is something serious. In fact, the Kantian suggestion about playfulness and disinterestedness offers a relevant understanding of this double character, or rather duplicity, of jokes. Incongruity demands that the story dissolve into nothing. When we finally laugh, we are already outside of the joke world again; the joke is terminated, and we return to our daily, practical world. If seen in this light, the joke is nothing serious, for it has suspended pragmatic and practical interests, and turned out to be a play of thoughts. Yet we also grasp the sense of senselessness, and in the post-joke situation we may think about this sense, seriously. Thinking about senselessness is a serious business. Yet these afterthoughts do not necessarily follow jokes. We know that jokes are both belief-indifferent and reality-indifferent. Hence they are also indifferent to their effects and aftereffects. Riddle jokes, e.g., rarely have an aftereffect, because the joy, the play is here concentrated on riddle solving alone, or on the failure to solve a riddle.

The suspension of pragmatic and practical attitudes, the disinterestedness of jokes and their indifference towards beliefs and reality, seem to problematize the power theory, and particularly the relief theory. It is impossible not to have a practical interest, even if it is not a pragmatic one, in the feeling of being empowered or relieved. This interest in suspending practical attitudes, however, is not a practical interest, simply because it is not an interest at all. The relief, and perhaps even the feeling of power, is spontaneous, non-rational, and entirely affective. One cannot bring such feeling to the level of concepts, which is in fact the condition of interestedness. We cannot have an interest without knowing that we have an interest and in what it is. It is precisely the unconscious character of relief, on the one hand, and the impossibility of living out in "real life" that which has been lived out in laughter, on the other hand, that confirms rather than refutes the theory of disinterestedness and playfulness in laughter as judgment.

While casting a last glance at the three theories of jokes (power, relief, incongruity), we can detect two common features in all the three. One is simply the following: a joke will elicit laughter, which, as an expression close to affection, is in itself a kind of psychological satisfaction. Second, suddenness (a sudden

ending) is the condition of the joke effect. Suddenness is a temporal concept or description, and it might also indicate something that, not having been introduced, comes as a surprise. This unconditional requisite of suddenness puts a limit to the length of a joke. Joke is a short genre. It can be very short, consisting of one single sentence or perhaps just two words incongruently put together, as the famous verbal joke of Heine that Freud so frequently quoted, about a poor relation, who brags that he was treated by Rothschild quite "famillionairily." In such cases nothing or almost nothing leads up to sudden relief. The whole joke consists of one punch line. Mostly, however, there is an introductory portion which leads to the point, and it is exactly in this introductory part that incongruity has to be established, since the punch line will annihilate the expectations raised by the introductory story. This makes the joke a joke.

I think that Arthur Koestler offered the best description of the structural essence of jokes and incongruity, with his theory of bisociation. According to Koestler, jokes are packages of two stories which are entirely unrelated. The listener is (mis)guided in following the path of one of the two stories, but suddenly, in the punch line, another story takes its place. Thus the expectation is thwarted, and the unexpected happens. We are lead by our nose, yet we are not cheated. There are two truths, since there are two stories, and both are, or can be, true stories. By substituting the unexpected story for the expected one, the joker upsets normal thinking. According to Koestler, it is not an emotion which upsets normal thinking; reason does the mischief. Everything appears as if in a magic mirror at the amusement park; it is upside down, but what appears still makes sense. Let me illustrate the theory with a puzzle joke.

> Question: What is it?
> Bush has a short one, Gorbachev a longer one, the pope has it, but does not use it, and Madonna doesn't have one at all.
> Answer: A last name.

The question is raised in a way that suggests one story as an answer. Yet abruptly, suddenly, the punch line (the answer) inserts the question into another story. This is what we normally call incongruity. Our expectation ends in nothing; it is erased, annulled. Yet the second story confirmed by the answer also makes proper sense. Without the sense in nonsense there is no joke. What are we laughing at? At a story which ridicules the simplicity of our one-track expectations; that is, at ourselves.

Raskin gives a similar account of the essential features of jokes. According to him, a joke consists of two competing, not opposed, scripts. In this respect, jokes are like metaphors. (This is also Fonagy's theory.) The punch line breaks the frame of reference. More precisely, the text is compatible with two different scripts, which are organized around chunks of information. Raskin exemplifies his theory with the following joke: "Is the doctor at home? The man asks in a bronchial whisper.—No, the doctor's pretty, young wife whispers in reply. Come right in."

In a sense, all kinds of jokes can be described within this scheme.

All authors of books on jokes offer several classifications of them. One can classify jokes according to their form, structure, or schemes; according to their stereotypes, to their representative persona, and according to their targets or ends. It is also relevant to classify jokes according to the comic message they carry. There are satirical jokes, humorous jokes, caricature jokes, and ironic jokes. One can also combine classifications in a quasi-heterogeneous way. For example, Lutz Röhlich, in his interesting book *Der Witz: Figuren, Formen Funktionen* (Stuttgart: Metzler, 1977), lists jokes, among other possibilities, also in the following way: children's jokes, surrealist jokes, logical jokes, animal jokes, black humour, dream jokes, gallows' humor, sexual jokes (jokes about unfaithfulness, penises, and impotency), ethnic jokes, madness jokes, political jokes, medical and psychoanalytical jokes, Jewish jokes, and mythological parodies (etc). Since this is not a book on jokes, but about the comic, and especially about the intimate relation between comedy and philosophy, I will dwell on the classification of jokes only briefly, in order to discuss mainly philosophical jokes, whatever form they might take, at greater length.

According to their formal characteristics, there are narrative jokes, puzzle jokes, aphoristic jokes, and double jokes. According to their communicative character, there are verbal jokes (puns) and referential jokes. According to the joke-persona, jokes can be schematic, representative or humorous, or they can be concretized and parodistic (via attribution). According to the kind of sense that appears in nonsense, jokes can be philosophical, linguistic, sexual, or sociopolitical. Classifications overlap with each other. Philosophical jokes are most often narrative, while puzzle jokes and aphorisms can also be philosophical. Some verbal (phonetic, semantic) jokes are also philosophical, just as some sexual jokes are socio-political jokes, but not all of them. Jokes told about the well-known American joke character, the JAP (Jewish American Princess). are usually sexual, not philosophical, whereas jokes about the Stetl character (the marriage broker) are, as Freud observed, frequently sexual, but also philosophical. The already mentioned Heine joke (a verbal joke) quoted by Freud with great gusto, namely that Rothschild treated his poor relation quite "famillonairily," is a social joke, not a philosophical one. The political (puzzle) joke "What is the difference between socialism and capitalism?—Capitalism is the exploitation of man by man, whereas socialism is just the reverse," is also a philosophical joke.

The length of a joke is one of its formal features. All jokes are characterized by brevity, but narrative jokes are usually longer than other types. Narrative jokes require the best storytellers, for the path leading from the first sentence to the point can be full of ceremonial variations. Embellishment and rhetoric play a role, and this is why the joke-teller is also a kind of actor. Telling a narrative joke is a performance.

Most philosophical jokes are narrative. There are a few schemes that narrative jokes generally follow, whether they are philosophical or not. For example,

they inform the listeners immediately about the location of the story and about the main characters. For instance: "Two Jews are traveling in the same car of a train . . . " or, "Hitler, Mussolini, and Churchill are traveling together on a plane . . . " or, "De Gaulle returns home to his wife and . . . " or, "Little Toto raises his hand during history class . . . " The incongruity theory can be best exemplified with narrative jokes, because the storyteller can freely play with the two scripts of the narrative text.

Puzzle jokes are shorter. They generally consist of a question and an answer. The ambiguity needs to be embedded in the question itself. This genre prides itself on several variations, such as "what is it?" or, "what is the difference between X and Y?" (as in the case of the socialism versus capitalism joke). Several ethnic jokes belong to this type of question: "Why does a man marry a much older woman?" Answers: "The American: because she has money; the Frenchman: because she is sexually experienced; the German: because she makes a wonderful housewife; the Russian: because she knew Lenin." Or there are "I have good news and bad news . . . , tell me the good news/the bad news first . . . " type jokes. Jokes about doctors, illnesses, and death often follow this pattern. Here is a random one, which is also sexual: "The doctor says to the husband of the patient: I have some bad news and some good news.—Please, tell me the bad news first.—Your wife has the clap.—Terrible! And what is the good news?—She did not contract it from you."

Another version is a combination of political and philosophical, the narrative with the puzzle joke. For example: "During the Nazi times, two Jews meet on the streets of Berlin.—I have good news and bad news, says one.—Tell me the good news, first, please!—Hitler is dead.—Oh, wonderful! After this news no bad news can matter, but anyway, tell me the bad news too.—It is not true."

Perhaps an even shorter form of jokes is the aphorism and its many versions. One type is the comic inscription on a tombstone. This type can also be longer, such as a strophe of a verse. There are aphoristic jokes attributed to famous people, e.g., as Voltaire told it, someone addressed him such: "I heard you love walking alone. So do I. Then we can walk together." The attributed aphoristic joke is often a verbal joke, and as such is untranslatable. Take for example the wonderful aphorism of Paul Valery: "Entre deux maux/mots on doit toujours choisir le moindre." This is, at first glance, just a phonetic joke, given that the word maux (evils) and the word mots (words) are pronounced in the same way. But the phonetic joke is over determined. That between two evils one should choose the lesser one is a proverb, a self-evident bit of wisdom; but that between two words one should always choose the shorter one is neither commonplace nor even reasonable, and is still a good, if ironic, piece of advice given to poets. Or, to mention a German joke about Wagner's *Lohengrin*: "Im Brautgemach angekommen fragte Elsa von Brabant Lohengrin, was Geschlecht er sei." [Coming into the nuptial chamber Elsa von Brabant asked Lohengrin what sex he was.] This is a difficult to translate semantic and sexual joke and, in addition, an ironical snub at Wagner's art.

Finally, there is the double joke. You tell us that A told a joke and you repeat the joke told by A. Then you continue, and tell us how the joke was retold by B, who entirely bungled the punch line. Yet in the second story, the bungled joke is, exactly because it is bungled, also a joke. There is such a well-known bungler in every joke-culture. In Hungarian, he is called Papp Jancsi.

In a way, double jokes unmask jokes in general. They display the secret of all jokes, namely that jokes upset the language game and do not aim at cooperative communication. But this is just the surface. Jokes do not aim at cooperative communication, because they—perhaps entirely unconsciously—unmask (among other things) the phony character of cooperative communication in pragmatic modes of life. Salvador Attardo, in his book *Linguistic Theories of Humor* (1994), gives the following joke as an example. "Two men meet on the street.— Do you know what time it is? –Yes."

Attardo enumerates several classifications of jokes, traditional and contemporary, in his 1994 work. Among the contemporary ones it is his own, and those of Greimas, Morin, Schmidt, Fonagy, Norrick, Raskin, Culler, Chabarine, Eco, and Bally which are of greatest interest. (We have met with Fonagy and Raskin already.) Since the book examines linguistic theories of humor (or rather of jokes), the classifications have essentially similar features. The main distinction is between verbal humor and referential humor, and verbal humor is further divided into phonetic and semantic kinds.[1]

Almost all of the major advocates of the linguistic theory of jokes agree that as far as the essence of jokes is concerned, there is no difference between puns and referential jokes. The overlapping of two different texts or scripts is embedded in a semantic phenomenon. Whether these different scripts need to be opposing or not is and remains a controversial point.

One can also classify jokes as regards stereotypes. Not only single jokes are orally transmitted, but stereotypes of jokes as well. More precisely, the stereotypes, in being transmitted, allow for the variations of the jokes, the replacement of one joke character by another, provided that they perform the same function prescribed by the stereotype. Persona is of the greatest significance in a joke. Joke stereotypes are related to certain well-defined persona. In this respect, jokes do not differ greatly from marketplace comedies. There are the joke equivalents to Harlequin, Punch, or Judy. The marketplace characters also change their names; they have a history, yet their essential function remains. There is always someone who gets beaten up, who outsmarts the mighty, and so forth.

A joke persona is not necessarily a human character. It can also be an animal. The comic genres and animal tales are in any case closely related. The stories of Lafontaine are almost always comic. The wolf, the fox, the lamb, the mouse, etc. are (at least in the European stories) standing characters. The fox is the one who outsmarts all. Walt Disney's pigs follow this tradition. However, the animal story characters, who normally represent human social, political, and gender roles, rarely play the part of protagonists in jokes. There are elephant

jokes (why?), dog jokes, etc. Most animal jokes are surrealistic. Such as: "My friend is playing chess with my dog.—You have a smart dog, do you?—How come?—He has already lost two games."

There are also stereotypical standing characters in ethnic jokes. Like the Scott or the Jew (playing the role of the miser), the French (playing the role of the eroticist) or the German (playing the role of the humorless complainer). In the French jokes, English and German cuisine is also a major butt. There are also self-ironical ethnic jokes. "In school the teacher asks Toto, (the French stereotype for the seemingly silly, but actually smart child)—Tell me, who was the first man?—Vercingetorix!—No, no, it was Adam.—I did not know that foreigners count."

There are stereotypical relationships, like doctor/patient, the sexual triangle, poor/wealthy, priest/disbeliever or believer. There are stereotypical butts, especially in sexual jokes, like those concerning mothers-in-law or marriage in general. Since jokes have typically been told by men, they follow the old aphorism according to which marriage is tragic for a woman and comic for a man. Jokes about love and sex (and not marriage or betrothal) are less one-sided. Look at this French joke: "He: My love, I implore you, tell me whether I am really the first in your life! She: But surely, my darling, you are. Now I wish to know why you men always ask the same question." Typical targets of sexual jokes are impotency, the penis itself, the frigid woman, oral sex, homosexuals, and masturbation. These jokes are normally very direct and less philosophical. The pleasure in telling such jokes reminds us of the pleasure of uttering so-called dirty words, like in the German aphoristic joke "Onanie ist Genuß an und fur sich." (Or, "masturbation is a pleasure in and for itself.") The joke also makes clear that employment of a philosophical *terminus technicus* (here, of a Hegelian variety) does not transform a joke into a philosophical one. Or like the American joke: "What does a JAP (Jewish American Princess) think suck and fuck are?—Two cities in China." There are more sophisticated versions of this kind of joke. Allegedly the following inscription was found in the bathroom of the university of Freiburg: "Such keinen Witz an dieser Wand, den Grossten hast du in deiner Hand." ("Don't look for a joke on this wall, you have the biggest one in your hand.")

Scatological jokes which used to be very popular (from Aristophanes to Rabelais) became less central in modern times, yet they are still present. They are normally combined with other stereotypes. Like: "Sagen sie nicht den Bishop 'Scheisse', sie sprechen über den heiligen Stuhl." (An untranslatable pun, but roughly: "Don't say 'shit' to the bishop, you are talking about the holy stool.")

In Eastern European Jewish jokes, the main stereotypical persona are: the schlemiel (the pariah), the schnorrer (the self-confident beggar), the schadchen (the marriage broker), the Hassidic rabbi and his following (the unworldly characters), the rebeccen (the rabbi's wife), the bocher (the rabbi's helper), etc. Many of them embody philosophical jokes.

I already mentioned the joke/practice of attribution. Certain jokes are attributed to well-known historical figures, first and foremost to politicians, artists and scientists. They are mostly wandering jokes. The French joke about Sacha Guitry (why?) is in its English version a joke about G. B. Shaw. There are Napoleon jokes, Hitler jokes and Stalin jokes, Mussolini and de Gaulle jokes, and there are also Einstein jokes, Rothschild jokes, and Caruso jokes (and why Caruso?). Joke motifs are like myth motifs. One can offer them as gifts to famous people, living or dead.

Not all jokes are philosophical, but many of them are. Philosophical jokes are the deepest, the most sophisticated jokes. Most wandering jokes are philosophical; they are the joke "survivors." The honorary witness to the intimate relationship between philosophy and the whole comic genre is this type of joke. I will just enumerate a few "tricks" of philosophical jokes. The first was noticed and noted by Peirce. He said that jokes argue in the following way:

> "All the beans in this bag are white; these beans are white; ergo these beans
> are from this bag." In a logic handbook, this is faulty reasoning, yet in a
> joke the trick is to mock reasoning itself. Entirely valid reasoning can also
> be ridiculous if it collides with empirical rules, thinking, and expectations.
> Like "Why are there schedules if the trains are always late?—How would
> we otherwise know that they were late?" Jokes can upset the language
> game; they can follow a way of thinking *ad absurdum* and break away
> from the ordinary way of thinking (absurd jokes can). Automatic thinking,
> sophistic reasoning, and breaking an established frame of reference are all
> tricks of philosophical jokes.

I will exemplify the main types of philosophical jokes with Eastern European Jewish jokes, one joke for each type. Of course, there are far more varieties, and my choice is, as usual, arbitrary up to a degree. The reader will surely notice that most of the presented jokes stem from the eighteenth, and some from the nineteenth-century. This is the case because I try to restrict the inquiry to "survivor" jokes. Some of these jokes, such as the schlemiel and the schnorrer jokes, are "social" jokes; others, like the schadchen jokes, are sexual, yet never directly; others, however, are purely philosophical jokes.

Many studies have been written on Jewish jokes, discussing among other things whether and the degree to which they are self-ironical, or why exactly Jews living in closed communities (schtels) in Eastern Europe excelled in the joke genre. These are important questions, but I cannot discuss them in a work on the comic. For simplicity's sake, almost all of my examples are selected from the volume *Encyclopedia of Jewish Humor* (Jonathan David Publishers, Inc., 2001), while the remaining ones are borrowed from Freud's book (*Jokes and Their Relation to the Unconscious*). So it should be easy for readers to check their veracity.

Type 1

A young man boarded a train bound for Odessa and sat down beside a prosperous-looking passenger. "Can you tell me the time, sir?" the young man asked. The stranger glanced at him contemptuously. "Drop dead!" he answered. "What the devil is wrong with you!" the young man exploded indignantly. "I ask you as a gentleman, and you answer so rudely. What is the problem?" The other passenger made as if to ignore him, then, sighing, he turned and said: "All right, I'll tell you. First you ask a question and I am supposed to answer, yes? So I tell you the time. Then you start up with discussion about the weather, about politics, about the war, about business—soon we discover that we are both Jews. So what happens? I live in Odessa but you are a stranger there so I must extend Jewish hospitality and invite you to my home. You meet Sophie, my beautiful daughter, and after a few more visits you both fall in love. Finally you ask my blessing so that you and Sophie can get married. So why not avoid this big megillah? I can tell you right now, young man, that I positively refuse to let my daughter marry anyone who cannot even afford a watch!"

The joke makes fun of so-called conditional necessity (if this, then that) as in, if I heat the water it will boil, if it boils it will evaporate, the kettle will burn, then it will smell, etc. The logic of conditional (hypothetical) necessity works in everyday thinking well, if the developments are regulated by certain simple, natural laws. Yet in human matters it does not work, because contingency upsets it. Whether the young man and Sophie are going to fall in love or not is an entirely contingent event. Contingent futurities can (as Leibniz used to say) be foreseen by God alone, because at every point in the chain of events there are human choices. In fact, Sophie's father (a fragile human being with a very limited capacity for foresight), claims divine foresight for himself, and this is funny enough. What is more, it is from his speech that the young man is informed that he has a big house in Odessa and a beautiful daughter of marrying age, with a considerable dowry. The old man's decision not to tell the young man the time, then to tell him nevertheless why he did not tell him (another source of fun!) could end up leading to just the consequence he wanted by all means to avoid. The punch line is entirely commonsensical and pragmatic (I will not marry my daughter to a young man who cannot afford a watch.). Yet precisely such a commonsensical point, which does not follow as an empirical statement of fact but from faulty reasoning, ceases to be commonsensical just because it is spelled out as if it were the conclusion of the nonsensical deduction.

This philosophical joke is a typical narrative joke; one should tell it slowly, with gusto. It is also a portrayal of the chutzpah of the Jewish businessman, a character always posing and answering his own questions, and always characterized by rigid, money-oriented thoughts, whether fitting or unfitting.

Type 2

An exceptionally pious Hassid of Drozhen was accustomed to a serving of chopped eggs as an appetizer for his Sabbath supper. But there came the inevitable time when his favorite dish was missing. He asked his wife the reason. "It is the end of the summer and the hens are laying very few eggs," she explained. "Now they are very expensive. Earlier in the season the price of a single egg was one groschen, but today is three groschen." "Praised be the Lord!" exclaimed the holy man. "We can only marvel at His exalted logic. He gives intelligence even to the lowly chicken so that she stops laying eggs at one groschen and starts in again when price goes up to three. Giuttele, what a businessman God would make!"

This joke is about the reversal of causality, as several other philosophical jokes are. This particular joke is, however, not only about the reversal of causality (the hen lays less eggs, because the prices are high), but it also makes fun of idealism in general. When Nietzsche enumerates the main errors of Platonism, the reversal of the cause/effect relation is one of his major points. According to the holy man of the joke, there is a higher logic, a divine logic at work here, which created the intelligence of hens to lay fewer eggs until prices are up. Up to this point what is ridiculed is the idealistic way of "walking on one's head," and the application of subtle/sublime thinking to common, empirical matters. But the joke goes further in the punch line. First common sense thinking is negated by philosophical idealism, and then in the punch line, the same idealistic way of thinking is exalted because it serves as the justification of utilitarian thinking. Anything can be proven, and justified, by anything.[2]

Type 3

This joke is old, but here it is told in an American setting by immigrant Jews.

A recent arrival to these shores was trying to orient himself to his new land. "Tell me something," he asked his friend, "how far is it from New York to Philadelphia?" "About a hundred miles." "And from Philadelphia to New York?" "Why, it is the same distance, naturally." "What's so natural?" retorted the immigrant. "Backwards and forwards are not necessarily of the same distance. For example, Purim to Pesach is one month. But from Pesach to Purim isn't it eleven months?"

In fact the immigrant was right. Backwards and forwards are not necessarily the same distance. From spring to winter, for instance, and from winter to spring, are different in a circular conception of time or space, although they are the same distance in linear time and space. But the question was absurd because it collided with everyday, taken-for-granted common sense. In this case of true and right

knowledge, the immigrant's thinking was out of context, and inadequate to the issue and the situation.

Type 4

A little old man approached his boss timidly. "Can I get tomorrow off? It is my golden anniversary." "By God!" snarled the boss, "will I have to put up with this chutzpah every fifty years?"

This is an absurd joke, yet unlike the one about the man who plays chess with a dog, it is not a surrealist one. It is also a time joke, like the previous one, yet here it is not the context-inadequate, circular concept of time, but the context-inadequate hyperbolic extension of linear time that makes the joke a joke. The other absurdity that intertwines with the time joke is the hyperbolic miserliness of the boss character.

Type 5

The loyal Hassid was defending his rabbi to the skeptical Litvak: "Do you realize how great the rebbe of Sadigora is? Why, every Sabbath afternoon God himself descends from on high, enters the rebbe's study, sits down on a chair, and keeps company with the holy man."—"How do you know this actually happens?" queried the Litvak.—"There is no doubt about it. The rebbe himself told us so."—"But how do you know he is telling the truth?"—"Blockhead!" cried the Hassid. "Do you think for one moment that God Almighty would have anything to do with a liar?"

Jokes with a similar structure abound in the Jewish joke folklore. This version belongs to the more complicated ones, given that the story can be read from the perspective of two philosophical scripts. Bisociation here is not just a narrative strategy.

The first philosophical text script is the ironical presentation of the *petitio principii*, or circular argument. This is the essence of the text from the position of the Litvak. From the perspective of the second philosophical script, however, there is no *petitio principii*, and the Hassid's answer is absolutely relevant. For the logic or religion is confronted or contrasted to everyday logic. In order to exemplify the essential difference between the two logics, the Hassid of the joke presents an absurd story. Yet in the spirit of religion the absurd can be true. We know from Moses that he heard the voice of God from the burning bush; there was no other witness. Yet Moses said it, and this is why it is true. In this joke both the *petitio principii* script and the religious logic script become funny. The first because of its rigidity (we know since Bergson that rigidity is always comic), the second because the Hassid elevates the local rabbi to the height of

the mouthpiece of God, although not in a positive, but in a negative manner (God would not converse with a liar), thus he puts the responsibility for truth onto God. He not only misses the proper measure, but also the proper way of speaking of God.

Type 6

A distraught mother came to the Hassidic rabbi about her sick child. "Rabbi," she lamented, "my baby is suffering already for a whole week from diarrhea. I tried every medicine, but nothing will stop it!" "Don't worry," the rabbi comforted her, "All you need do is to say tefillim, and I have no doubt that you will witness a miracle." Three days later the worried mother appeared at the rabbi's house again. "Rabbi, I did exactly as you suggested, but now my little boy is suffering from the opposite symptoms. He can't go at all!" "Say the tefillim again," recommended the Hassid. "But Rabbi," protested the woman, "tefillim are constipating!"

Here we meet Hume, in fact twice, that is in both readings of the text. The rabbi recommends a prayer against diarrhea, and it works where medicine has not; it actually works miracles, and the diarrhea stops. The joke ridicules causality: *post hoc, propter hoc*. But now comes the second script. Miracles happen in single cases. But this "miracle" establishes in the mother the belief that the single case is a general case, that stopping diarrhea is the necessary effect of praying with tefillim; that is, no miracle has happened, the rabbi really just recommended the general medicine against diarrhea, and as a consequence saying tefillim is the cause of constipation, constipation its proper effect. The belief in miracles and the belief that everything works like 'science' over-determine one another. Two senses make a nonsense.

Type 7

This type is the opposite of the previous one.

It happened in the mid-1800s. A pious Hassid was relating the wondrous miracles wrought by his rabbi. "For example," he said "our great rebbe and several of his followers were taking a walk on a fast day when they noticed a Jew leaning against the wall and devouring a piece of bread and herring. 'Infidel!' cried one of the Hassidim, 'May that wall crumble and crunch your renegade bones!' But the rebbe spoke in gentle tones: 'He has ignored this holy fast day but perhaps he had good reason for committing his sin. Let us remember that even a sinner is a child of God. Rather than curse him I shall bless him, and I shall pray to the Almighty that the wall does not crumble and crush him, but that it remain standing.' And what do you think happened?" concluded the Hassid tri-

umphantly. "No sooner had the rebbe uttered his pronouncement than the wall remained standing and the sinner escaped unharmed!"

The perspective of this joke is again double, and this is one way to produce bisociation. The story is told from the position of "Litvaks," that is, the followers of another rabbi, who ridicule the impotency of the famous rabbi of another community (his miracle consists of everything remaining as it was, unaltered), yet also from the position of the followers of the rabbi, because the story is about the goodness and the moral holiness of the rabbi. The rabbi in fact does the greatest miracle: the softening of the hearts of his followers, the miracle of forgiveness; yet in the follower's mind a "material" miracle happened, since the words of the rabbi kept the wall intact and the heretic physically unharmed. For the follower, a spiritual effect does not count, only a material one does. This is what the teller of the joke ridicules, both in the Litvak and in the rabbi's Hassidic followers. Here one reads two texts in one. The alleged effect of the rabbi's word was no effect at all. The real effect, however, has been displaced. Displacement, as we know, is one of the major strategies of jokes.

All of the following jokes are told about the same or similar characters, the sages of Chelm. The sages of Chelm are characterized as fools of the comic tradition (see Shakespeare). They are seemingly stupid, or play stupid, when in fact they are naively sage. They generally say non-rational things, or things which make much sense but still sound nonsensical to others. As in the previous cases, I choose also here only one joke for each philosophical type.

Type 8

This joke went through several mutations. One of them was circulating in my youth, during the totalitarian regime of Rakosi. I put down an earlier version.

> Tachnum, the water carrier, was returning home one evening when a stranger rushed up to him and slapped his face. "Take that Meyer!" yelled the attacker. Tachnum picked himself up from the street and stared at the man in amazement. Suddenly a broad grin spread over his face and then he laughed uproariously. "Meyer, what are you laughing at?" exclaimed the other, "I just knocked you down." "The joke is on you," chortled Tachnum. "I am not Meyer."

This is a clown joke and a social one, even if in the early version there is no direct reference to a socio-political situation. Yet the philosophical game played by this joke works for the kind of jokers who are oppressed, poor, and at the mercy of unprovoked, irrational punishment or brutality. Sartre speaks about the radicalization of evil. Radicalization of evil means to reverse positions, to reject the identification imposed upon you by the oppressor, to identify oneself, to take for oneself the position of superiority. That happens in this joke. Laughter, especially laughing in the face of the person who was beating you up, means that you

have assumed the position of superiority. But the joke is a joke because it also displaces the move of the radicalization of evil. The rejection of identification by the oppressor and the move of self-identification is not an act of revolt here, but an empirical statement of fact. Tachnum is indeed called Tachnum and not Meyer. He was wrongly (empirically wrongly) identified by the attacker as Meyer. The attacker did not attack Meyer but Tachnum. The move of the radicalization of evil is funny, because nothing like this happens, only it seems (for a moment for the attacker) as if it happened.

Type 9

There are many jokes about the use and misuse of counting, numbers and mathematics, and this is one of them. I chose it because it is also a sexual joke and characteristic of the "Chelmic" way of thinking.

> Shloime, the young apprentice cobbler of Chelm, took as his bride a girl of his own age—eighteen. Imagine his surprise when, three months later, his new wife gave birth. He rushed to the rabbi's house for an explanation. "Rabbi," he exclaimed, "you will find this difficult to believe, but my wife just gave birth to a baby." "Wives usually do," commented the sage wryly. "But we have been married only for three months. My own mother, she should rest in peace, told me it takes nine months to make a baby. Believe me, I am terribly worried." The rabbi stroked his beard and reflected upon this strange occurrence. "We will solve this mystery with talmudic logic, through the asking of questions. First, my son, you say you have been married for three months?" "Yes, rabbi." "Your wife has lived with you for three months?" "Yes, she has." "And you have lived with your wife for three months?" "Yes." "There you have it, good man. Add up the total: three months plus three months plus three months. How much is that?" "Nine months, rabbi." "Correct," said the rabbi gently, "Peace be with you and yours. Now go home to your wife and your nine-month-old baby."

To jongleur with numbers stands for the jongleuring with speculative thinking in general, and first and foremost for talmudic logic. The well-known and often employed joke trick, the confusion of bad logic and correct empirical observation, or vice versa, is especially clear in this case. Yet it is also a beautiful example of the characterization of the persona in narrative jokes and of the frequent ambiguity of the characterization itself. We can take the rabbi to be a good man, a stranger to fundamentalism, who saves two young people and a newborn child from suffering. Yet this is just one reading of the script. One can understand the rabbi also as an absolutely unworldly man, who cannot even imagine that a child can be born by other means then the embrace of a legitimate husband, who really believes that he is confronted by a problem which needs to be solved by talmudic logic. Thus, the joke makes fun of talmudic logic and of the cobbler, this typical fool of the Chelmic type jokes, naïve and credulous. Moreo-

ver, in one (optional) reading of the script, it makes fun first and foremost of the rabbi. The joke is also about credulity, but credulity with a happy ending.

Type 10

The following is a wandering joke that has obviously been but little altered. It is a joke which does not tolerate, at least not in its main body, variations. I first heard it in the same way as it was told in the eighteenth century, quoted here. In the introductory part of the joke we learn that Lekish, the head of Chelm philosophers, failed to appear in the synagogue for the Sabbath services. He was ill, and could not speak a word but lay silently in his bed. The rabbi visited Lekish and implored him to tell what was tormenting him. Now comes the "body" of the joke:

> "Yes rabbi, there is a thought that is tearing me apart." "Tell it to me." "Well, suppose that every living human being became one gigantic man. And further suppose that all trees on earth became one tree, and all the axes of the world became one ax. Now suppose that the man took that ax and chopped down the tree and it fell into the ocean." "Yes, yes! Go on! Don't stop!" "Can you imagine," whispered Lekish hoarsely, "what a splash that would make?"

The point of the joke is very similar to the one quoted by Kant, and the Kantian interpretation of jokes (expectation suddenly ending, dissolving into nothingness) applies to this joke perfectly. Yet it is far more complex than the two jokes told by Kant. First, the main character (the persona) of the joke, Lekish, is the dean of all philosophers, the greatest, most renowned, most respected philosopher of Chelm. And when he begins with his hypothesis "Suppose . . . " the rabbi also begins to enter the philosophical mind; he thinks with Lekish, he follows one hypothesis after the other, yet when he urges Lekish to give the final clue, to decipher the philosophical sense of the whole story, it is then that the story (in the punch line) runs into nonsense or nothingness. This is a marvelous joke about metaphysics on the one hand, and logic on the other. The form of the argumentation is logical, the content is speculative/metaphysical. We, philosophers, are constantly speculating about things that "normal" people never think about; we worry about many things which never enter a normal person's mind. We know that there is a philosophical name for all the hypotheses enumerated by Lekish. The tree which is all trees is called the Idea of the tree, the ax which is all axes is the Idea of the axe, and the man who is all men is the Idea of man; in any metaphysical system all these Ideas act. Yet the Idea of man cannot take the Idea of ax into his hand and chop down the Idea of the tree. Still, in the mind of Lakish, everyday, empirical thinking and speculative thinking are hopelessly confused, and it is because of this confusion that his problem is a joke. Ideas do not splash, but he asks the rabbi to imagine it.

Type 11

The next joke exemplifies sophistic thinking, the type enumerated in most theories as one of the main techniques of creating philosophical jokes. Here is the story:

> Simon the winemaker was deeply disturbed about a strange event that had occurred that morning, so he went to the wisest member of the Council of Seven for an explanation. "It is an established fact that whenever a poor man such as I drops a slice of bread it always falls butter-side down," began Simon. "Yes that is true," agreed the Chelmic dignitary. "Well, today I dropped my bread and it fell butter-side up!" "What! That is impossible!" exclaimed the Elder. "I never heard of such a thing!" "But it happened!" The old sage considered the unusual occurrence for some time. At last he smiled as the simple truth dawned at him. "Simon, go home and be at ease," he counseled. "You buttered your bread on the wrong side."

The joke is, again, far more complex than a usual sophistic argument. The sophistic argument is the point, given in the punch line, but the argument which precedes it is as absurd as the punch line. Both the winemaker and the wise man agree absolutely, that a poor man's bread falls down always and without exception with the butter-side down. From the case of an entirely contingent outcome (a probability of 50 percent), they establish a kind of necessary relationship between two unrelated things: the material condition of a person dropping a piece of bread, and the bread's behavior in dropping butter-side down. They agree about one absurdity. So what needs to be explained is in fact why the absurd presupposition was correct. Since both interlocutors share the belief in the absurd presupposition, the non-existing problem can be unknotted only with sophistic logic. One nonsense gives sense to another nonsense. And this is one game of the jokes that poke fun at the wisdom of Chelm.

Type 12

> Two of the brightest students in Chelm, if not in the whole world, were discussing the difficulties involved in learning to spell biblical words. "Let me ask you a question," said one. "Ask!" replied the other. "Who needs a gimmel in Noah?" "But there is no gimmel in Noah." "Tell me, why shouldn't there be a gimmel in Noah?" "But who needs a gimmel in Noah?" "No, just a minute," protested the first student, "that is the same question I asked you to begin with! Who needs a gimmel in Noah?"

So, two people ask the same thing, yet it is not the same thing. One spells rightly, the other wrongly. This is in itself not a joke. The joke discloses itself as the identity of the non-identical. The right question and the wrong question, the question of the knower and of the ignoramus, are exactly the same questions. Yet

the ignoramus (and this is the punch line) is adamant that since their questions are the same question, both he and the other student are right in asking, and that he himself has not even been given an answer. However, those same questions are actually entirely different, if placed in the context in which they originally appear. The first student (the ignoramus) is also a Chelmic; he believes that he is always in the right. The punch line indicates something about his character, namely that his question was not meant as a question at all, for he was not interested in the answer, but only in himself. The Chelmic student is here treated satirically.[3]

Type 13

The punch line is similar, but both the sense and the nonsense are different in the following story, also quoted by Freud.

> "You told me a deliberate lie," a prospective groom complained to the marriage broker. "I am shocked! A man of your age and your background! Thinking I lied? What are you talking about? She isn't beautiful to you? She doesn't have excellent manners? So how did I lie?" "You told me her father was dead, that's where you lied! The girl told me herself that he's been in prison for the past ten years." "Now, I ask you," countered the broker, "do you call that living?"

Philosophers, since Aristotle, have hastened to make the distinction between life and the good life. A life which is not a good life, but biological survival pure and simple, cannot be called "life." The same basic punch line was absurd in another joke (the stranger from Chelm identified the dead man's lush memorial site with prosperous living). But this latter joke is not at all absurd, if one insists that life in a prison is not life (worth living). As it happens in several jokes, abstraction from the situation, from the context, is itself a case of displacement. In the last case, the discussion was not about whether life in a prison can be called life (a reasonable question) yet about whether the prospective bride's father was dead or alive. Moreover, the discussion was not theoretical but pragmatic. It was about marriage, about whether it makes a difference for the bridegroom whether his bride's father is dead or in prison. That is the point, which is in itself far from senseless, yet it becomes senseless because the context gets shifted without warning.[4]

Type 14

The following is a semantic joke. It is a specific semantic joke, because in contrast to many semantic jokes, this one is translatable at least into the languages I know, and is funny for the same reasons in all of them. The joke tells the story of

Rabbi Mordecai Koppelmann from Brooklyn, who participates in a rabbinical conference in San Francisco. He writes the following letter to his wife: "Dear Leah, Send me your slippers at once. I write 'your slippers' because if I wrote 'my slippers' you would read it as my slippers and you would send me your slippers. And what do I need with your slippers? So I am saying plainly 'your slippers' so that you understand and read it as your slippers and not as 'my slippers,' and thus send me my slippers."

Here we have a joke about the use of personal pronouns, and especially about the "I." What does it mean to say "I" or "mine"? Wittgenstein would say that "I" is not a person. This joke takes Wittgenstein's language game theory seriously. "I" is different from the perspective of the writer and the reader, the speaker and the listener. Who is the "I"? The rabbi? Or his wife? It is not self-evident, according to the joke, that the reader of the letter will take the writer's perspective when she reads "mine," instead of naturally assuming her own perspective. Now, the letter writer tries to overcome the Wittgensteinian impediment by writing "my slippers" or "your slippers" in quotation marks, as philosophers in similar cases frequently do. The joke is about the limit of language as regards perception, against which even the rabbi cannot successfully win.

Type 15

Since I did not otherwise find good illustrations for the two last types of philosophical jokes, I turn for help to Freud's book on jokes. From the jokes he tells there, I choose two.

> A borrowed a copper kettle from B and after he had returned it, he was sued by B because the kettle was returned with a big hole in it, which made it unusable. A argued his defense thus: "First, I never borrowed a kettle from B; second, the kettle had a hole in it already when I got it; and third, I gave him back the kettle undamaged."

According to Freud this defense is funny, since any one of the three reasons would have been sufficient for a defense. Instead, A argues all three possibilities, so that each argument annuls the others. Freud identifies this line of argumentation as sophistic. It is sophistic, not just because A argues three times, annulling each of his other arguments, but also because he aims at impressing his judgers with the opposite, namely that his three arguments reinforce one another.[5]

Type 16

> A Shnorrer borrowed twenty-five florins from a prosperous acquaintance, with many asseverations of his necessitous circumstances. The very same day his benefactor met him again in a restaurant with a plate of salmon mayonnaise in

front of him. The benefactor reproached him: "What? You borrow from me and then order yourself salmon mayonnaise? Is that what you have used my money for?" "I don't understand you," replied the Shnorrer. "If I had no money I couldn't eat salmon mayonnaise, and if I have some money I mustn't eat salmon mayonnaise. When then am I to eat salmon mayonnaise?"

Freud analyzes the joke the following way. The answer is seemingly logical but it is illogical. The Shnorrer, in his answer, disregards the meaning of the question. His benefactor did not reproach him for eating salmon mayonnaise, but for doing it with the money he said he required for bare necessities. He is not supposed to eat delicacies at all.

Freud analyses the joke beautifully, as a social joke. And it is a social joke. But it is also a philosophical joke. It is a joke about free will. This is why the Shnorrer not only repeats the word "salmon mayonnaise" (this is stressed by Freud as the employment of a well-known joke technique) but speaks the first time about "I cannot," and the second time about "I must not." That is, he speaks about causal relation on the one hand, and about moral imperative on the other. A man is a plaything of causality; 'I cannot' means I do not have the sufficient cause (the money) on hand, yet also that 'I must not' or 'should not,' meaning that it is not permitted, even if I do have sufficient money at my disposal. If squeezed between causality and imperative, then, and this is the question, when am I free to do something that I wish to do? How can I be free? The practical answer of the Shnorrer is to disregard the moral ought. He cannot eat salmon mayonnaise if he does not have sufficient funds (cause), and such an impediment cannot be overcome. But if he has the means, then why should he not use them? In the first case the Shnorrer has no choice; in the second he has, and he chooses to eat salmon mayonnaise, just like Eve chose to eat the forbidden fruit. The joke is a joke; it is funny, not just because the answer is illogical in the context of a social joke, but because it concerns a trifle (eating salmon mayonnaise or not). The philosophical question, however, lingers in the air; it remains. We can also ask ourselves, are we, without breaking a norm, free to eat our salmon mayonnaise? When can we, and when are we also permitted, to just eat the salmon mayonnaise?

I exemplified a few types of philosophical jokes—purposefully neglecting the distinction between verbal, phonetic, and semantic—and of referential jokes, mostly with narrative jokes. My discussion of jokes in general was even more restricted. I discussed only so-called "canned jokes" (wandering jokes, relatively stable jokes) and neglected the problems of occasional social jokes, that is, jokes we make spontaneously about persons who are present in, or just then absent from, our company. Occasional jokes are rarely jokes proper. One does not tell jokes, but is rather "joking," teasing others, in good or bad taste. "Joking," also in the sense of teasing, is situated and context related, and even very witty remarks are soon forgotten, unless they are preserved in an anecdote. In such a

case attribution is soon substituted for the truthful rendering of the witty remark. One attributes contextually witty remarks often to well-known jesters, humorists, to historical figures and to typical joke characters, and thus transforms them into canned jokes.

The people who make good witty remarks in the company of friends, or also in a relatively accidentally selected group of famous or unknown people, or on a television show, are usually people who like telling jokes, and who tell them well. We say that these people have "a good sense of humor." In everyday parlance, a person is said to have a good sense of humor if she is witty, tells funny stories well, and is also a gracious listener who reacts with hearty laugher at others' jokes.

I also discussed so-called pure jokes, and sidestepped tendentious ones, which in my mind do not belong to the realm of a "high joke culture" anyhow. The Kantian description of the "free play of thoughts" cannot be applied to tendentious jokes. These jokes have a purpose, which is namely to kill with laughter. In the language of another philosophical school, I would distinguish between jokes which are illocutionary acts and jokes which are perlocutionary acts. Pure jokes are illocutionary acts. Not every satirical joke is necessarily also tendentious, only the concretely polemical ones are. Tendentious jokes are mainly social, political, and sexual. But all three of these possibilities also appear in several pure jokes. I neglected them too (unless they were also philosophical jokes). Now I will try to briefly make up for my neglect.

The techniques and strategies of social jokes, political jokes, and sexual jokes are very similar, although their objects are different. Philosophical jokes employ the same techniques and strategies and they can also be, as far as their subjects are concerned, political, social, and sexual. The butt of philosophical jokes is mostly thinking itself. Sometimes everyday thinking or ordinary language is lampooned, but mostly philosophy, logic, and idealism are. The Nietzschean "four main errors" of metaphysical thinking or Platonism are frequently made fun of. Yet the most challenging feature of these pure jokes is their ambiguity, their vacillation concerning the butt or target of ridicule itself. A philosophical joke is in fact always a kind of play of understanding and imagination, for neither of them gets the upper hand, given the constant vacillation, the never sublimated ambiguity, in every philosophical joke.

Joke-imagination is compared by Freud to the dream world, and in fact, everything can happen in a joke; we take it as it is, as in a fairy tale. Contrary to fairy tales though, the unbelievable and irrational are rarely fantastic, although they can be, as in surrealistic jokes. What appears as unbelievable or nonrational is the way of thinking itself, which is both expressed in, and exposed by, the jokes. Could the letter written in the joke about Rabbi Mordecai Koppelmann be written at all? Is it not as absurd as a dog playing chess? The wit of the characters in a joke, and their unreasonable rationality, are products and provokers of imagination and cannot be subsumed under other concepts. One cannot sum up a joke by reciting its content. One cannot conceptualize the punch line of a joke;

one can only repeat it. Thus a philosophical joke behaves like a work of art; it stands for itself, it is autonomous, it manifests free imagination which cannot be conceptualized. Yet it is not a work of art in the same sense as a painting, or a novel or even a short story (although a comic novella normally ends with a punch line). The specificity of pure, and especially of philosophical jokes, among all the works of art (if we can count them among works of art at all) is that they are through and through intellectual.

All comic genres are intimately related to rationality. Laughter as a response to the challenge of a comic phenomenon or work is always rational. In the second chapter, I called laughter the instinct of reason. Sure, there are two kinds of rationality. One of them I have call the 'rationality of reason,' the other the 'rationality of intellect' (see my 1985 *The Power of Shame: A Rationalist Perspective*). The rationality of reason is the rationality of common, pragmatic life. I act rationally or I think rationally if I act or think in accordance with general expectations. Weber distinguished between *Zweckrationalität* and *Wertrationalität*. If someone acts in either of these two senses of reason, one acts rationally, in that others understand why the act was undertaken, regardless of whether it is then considered right or wrong. If someone breaks the expectations of everyday rationality, and seems to do no harm except to him- or herself, we might think it funny, and we might also laugh. This rationality of general expectations, the 'rationality of reason,' can be challenged by another, competing kind of rationality. One can occupy the position of a value (it is usually that of Freedom or Life) and reject the commonsense rules of reason as rules of unreason, while instead substituting new, alternative norms that should replace them. People who occupy such a contrary position normally argue on behalf of the justice and reasonableness of the value or norm that they have placed in juxtaposition to the existent, already validated one. They usually call traditional, validated norms names, such as stupid, conservative, biased, rigid, heretic, evil, etc. In the comic genres like the comic play or novel, we have encountered both types of rationality, and have seen how one of them ridicules the other. Mostly, they make reciprocal fun of each other, as in Molière's *The Misanthrope* or in Shaw's *Julius Caesar*. In a typical comedy, one kind of rationality is ridiculed more radically than the other one, and the play can have a relatively or entirely happy ending. The same division of rationalities is also typical in the comic novel; one need only recall Don Quixote and Sancho Panza.

In a philosophical joke something remarkable happens: both rationalities are normally represented as each of the two scripts of the same story, and, if they are complex enough, also within one of the two scripts of the same story. The jokes do not take sides. They do not represent either the rationality of reason or the rationality of intellect, but both and neither of them. The division of roles, if it exists, is relative; it is often turned upside down or displaced. The same joke makes fun, from the perspective of one kind of reason, about the other, and vice versa, and does so suddenly, in the punch line. This is exactly what the free play of thoughts in a joke means. Moreover, this double play, the simultaneous pres-

entation of two contrasting rationalities, each making fun of the other, is over-determined in a manner that causes the scheme (the argument or story) which normally supports or justifies these rationalities to be lifted, suspended in the whole joke work. According to the rationality of reason, everything is rational that answers expectations, whereas in the joke world everyday expectations must be crossed. According to the perspective of the rationality of intellect, one should argue on behalf of one's just position and against the expectations of common sense. This move is normally performed in philosophical jokes, yet the arguments are then sophistic, false, and in more ways than one, grossly misplaced. All sorts of rationalities ridicule, in the name of reason, all the others, but the way they make fun of the others also upsets their own methods of justification, and appears in a ridiculous light. Reason ridicules reason rationally, while unmasking its unreason. This is how the free play of thoughts works—as the self-irony of reason.

Now I would like to return to an earlier exposition offered in this chapter. I mention earlier that there are three major theories about jokes: the theory of power, the theory of relief, and the incongruity theory. I take the position that the three theories, each of them, can be accepted, yet from different perspectives. First, the joke-teller is in the position of power; he is an exhibitionist; he monopolizes the discourse. Second, the recipients of the jokes are liberated from their inhibitions, from the censorship of both external and internal authorities, for they can laugh at things they are not even allowed to think about usually, like the madness of the dictator, their desires and impulses, their stupid or adulterous spouses, their so-called perversions, etc. They can let every thought flow freely. Finally, as far as the technique and strategy of the body of the joke is concerned, incongruity theories best describe how jokes are constituted and how they work to take effect. I write early in this chapter that one could conclude, perhaps too soon, that there cannot be any particular conscious or unconscious desire found, which gets satisfied by telling jokes or listening to them. I want to finally return to that suspended question.

In the second chapter, on laughing and crying, I indulge in an inquiry into the anthropological sources of those two spontaneous, innate affect-like expressions, which are, however, not affects proper. I tell a story about the human condition, of being thrown into the world by accident, insofar as our genetic a priori has no connection with the social a priori in which we find ourselves (that is, with the particular world into which we were thrown). I go on to say that the two a priories usually slowly dovetail in the course of our lives, but that there remains an abyss between them which can never be entirely filled or bridged. We leap through this abyss while laughing and crying, and, among other things, this is why such expressions are entirely spontaneous and cannot be conceptualized. While laughing or crying we cannot do anything else, and first and foremost we cannot speak.

Laughter is always about leaping over the abyss. The joke is the only genre which is "specialized" to elicit and solicit laughter; it allows us to leap over the

abyss. The abyss, of course, remains there, for we must also stop laughing, and what remains in the aftermath of laughter is an awareness of the sense of sense-lessness, the very presence of the abyss, and the recognition that it remains there, whatever we do.

Relief or liberation, power or incongruity, all refer in the last instance to the same thing. Whatever makes us leap over the abyss suddenly lifts us from the before and the after, fills us with the feeling of empowerment, of liberation, of relief, is in every case the awareness of absurdity or incongruity. Incongruity points at the abyss, whereas relief and the sense of power, that "sudden glory" promises something in the past tense. It promises something that is senseless, something that makes sense in its senselessness. It assures us, namely, that we just overcame our human condition, within the limits of our finitude. We over-came, for a moment, a human condition that cannot be overcome.

The "relief," even in sexual jokes, does not come from our crossing the proper boundaries of sexual behavior, but from crossing thereby and simultane-ously the boundaries which divide our desires (the genetic a priori) and the rules presented by our world (the social a priori), in general. The relief itself is not sexual. No one gets aroused from listening to a Schadchen joke or even from a rude joke about a girl who does know what to suck is. A joke does not generally present sexual encounters in a pictorial way. It speaks; it employs words, thoughts, and arguments. The glorious moment is not due to the "living out" of a desire; the satisfaction itself is not sexual or aggressive; it is satisfaction in the freedom of talking about everything we desire to talk about, the freedom to speak about everything we desire to do and to experience, the freedom to spell out our unarticulated wishes or to recognize those wishes in the joke. Similarly, in political jokes the relief is not political. When a political joke is told nothing changes. Not even my political judgment changes. One already has a firm politi-cal judgment ready before listening to a political joke; the joke just satisfies a desire to spell out the forbidden, to hear the censored texts, to speak freely, without responsibility. The joke is play, a game, and as in all authentic games and plays, one may act, and speak, without responsibility.

Almost all jokes challenge or cross authority, but authority does not only represent itself as directly described (the sexual norms, the political system, so-cial oppressors), for all authority figures also stand for a kind of rationality. Jokes challenge those rationalities while making fun of them, in the name of rea-son. But reason in the name of which rationality is ridiculed is also ridiculed. For otherwise, one could not leap over the abyss. In a joke, there is but one overarch-ing logic, namely the logic of the joke itself. And the logic of the joke is the logic of spirit unbound. The reader may suspect by now that with all this I have done nothing but elucidate Schlegel's definition of joke: "Witz ist eine Explo-sion vom gebundenen Geist." ("Wit [or Joke] is the explosion of confined spirit.")

Notes

1. The semantic field of humor employs homonyms, synonyms, repetition, paronyms through addition and substraction, diminutives, deformations and figures of speech. Referential humor employs the devices of similarity, deception, the impossible, the possible inconsequential, the unexpected, unconnected and incoherent discourse, etc. The referential is not identical with the narrative. According to Morin, e.g., all jokes can be reduced to a narrative model, whether verbal or referential. (As I mentioned also above.) In Chabarine's view, the main difference between verbal and referential jokes is that the latter are translatable, whereas the former are not. He speaks also of paradigmatic reversals, which characterize both phonetic and semantic jokes, and sometimes also referential ones. He exemplifies semantic paradigmatic reversals with the quasi-puzzle joke "What is diplomacy? The noble duty of lying for one's country." Among the deviant semiotic strategies, Fonagy mentions automatic thinking, sophistic thinking, and the employment of formal logic. Since those strategies are characteristic of philosophical jokes, I will return to them shortly. Fonagy sums up his theory by emphasizing that both metaphors and jokes involve a "violent and intentional contrast with common sense."

2. Since the cause/effect reversal is a very typical pattern in Jewish philosophical jokes, I should mention a few which introduce some modification into the pattern. Look at some jokes from Chelm about the eminent philosopher Lemach, who can answer any question. Someone asks him, e.g., "Why is the sea salty?" and he answers "Because so many salty herrings live in it." Or another joke, also from Chelm, "Which is more important, the sun or the moon?" And the rabbi answers: "The moon of course! It shines at night when we really need it. But who needs sun to shine when it is already broad daylight?" Or finally, "When fire broke out in Chelm, the rabbi addressed the citizens thus: 'My friends, this fire was a miracle sent from heaven above. If it were not for the bright flames, how would we have been able to see how to put the fire out on such a dark night?'"

3. One can hardly forget that the joke belongs to the empire or rather republic of comic genres. Almost all narratives jokes make fun of characters, yet not in the same comic manner or in the same mood, and not all of the characters of a joke are the main butts of the joke. Some of the characters are treated ironically, others satirically, others again with understanding humor. For example, the rabbi in our example 5 was treated with understanding humor, whereas the winemaker and his advisor were treated ironically. Black humor generally calls for ironic treatment. Many Rothschild jokes are of this kind. Take the story of the poor barrel maker of Chelm, who after a vicious pogrom and many months of strenuous wandering arrives in Germany. There he visits the Jewish cemetery in Frankfurt am Main. He there sees the magnificent grave of Amshel Rothschild, founder of the banking clan. And he exclaims exultantly: "Now that's what I call living!"

4. I will not quote the most general type of shadhen or marriage broker jokes, where it turns out that the bride is ugly, a hunchback and that she squints. Freud analyzed them in detail, unearthing the unconscious motives behind such jokes. On the face of it, the absurdities do pile up, but they also say something true about the institution of marriage, Freud argues.

5. Many a political joke belongs to this type. I know a very similar one, told about Hruschchow, in which the kettle is replaced by a bear's skin.

Chapter Seven

The Comic Image in Visual Arts I

The Comic Picture

The archetypes of all comic genres are those elementary comic situations like grimacing, wearing garments that are too big or small, mistaking someone's identity, stuttering in the midst of an oratory, using words in the wrong way, stumbling while walking carefully, imitating someone else's gait, speaking, personal, or professional mannerisms. Elementary comic situations are always made use of by marketplace and circus clowns, just as they once were by professional fools and jesters. Their puns, their fancy dresses, studied facial expressions, facial painting, and acrobatic tricks, their funny little stories and practical jokes are all combinations of the archetypes. The "high" comic genres, such as the comic drama, the comic novel, the joke, and the existential comedy, have also had recourse to the elementary comic situations, of which some become primary and others secondary, some of them determining, others, subjected to other elements. These genres cannot combine all of the major archetypical comic gestures, utterances, and events. So in this process of homogenization, the "high" comic genres sublimate the elementary comic situations.

I cannot agree with the influential aesthetic tradition of contrasting, as opposites, the comic, and the sublime. On the contrary, I believe that there is a strong family relationship between the comic and the sublime. This family relation becomes explicit in existential comedy, whether it is ironical or humorous. When Berger refers (in his 1997 *Redeeming Laughter: The Comic Dimension of Human Experience*) to "redeeming laughter," he does not have existential comedies first and foremost in mind. I experiment with the idea, in chapter 6, that laughter does not just have a redeeming effect in existential comic works.

Yet the response to other "high" comic genres (philosophical jokes included) is indeed redeeming laughter.

Those works which are not sublime in the above strict sense also sublimate everyday elementary comic situations and gestures; they also transform the affective reaction (laughter) from a quasi-instinctual reaction into a spontaneous one; they convert stupid, rancorous, socially "prescribed" but egocentric, and in this sense unfree laughter, into rational, free laughter. Sublimity in this broader sense has little to do with its topic. The work of a "high" genre can be sublime, even if the topic and its language are obscene, as in scatological humor. Don Quixote as a character stands for the "high" comic genres. He transforms the publican's daughter into a princess, and the pub into a castle. This happens in every significant comic work. Still, the comic effect remains more dependent upon perspective, than does the sublime in general.

This is nowhere as eminently important as in the case of comic images. The visually comic is one of the most conspicuous constituents of elementary comic situations. The distortion of the face or of physical proportions is one of the major triggers of quasi-instinctual laughter. We all know the game adults often play with little children. The adult covers her face, then suddenly uncovers it and smiles at the child, or alternatively she covers the child's face, then suddenly uncovers it. In both cases the child will react with a quasi-instinctive laughter (as in the case of tickling). To alternate the presence and absence of a face or of things is an elementary practical joke situation. So is making a grimace. Whenever we make a grimace children react with laughter. We only need to see a face with unusual or loud make up, someone using a spoon to cut meat, wearing two differently colored shoes, or a pair of shoes double the size of the feet wearing them, and we will laugh. The high comic genres I have discussed until now relegate the visually comic, this main ingredient of elementary comedy, to the background. We even laugh at the appearance of tricksters in a comedy, not essentially because of the way they look, but because we already recognize their characters, and we expect them to execute some new maneuver.

Albrecht Dürer made a series of drawings and woodcuts to illustrate Terence's comedies. They are wonderful drawings, yet they are not comic images. They are illustrations of comedies; however, they do not appear as comic, since the characters of Terence's comedies are not comic because they look funny, but because they act and talk in a funny way and because their tricks contribute, albeit grossly, to a happy ending. Comic images, though, are not illustrations of comic novels or plays (although they can be); they need to present and represent the visual kind of the comic in their own right, independently of associations with other comic genres. What I call "the comic picture" is the homogenization of the visual aspect of the comic. Everything that is comic is concentrated in the picture. Visual comedy, represented above all in comic painting, drawing, photography, and sometimes also in comic sculpture, is the "sublimated" kind of the comic image.

I advance my impression that the comic effect is more dependent on perspective with comic images than in the cases of other comic genres. I say "im-

pression" instead of conviction not because of an ill-advised modesty, but because I rely upon a European model. What can be "seen" as comic and what cannot is highly idea- and expectation-dependent. In Europe, the eye of the beholder was tuned, for a long time, into the Platonic and Christian heritage. Later on, even if something was "seen" as comic, the question of whether its form of representation deserved high standing within the world of representations was answered historically and thus remained idea-dependent. It frequently happens, in the case of images (paintings, sculptures), that a work which was not meant to be comic will strike people as comic, perhaps only a century after its creation. Before the nineteenth century, all the other comic genres were immune to the influence of the Platonic heritage and therefore also to the changed understanding of this heritage. All comic genres were immanent; they had no relation to faith and belief, unless this faith or belief served as a butt for a parody or a joke.

Take the case of the representation of divine figures. The statues of Greek and Roman gods followed a specific canon of beauty. One could make fun of gods and demigods in a comedy, but since sculptures of gods and even of demigods had to strictly follow the canon of beauty, their bodily proportions could not be distorted, and their faces could not appear with a funny grimace. They were excluded from the world of comic images. Comic statues of satyrs and other sensual monsters were widespread in Greece and especially in Rome, but these were not gods. In contrast, Ganesh, roughly the equivalent of the Greek Hermes in Indian mythology, was born from Shiva's laughter and—as a divine trickster—was presented in sculpture with his elephant head and fat, yet elegantly seated, body and his fine legs: a lovely comic god. No wonder that Indian sculpture excelled in the presentation of comic images of gods. I do not know whether they were meant as comic, or whether they just now strike us, and modern Indian culture, as comic. But I must restrict my discussion to European and Mediterranean cultures.

Although I do not mean to offer even a brief story of all comic presentation, I still need to mention that in Roman painting, especially in Imperial Rome, comic presentation was part of the most rich and tasteful decoration of private palaces and homes. These were clandestine, sometimes erotic scenes or mythological topics, for example, from the stories of Homer's *Iliad* and *Odyssey*. I mention this only because it influences some representative works of Renaissance painters, e.g., the stanza of Raphael. The word *grotesque* was coined by painters and sculptors of the fifteenth century, who descended into the Casa Aurea, first believing it to be a grotto. They described the character of the wall paintings they discovered there as grotesque. Yet not all paintings termed grotesque are comic, only some of them are, and it is not easy even now to detect the purpose behind them, unless there is a comic mass painted underneath, to make the intention clear.

What is particularly interesting regarding the history of divine figures is that whereas on the Day of Fools, at least, the sacred was ridiculed in the Middle Ages, and fun could be made of priests, cardinals, and even of the last supper

and of the painted or carved images of God/Christ, none of the saints were found comic. Neither was hell or the seven virtues. Why? One can experiment with several answers to the question, and perhaps there is some truth in each of them. First, because images were charged with magic power. The magic power of the comic image is uncanny; one cannot confront innocent bystanders with it, and even less pious worshippers. Or we can try another line of explanation. In contrast to the Jewish tradition and the Iconoclastic movement, Catholicism embraced representation of the holy stories, as the bible of the "*idiota*." The emphasis is on the narrative of the life of Jesus, not on representation as such. And comic presentation would thus do disservice to the aim of educating piety.

But since there is a kind of continuity, despite some discontinuities to which I will shortly turn, between the Greek, the Roman, the Christian, the Renaissance, and even the eighteenth-century classicist way of presenting images, the deepest motives for the suppression of the sublimated comic image can be found in the European metaphysical tradition. I have in mind here the metaphysical "position" of the concept of the Beautiful. The Beautiful (the idea of the Beautiful) was considered identical with the Good (the idea of the Good), and with Truth (the idea of the Truth). Beauty is perfection; it is Beauty that we love, when we really love at all. While loving Beauty we love the Good and the Truth. Ugliness is lack, *steresis* and privation; ugliness is the bad, or evil, and the untrue.

The task of fine arts is to present the Good and the True as the Beautiful. Whatever is presented as distorted and imperfect is ugly, and in being ugly it is also untrue and bad (evil). This metaphysical construct is Platonic, although the identification of heavenly beauty with the perfect statue was formulated best by Plotinus: the sculptor imitates the spiritual idea of the Good and the Beautiful in his own soul. Werner, Gombrich, and Belting almost unequivocally see in Hegel the last philosopher still committed, up to a point, to this metaphysical legacy. The Beautiful (Hegel says) is the ideal, the sensual appearance of the idea. I would add that Hegel, who was not entirely taken with his own theory, developed a few interesting thoughts about the comic aspect of Dutch painting. One of Hegel's best students, Rosenkranz, in his important book about the Aesthetics of the Ugly, was, after the Romantics, the first to philosophically and methodologically challenge the Platonist tradition in the philosophy of art. To do this, he had to abandon the theory of privation. The ugly is not the absence of the beautiful and is certainly not identical with untruth or evil; it is a major experience of life, as is the horrible, the uncanny, the enchanted, the comic, etc. Thus the ugly deserves beautiful, that is artistic, presentation. We are of course, in the age of *Les Fleurs du Mal.*

I would add briefly one thought about the discontinuity between the ancient Christian understanding of beauty. The ancients allowed the presentation of creatures that combined human and animal forms (e.g., the Sphinx of Giza). In the East, from Egypt to Babylonia and India, these creatures occupied a central place in mythology, and because, as far as I know, Eastern high cultures did not develop a Greek-type canon for the representation of a beautiful body, they

allowed for all kinds of presentations of the gods, divine figures, daemons, etc., including the comic. In Greece and Rome too, sculptures with human and zoo-morphic bodies were generally not ugly or funny, since the creatures they represented were not necessarily seen as funny, ugly, or vicious. Centaurs were, in fact, brave and brilliantly beautiful creatures. In contrast, the combination of man and beast was presented as ugly, uncanny, devilish, and fiendish in Medieval Christian painting and sculpture. And even later, when Platonism began to whither, the combination of man and beast looks funny and also ugly, since here ugliness and being comic has already been identified (see, e.g., Pan in Rubens). Pagan gods, the gods of Greek/Roman mythology, could then be portrayed as ugly and funny, yet certainly not the Christian God or saints. I mention only on the side that Rubens' art became the model emulated by Daumier.

So when do comic images appear? And what is their status after their appearance? What kind of comic images make their appearance and when?

I will proceed in the following stages: first I will address Medieval and Renaissance representations, or the comic unwarranted; second I will look at mannerism and Dutch painting, or the comic warranted; third I will deal with the appearance of the comic as the program of anti-art; fourth with the claims of comic images to the status of art; and fifth I will take up the comic image as the critique of art. This is indeed a historical sequence, though by now, the claims of all comic genres are equally and simultaneously acknowledged.

Every sort of presentation, sub-genre, attitude, or game that we encounter in comedy, the comic novel, jokes, and the existential comic, finally make a radiant appearance in painting, sculpture, photography, or some such visual art. In comparison to comic plays, comic novels and even jokes, the comic image is a relative "latecomer" in the world of the comic in modern Europe. Yet, in the twentieth century it obtained, if I may say so, an "equal status" with the presentation of "the beautiful" (abstract art, minimalism). Among comic images, we encounter satirical presentation—in its polemical and humorous versions—parody, the parodistic, caricature, portrait caricature, irony, jokes, constitutive irony and constitutive humor. In fact, we find everything that ever characterized the comic. And perhaps most importantly in the contemporary history of the comic image was and is the constantly innovative parody of the religion of art.

When we contemplate certain typical figurative carvings on medieval cathedrals, such as figurative water-sprouts, and want to "name" their style or kind of representation, we often say that they are grotesque. The word "grotesque" also has its history; it became trendy in the twentieth century and was used (among other things) to put an emphasis on the comic aspect of works that were not meant to be comic at the time of their creation. Thus certain figures carved in medieval churches were termed "grotesque," since they strike the spectator as ridiculous and funny, although the spectator knows that their creators believed in the existence of their originals, in their sinister influence on the human world and in their evildoing. This is why the word "grotesque" included the connotation of

"uncanny" or "sinister." The discovery of the medieval "grotesque" already presupposed a change in the eye of the beholder. In times of classicism, medieval art was considered unskilled and primitive. Many a classicist believed that medieval sculptors were not skilled enough to carve a person according to the ancient canon, in proper proportions. The eye of the beholder underwent changes in the nineteenth century, when the coalescence of uncanny and ridiculous became programmatic for the first time in the Romantic movement. Jean Paul refers to the upturned world (*die verkehrte Welt*) as the source of the comic, or of "caricature"; he speaks of diabolic grimaces, and in the Introduction of his *Aesthetics*, he refers to the "ambiguity of seriousness, like the Feast of Fools."

Distorted faces, disproportioned faces and bodies, dwarfs, a combination of human and animal forms, all of which were later called "grotesque," were (contrary to the performances at the Feast of Fools), in all probability not meant to be ridiculous at the time of their creation, or to trigger redeeming laughter. Even so, they did not assume the ugly or comic form they did because of any lack of skill or sense for proportion. In great cathedrals like Bamberg or Rouen, one sees both figures of beautiful proportions and figures of different sorts of disproportion. Since evil, untruth, and ugliness were thought, in the last instance, to be identical, since all three were thought to signal the "lack" of goodness, beauty, and truth, the "grotesque" presentation was meant to be the true presentation of the untruth, the evil, daemonic, and underworldly creatures by which all decent Christians (the sculptors themselves included) are always surrounded, tempted, and misled. I would include in this group of works the paintings of Bosch. In Bosch's *Last Judgment* the damned look funny, although they are not funny, but wicked. Wickedness is a serious business. This is even more obvious if we cast a cursory glance at Bosch's oil panel *The Tribulations of St. Anthony.* The painting is full of dream creatures and monsters, some with many feet, others looking like birds, others crawling, and again others hatching from eggs. These monsters are daemons; they tempt decent human beings and destroy them, unless they remain true to the one true faith, like a rock. One can, however, detect in Bosch also a gesture of distancing, e.g., in *The Ship of Fools* where the comic effect is obviously intended.

I am far from making the dogmatic statement that comic presentation was never candidly attempted in the Middle Ages, since I cannot know if it was. Besides, I have seen a few works which I would guess had to be intended as parodies. There is, for example, a small statue in the shape of Aristotle and Phyllis, circa 1400, in bronze, and now in the Lehmann collection. Aristotle is down on all fours, and although he is, he behaves and is treated like a horse. Phyllis is riding on his back. Aristotle's face is unlike traditional Aristotle portraits or busts; it seems as if it were a portrait caricature. Phyllis has one hand on the buttock of the philosopher, and the other on top of his head. The little statue is beautifully carved, and wonderfully funny. This cannot be a mere accident.

But it is true that I should be a little more cautious. For sometimes one cannot decide whether a painting was meant to be humorous or just entirely serious. When I contemplate, for example, Pietro Longhi's painting *Exhibition of a Rhi-*

noceros at Venice (1751), I see in the picture a model of parodistic humor. In an empty circus, we see a group of curious people, presumably scientists, looking with admiration at the exhibited Rhinoceros, who on its part, does not care and peacefully eats his hay. The exhibition of exotic animals was a fashion at that time (another painting shows the exhibition of a giraffe), and it is surely debatable whether Longhi was making fun of such exhibitions and the cult of the exotic, or whether he just acted as a photographer who shoots a souvenir of an interesting event. Uncertainty of this kind may also occur when one judges contemporary works. Look at the case of Fernando Botero; take his painting *Our Lady of Cajica* (1972). You will see a huge, fat Virgin, with an ugly face with a double chin; the little Jesus with a disproportionately small head is in her lap. In my eyes this is a caricature, a humorous, not satirical caricature, but a caricature all the same. It is not a caricature of the Virgin, but a caricature of the kind of Virgin worship which is orchestrated by fat and ugly priests and cardinals, whose disproportionately small heads replace in this painting the usual angels, and whose fat faces are surrounded by green clouds. Yet I just read from the pen of an eminent art historian that this is a very Catholic painting, born out of faith and religious upbringing. Why do I doubt it, although I cannot "refute" it? Perhaps because I just see the painting in another way. Perhaps also because I have seen another work by Botero, *Joconde* (1978), painted in the same style. It says: our *Mona Lisa* is fat, she has also a double chin, her hands are disproportionately small, and she looks stupid as hell. And this is a caricature, no doubt about it. Botero's *Joconde* belongs to the series of *Mona Lisa* caricatures, not in making fun of Leonardo da Vinci, and even less of the young lady sitting for him, but of the religion of art, the worship of artworks. Still, I will not confront the understanding of art historians, whose profession it is to make claims with expertise. I will only stress that the decision as to whether a painting is "meant" seriously, or even more, whether it is supposed to be a parody or a caricature, frequently depends on the judgment passed in the eye of the beholder.

Both Belting and Hoffmann tell the story of the worship of Beauty during the Renaissance. Belting discusses how the *Venus of Milo* or *Apollo of Belvedere* or Rafael's *Sistine Madonna* were transformed from artworks into objects of worship and models of absolute Beauty. Needless to say, those times were not very favorable for comic presentation, especially not in Italy. As is well known, in his *Art of Painting* Leonardo recommended confronting the beautiful with the ugly, and he also offered a study with five heads, four of them ugly. Let me quote Hoffman:

> The nineteenth century interpreted their features as the grimaces of madmen, later the classical expression of the central head was recognized, and it was thought to be surrounded by the personification of the four temperaments. When the drawing reached Northern Europe [. . .] it was natural that its inner meaning would be transferred to biblical themes.

We can take it that Hieronymus Bosch knew of Leonardo's study when he painted his "crowning with thorns." In this painting the distortion of the faces is

an expression of the wickedness of the torturers of Christ and is not meant to be comic. We also learn from Hoffmann that the judgment of the "eye of the beholder" will differ depending on the tradition of a "place" and not just on its "times." It is, however, noteworthy, that although the interpretation of Leonardo's heads widely differed, none of the interpreters saw the faces as funny.

I would pinpoint the appearance of the comic image in the sixteenth century. It appears overtly in Italy in the mannerism of Carracci and Arcimbaldo, in the Netherlands with the first great master of comic images (as of many other things) Brueghel, and it appears in the representative genre painters, among them Jan Steen. I will dwell a little on these latter figures.

I must lay stress on the fact that the great career of the comic image begins with Brueghel. He liberated the portrayal of the ugly from its association with wickedness; he was the first to use artistic quotation for ironical presentation; he introduced understanding humor into the portrayal of daily occupations; and he launched biting social satire as metaphor into the world of artworks.

Let me illustrate the liberation of the ugly from its association with wickedness with one representative engraving. *The Yawning Peasant* of Brueghel does not look like an ambitious painting, yet it is a remarkable feast of the changed attitude to life. Brueghel was interested in everything, and nothing remained unworthy of artistic portrayal. Yawning, we know, cannot be portrayed at all under the star of Beauty, because it distorts the face and a distorted face is ugly. Moreover, it is not even representative distortion, for the peasant's face looks different when he does not yawn, the presentation of the yawning peasant is not a portrait, not even a portrait caricature; this particular distortion of the face is generally human and thus not representative of any certain character. Brueghel's *The Yawning Peasant* seems to offer a realistic, true to life image of yawning. The young peasant opens his mouth and closes his eyes. His face is distorted. Yet the distortion is not the expression of his wickedness. He is not a daemon or a devilish creature. He does what all humans beings do; we all yawn. Our faces do get distorted (and not just while yawning). The painting makes a statement: distortion of the face belongs to human condition, whether we are rich or poor, beautiful or ugly. This painting is, in a way, "equalizing," but it is not a death dance. Nothing is more alien to Brueghel than a death dance. He is a painter who loves life, joy, and pleasure, although he does not love men as such. This is the attitude of a true comic master.

Let me emphasize again that in Brueghel all the great innovations look simple. Compare for a moment Archimbaldo's *Four Seasons* with *The Yawning Peasant*. Archimbaldo's comic paintings are lovely, since they are playful. He hits the jackpot in a game when he "portrays" a man clad in an elegant golden garment, whose head and facial expression are composed of fruits, cucumber, leaves, cherries, plums, pears, onions, etc. In this manner he "portrays" Summer, and makes a metaphor appear on the canvas (as we say that summer is coming, as though summer were a person who could come and go). I do not want to belittle Archimbaldo's humorous invention, but it does not open entirely new horizons. Brueghel's very simple statement does.

Quotation of earlier "classic works" in painting and sculpture was a common practice by Renaissance masters. Mostly Greek and Roman models of beauty were quoted. Yet I do not know of any ironical quotation earlier than Mannerism. Perhaps an art historian could enumerate a few cases. Still, when the first, second, or third occurred does not really matter. What matters is that among many other kinds of comic presentation, Brueghel also excelled at the practice of ironical quotation. I will not take sides in the controversy as to whether there are parodistic elements in his Italian landscapes or not. I will refer instead to an obvious and, again, very simple case, the engravings of the Seven Vices.

In Brueghel's tableaus of the seven vices, we recognize, beside the central figure or in the background, the well-known monsters of Bosch, not the men with distorted faces from the scene of the Crucifixion, but the little, uncanny, ugly dream creatures, the zoomorphic dwarfs, the fancy daemons. Brueghel does not simply "copy" Bosch; he quotes Bosch, who preceded him by a half century. By quoting Bosch (the grotesque monsters of Bosch) he changes the way that we look at them. In Brueghel's quotation they appear unconditionally funny. It is Brueghel's intention to make fun of Bosch's monsters. But it is not just Bosch's monsters that Brueghel treats ironically, there is still more to these engravings. The engravings make a pictorial statement. And the statement sounds: the seven vices are funny. This is, however, not a theoretical statement; it is a statement in the spirit of the comic drama of Terence, Shakespeare, and Molière. Yes, sloth, vanity, gluttony, covetousness, pride, and greed are comic; they characterize the comic "hero" of a comic play, and they are comically self-defeating.

Brueghel also employed the religious and pictorial tradition for the kind of presentation which would come to be called "social satire." He fashioned a polemical, satirical, pictorial "criticism" of social inequality and the plight of the poor. Take for example the two engravings *The Rich Men's Feast* and *The Poor Men's Feast*. As Hoffmann points out, one of the customary comic devices is present here, the contrast of the very fat and the very thin. In *The Rich Men's Feast* not only the men are fat, so too are the things, whereas in *The Poor Men s Feast* the men, and the things, are very thin. In the first, a huge woman with gigantic breasts feeds an extremely fat baby, whereas in the second an emaciated woman feeds an emaciated child. In the biblical tradition, as also in the images of social satire from the eighteenth to the twentieth centuries, from Hogarth to Grosz, our sympathies are asked to go entirely to the poor. This looks like the case here too, since the poor look very hungry and fight even to grab their unattractive food, whereas the rich are unhurried and have plenty of delicacies to eat. But this is not entirely so. For there is something in Brueghel's "social satire" which transforms it also into an allegory for the "human condition." There is an open door in both engravings, through which a man is trying to enter. A thin man tries to enter the door of the rich, and a fat man tries to enter the door of the poor. And both are equivalently rejected entry. In my reading, they are both

thrown out. The allegory contrasts too the poverty and the richness of spirit or faith.

Brueghel is also a great master of humorous genre painting. While the engravings *The Rich Men's Feast* and *The Poor Men's Feast* are polemically satirical, Brueghel's genre paintings cover the whole territory from ironical-satirical presentation, on to humorous portrayal. *The Peasant Wedding Feast* (1566) is a typical humorous presentation. Surely, there are crude (but never brutal) faces. The frozenness of the bodies is far from the ethereal or sublime, but it is earthly. There is no contrast between fat and thin, yet the backdoor of the room is also open, and huge crowds enter that door; they are welcome. This is symbolic and not "just" realistic. The celebration goes on in a good mood, and Brueghel shares the mood. In another of Brueghel's genre paintings, *The Dancing Peasant*, we are, again, witnessing a feast. Here the movements and faces are more distorted; some of the peasants look stupid, yet we do not know why. When dancing, drinking wine and becoming intoxicated, people's faces and movements look often grotesque to the observer. This painting is more ironical than the *Peasant's Wedding Feast*; the painter distances himself from the dancers; still, he seems to share their merry mood. If we want to go one step further, we can look at the painting *Schlaraffenland*, the dream of the poor appearing on canvas, where three young peasants lie on the ground sleeping and wait for a cooked pigeon to fly willingly into their mouths. This painting is ironically—not polemically—satirical. The painter keeps his distance from the dreamers; he ridicules their dream, yet with understanding and some empathy.

Perhaps I can sustain my view that Brueghel quite consciously and purposefully began to cultivate—or rather to discover—the power of the comic image, by pointing to two more of his canvases: *The Feast of Fools* and *The Games*. Both paintings depict (and explore) the means of soliciting laughter by presenting something meaningful, perhaps even critical (world upside down) and satirical, with practical jokes, puzzle solving, jongleuring, tightrope walking, or otherwise competing without "serious" consequences. We may at this point recall the brief discussion of games by Kant in the *Critique of Judgment*, where he explains that games, besides music and jokes, allow for the "free play" of imagination.

Brueghel's humorous genre paintings (which excelled as much in the application of colors as his landscapes) themselves became a tradition. In genre painting, it is difficult to tell the "serious" from the "humorous." In some of the paintings of almost every genre painter (greater or lesser) from the Netherlands of the sixteenth and seventeenth centuries, painters such as Gerrit Dou, Gabriel Metsu, Jan Steen, Gerard ter Borch and even Johannes Vermeer, one can detect some humor or irony. Yet among them I only dare speak of Jan Steen as a painter who cultivated humor and irony. He also introduced narrative into his humorous paintings. What ties Steen to the heritage of Brueghel is not just his interest in depicting feasts (he was a publican and an organizer of merrymaking), but his understanding humor for the weaknesses and small vices of men and women, and his sympathy with their good moods. As I said earlier, the great humorous

vein of Brueghel had two sources: his love for life and his skeptical view of the human character. The latter is lacking in Steen's paintings and is often replaced by allegories. For example, in his painting *The Christening Feast*, we again see a merry party, drinking, eating, and generally having a good time at the christening of a baby, yet in the foreground eggs are broken, reminding the spectators and the merrymakers of our shared mortality.

I would dare propose that Brueghel was also the first whose fantasy embraced the existential comic. In the paintings titled *The Metaphor of the Blind* and *The Misanthrope*, he bridged over centuries from medieval themes to modern reflections on the human condition. In the first we may discover our own blindness, and in the second, with the figure of the little village fool who makes a big fool of the high and mighty misanthrope by robbing him of his purse behind his back, we find a wonderful combination of the story about the Thracian maid and Molière's comedy with the same title.

In the Netherlands, painting comic presentations was not polemical, as it was already in Carracci, since the "Southern" cultivation of antique beauty did not there obtain the exclusive status it did in Italy, France, England, Scotland, and Germany. Comic art in the Netherlands was not born as anti-art. It became anti-art in the eighteenth century.

What counts as anti-art and what not, whether all comic images deserve the title anti-art or just some of them, is a controversial issue. If you look at Boucher's *Odalisque*, for example, with her naked buttock, it looks pretty erotically comical. The erotic "pose" and the comic are, in any case, very closely related. But Boucher was not regarded as a comic painter, just as a frivolous one. His paintings were sought after, not judged as anti-art, perhaps on the single ground that something like the not perfectly shapely, but still pretty buttock of a young woman could be closely fitted into the canon of traditional beauty, and in the age of rococo, frivolity was welcome anyhow. And as far as Goya is concerned, only his later works, his dark grotesque paintings (e.g., *Kronos Devouring One of His Children*) are masterworks of anti-art, and certainly not the light, merry paintings of his youth, which remind us of the "island "of Wilhelm Meister, the paradise of Enlightenment fantasy, which was equally welcome by the court and the burghers.

The signature of anti-art is the oeuvre of Hogarth, and he prides himself on this title. The honorary title was, almost a century later, inherited by Daumier, although under his "reign" comic art was transformed from anti-art into art, full stop. During the second half of the nineteenth century, comic images became the legitimate descendants of the Venuses and Madonnas of the past. I mention incidentally (although it would need to be confirmed or rejected by a historian), that in the very times that the comic appeared as anti-art, and in the process by which it became accepted as art, the "comic genres" began their great career in the printed press, where the comic picture, especially caricatures and portrait caricatures, became as important an ingredient of the venture as the comic texts. In the nineteenth and early twentieth centuries, papers had a column for humor,

and humorous images, satirical presentations, caricatures, and portrait carica-
tures often occupied an important, sometimes central role. Such images elevate;
they kill and they make us laugh. Nowadays, as far as the printed press is con-
cerned, political and sexual comic images appear, more directly than ever, at the
center of interest. Anti-art it is no more, yet the degree to which it may still be
considered art remains in question.

In the chapter on the comic novel, I mention that Hogarth and Fielding were
very close friends. At that time, the novel was also considered a kind of anti-art,
a lower kind of entertainment. The friendship between Fielding and Hogarth was
not only personal; they were also allies in the struggle to get the comic genre
accepted as social criticism and subtle entertainment. The English comical and
satirical novel and the comical and satirical images of Hogarth were not just
coeval; additionally they shared an essential passion: contempt for lies in art.
They shared the conviction that writers and painters of traditional styles and
interests, in both epic literature and in the fine arts, artists who concentrated on
the presentation of beauty, elegance, good manners, and refined sentiments,
were simply lying. England is the land of robbers, charlatans, newly rich gigo-
los, prostitutes, corrupt politicians and judges, of madhouses and debtors' pris-
ons. It is the land of covetousness, of miserliness and greed, of luxury and sloth;
it is a paradise for hypocrites and moneybags, and unmerciful to the poor. Ho-
garth—like all the remarkable comic writers of his time—declared that if art was
just classicism, with its classic ideals of beauty (as it was indeed commonly
accepted to be), then he was not an artist, but an anti-artist. The artists of Ho-
garth's time made this statement not just with their words, but in their works. In
Mariage à la Mode, Breakfast Scene (1745), Hogarth introduces us into the huge
saloon of a pair of nouveaux riche and their fellows, and shows the distasteful
and ridiculous art objects placed on the mantelpiece of the fireplace. I would not
say that the comic artists always did justice to the works they treated with biting
irony and parody. *Shamela* did not do justice to Richardson's *Pamela*, and the
wonderful *Beggar's Opera* did not do justice to Purcell's operas. But this is not
my point.

The close relationship between Hogarth's satirical images on the one hand,
and comic novels and the *Beggar's Opera* (one scene of the latter was illustrated
by Hogarth) on the other, is not just of historical interest. It tells us something
about the relation between different arts, between art and literature. Hogarth, the
first great modern master of social satire, was a storyteller. His art of presenta-
tion shows some affinity with movies or with cartoons. His most famous works,
such as *The Harlot's Progress*, *The Rake's Progress* (from which Stravinsky
drew inspiration for his opera) and *Mariage à la Mode* are each a whole series
of paintings. Each series tells a story. The single pieces depict scenes from the
larger story.

This is, in itself, not an innovation. After all, religious painting has always
practiced it, in narrating the life of Jesus or of the Virgin, or of a saint from birth
or initiation until the bitter end. According to Bill Viola, Giotto's frescos in the
Arena chapel are the great works of a video artist, who lacked nothing but tech-

nology. In this spirit we could say that the series by Hogarth are the great works of a cartoon artist, who lacked nothing but animation technology. And although Hogarth's paintings are satirical, and in this respect essentially alien from the tradition of pious stories, they share one thing: the moral. Hogarth has a standpoint and a purpose. He is a moralist, who unmasks immorality by making it ridiculous. And this is not all. The stories he tells are instructive; they also teach morality. Everyone comes to a bitter end: the harlot, the rake, and the rich fiancée from *Mariage à la Mode*. The harlot (Molly) arrives from the countryside, gets accosted in London by a renowned procuress, and the next time we see her (in the next painting), she is dining with a wealthy "friend" in a very rococo suit with a very rococo little servant boy, and she shows her indignation and anger. The next time/painting in which she appears, she is in a shabby room where the police arrest her, and in the next, she is in prison. In the last two paintings, she dies, and no one gives a damn. She is a victim, yet also "guilty," since she did not resist temptation. The "end" of the Rake's progress is not any happier. The rake dies in the madhouse (which was allegedly first "portrayed" by Hogarth). He is guilty and deserves his bitter end. In the paintings *Industry and Idleness*, an industrious young man is elevated to become a respected mayor, whereas the idle man is executed. Thackeray (who wrote a book on the English humorists of the eighteenth century) felt sympathy for the poor idle Tom.

In fact, the narrative comic genres, especially the comic drama, generally have a happy ending, where fortunes turn to the better for the deserving and to the worse for the undeserving or wicked. Hogarth, as a narrative satirist painter, belongs to this tradition. Yet with Hogarth one can also abstract from the story and look at each and every painting as a separate work. This is not difficult, for Hogarth also paints single satirical scenes that have no sequels. If we abstract from the narration and the moral, then we can look at Hogarth's painting from a different, perhaps opposite, angle. Hogarth would then be not only the first master of social satire and polemical irony in painting, but also the first master of the comedy of manners in painted images. The comedy of manners is also the critique of manners. Yet it is not necessarily biting or satirical. Let us cast a glance at the pair of paintings *Before* and *After* (1730). The first scene shows a man and a woman before sexual intercourse, the second after it. A painting of Amor is hanging on the wall. In the first scene the young man kneels before the woman and grabs her clothes; in the second, the woman kneels before the young man and grabs his clothes. We find the symmetrical reversal of the relationship funny, because it is presented as the symmetrical reversal of positions (standing versus kneeling). In this painting (perhaps in contrast to Boucher's frivolous lady with the naked buttock), we are aware of the humorous, ironical message of the presentation, yet we need not seek any moral in those pictures. Their humor (erotic humor) lies in the presentation itself: the asymmetrical social relationship between the sexes, as regards the needs and pleasures of sexual intercourse, is presented precisely through the symmetry between the two paintings. The reversal of the kneeling/standing position, and the reversed act of grabbing, express the asymmetry of desire between men and women. This type of reversal in

erotic/sexual relationships will be typical of the so-called comedy of manners and of the comic opera. Mozart's *Marriage of Figaro* or *Don Giovanni* come immediately to mind. One can also look at the first four paintings of *The Rake's Progress*, to see in them the funny image of the comedy of manners without lessons.

The comic effect of Hogarth's paintings and engravings is produced by the presentation of a comic situation, and the characterization of the major figures in the comic situation. There is exaggeration in the portrayal of facial expressions and movements yet it very rarely becomes a massive distortion of proportions, either of the face or of the body. When Hogarth paints distorted faces, which he sometimes does, he does it "realistically," as in the presentation of a laughing theater audience or of common people drinking beer. He also paints portraits, but none of them is a portrait caricature. I would say that the pictorial humor of Hogarth is of a "literary" character even in his non-narrative works.

In the brief discussion of Hogarth in his book *Art and Illusion*, Gombrich (in his 1972 *Art and Illusion: A Study in the Psychology of Pictorial Representation*) calls to our attention the idea that Hogarth was not just an anti-artist or a critic of "beautiful art," but that he could also mobilize irony. On the title page of his book on perspective, Gombrich notices, Hogarth places a drawing with false perspective, the imitation of "bad painting." Hogarth also wrote a book on beauty, in which he set down some rules for beautiful presentation (not for the idea of beauty), which are more technical than philosophical in character.

In the century following Hogarth, critical and social passion, not hatred, fueled and inspired the creation of the comic image. Since I am not writing a history of comic painting, and must at least try to discuss only one figure for each type of comic representation, I need to neglect minor masters. Between Hogarth and Daumier, an entirely new kind of comic imagination appears, I believe, only in the works of Goya. Although in Goya's gigantic body of work, comic painting takes up only a small space, it is a unique one, but one not without a certain tradition in the European dream-imagination.

I say dream-imagination, because contrary to the down-to-earth presentations of Brueghel, Steen, and Hogarth, with Goya we are returned to the world of Bosch by another route. The nightmares of wickedness, evil, and the daemons of the underworld reappear in Goya. His presentation is dreamlike, his associations surrealistic, his horror great. Yet we have already encountered daemons, zoomorphic creatures, and mythological horror in Bosch. I have already said that I believe that Bosch did not mean to portray these daemons as comic, for he did not perceive them to be comic. He believed in them, in their existence, power, and destructive influence. This was a common belief, a belief of his age. The daemons were the daemons of the medieval Christian world, the nightmare was a shared nightmare; only its presentation was a personal one. I make mention of Brueghel's citation of Bosch's monsters in his engravings of the Seven Vices. He quotes Bosch, but he does not believe in Bosch's monsters, or in the terrifying power of vices. Vices are not sins, but human shortcomings, ridiculous and self-defeating, and perhaps, up to a degree, corrigible. In the Hogarthian

universe of a despicable, unjust social world, nothing was meant to be horrible outside of the human world. The commonly experienced life in the city of London was a dirty comedy there for everyone to see.

Not every kind of terror is daemonic in Goya's presentation either. In many drawings about the cruelty and suffering of war, albeit with several sadistic scenes depicted with, perhaps, too much gusto, there is no sign of a satirical, humorous, or even an ironical mood. It is only in Goya's personal nightmares that the daemons return–daemons with distorted faces, with crippled or zoomorphic bodies, daemons who are not just ugly in a traditional sense, but who laugh at us, ridicule us, and make fun of us. These paintings are uncanny; they are very similar to some works of existential comedy two centuries later. Yet in the painted images of Goya, in his existential comedies, if I may say so, there is no solace, no sentiment, and no rationality. His is the entirely irrational diabolic universe, ironic in the Romantic sense and in the double meaning of the world. There is no identity in this universe, nothing solid, no foundation; all men are monsters, yet we do not know who is who among these monsters. The daemons or monsters are bestial. We have entered the bestiary. There is the terror and anxiety of the nightmare painted in dark colors. In comparison to the existential irony of the old Goya, the paintings of Daumier look like child's play. But they are not child's play.

Goya's grotesque and uncanny paintings must also be described as anti-art. They are polemical against the beauty in art, and among other things against the presentation of beauty in his own youthful work. The turning point of the anti-art tide will be in Daumier. It is in Daumier's oeuvre that anti-art is finally assimilated as art. And I must repeat that after Daumier, the comic image will begin its great and then still unforeseeable triumphant march, which is still going on now.

Counter-art is not provocation. It is critique, rejection, negation, disgust, moralizing, and in Goya's case, it is also hatred. Daumier is the provocateur. He provokes, yet he will be "assimilated." We are in the midst of the modern world where, to speak the language of Hegel's *Phenomenology*, reconciliation comes about via negation, with, that is, some provocation. Perhaps this cannot be said about everything, yet it can surely be said about the world of modern "high art." Daumier ends his life not just as a subtle entertainer, a social critic, and a polemicist, but as the author of a polemical, critical Art, with a capital *A*. An artist proud of his marginality will open a new path to the center. One who made thousands of cartoon lithographs but few paintings was soon to be followed by mainstream painters like Degas (who collected Daumier), Toulouse-Lautrec, and Seurat, and later by Severini and Leger. It is on the canvases of these latter painters that humor or the comic and beauty will ultimately merge.

In Daumier, everything is sucked in by the image. It is not the story that inspires the picture, because the picture itself is the whole story. Daumier's vision is comic, ironic, and satirical. He presents in his paintings and drawings all the

attitudes and variations of the comic genre, such as light humor, humorous irony, biting irony, satirical and polemical-satirical presentation, caricature, parody, parodistic presentation and portrait caricature. His works can be realistic, surrealistic, or allegorical. Anything and everything can become the butt of his humor.

His famous lithograph of Don Quixote and Sancho Panza is a "portrait" of the two main characters of Cervantes. It is not a caricature, but a portrait. It says: look, thus they are! It is the faithful portrayal of two comic figures, who are not comic in their own eyes. All the comic "tricks" are applied in the painting, such as the contrast between the tall and the small, the thin and the fat, the horse and the donkey. Still, the face of Don Quixote is sad; he is not laughing; he has a painful and dignified expression. It is traditionally accepted in the Daumier literature that the painter painted himself as Don Quixote. He did not identify with Don Quixote externally, but with his position as marginal, outsider and idealist; a fighter of windmills. This—in my mind fine—observation, however, changes the perspective of the spectator. If Daumier identifies himself with Don Quixote, then the painting becomes more than a mere portrait of fictitious characters; it becomes an ironical presentation of the painter himself. Not just the figures, but the painter himself appears in a comic light. This irony, however, is not biting; it is mild; there is love in it. The light, shining colors of the picture, the colors of hope in the medium wherein the two figures are somehow melted, confirms this love.

Daumier's *Pygmalion* is, on the other hand, an ironical parody, and also a palimpsest, which catches the moment when a model—a very much alive model—turns towards the astonished painter. The picture follows the joke logic of association. We expect one story: the sculptor falls in love with his statue, which becomes a woman; yet we get another story, about a sculptor who has seen in a living model only the statue he was sculpting, and is astonished that she lives at all (then obviously falls in love with her). The picture is the parody of the legend, and it is also an ironical portrayal of artists, himself included.

In going a further step away from the loving-humorous, and towards the satirical presentation, we find works like *The Orchestra During a Tragedy*. In the foreground, we see four players of the orchestra, one of them yawning, two of them seemingly already asleep. The scores are before them, yet obviously they have no role to play in the scene on the stage. We see the stage from their perspective, that is, only the lower halves of two bodies are visible, one of a man, the other of a woman. They are dressed in period costumes: perhaps they are doing Racine or Corneille. On the stage, a tragedy unfolds, passions collide, and people are destroyed, but in the underworld of the orchestra this is just daily routine, tedious and boring. One can rarely see a picture which tells so many things at once, with so few strokes. It can hardly be seen as a parody or as a caricature (of what? we might ask) but as an ironic/satirical presentation of the "relation" between art and its recipients, between the world of spirit and the everyday world. It is not just the image of *vanitatum vanitas* (all your passions are wasted, you are tedious) but also a picture of the paradox of acting. The

passions on the stage are not the passions of the actors, but of the roles they are playing, thus the yawning in the underworld is not entirely unwarranted, because the musicians' role is just playing the scores. Both the musicians and the actors are simply paid professionals, they do their bit, and what others do is not their concern. One could tell several stories about the picture which would explain what all of them are doing with a few strokes.

The Print Collectors, however, is a caricature. It is a subtle caricature. The caricature-effect is not reached through the distortion of proportion. By this I do not want to say that portrait caricature through the distortion of facial proportions is an inferior genre. If the artist succeeds not just in pointing out the likeness, but in making us see on a face the character traits of the model which were hidden before our eyes earlier, portrait caricature can be a great achievement. I only want to say that in this caricature of Daumier, *The Print Collectors*, the caricature-effect is reached in another way. We see on the picture two obviously wealthy gentlemen looking at prints in a gallery, selecting among them the ones they want to buy. One is sitting, the other is standing. The way they touch the album of prints and the very way they look at them expresses their merely pecuniary interest. Perhaps it is a caricature of two real people, but I think it is a caricature of the commercialization of art. Daumier was after all Balzac's contemporary. The picture is not a friendly or humorous caricature, but a satirical one.

The Triumph of Menelaus is a biting satirical parody. It is a parody of a well-known mythological "hero" of Homer's *Iliad*, a biting satirical pictorial comment on heroism in general, and on heroism in war in particular. It is a political statement in Goya's spirit, drawn with a righteous and poisonous pen. Menelaus marches proudly on the battlefield, his sword drawn. Around him lay scattered corpses, burning houses, a cloud of smoke, an emaciated, lonely horse. Menelaus is fat, his belly nakedly protrudes, and he steps as a ballet dancer on his toes. He has a woman by her arm. The woman walks behind him; she is ugly, round-faced, and is thumbing her nose at him behind his back. The contrast of the two clownishly comic figures and the devastation around them; the contrast between the ugliness of Menelaus (drawn also with disproportion) and his self-indulgent manners and gestures; and the contrast between Menelaus and the woman making fun of him behind his back all together make the parody biting, satirical, polemical, and political. Once again, a few strokes of the pen can create a world.

At one of the extreme poles of Daumier's comic genius we encountered Don Quixote and Sancho Panza, portrayed with loving humor, at the other extreme pole, that of the biting satirical political statement with no parody. The latter can also be exemplified with *Council of War* (1872). One sees a door with the inscription "Conseil de Guerre," and before the door, outraged skeletons are storming the house as if it were the Bastille of 1789. Among them, there is the skeleton of a child, a woman and a beheaded man, and one skeleton, the tallest, points his finger at the door with the gesture of accusation. The allegory is as obvious as all allegories are: the victims of war are accusing those who sent

them to the slaughterhouse. Does this lithograph still belong to the comic genre? I leave the question open. Yet if the old Goya's nightmarish visions have some affinity to dark comedy, if Beckett's *Endgame* has comic aspect, why not this lithograph of a comic artist? One could even add that the medieval "death dance" was also in a way comic. Or that in Mexico, on All-Saints' Day, skeleton toys are sold in the market, while in the street, images of death (the symbolic Skeleton) are celebrated and become the playthings of children. Yet this lithograph is different. Its skeletons are not allegories of death, but of violent death. We can laugh in the face of death, not in the face of violent death. It is not the skeletons whom Daumier treats with satire, though, but the inscription of the door, Council of War. Where is the war council? Inside or outside? Are the skeletons not the war council proper? If seen from this perspective, one can include this lithograph in Daumier's comic art, as the extreme embodiment of its darkest side.

Since I have mentioned children's play I can immediately add "children's books" to the discussion, this time not in Mexico, but in Europe, and specifically in Germany. In Daumier's times, comic picture books were favorites of children. I mean first and foremost *Max und Moritz*, on the one hand, and *Struvelpeter* on the other hand. Both are narrative picture books, wherein the drawings are eminently funny. Things behave like people, and people look like puppets; the world is constantly turned upside down. Never before or after did children have more original works of art in their hands. By now Busch, the inventor of *Max und Moritz*, is regarded as an eminent caricaturist, and in Frankfurt there is a whole museum just for the cult of *Struvelpeter*. But do we remember their stories? Max and Moritz, the bad boys, are ground up in a mill, while in *Struvelpeter*, in each and every story, the main character meets a bitter end, once because he refuses to eat soup, other times because he always looks up at the sky instead of looking in front of him (just like Thales) and so on. Are they sadistic, or just funny, satirical, and parodistic stories? I think that they are great fun and belong to the classics of the comic genre.

In the twentieth century, from expressionism, dadaism, and surrealism onwards, there are so many comic artists and superb comic paintings, photographs, lithographs, and more, that I now need to take a different approach in discussing at least a very few of them. I will take roughly one single work for the exemplification of each and every attitude, genre, and sub-genre. Since I will discuss only works which are obviously comic, which were meant to be funny statements, jokes, farces, parodies, etc., I need to first say a few words about artists whose oeuvre is not "obviously" comic, but who still represent two of the essential attitudes in comic art: irony and humor. I have in mind Picasso and Chagall. My choice can be seen as arbitrary; after all, many painters besides Picasso excelled in irony, and even more besides Chagall excelled in humor. Yet my selection is still not arbitrary. I think, namely, that almost the whole oeuvre of Picasso is ironical, and almost the whole oeuvre of Chagall is humorous. Had I selected, e.g., Klee for "humor" or "irony," I would have to add immediately that he ex-

celled in both and that in addition he also painted satirically, as in his etching *Two Men Meet, Each Supposing the Other to Be of a Higher Rank* (1902), a typical social satire. And in Klee's illustration of Voltaire's *Candide*, he faithfully translates a comic novel into the language of images. The choice of Picasso and Chagall should allow me to make my points most precisely.

Picasso is an ironic painter in the sense that the Romantics understood irony. He depicted a world of marginal and/or multiple identities almost throughout his whole lifetime, and in all his styles (with perhaps the cubist episode excepted). In his youth, Picasso still worked in the style of direct representation: he painted clowns and fools, and sad and suffering jokers. He never entirely abandoned direct representation (see his statuettes of donkeys), yet he did leave behind the traditional topics of direct representation, such as clowns, prostitutes, dancers, jongleurs, the circus, animal tamers, etc. Needless to say, I do not want to belittle either the comic message or the beauty of humorous or ironic direct representation on the canvases of Toulouse-Lautrec, Degas, Seurat, and others. Neither do I want to follow a quasi-historical sequence. In 1923, for example, Francis Picabia painted his wonderfully humorous parody *Dresseur d'animal*, in which the animal tamer, who looks like a Greek statute in black with a Cyrano nose, is in the process of taming his animals, four dog-like creatures and an owl, who look as if they were painted by the hand of a child.

But Picasso's great genius lies in the invention of dreaming multiple identities indirectly into the canvas, of reversing the signs of the "world" and the "eye." Thus he almost always paints traditional "topics" such as portraits, bathing women, lovers, naked girls, musicians, still-lives, etc. The images of these traditional "topics" will be distorted, not because Picasso decided to make fun of them, but because he sees the world itself as distorted, and so depicts the distortion faithfully. This is what I call "constitutive irony." The irony is in the world, not brought into it by someone's regard. And the painter's eye does not revile this everyday world; he does not conduct polemics against it, nor does he treat it with biting satire. Sometimes the ironic world is portrayed with understanding and empathy, sometimes with distance, and sometimes with fun and laughter. But the world remains ironic in its constitution. I would stress that constitutive irony is not identical with constitutive surrealism. Constitutive surrealism (which I will come to shortly) follows dream logic, either as joke logic or as nightmare logic. Picasso is a playful painter, but he is rarely a joker. And he is also an instinctive, spontaneous painter, a "natural" genius. His ironical art is less philosophical than that of Duchamp or Magritte, for example. On the other hand, although he can put terror and suffering on the canvas, those paintings are not at all funny. *Guernica* is not funny, and cannot even be seen in a humorous way. The distortions of these paintings differ essentially from the kinds of distortions we encounter in Picasso's ironic works. Not only are the proportions of the body or the head distorted, not only are people pictured as geometrically constructed puppets, but here their limbs are entirely disjointed because their bodies are torn and blown apart. One associates *Guernica* more with the "tearing apart" of the body of Osiris or Dionysus than with the girls with three noses.

I mention that I would hardly count Picasso's cubistic period in his comic oeuvre. Yet the techniques of cubism became perhaps the most important artistic vehicle in his ironical presentation of the world. Look at his portrait of Dora Maar, his lover. She is portrayed with two noses, with a geometrically distorted face, and still she is beautiful. Only we see that the painter does not know exactly who she is, and that he cannot, for she is not what she is. I refer the reader to one of Ionesco's comedies, where the young man wishes for a wife with three noses, and, in the end, compromises with one who has only two. This theatrical farce tells a very similar story. Who cares about a woman who is entirely self-identical? To return to Picasso, there is no mysterious secret in *Dora Maar* (as, perhaps, in *Mona Lisa*); it is not the hidden essence which appears in the image of a geometrically distorted face with two noses. Rather the uncertainty of identity, the ambiguity emerges. Or, to express myself in another way, it is not the soul that is torn, but the identity. Although the *Weeping Woman* (1937) was painted around the time of Guernica and gives the impression of deep sorrow, it is as I see it, in contrast to *Guernica*, an ironical painting. The face (painted in white, green, and yellow) expresses despair and sorrow, but the hat! The tiny elegant red hat decorated with an artificial blue flower is in such an extreme contrast to the distorted, weeping face, that we are immediately hit by the feeling of ambiguity and distance. Is this lady perhaps only blackmailing her lover with her tears? Or is she the mother of an innocent victim? The painting's objective is, if I may say so, to leave us, spectators, filled with the feeling of uncertainty and unease. What is true about faces is also true about bodies, such as in the case of *Les Mademoiselles d'Avignon*, and such is also true about Picasso's still-life paintings. The tables, vases, flowers, fruits, etc., these very traditional paraphernalia of the genre of still life are distorted, both in their proportions and relations. Take for example *Femme aux Tulipes*, where the woman is but a parody of a Greek bust, standing on books and the little legs of a table—beside a basket of tulips—where nothing could stand at all, because it is blue paint and not a table. That is, Magritte's wonderful philosophical joke is not a joke here, but an ironical presentation. Picasso does not paint a table with the inscription that it is not a table; he paints a table which is not a table. All items in the picture wear bodily the spirit of the world, as they always do, and in Picasso's case, this makes for constitutive irony. The woman is not a woman, she is a distorted Greek bust; the table is not a table, but blue paint, and still, the woman is a woman and the table is a table. And, again, just as in the case of his portraits, the ironical presentation is also beautiful.

It is needless to analyze even one single painting from Picasso's "classic" period in order to perceive the work's irony, although the techniques of ironical representation are entirely different there. With the classic pieces, we encounter palimpsest, ironic quotations, parodistic representation, and of course, the distortion of proportions. Also these works are, or at least can be, perceived as beautiful, and I stress again that Picasso's constitutive irony does not abandon beauty; it does not even conduct polemics against the beautiful, but presents it as it is, and as it can only be in the modern world, without lying.

Similar things can be said about Chagall in the first period of his artistic production. Similar, but not the same things. Picasso's oeuvre is ironic; Chagall is a humorist. I do not want to overstretch my Kierkegaardian interpretations. Still, I sometimes like to play with the thought that Picasso's art unfolds in the sphere between the ethical and the poetic, while Chagall's art develops between the religious and the poetic. This would not be due to the themes of their representations, an obvious but cheap approach, but due to their expressed artistic imaginations.

The most representative paintings of Chagall are dreams of happiness. There is the town, Vitebsk, with its little, clumsily drawn houses, looking as if they were tipsy and made with a child's unskilled hand. It could also be a miniature model of a city, not in order to be built, but in order to be remembered. Among the papier-mâché "model" houses there are old Jews in caftan, young Jewish boys with side-locks, also to be remembered. The dream is a painted reminiscence, yet also painted expectation. The tension of these two presents, among other things, the humorous effect. You see the calf in the cow's womb (see the invisible future), as you see the two betrothed flying above the town (see the impossible). The motif of flying, which also appears frequently in Ionesco's half-comedies, is the symbol (not the allegory) of redemption and also of sexual intercourse. The promise of the happiness of redemption and of intercourse, of the unity with God and the unity with the beloved, is represented by the flying lovers.

The vision is lovely; it is warm, merry, sublime, and pleasing to the eye and to the heart. The painting smiles at us, and we smile back at the painting. Yet the humor is constitutive. For the dream of happiness is a dream; it is painted as a frozen moment, as the unreal reality. All dreams are personal and unshared, as Heraclitus remarked a very long time ago, and if presented to unconcerned others, they become either horrifying or humorous. Nightmares on canvas are horrifying, dreams of happiness on canvass are humorous, and puzzling dreams are jokes.

Let us cast a brief glance at Chagall's painting *Above the Town* from 1915. Above the tiny houses of Vitebsk, a young woman and a young man are flying, in a very funny position. The woman looks taller than the man, and she flies in the lap of the man, like on a pillow, relaxed. The young man puts one of his hands on her breast; one of his legs is hanging downwards, in an obviously uncomfortable position, and the other leg is unseen; probably it is behind the woman's long dress, but perhaps he has none. The position of the flying pair looks odd, although for them it seems natural, since they are the dreamers of the dream. The spectator shares the regard of the painter. What is presented as humorous is received with a kind of humorous satisfaction, certainly due to the pictorial presentation of the dream. The dream of happiness must appear in bright colors, as beauty, painted with love. For beauty, happiness and love are again one.

Most of Chagall's canvases are painted with understanding humor and love, since they are inspired by the double sense of flying. Whether there are flying pairs actually painted on the canvas or not is almost irrelevant.

I cannot even superficially discuss the kind of portrait caricature which became a special skill of professional caricaturists. There are some excellent caricatures of a few representative politicians, renowned persons, and cult figures, and since we live in the times of universal commerce and democracy, any of us can get a likeness drawn for a little money. Whether it is meant to be a caricature or not, it will be one, not necessarily the caricature of a person who can recognize himself on the paper, but a caricature of the portrait. There is bad art, and this is an example.

Yet modern artists also painted complex portrait caricatures. I would exemplify this with Otto Dix's portrait of *The Businessman Max Roesberg from Dresden*. The title of the painting suggests a palimpsest. Why does Dix indicate the profession of Max Roesberg in the title? The picture itself gives the answer. It is a palimpsest of Holbein's painting of merchants. As in Holbein, here too, the things which characterize the occupation of the businessman appear on the canvas as allegories of the profession. Yet contrary to the pomp and colorful, decorative lifestyle of Holbein's merchants, this painting suggests the spirit of capitalism à la Max Weber: frugality. The suit of the businessman is grayish blue; it fits the profession, yet nothing is personal, and still this professional suit is painted with the greatest care. The wall is painted in grayish green. There is a clock and a calendar hanging on the wall. No painting, no photograph (we are in 1922!), no flower, nothing of beauty. On the writing desk sits a telephone, a used map, an inkstand with ink, and before this "utilitarian" table the gentleman stands. He is the embodiment of professional frugality. From his thin body, which looks more like a broomstick than a body (it is after all a caricature) his face protrudes, with clever, curious, suspicious eyes. The face is distorted, yet not in a conspicuous way, for the proportions are not essentially altered (as for example in several caricature-like presentations by Dubuffet), only, perhaps, the ear. Yet the whole face (except the eyes) looks like a mask. This painting is not just the caricature of a man, but, as palimpsest, also the caricature of a profession; of its empty, pedestrian, utilitarian, functionalist reality, of the "disenchantment of the world."

I ventured to call Dix's portrait a palimpsest. Palimpsest is widely practiced in modern and postmodern art, in painting as well as in literature. Many paintings which I will briefly discuss are also palimpsests. However, to keep some order in the jungle of modern comic art, I will arrange my discussion around the central topic "Critique of Art." Although very different comic approaches and sub-genres can be discussed by unpacking this basket, not all of them are in the basket. All the paintings, sculptures, photographs, and videos that can be placed in the "critique of art" basket are playful. Their seriousness, even their sarcasm is playful. They make us laugh. They can be jokes. They question themselves.

Finally, they are not always, but usually, also philosophical. They have a "text," not necessarily written de facto on the image (as in Magritte) but, nevertheless, incorporated in the image. Dark humor, the direct presentation of the uncanny, the monstrous, the terrible, and the grotesque are all such incorporations. In some paintings by de Chirico or Dali, the uncanny or monstrous is represented indirectly, not as grotesque, but through the combination of allegories or symbols, which call for description, if not for a full story, and have some affinity with the playful. In this respect there is some similarity between their comic or almost comic art and the plays by Ionesco.

Both modern paintings I chose to illustrate the genre of uncanny grotesques are, for simplicity's sake, palimpsests. From Francis Bacon, let us consider *Pope I* (1951), instead of the better-known *Study After Velazquez: Portrait of Pope Innocent X*, because there is no allegory here, no obvious and indirect reference to horror as in the earlier work. Whether this Pope is painted "after Rafael" or "after Velasquez" is of no importance. It is a Renaissance painting of a body, with a telling difference: the hands are asymmetrical; the right hand resembles a bird's claw. From the overly broad neck grows an entirely distorted face. The mouth (if it is a mouth at all) seems both cruel and suffering. We do not know which, perhaps both, as in Dostoevsky's grand inquisitor. The eyes somehow squint, and look at the spectator with an inquisitive gaze. The purple head-covering is painted as if it were a fool's cap. With this headwear the cruel/suffering pope looks like a clown. A suffering clown or a cruel clown maybe, but a dangerous clown. All this gives the painting an uncanny optical effect. This painting is not grotesque, but dark and disturbing.

Even more disturbing, although grotesque, is the painting by Pierre Bettencourt, *La Bouchée* (1963). The picture is a palimpsest of Goya's *Kronos Devouring One of His Children*. One face covers the whole canvas. It is a mask-like face, just like the face of a pagan god. It is not a Greek face, not an elegant face, but a brutal and at the same time essentially indifferent face. In the mouth of this god/beast we see a small creature painted white, which indicates here too, as it usually does, innocence. The monster does not swallow the creature, but keeps it between, and grinds it with, his big, even, and carnivorous teeth. The small, white creature, a fainted or already dead victim, whose pain-ridden face (in contrast to Goya's painting) can be seen, is a girl. In fact she is a woman, or a beautifully proportioned female body, or a corpse. The palimpsest thus translates one myth into another myth. The myth of a father destroying his son, becomes the myth of a man destroying a woman, this time naturally, with the utmost indifference, as if it were the nature of things. Still, this horror looks also ridiculous. Not just because of the obvious change of proportions (a huge face, with a puppet-sized female body), but also because the face is a mask; it is unreal. Goya depicted the myth in a literary sense, Bettencourt transposes a sad but everyday occurrence into a myth. And both are grotesque.

Modern artists make fun of the world of art and make fun of the world with art. They play with dreams and dream of playing on the canvas in thousands of different ways. They invent jokes. Comedies and comic novels have always been inspired by philosophy, they were always philosophical. This philosophy was never Platonic, because Platonism (I do not mean the man Plato, obviously) did not understood humor. It would be difficult to single out one particular philosophy as the main inspiration for comic literature. If I had to, I would name rational skepticism in that regard. The comic genre allows for the relation to transcendence—this is one aspect of constitutive humor already in Plato, although not in popular Platonism—but it has nothing to do with metaphysics. Sure, there was a direction in modern art which defined itself as "metaphysical painting," but the word "metaphysical" stood for "mystical" there. One needs only to cast a brief glance at Carlo Carra's otherwise also humorous painting, *The Metaphysical Muse*, to see that it has nothing to do with metaphysics in the philosophical understanding of the word.

To refer once again to Belting, creative arts, painting, and sculpture were inspired by Platonic metaphysics for a long time. During that time, the comic genre could appear only on the margins, or when it was present at the very center, it was not acknowledged as such. Yet in the times of the deconstruction of metaphysics and of Platonism, in the age of the "Twilight of the Idols," the comic genre could move from the margins to the center, and could be inspired with all kinds of fragmented philosophies, personal philosophies included, rational skepticism being just one of them. All the philosophical doctrines that the comic novel made fun of are finally also ridiculed in comic images: the ideas of an ordered world, of fulfilled expectations, of the external which faithfully expresses the internal, of well-founded knowledge, knowledge of oneself included, of certainty, of everyday reasoning, of the unity of the good, the true, and the beautiful, of unreflective beliefs, of totality, of wholeness and holiness, of the unconditional—all become the objects of imagistic comedy.

In order to introduce some kind of order, I will present the paintings and photographs I want to discuss in the following way: 1. Making fun of art critics and of interpretation; 2. Making fun of the standard of Beauty; 3. Making fun of the religion of Art; 4. Making fun of the relation of the sign and the referent, and of the concept of and belief in "representation"; 5. Making fun of the traditional logic of painted images; and 6. Making jokes in "pure" fine art.

I must admit that since the material here is practically infinite, my choices may seem entirely contingent. Although entirely contingent it is not, up to a point, once again, it is. I will write only about paintings that I have seen and that made a strong impression on me. The latter is a matter of taste.

Making fun of art critics, art writers, art merchants, and art patrons has its own tradition. The artwork itself has to cheat the eye. The regard of the pompous, self-assured, knowledgeable assessors of artwork has to be ridiculed by the artists. One can do this by painting a *tromp l'oeil*. But the most widespread practical joke is to present the "critic" with a fake as if it were an original, let it be acknowledged by him, e.g., as a Greek statue, and in the end, enlighten the

art-world and the public as to the truth of the matter. These kinds of practical jokes are no longer on the agenda. From the twentieth century onwards, art-works made fun of art critics in a more direct way, by putting the critics' "ideas" about true art or true criticism on the canvas, and ridiculing them. One can ridicule art critics satirically, ironically, or humorously. Even more than modern comic pictures in general, paintings making fun of art critics are textual, reflective and sometimes even narrative.

The well known photomontage by Raoul Hausmann (1919-20) illustrates the satirical polemical style well. As a dadaist and a subversive artist, Hausmann merges the satirical presentation of the art critic with social criticism or social satire. The art critic whose head occupies the center (the small body is glued to the head) sees through someone else's spectacles; his ugly open mouth makes bare biting teeth, yet the other half of his mouth is entirely toothless. There is a banknote glued to his brain, another to his neck. He holds a Venus pencil in his hand, and two names (one of them of George Gross) are written and on his suit and crossed out. The message is obvious: the art critic, the agent of capitalism, lionizes Venus and kills "alternative" artists. He does not look at things with his own eyes; he bites, yet he has also already half divested his power.

Mark Tansey's painting *The Innocent Eye Test* (1981), is less ambitious and more humorous. Its lesson is not thrust upon the spectator. The painting shows a museum, where a new acquisition (or a newly painted canvas) is just being unveiled to patrons or art critics. But their opinion is not what matters. The painting, which presents two cows in a meadow, is to be judged by the "innocent eye," the eye of a third cow. The painting makes fun of the opportunism of art critics, who have lost the courage to present a standard themselves, and who accept that self-complacent attitude of ignorant fools: that the real eye is the innocent eye, the eye that cannot compare, because it has not seen any other painting. Moreover, only the eye of someone who is like the one in the painting can assess the quality of the painting. One of the "ideologies" of modernism is ridiculed here, without hatred or polemics, but in a joke-like manner.

Since for a long time three works embodied the standard of female beauty, a kind of competition developed between palimpsests painted on the "theme" of *Mona Lisa*, the *Venus of Milo*, and the *Sistine Madonna*, but especially on the first two. Duchamp, who as in much else, also spearheaded a new vision with his *Mona Lisa with Moustache*, followed this work with other parodies or caricatures of Mona Lisa and of the Venus of Milo, and was followed also by several others (among them the Mona Lisa caricature by Botero was already briefly discussed). Yet not only classical ideals of beauty deserve a parody or caricature; so do the beauties of popular culture. They are also cult figures. Andy Warhol, who also painted a Mona Lisa parody, treated Marilyn Monroe in the same way, and not only in his 1976 screen-print on paper, where the open mouth of the actress painted in "rouge" gives the image a comic character, but also in the canvases of "multiplied" Marilyns which look just like the multiplied Mona Lisas. Himself an artist of the age of mechanical reproduction, Warhol not only expressed, but also bracketed, packaged, and ironized the spirit of reproduction.

As far as reproduction is concerned, there is, indeed, no difference between Marilyn and Mona Lisa; both are postcards for mass distribution. *Ready-made Bouquet* by Magritte selected another "beauty model" for humorous treatment, the *Allegory of Spring* by Botticelli, which happens to be exactly copied on the back of a man's black coat, pictured walking in the forest during springtime (1957).

Making fun of the standards of beauty is not restricted to ideals of female beauty such as Mona Lisa or Venus or Marilyn Monroe. Parodies of traditional ideas of beauty expand to the whole field of the "sublime." Everything "sublime" can be exposed to parodistic presentation, mythologies included, and they are in works by Beckmann, Dali, and especially de Chirico. In the latter's *Hector and Andromache Before Troy* (1968), we see the most sublime "pair" of Homeric poetry, in the most sublime moment of their kissing farewell before Hector's death. And what we see are two wooden figures painted on canvas in various shades of brown color. Instead of heads, egg-like wooden things sit on their wooden bodies; they have no faces, although something (two lines and two points) indicates the place of a face. They are surrounded by scaffolding. The mythological figures thus look entirely artificial; they are not alive, or of flesh and blood. This parodistic palimpsest is more than a palimpsest. It is also the parody of Love.

And there are humorous, merry parodies too, such as Niki de Saint Phalle's colorful statue *Temperance no.14*. As in Magritte's *The Ready-made Bouquet*, here too an allegory becomes the butt of a joke. This Temperance is a huge woman, with big legs and arms, immense breasts, and is clothed in a mini-dress from which her breasts protrude. She has two wings which look like chocolate cakes, and she is merry, although she has no face. She is obviously dancing, standing on one leg. This Temperance in not the reversal of Virtue; she is not Intemperance. The girl is someone who does not give a damn about the traditional models of virtue, but she does not suggest that their contraries would be a more real virtue. She does not teach us anything; she is simply happy and alive.

One cannot make fun of the religion of art without making fun of the institution of art. The "classic" flip is exemplified in a practical joke by Duchamp. *The Fountain* (in its first telling in 1917), was a piece purchased by the artist from a plumbing supply store and sent—signed as Mutt—to an art exhibition. This piece tells the whole story. Duchamp's practical joke was a philosophical gesture. The gesture suggested that the main question was no longer "What is Beautiful?" but "What is art?" and "What makes art an art?" Perhaps here, for the first time, an essential question raised in art, about art, was raised in and through a practical joke. Since Duchamp—at least until the emergence of a distinctly postmodern perspective—the same question has constantly been raised. By now it has become a marginal issue. It is no longer really worthwhile to make fun of the religion of Art, given that the universal concept of Art has already withered, and "paganism" in art, a certain denial of the very existence of high art, has replaced it.

Lately, comic images instead make fun of certain "prejudices" about representation and also about the idea of representation. Gilbert and George especially excel in this play through images, for example in *Hands Up!*, where six young men are sitting and standing, behind them three big hands painted on the wall in white; or in the photo *Thumbing* (1991), where two men (the artists) are seen positioned with a green apartment house in the background, both of them thumbing at something. Who or what are they thumbing at? Evidently at the idea of the "perspective," for there is none (in a photo), or at certain ideas about art, we may guess, or about photography. But we can only guess.

I have arrived at the last three issues in the series of "making fun of art": the issue of the critique of representation, the issue of art logic, and the issue of the pictorially embodied jokes. All three issues can be best exemplified by looking at the work of Magritte. And not only by his work. If we accept the bisociation theory of jokes (as I did) one could offer wonderful examples of jokes in images by other artists. I choose randomly jokes made by painting a man's suit. In the *Felt Suit* by Beuss, for example, the suit is presented not on the body but on a hanger. Even more joke-like is Mappelthorp's photo *The Alpacca Suit*. Here, one sees a very elegant man in a very elegant alpacca suit, while from his open zipper a beautiful and fairly big penis shows itself to all. Bruce Naumann's *Study for Mean Clown* from 1989, where clowns greet one another with very big hands and very big penises, could also be mentioned here. There are also several artists who make fun of the concept of representation, of the thing-character of painted images. Among several canvases painted in the same spirit by Salvador Dali I mention (randomly, again) *The Persistence of Memory* (1931), with the well-known "watches" which do not behave like the solid things that they allegedly "represent," but look more like mollusks. In Andy Warhol's *8 Revolvers*, there are not eight revolvers, but at most two; the others are just their shadows, or perhaps the same two in different positions. The gigantic quotations of the most commonplace things, of commercialized ideals or junk food, also make fun of the claims of representation, since they imitate (or are?) advertisements, of things, lifestyles, or junk food. Advertisement, unlike visual art in general, performs an act of perlocution not of illocution. Pop art makes fun of popular taste and represents it simultaneously, like Lichtenstein's *In the Car*. There, the double portrayal of the entirely empty faces of a man and a blond woman sitting in a car represents the ideal, or the supposed role model of the American lifestyle. Oldenburg's *Giant Hamburger* and other works make fun of popular culture and at the same time represent it.

Still, I am going to carry on with my plan and illustrate the visualization of the last three ways of making fun of the world, philosophy, and art, with the work of Magritte. Magritte is the greatest modern comic artist of the fine arts. In my opinion he is, besides Brueghel, the greatest comic artist in the fine arts of all times. But this is a very personal judgment. What is less personal is Magritte's unique status in our story of comic images in at least three respects. First, almost all of his art is of a comic character; second, he excels in all kinds

of comic genres, jokes included; and third, he embodies the intimate relationship between philosophical thinking and comic art most radically.

The painting *This Is Not a Pipe*, and another painting called *The Two Mysteries*, which references the first, are beautifully discussed by Michel Foucault in his essay *This Is Not a Pipe* (now available in English in *The Essential Works of Foucault: Volume II*, edited by Paul Rabinow). I will speak only about the first picture, which presents one big, single pipe, and underneath it, the handwritten text: *Ceci n'est pas une pipe*. I cannot discuss Foucault here, so I will only briefly mention some of the thoughts that are indispensable for a discussion of the comic genre. Foucault accepts Magritte's interpretation of his own work, namely that he distinguishes sharply between resemblance and similitude. Resemblance presumes a primary referent, whereas similitude does not. Certainly the painted pipe is not a pipe, although it is similar to one. It is something different, since one cannot smoke it, or otherwise make use of it in the way one uses a pipe. Yet the statement 'this is not a pipe' is also untrue, in the light of convention. According to convention, if there is a painted pipe, then this is a pipe, given that resemblance stands for representation. Children learn writing and reading by the use of this convention. Foucault writes:

> Two principles, I believe, ruled Western painting from the fifteenth to the twentieth century. The first asserts the separation between plastic representation (which implies resemblance) and linguistic referent (which excludes it). [. . .] The second principle [. . .] posits the equivalence between the fact of resemblance and the affirmation of a representative bond. [. . .] The essential point is that resemblance and affirmation cannot be dissociated. (pp.195-96)

This happens only, says Foucault, with Kandinsky and Klee. The reader may remember that in jokes resemblance and affirmation are dissociated, by doubling resemblance and abruptly changing the expectation or affirmation into a negation. What Foucault did, among other things, was to indicate the similitude between something we do with language and something we do with pictures, or pictures and language together: we crack a joke, a philosophical joke.

There are two major comic constituents in Magritte's work. One is dissociation, which we know from jokes; the other is presenting metaphors in a literary sense, a technique we know from existential comic dramas. In fact, the picture *This Is Not a Pipe* stands for both. Bisociation is also typical of those of Magritte's pictures without text, e.g., *Red Model* (1935), where feet and boots merge into one picture, and *Collective Invention*, where we see in the foreground of a seascape a fish head on a woman's body, lying sleeping or dead on the shore and painted in blue and pink colors. We can also see bisociation at play in *Infinite Gratitude* (1963), where two tiny men in black, one with a stick, reminding us of two clowns, stand on or between the clouds of a cloudy sky; or in *The Rape* (1943), where a female body and head/face merge into two eyes that are two breasts, a mouth that is a vagina, etc. In *Waterfall*, we see a painting standing on an easel in a thick forest, and on the painting is a painting of the forest, perhaps the same forest. These are all examples of dissociation, showing the

joke-like imagination of the pictures, even without a written text. True, titles themselves are texts, and as texts they create puzzles. Why is the merger between the female face and body termed *The Rape*? Does the distortion of a face as if it were a body, and vice versa, hold a kind of similitude with the internal experience of raping or being raped? Or why is a painting titled *Collective Invention*? Who invented what? Does the word "collective" suggest that there is a common experience portrayed? And what about invention? Why is the picture which shows an almost (and perhaps entirely) naked man, beside him his standing garment, and a black top hat hanging above it, titled *The Road to Damascus*? The title points to a philosophical message which needs to be deciphered only if we care for deciphering it at all, because the pictorial joke has a direct effect even without having been deciphered.

Magritte also excels in pictorial puzzle jokes. There is the picture of a big apple with the inscription *Aux revoir* titled *Guessing Game*. His inexhaustible oeuvre includes also narrative jokes like *Man Reading a Newspaper* (1928). There are comic pictures, which are not jokes, but suggest a humorous understanding of an idea, thought, or institution through pictorial associations, like *The Right of Man*. There are also uncanny and mysterious works like *The Lost Jockey* . . . and I could enumerate finally Magritte's whole oeuvre.

What is reality? And what an illusion? What dream? What fiction? What is inside and what outside? What is the relationship between humans and things, and between things and things? What is a face? A body? All four explanatory possibilities enumerated by Aristotle, the formal, material, efficient, and the final cause, are absent. Can anything be expected; is there any logic or continuation in things?

No, there is none (this is the comedy) and yes there is; it is constituted by the artist's imagination. It is a personal imagination, but not accidental. Things, stories and relations are torn apart and put together in a unique way, the meaning of which is not "easy" to find. After laughter comes reflection about the picture: what it really means to present, even if it does not *represent* anything.

Laughter is the laughter of reason. The aftershock of the pictures entails thinking. What looks absurd for the conventionally blinded eye comes to make sense when we start thinking. Picture *Hegel's Holiday* (which shows a glass of water standing on an umbrella). Magritte chronicles:

> I then thought that Hegel [. . .] would have been sensitive to this object which has two opposite functions: simultaneously not to admit any water (to repel it) and to admit it (to contain it). He would have been delighted, I think, or amused (as on vacation) so I called the painting Hegel's Holiday.

Who would have guessed it? Not only Hegel would be amused. So are we.

Chapter Eight

The Comic Image in Visual Arts II

Film Comedy

Had I undertaken to write the history of the comic genres, I would have spoken about moving images rather than about comedy in films. The one-hundred years of filmmaking is an episode—although in my mind a decisive episode—in the adventures of moving images. The play of shadows (silhouettes) and play with colors were, for example, once popular, and were even enumerated among the arts by Kant. There are comic moving images in contemporary video art, and even a few installations could fit this description. But I am not writing a history, so I can speak only of representative genres (or at least those that are representative in my mind), and film comedies belong to these.

With the exception of jokes, the one-hundred-year-old film industry can be credited with the greatest output of comic presentations. When we visit a video store, we see that comedy occupies even more shelves than drama (but not tragedy!). Stand-up comedians (such as Seinfeld) and humorists (such as those in the British series *Yes, Minister*) are indispensable in television programs and sitcoms. The amount of comic "output" is, of course, made possible by mass production. Mass production normally satisfies (perceived) needs. The mass production of comedies by the film industry thus satisfies the need for "the comic," the need for a good laugh. Film, as a relatively new medium, has replaced in one aspect a few more traditional comic genres. There is no "Punch and Judy" at the market, the circus has become entertainment only for childern, "clowing" has ceased to be one of its greatest attractions, and even cabaret has lost its lustre. In the golden days of the movie, a new public space was opening

up around the movie theaters in the cities, and also in small villages. This was the time of "cinema paradise." The audience cried and laughed together. These times are over. In television comedies, the laughter situation is restircted, because people normally laugh in the company of others, giving themselves away to the contagion of laughter, and this cannot happen alone in an armchair. This is why sitcoms, or stand-up comedies, insert the soundtrack of laughter at the proper place and time, that is, just after the gags at which one is supposed to laugh. They produce a kind of pre-laughter for their viewers, which is of course only a copy of the original experience.

Still, film comedies do satisfy the need for the comic. And in mass society and modern democracy, they have to cater to different needs. There are only a few great comic artists who can satisfy the need of (almost) all people on the highest level, since viewers enjoy different layers of humor usually depending on their level of sophistication. I will later discuss some of these grand comedians, people such as Charlie Chaplin, Buster Keaton, the Marx brothers, and Woody Allen. Mostly, however, film comedies do not raise any claim of being "art"; they are satisfied with fulfilling the function of entertainment. There is good, mediocre, and bad entertainment. Good entertainment can be enjoyed equally by viewers at different levels of sophistication.

The difference between good entertainment and art can be pinned down in comedy, indeed far more so than in the case of "film drama." It can be pinpointed with the presence or absence of a "third dimension," which in film comedy, as in all other comic genres, is occupied by philosophy. The third, philosophical dimension can also be deep to a relatively greater or lesser extent. Since interpretation is nowadays an increasingly personal matter, there can be a great difference of opinion as to whether one or another film has or lacks a third dimension. Take for example the "Eve" films about second marriages. Stanley Cavell wrote a book (*Pursuits of Happiness: The Hollywood Comedy of Remarriage*) about these films from the 1940s and 1950s, and he discovers and explores the third dimension in them, whereas in my mind they are just late and kitschy variations on the old themes of social comedy à la *Sardou and Scribe*, neither interesting nor attractive. The main thing is, however, not the difference in the assessment of single movies, but agreement about the principle. Stanley Cavell discerns the philosophical dimension (from Kant to Wittgenstein) where I do not see it, yet we are both certain that it is just this dimension which determines the high quality of a comedy.

Movies can produce unique comic effects insofar as they can preserve and simultaneously condense the heterogeneous elements of elementary, spontaneous, everyday comic experiences. The comic can be registered by the eyes and ears in any situation or event that can be presented or told. If someone grimaces, we register it with our eyes. If someone makes a funny remark, we register it with our ears. If a man of gigantic bodily proportions begins to speak in a very thin voice, the contrast between the experience of the eye and the ear makes us

laugh, and this is already a comic situation. If someone imitates the gestures of someone else, we register it with our eyes; if someone imitates another's way of speaking, we register it with our ears. Both are the elementary cases of parody. If a waiter drops his tray and spills juice on an elegant guest's suit, we may laugh at the situation; if we witness the avowal of innocence by a husband, who, upon the departure of his wife, becomes entangled in an intimate position with another woman, we may laugh at the story or narrative. All comic genres must produce an illusion in order to do justice to all aspects of everyday comic experience.

Theater comedies can tell a story by showing characters and gestures, that is, by employing images (the change of image included) and by speech, that is, by the sense or nonsense uttered, by the voice, by the modulation of the voice of the actors, and by their silences. But they cannot—except in an opera—produce several scenes or stories or speeches (voices) simultaneously. In a theater play one cannot simulaneously present the talk and the thoughts of the speaker, his past remembrances and his present doings, his dreams and his real-life situation. The Romantics saw in these limitations the shortcoming of comedies. Even though I do not see these limitations as shortcomings, I must admit that the need for the movie was already present before cinema technology was invented. The movie can do everything that Schlegel hoped for from theatrical comedy.

The comic picture (just as the picture in general) frequently tried to tell stories, to volatilize situations presented on the canvas (e.g., jumping horses), to narrate. Hogarth's series of paintings are cases in point. Sometimes painters also used captions, just like silent movies. Still, silent movies tell stories even without captions, since the characters' interrelationships change constantly, and every change creates a new situation among them, and also between them and the rest of the world. And there is no talkie without a story or several stories.

One can also tell jokes in movies, not just one, but many; practical jokes are one of the major components of comic movies, and first and foremost of the silent movie. To put it briefly, the movie restores the original comic experience, the total comic experience—which normally triggers spontaneous laughter—in an "aritificial" way. It combines comic situations, humorous gestures, and characters, funny talk, puns, ridiculous motions, and ties them all onto a string running through a story or several stories. The dominant attitude of comic movies can be slightly humorous, satirical, sarcastic, or ironic, and they also can and usually do include parodies or certain elements of parody.

The comic movie exploits the whole tradition of the comic genre, especially the tradition of the comic drama. The world of the comic drama has always allowed for "light" entertainment. The bourgeoisie of the nineteenth century needed this kind of light entertaninment. They went to the theater to laugh at the silliness of others and to forget their daily cares. Since the great majority of comic films provide such light entertainment, to loot comic drama in search of gags and stories is an obvious choice. Most comic movies are good or less good variations and modernizations and, incidentally, are also remakes of *la comédie larmoyant*, the social comedy or comedy of manners. Elements of comic opera,

and especially of nineteenth-century operetta, are also exploited by comic movies, and not just in the soundtrack. They make use of music and songs which in fact become the "signatures" of certain comic (and not only comic) movies.

And again, we meet the major topics and tricks of the comic drama in film comedy. When a certain situation has lost its social relevance, historical comedies can be created, wherein old tricks are still usable (e.g., the humor of master/servant relations), or the characters of old can be modernized. The center of comic films, just as in comic theater, is, of course, love: the almost fatal, yet never really fatal misunderstanding of lovers; the swapping of social or sexual roles. Sex—desire, impotency, the lust of the old for the young, etc.—becomes, after the sixties, no longer a topic of hints, but the direct subject of celluloid. Yet even this is just a minor variation. The humor of love relations is inexhaustible, and so remains the butt for humorous presentation, as do the quarrels between couples and generations, and also the usual old vices. The miser, the spendthrift, the womanizer, the pedant, and the fanatic are and remain ridiculous, and they will be punished, at least by public laughter. There is also mistaken identity and faked identity, e.g., the swindler posing as the well-to-do situated gentleman. But surely, these films must have a happy ending. This is what we expect from a comedy.

Making fun of or parodying institutions, parodying the language of institutions and institutional behavior, is the heritage of Aristophanes, Molière, and the comic novel, and is resuscitated in comic movies. Since in the twentieth century institutions play a greater role in life than ever, institutionalized, "professional," or role-conforming behavior and speech has become even more frequently the target of satire, parody, and otherwise humorous presentation in films; in film, institutional behavior is lampooned even more than it was in comic drama. Among the ridiculed institutions are the stock market, the business dinner, the party, the military, the police, the institution of call girls in hotels, political institutions, the guided tour, and, self-ironically, the entertainment industry itself. In totalitarian countries, especially in times of a "thaw," the comic presentation of totalitarian "talk" and behavior and the irrationalism of dictatorship is satirically or sarcastically presented (e.g., by Menzel and Bacso).

After the first decades of shorter silent pictures, the length of feature films stabilized at between 90 and 120 screening minutes. The duration of a comic drama is roughly the same. Yet because of its imagistic character and its almost epic sort of narration, dialogues play a secondary role in film comedies, and not just in silent movies. Moreover, comic movies generally have a less "dramatic" character than non-comic movies, since in reproducing elementary comic situations they need to employ visual gags and related images far more broadly and radically than other films. The time-limit of comedies is even more stricly imposed than in other films. *Gone With the Wind* takes five hours of screening time or more; *Lawrence of Arabia* or *Ben Hur* (uncut) take four. This cannot happen successfully in comic films, since a kind of homogeneous atmosphere must be maintained. One must preserve one's readiness for laughter throughout the screening, and one cannot maintain this readiness for more than two hours,

maximum. Of course, there are sequels of successful and funny, well-conceived and acted, if also somehow shallow, comic films, like *The Odd Couple* or the detective story parody *The Pink Panther*. Great comic artists (like the Marx brothers, Sellers, or Lemmon) do not alone make a comic film great. While the comic talent of Groucho Marx is at its peak, his film may remain a witty yet flat music hall comedy.

Most comic films are indeed shallow; that is, they lack the third, philosophical dimension. Others are much too up to date, too directly polemical, or obviously satirical. In what follows, I will not speak about them. I will select instead, for a brief discussion, only a few artists, those alone who created something entirely new in the world of sublime comedy (here I understand with *sublime* the sublimation of everyday comic experiences) by using the medium of film.

Great comedy requires comic genius. One needs to see the world "naturally" in a comic light to be a comic genius. This is truer in film than in any other case. The reason for it is simple: the comic film sublimates all the laughter triggering stimuli in everyday life; it does not merely sublimate comic situations, images, and puns; it sublimates all of them together. Of course, this is not an explanation, just a description of the circumstance.

Indeed, there are no "rules" here, just observations and personal judgments. In my personal judgment, the greatest artists in the medium of film are not comic artists. This is already too restrictive a judgment, since by "greatest artist" I have in mind film directors, such as Gans, Renoir, Fellini, and Bergman. Now some of these film directors whom I consider to be the most sublime also tried to create comic films, and those films were bad or fairly bad, perhaps the only bad films they ever created. Surely there are wonderful comic scenes in their movies, just as there are wonderful comic scenes in several Shakespearean tragedies. However, they do not perform the synthetization and sublimation of the total everyday comic experience. Their comic effect is either the effect of the situation or of the characters, who are never the main characters, although the non-comic main character can also be portrayed in a comic situation (e.g., in Fellini's *La Dolce Vita*, *Rome*, or *Amarcord*, in Truffaut's *Jules and Jim*, or in Almodovar's *Kika*). One can see also wonderful clowning (as in *The Children of Paradise*, Carné, Jean-Louis Barrault), yet no masterful clowning will transform Barrault into what he is not, namely a comic figure.

The special and unique contribution of film to the world of the comic is the creation of a unique comic "persona." One may find comic figures typical to all cultures. Perhaps they are as old as human civilization. Besides jongleurs, acrobats, and animal tamers, clowns and the puppet theater also occupied an eminent place among the entertainers of the marketplace. A puppet was a "persona." When a puppet appears, we already know the role he is going to play: whether he will be beaten or will beat others; whether she will be in love, or not, with another persona; whether he is clever or an idiot; whether she is nice or a shrew.

There were also double actors, actors-in-a-pair such as Punch and Judy or Pierrot and Pierette, and there were also single ones, like Punchinello on his own. Whoever created the puppets and/or pulled the string, the figures still remained (within a given time-frame) the same, and the distribution of their roles has not changed either. Perhaps not even the basic puppet story has yet undergone substantial change. The puppet audience liked repetition, they were amused by it, and they always expected the victory of the cute and good-hearted puppet and likewise the downfall of the stupid and wicked one.

Great comic films create the sublime version of the old puppet theater and of the master clowns. The comic film does not stand entirely alone in doing so. We have seen how Beckett reshapes the clown persona in his novels and dramas, such as *Vladimir and Estragon*. The comic film mobilizes all the possibilities offered by its medium for the same purpose and in a unique way. The comic artist is the one who invents the film, who writes the film (if there is a script at all), who plays the main character in the film, and who directs the film. That is, the whole film is created by one single person; it turns around this single person, or more precisely around the persona of this single person. Moreover, in (almost) all films created by the same person, he or she plays the same persona. There can be a dozen films, all of them with the same persona. The persona is the signature of the film. The moment the persona appears, the audience begins to laugh, because his or her appearance itself carries all its connotations, and also the hope of the persona's return.

The persona fashioned by the creator of the film is not identical with the creator of the film. Although it appears in his body and speaks with his voice, still, they are far from being identical. The creator of the comic film, the comic genius of filmmaking, also creates himself as a particular comic persona. It can take a long time until one finds one's persona. Chaplin, for example, found his persona after a relatively long time of experimentation. The persona was, of course, never Chaplin himself. But it was Chaplin, insofar as it was the product of his self-creation. Woody Allen said once that he always cracked jokes when he was in school, and in this sense that comedy was always his life element, but that as far as his persona is concerned, he denied that it had much to do with him. In an interview, Allen made the funny remark that his persona was actually closer to his mother than to him (!). Take this with a grain of salt. Yet however great or small the distance between artist and persona, the distance is there. If the creator and the persona were identical, then the creation of the self as a persona would not be possible. In the case of Woody Allen, I refer the reader to the interesting book on his art by Vittorio Hosle.

The identity of the persona is neither, by any means, the identity of the character it may inhabit. The same persona can appear as several entirely different characters. Chaplin (the persona) can be both a little Jew and Hitler in the same film. Woody Allen can be a schlemil, an impostor, and a famous writer, yet his persona remains the same. Whatever character the persona plays, be he a good man, a scoundrel, a shlemil, a rich and famous writer, or film director, still the persona remains. And the very appearance of this persona brings hope. In-

deed, the persona embodies hope. When we see him on the screen, we know that justice will be done, that there will be a happy ending, or at least, that there will be a moral of the story. The persona is the promise of the moral of the story. The philosophy, the third dimension in such comic films, is already created by the persona, with whose character the moral will be exemplified.

Great comic movies with a great persona do not moralize, but they have a moral. They do not moralize, since they always do justice to the fallibility, weakness, and frailty of human beings. Unless we trespass the limits where crime or evil begin, we can be treated with understanding humor. This is redeeming laughter: to make peace with ourselves without self-righteousness. The comic film brings hope, since the comic persona, unless he trespasses the limits and becomes evil (which happens only in two of the films by the later Chaplin), will be elevated or forgiven, even if he dies.

In the one-hundred-year-long, or -short, story of "motion pictures," among hundreds of thousands of comic films, only a few fit the bill, for only a few exhaust the possibility contained in the film medium to do something new, to add something to the richness of the comic genres, something which did not exist before, not just technically, but in spirit. Still, even if short, one hundred years is a long time, and the comic film has experimented with a few variations. Changes in technology also played a role here, especially if we consider the transition from the silent movie to the talkie, and then at the end of this development, the time that film, as art, came to be conceived of as problematic, and then the time of the deconstruction of comic film. Though only a few of the comic films that "fit the bill" are to be enumerated here, they are still too numerous to discuss even briefly. This is no different from the preceding chapters, whether we address dramas, novels, jokes, or paintings. But if I may say so, the discussion of film will have to cover a relatively broader field than the preceding discussions.

My selection (I do not think entirely arbitrary) of the representatives to cover this broad field is Charlie Chaplin, Buster Keaton, and Woody Allen, and also of two "single" films, *Life Is Beautiful* by Roberto Benigni and *Get Up, Buddy, Don't Sleep!* by Jancso.

The silent comic film and the early talkie are America's greatest contributions to the comic art. Chaplin, Keaton, and the Marx brothers grew out of folk art or entertainment, several products of which we can still watch on the Nickelodeon television station. These generally short films were the first swallows of "cinema paradise." They presented in black and white a dream world (serious or funny) for people, and particularly for the poor. Although the film industry is as old as the movie theater, one can justly talk of folk art, because movies offered something for the broad public which they previously encountered only at the marketplace, and it was still a public genre. The movie was an insitution of collective daydreaming.

Funny dreams are also dreams, and laughter, as we know, is most satisfying in public. Since the plebs required good entertainment for little money, every film which promised success was welcomed. This is how it happened that the greatest silent comic pictures were sublime and still popular. The greatest challenge for intelligent and spirited artists and comedians was to produce something that everyone could enjoy, and still express something that only a few sophisticated viewers could understand. America of the early twentieth century happened to be the most fertile ground for the growth of this new genre. American Jews, whose sense of humor was sharpened by the folklore and tradition of Eastern European Jewish jokes and humor, were a vital element in the budding genre, whether they were producers or artists. This tradition continued to influence significant comedies in the times of the talkie, and later in the art of Woody Allen, who created his persona as a Jew.

There is a great continuity in comic movies between the silent film and the talkie. Certainly some significant silent film artists could not reinstall themselves into the world of talkies. But Chaplin continued to create films later, and even if one agrees that none of them grew to the level of sophistication of *The Gold Rush* or *Modern Times*, they were still excellent examples of comic movies of the talkie period. Yet this is not just a personal matter. The silent movie achieved its comic effect mainly by motion, facial expression and gestures. The comic talkie movie has, of course, the spoken language at its disposal. The script plays a special role; the text itself must be funny. One could publish the scripts of Woody Allen's movies in print; they are also funny as books. In addition, not only the text matters, but the voice, its modulation, and speed, are also constituents of the comic effect, and must be attended to. It must be said, however, that in spite of the increasing importance of the text and the way of talking, speech itself preserves the gesture character, and what is perhaps more important, gestures and motion, in the traditional clownish style, characterize all comic artists of the last few decades. This is true about Allen, Begnini, Sellers, Toto, et. al.

The persona of a silent comedy still looks, at least in two respects, like a circus clown, first in his appearance, and second in his movements. Just as the face of the clown is generally powdered or painted, so are the faces of Chaplin and Keaton chalk-white. They wear special garments, like Chaplin's big shoes or Keaton's top hat. Their way of walking is one of their most important signatures. They are acrobats, just like circus clowns. They overdo their clumsiness, awkwardness, and blunders. Keaton (in *The General*) cannot pull out his sword. This changes in the times of talkies. The comic persona of a talkie does not need to look like a clown, even if he likes to move like one, which happens often with Allen and (in *Life is Beautiful*) also with Begnini. Still, in heard movies, speech becomes the most important signature of the persona. Allen's voice and the speed of his talk are unmistakable, whichever character he plays. But what he says and its comic effect depend not just on the persona he has created, but also on the character being played. Whereas silent movies remained true to the tradition of comic drama insofar as they always ended happily, with some bliss or requited love, this is not always the case in heard comic movies. Here the "com-

edy of existence" can complement or replace traditional comedy, as in the latest works of Woody Allen.

Movies offer several possibilities for comic effects which never before existed. They were dreamt of, yet never presented. It is impossible to play, for example, certain representative works of Romantic comedy (e.g., Tieck) in the theater. One cannot present simultaneously on stage the actions and images of a character, and the actions and images which should pass through the mind of the character. Yet in film this is possible. In *The Gold Rush* we see Chaplin becoming a chicken, when his starved buddy sees him as a chicken. No one needs to indicate the desire for cannibalism; the picture tells it all. And this is how the scene becomes hilarious, although starvation and cannibalism are in themselves not funny. In *Stardust Memories*, where Woody Allen plays a famous film director, one sees two memory fragments simultaneously with each other and with the action.

Stardust Memories also belongs to the movies which operate with the Aristophanean technique of parabasis. We do not know whether we see the process of making a film or the film itself, whether we are in or out of the "real" action. Which is the real action? We can easily compare this picture with Fellini's wonderful film *8½*, where we are involved in filmmaking that is complicated by the story of a man caught between two women. Yet in Fellini, there is no play between inside and outside, no parabasis.

The comic movie can present the absurd. The symbolic absurd, the playful absurd, the dreamlike absurd. And the presentation of the absurd can be hilarious. It can be hilarious, but also symbolic and serious. I have mentioned already Chaplin's metamorphosis into a chicken. In the same movie, the metaphor of "dancing above the abyss" is visually presented. There is a tiny little house on the verge of an abyss, where Chaplin and his buddy dance from right to left and back. If they dance in one direction, the house almost plunges into the abyss; if they dance in the other direction, the house becomes more stable. This play goes on for a few minutes. And this is, indeed, our life. In *Modern Times*, while running to catch up with the assembly line, Chaplin is caught in a machine, as its product. This is not just a satirical presentation of inhuman modern technology; it also hints at the inversion between people and things. Or, in Allen's *Zelig*, a fake biography, real figures of New York cultural life, such as Irving Howe and Susan Sontag, recite their "memories" about the "hero" of the film and interpret his story psychologically and sociologically. All the while, the hero in question crosses the Atlantic Ocean in a plane upside down. We have a most funny story about a person with an "unnatural, chameleon-like capacity" who has the ability to become like the people with whom he speaks, such as Japanese among the Japanese, psychoanalytic in the company of his psychoanalyst, a Nazi among Nazis, a Jew among Jews. That this "unnatural" skill of a human chameleon is just the absurd, because extreme, form of the required, recommended, and promoted American value of "adaptation" is obvious. With Allen, the absurd can also serve as a vehicle of parody. The absurd scenes in *Shadows and Fog* are parodies of detective stories, and the entirely absurd scenes of *Sleeper* are paro-

dies of science fiction. *Play it Again, Sam*, is, however, not a parody but a pal-
impsest. Allen in fact creates comedies in all their versions and kinds, but many
are around the traditional comic themes of love, family, sex, betrayal, and trust.

The fun of the text is as important in Woody Allen films as the fun of the
seen images. And the two are so intimately connected that one cannot tear them
apart. When he (his persona) protests that he is not an atheist, but God's loyal
opposition, or when in the pseudo-Greek play, *Mighty Aphrodite*, the chorus
cries "Zeus! Zeus!" and an answering service responds that Zeus is not available
at the moment, and that they should call again later, then texts are embedded in
the story; they are not just gags or puns.

I have already mentioned that the best, most complex comic films carry on
the tradition of the comic genre. They are philosophical, they have a "third di-
mension," they are serious in being funny, they activate all the attitudes belong-
ing to the comic genre (humorous, satirical, and ironical attitudes) and to a few
sub-genres (parody and travesty); they are also sentimental, and they each have
a moral. They do not teach or moralize, but they do each have a moral. In Al-
len's *Crimes and Misdemeanors* (which is only a comedy in part), the lesson is
spelled out. We are all weak creatures with strong passions; we are blundering,
we do damage, yet there is a limit beyond which it is forbidden to go. Whoever
crosses this line is lost, for he has become evil. There are no moral laws (so the
Allen persona thinks) which could offer us an absolute guideline for the choice
between good and evil, yet there are stories at our disposal, and we can also tell
new ones in movies. In one comedy after another, we can be offered a paradigm
(*a* paradigm) about the choice between good and evil. Moral questions and the
question of God are constantly on the mind of the Allen persona; he struggles
with them all the time, and his answers are always concrete and situated. In
Manhattan, the answers come through trust and hope; in *Midsummer Night's
Sex Comedy* it is a fundamental, final fidelity; in *Deconstructing Harry*, it is the
lesson that a person who cannot love should instead remain loyal to what he can
do (writing in this case). In *Annie Hall*, the lesson is the ability to become re-
signed in good faith and without bitterness, while in *Hannah and her Sisters*, it
is an insight into our foolishness and trust. I think that in the moral of Allen
films there are three fundamental values: trust, assuming responsibility for our-
selves, and resignation "without bitterness."

Absurd portrayal, the presentation of absurd images as funny images, is a com-
mon feature of the comic movie with a philosophical dimension. There are,
however, different kinds of the "absurd." There is absurd as impossible, absurd
as utterly exaggerated or extreme, absurd as unimaginable, absurd as uncanny or
daemonic, absurd as paradoxical and absurd as reality. Paradoxes are not im-
ages, they are things of thought, even if images can be thought paradoxically.
Thus, in discussing films, we can dismiss this type of absurdity. Most of the
absurd scenes in comic movies are the kinds of absurd I associate with the oth-
erwise unimaginable or impossible (for example, the little house over the abyss,

or crossing the Atlantic Ocean in a small plane upside down). Presentations of the absurd can also be uncanny (Chaplin as a chicken, the penal institutions of *Sleeper*). The absurd as reality and reality as an absurdity are essentially different. Absurd reality is the reality of totalitarian systems of mass annihilation.

Traditional comic films excel in absurd imagination. The presentation of absurd reality, however, does not call for absurd imagination; in fact it does not call for imagination at all, but for an understanding of absurdity, that is, for an understanding of the un-understandable. Totalitarian institutions of mass murder were portrayed in several stories on the movie screen, yet (in my mind) comic movies can actually do more justice to the presentation of the real absurd than any movie drama. The reason is that because the genre of comic movies itself calls for a presentation of the absurd. Comic movies do not need to pretend to have understood the un-understandable; they can present the ungraspable not as "terrible" or "catastrophic" or "awful," but as it is, was, and remains: as absurd.

Life Is Beautiful, the much-discussed film by Roberto Begnini, starts off as a typical, traditional comic movie. Begnini (writer, actor, director) plays as usual the role of the comic clown, who falls in love with a girl of higher social standing, and worse, who is already betrothed to another man. The clownish lover plays the usual comic games to conquer his "princess" and finally elopes with her on the night of her wedding. They will live happily ever after, unless. . . . unless life itself turns absurd. The Begnini persona is a Jew, and we are in the times of Mussolini and the German occupation of Italy.

The persecution of Jews seems, at the beginning, also to be a kind of stupid rancor open to the usual comic presentation, as for example, when anti-Semites paint the uncle's horse with the statement "Jewish horse." Chaplin's important film *The Great Dictator* portrays the world of Hitler in this way. These were the times well before audiences knew of Auschwitz. But the Begnini-persona and his little boy and wife are deported to an annihilation camp (Auschwitz or Buchenwald). Here, in the camp, the relationship between imagination and reality become reversed. The reality of Auschwitz is unimaginable and un-understandable, like a crazy game without any logic. Some adult men play a deadly game with human material, inventing new and newer tricks to murder them efficiently. When the father tells his son the "story" that they are participating in a competition, collecting points, and that the winner will receive a tank, he is not lying, because this is as good or as bad a description of what is going on as anything else. The utterly irrational and indescribable reality could be described in any way, and all descriptions would be equally irrelevant. This is the source of the black humor, the humor of despair, or, to speak with Kierkegaard, the irony of despair.

In the black comedy of Miklos Jancso, the latest of the four films he has produced in recent years, *Get up, Buddy, Don't Sleep!* best shows the transformation of contemporary comic movies. It is not a narrative movie. It does not tell one story, but several, and not in historical sequences. Historical truth is lifted in order to tell a truth about history. We see the Budapest of today, with its new hotels on the bank of the Danube, yet on the bridges Jews with yellow stars

on their coats are driven by fascists to deportations. Trucks are carrying soldiers to the Russian front singing, and the Stalinist youth group is marching. History is here, in our minds, in our present; we just pretend that it is no longer around. Still, it is a comedy. We encounter the clown-pair, Kapa and Pepe, who behave in the usual clownish manner. And there is, again, the well-known division between persona and character. Kapa and Pepe play different characters; they are at once Jews, and in another episode they are soldiers, while in a third they are doctors, then they are again just themselves, clowns. There is parabasis: the director also plays in the film, he dies, and he will be operated on and brought back to life. Eventually we do not know when we are inside and when outside of the stories. There are parodies, mainly of commercial films. There are parodies of World War II films, of deportation films, and of hospital/doctor series as on the television show *ER*. The film is suspended between representation and the deconstruction of representation. It tells the truth by telling us "I am not telling the truth," for representation is impossible. The film says: I am just a film; those who die here will get up immediately, they are not dying, we cannot represent the dead. We are laughing instead at ourselves." Yet here too, also in this non-narrative film, there is a grain of sentimentalism that is obviously inseparable from the comic motion picture. Perhaps this is why at the end of *Life Is Beautiful*, the boy has to meet his mother, and we, as sophisticated spectators, would rather forget this ending.

This circumstance deserves a brief afterthought.

The comic drama is not "sentimental," and neither is the comic novel, let alone jokes. Yet even the best, deepest comic movie has a sentimental aspect. Still, we may remember, comic film is not the sole comic genre with a light sentimental touch. Interestingly, the same can be said about a few masterpieces among Beckett's comedies of existence, like *Waiting for Godot* or *Mercier and Camier*. I mention Beckett in order to avoid the easy answer to our question: movie is a genre which presents itself to the broad public and sophisticated viewers together, and the broad public needs the sentimentalism. But Beckett did not intend his works for the broader public. And if this is not a reassuring explanation; perhaps there is another: the clown. Clowns of the marketplace are sentimental. They often shed tears. Even in painting (see Picasso, et al.), clowns look affected. Even in the opera (take *Bajazzo* or even *Rigoletto*), clowns are portrayed with a grain of sentimentality. Thus when in a sublime genre clowns play a significant role, this sentimental tradition cannot be neglected. We owe the clowns gratitude for making us laugh. Gratitude is paid for with tenderness, tenderness with at least a little heartbreak.

Chapter Nine

An Address to the Faithful Reader

I am afraid that the last chapter of this book will resemble a comic novel. I could go on and on, writing about comic genres here so far neglected, or I could return to the discussion of comic phenomena in everyday life, a topic about which I have said too little. I could dwell on the presentation of the comic in the marketplace, or on popular comic ceremonies, which were otherwise entirely omitted here. I could also take more seriously the scattered remarks found in different philosophical works on the comedy of life, which I mentioned only in a very sketchy way and only as regards works of Plato and Kierkegaard. Yes, I could go on writing this book for many years; still, as in any comic novel I would need to stop, and finally to type or scribble the words "THE END."

Like a character in a comic novel returning home from journeying, I could also ruminate about my own adventures, which were neither external nor internal. They were not external, for I remained here, sitting at my desk throughout all of the journeying and even when preparing for new excursions. Nor were my journeys internal, for I did not delve into my own soul and tell a story of my own experiences. In brief, this passage was a philosophical journey. Philosophical journeys can be simultaneously internal and external, given that they travel in, on and through the continent of the "human condition." Thus my philosophical journey must end with the question: *how and why is the human condition itself comic?* I could continue this book considerably; but still, before scribbling down the words "THE END," I could not avoid this question.

Let me first openly ruminate on the adventures to which I invited you, my faithful reader, asking you to be a witting or unwitting companion on this common journey of shared adventures. What did we experience during our travels?

We found out that the comic phenomenon is omnipresent. There is no known culture without comic experience and no known high culture without a formal presentation of comedy. Perhaps there is no culture at all without presentation of the comic, whether in pictures, dances, rituals, sculptures, or writings—yet I still do not dare to generalize.

We also found that laughter is omnipresent. "Homo sapiens" are laughing and crying animals; laughing and crying belong to the family of our "affects." Affects—such as rage, elementary fear, disgust, and elementary non-physical pleasure and displeasure—are what some call "instinct remnants" of the process of self-domestication, experiences which are innate yet which occur as responses to outside stimuli or experience. They are also learned. That is, a rage reaction, like every affect, is innate, yet one learns to what one should react with rage, and how the rage is to be best expressed. Shame is also an affect, although it is questionable whether it can be described as an instinct remnant. Shame is a social affect, and as such it plays a prominent role, together with pain and pleasure, in the process of socialization. It is also one of a basic (for a long time it was the sole) authority of moral judgment. It is noteworthy that philosophers who for so long hostilely nourished grudges against the drives (the other kind of instinct remnants), showed a greater sympathy to the affects. Kant, for example, distinguished between the faculty of lower desires or drives, on the one hand, and the faculty of pleasure and displeasure on the other hand.

Laughing and crying, we thus came to believe, are related to the affects, for they share several characteristics with them. Foremost, they are innate in the human species. But whether they are instinct remnants cannot yet be ascertained. There is also a discussion pending about the question as to whether some domestic animals can in fact cry and laugh. I have thus far assumed that they cannot. Like other innate human affects (in the human species as it now exists, for I am not interested here in the issue of human evolution, but only in its resulting circumstance), laughing and crying are answers to outside stimuli, events and experiences. As with rage, shame, or fear, those outside stimuli may be entirely different; indeed they are absolutely different. One can be afraid of lightning, daemons, or bombs; of being found out; of a loss of honor, and so on. Laughter and crying can be triggered by entirely different events or phenomena. In elementary laughing and crying, as with all elementary affects, the whole person is 'taken over' by the affect: voice, body, and gestures together express the affect. Being possessed or taken over by laughing or crying entails being unable to do anything else; one cannot think, speak, or perform manual operations. Yet as with the other affects, cognition and perception of the situation at hand can also get incorporated in laughing and crying. One can smile, that is, instead of bursting out into laughter, just as one can cry silently.

We have found, however, that although laughing and crying are close relatives, they are also opposites. Elementary crying is solitary, even if such crying happens in the company of others. Laughter is a social affect. We laugh in the company of others, even if we are alone. And laughter is contagious. We have tried to understand this funny business, namely how two affect-like, empirically

universal expressions, although very similar, could end up being opposites. Thus, we bumped into the following hypothesis.

Metaphorically speaking, but referring nevertheless to what are scientifically established facts, all people are "thrown" into a concrete social universe. The human genetic endowment is programmed for social life, but there is nothing in the genetic endowment which would encode a newborn for this or that particular, concrete social environment into which he or she is thrown. Philosophically speaking, there are two initial a priories in human life: a social a priori (the world into which each is thrown) and a genetic a priori (the inherited endowments of the thrown being herself). Since there is no initial connection between the two, and since only the experience of any single person can forge this connection, it is philosophically correct to speak of two a priories, given that they are prior to experience for all human newborns. To use a term coined by Hannah Arendt, this is the condition of human natality. In the process of socialization those two a priories must come together; they must dovetail in order for the individual person even to survive. But—and this is my hypothesis—the two a priories cannot be entirely dovetailed; there remains a tension between them. To use another kind of metaphor, an unbridgeable abyss remains between the two a priories. I call this *existential tension* and an *existential abyss*. According to the conception of laughing and crying presented here, both of these are reactions to the impossibility of a real jump over the abyss; laughing and crying are responses to the failure of any complete dovetailing between the social and the genetic *a priori*. This is, of course, a philosophical hypothesis, but illuminates several things. First, it explains why laughing and crying are omnipresent everywhere in the life of the human species; it also illustrates why the occasions or triggers for laughing and crying so differ historically, culturally, and individually; and finally, it clarifies why people who identify themselves entirely with some social a priori (without having leapt over the abyss) are incapable of laughing and crying. To this last issue I will return shortly.

First, it must be remembered that this hypothesis alone does not account for the opposition between laughing and crying. Thus I followed up my hypothesis with the inference that a person can react to his or her own inability to leap over the abyss from the perspective of both a priories. While crying, one identifies oneself with the self of a fellow creature, feeling sorrow over the world's injustice, fate, and loss; whereas in laughing, one takes the position of the world, or of some idea about it, and laughs at the foolishness of people, one's own follies included. There is no emotion in laughter. This is why I conclude that laughter takes the position of reason, or the position of rationality.

At this point one can, perhaps, better understand two seemingly unrelated phenomena. First, trigger events or the occasions for crying are far more regular and far less culture-dependent than the triggers that occasion laughter. We identify with ourselves and with our fellow creatures; we feel compassion for ourselves and others in basically similar situations. If we see someone crying we assume, as we have always assumed, that he has suffered or is going to suffer some tremendous loss (of love, of life, of country); we assume that he feels

helplessly "unhappy." But people laugh at entirely disparate things, and, to re-peat, these are culturally specific and also often individually specific. People burst out laughing at the sight of shitting, of a hunchback or physically disabled person, and at hearing the news of a disaster befalling an enemy. People also laugh at instances of self-righteousness, pomposity, self-importance, and the over identification with a social role; people laugh at miserly or rancorous char-acters, at bad poems and at good funny poems, at tyrants and slaves, at the use and misuse of language, and at the way someone is dressed. To cut across this vast terrain, I differentiate between two major types of "reasons" or standpoints that can be assumed in being overcome by laughter. Needless to say, one does not take either position consciously, but quite spontaneously, without thinking. I describe a position of rationality or reason which is the standpoint of common sense. From there, we find that one can easily distinguish different kinds of common sense. There is a different common sense for the uncouth and for the sophisticated. Yet in both cases it is from the standpoint of common sense that laughter makes its judgment. Rationality of intellect, however, is the Reason of ideas; it is a normative kind of Reason (with a capital "R"), which can even make one laugh at common sense. Whatever attitude one spontaneously takes, or whether one switches from one attitude to the other and back, as frequently happens, one always laughs from the position of reason at unreason.

Thus we came to the preliminary conclusion that laughter is a judgment, and namely one similar to the Kantian judgment of taste without a concept. Rationality or reason judges here without a concept, which is why I called laughter "the instinct of Reason." This essential difference between laughing and crying can also contribute to understanding another difference between them, discussed mainly in the second chapter. Although both crying and laugh-ing are empirically universal expressions of an existential tension or abyss be-tween the two a priori, high artistic genres are created only in connection with laughter, not crying. One can certainly shed tears at the fate of Anna Karenina, yet Tolstoy did not write the novel to make readers cry. As a girl, I always shed tears when listening to a Beethoven symphony, but Beethoven did not compose his symphonies to make young girls cry. In contrast, all comic high genres—comic dramas, novellas, novels, jokes, pictures, and films—are intended to make people laugh. Only "low" genres such as kitschy novels or weepy movies intend to make readers or audiences cry. To intend to make the reader cry war-rants the very inferiority of the work, whereas one can make the reader laugh with trash yet also with great works of art.

Maybe some of you, dear readers, would now interrupt to tell me you accept my initial hypothesis. But, you will ask, after making my hypothesis credible, why the hell did I go on to analyze, one after the other, all those comic genres? I could have—perhaps I hear you saying—immediately followed the second chapter with this chapter here, making for three chapters instead of nine, and speaking straightaway about the essence of the comic phenomenon instead of boring the reader with an analysis of comic dramas, novels, jokes, existential comedy, the comic picture and, alas, the movie. Had I done so, you will notice, I

could have written an elegant and really quite slim, interesting and not boring book. And maybe you are right, dear readers; perhaps I should apologize. Perhaps curiosity alone made me write those last six chapters. But perhaps not. Maybe the detour was not a detour at all. Maybe it was the only way to demonstrate something that, in my view, require a demonstration and not just hypothetical mention, namely that all the elements of everyday comic situations are presented in high genres, though not all of them in the same genre, and that the "division of laboring laughter" among genres also indicates the lines of division (at least partially) between the different varieties of the comic itself. Dear readers, this time the boring task was the philosophical task proper.

One should not forget about philosophy. After all, we became involved in the puzzle of the comic phenomenon when it was discovered that philosophy remained largely silent about it. Philosophers have oft enough incidentally mentioned the comic, but, as I mention, with the exception of Plato and perhaps Kant and Kierkegaard, none were seriously interested in it. Tragedy was and remained the favorite choice of philosophy, from Aristotle via Hegel to Heidegger and Lukacs. The tragic hero was the philosopher's real hero. Within the discussion of literary genres, among them of the novel or the drama, comedies have of course been mentioned, and almost always it was then Aristophanes' comedy that was addressed—at times it seems for no other reason than that the author was a Greek. Obviously those who wrote about Shakespeare were also interested in his comic works, but, as I cannot repeat enough, the comic phenomenon *per se* was considered below the standard of any phenomena worthy of philosophical interest. At the very beginning of this book we asked—*why?*— And we found a preliminary answer: metaphysical philosophy is interested in final homogeneity. Everything heterogeneous has its own place in the world and is worthy of interpretation, but, in the end, the heterogeneous must be placed in a homogeneous whole, since everything needs to be fitted into the whole. According to the well-known metaphysical truism, the whole is greater than the sum of its parts. Tragedy is a homogenizing genre. As Aristotle says, tragic heroes are greater then life-size, for tragedies portray people as they should be or as they might be. The "essence" of tragedy can be summed up, and the various philosophical summaries are very similar to each other. Something like an ultimate, a value higher than life and death, a peak experience and guilt will figure in all of them.

So my suggestion is, in short, the following. Philosophies are not keen on addressing the comic because comic phenomena are entirely heterogeneous. Moreover, it is not the great exception, as portrayed in the tragic, that is omnipresent and that continues to appear everywhere in something different. Philosophy remains disinterested in heterogeneity for at least two related reasons. First, the heterogeneous cannot be grasped elegantly in a philosophical thesis. Second, the mathematical or geometric truism of metaphysics is circumvented by the heterogeneous. The whole does not stand higher than its parts or any sum of them. My dearest reader will cleverly object that I have just grossly misinterpreted the relation between the individual substance and the concept. The Trag-

edy (the concept) does not stand higher than single tragedies as individual sub-
stances, you protest. The concept will be determined by every case that is en-
compassed by the concept. And this is true, but it does not apply in the present
case. For the "comic phenomenon" is not a concept, at least not in the sense that
"tragedy" can be a concept. As I have maintained, the comic phenomenon, how-
ever well delineated, cannot be ultimately defined. The comic phenomenon fits
neither *genus proximum* nor *differentia specifica*.

My readers will be impatient. Alright, you may say, but this does not ex-
plain why we had to go through all the discussion of those comic genres. I think
it does explain why. At least it has been my intention to make this clear. If one is
involved in the game called philosophy, one cannot entirely escape its tradition.
I will presently return to the expression "being involved." But first, let me ad-
dress this tradition, specifically this tradition of preferring homogeneity. If the or
some world falls apart, leaving only fragments, philosophy tries to put the pieces
together, as best it can, like a jigsaw puzzle; or, alternatively, philosophy im-
merses itself in selected fragments as though they were wholes. This is what it
means to identify and comprehend concepts. There are concepts which can
never be grasped as wholes, because the general concept itself cannot be deter-
mined by *differencia specifica*. These concepts are the existential or final con-
cepts, or, if you want to speak in Hegel's terms, they are ideas. Take for exam-
ple the idea of Time. Since Augustine, nothing entirely new has been said about
the impossibility of forging a general idea of Time. One can either piece a few
fragments about the nature of time together, as in a jigsaw puzzle, or one can
scrutinize each and every fragment, in its own right, as a whole. This may be
one of the reasons traditional metaphysical thinkers neglect temporality; it pres-
ents too heterogencous a puzzle. But the practice of putting together a few frag-
ments or of scrutinizing one fragment as though it were a whole saves the most
important aspect of homogeneity: its understandability. Without even a relative
understandability, one of the main tasks of philosophy cannot be accomplished.
One can gladly say "I do not know" or "this cannot be grasped" when the very
absence of any possibility of understanding itself serves as a springboard for
understanding something else, something that can, therefore, be grasped. In the
case of comic phenomena we fare even worse than in the case of Time, since
everything can be comic; anything at all can have a comic aspect or can be pre-
sented in comic mood, time included. As I can only repeat, 'comic phenomena'
is not even a concept or an idea, but a preliminary reference to an open cluster,
the existence of which we know empirically, but from whose empirical exis-
tence we cannot definitively deduce contents. If one is philosophically involved
in the puzzle of comic phenomena, one needs to select representative fragments
which can be scrutinized as relative wholes—since only this sort of exercise
makes philosophical understanding at all possible. I think that comic high genres
may indeed be thus considered as relatively homogeneous, representative
wholes. The dear reader may interrupt again with two questions: why then not
pick one, or the best representative genre, or if you must choose to address so
many comic genres, why not just take on all of them? Why not choose one sin-

gle work within each and every genre? To the first part of the question the answer is simple. I try to show, and to allow you to decide whether or not the presentation was successful, that each separate comic genre represents, besides certain shared components, also entirely different elements of the comic phenomenon, and thus that each obliges different relations between those phenomena and their recipients. To the second part of the question I can answer only in pragmatic terms. It was, in my mind, enough for my purposes (enough to make my theses evident) to limit the discussion of a few other genres and subgenres. Thus I invite my readers to fill the gap I left behind. To the question of why I did not select just one representative work from each and every genre, I can answer that, had I done so, we would not have been able to detect the common features and strategies of comic presentations within each and every genre, which was the major philosophical task of this work. I do not claim the laurels of an art critic. Still, if some more impatient readers want to arrive quickly at the inconclusive conclusion, they are at liberty to jump from the second chapter directly to the last one.

Dear reader, I promised to return to my claim that in this book I am involved in speaking about the comic phenomena philosophically. I have been directly, not indirectly, involved in articulating something about the comic. Which means, in other words, that my book is not comic. I have written about the comic in a non-comic, let me say in a "serious" manner. But, as the impatient reader will interrupt, is there anything more serious than a joke? Or a comic drama? Though "nothing" may be the easy answer, and though this "nothing" might even be true, that answer would sidestep the problem itself. If I say, for example, that nothing is more serious than a joke, I distinguish seriousness from the joke. I do not mean that the joke and seriousness or the comic novel and seriousness are identical; I mean something else. Let me remind you of Kierkegaard's distinction between two kinds of irony: either one says something seriously and means it in jest, or says something in jest and means it seriously. There must be a difference between jest and seriousness; otherwise one could not point at the other. But this difference cannot be in the message itself; it must be in the presentation or the communication of the message. If the difference were merely in the message, the game between 'meaning' and 'saying' could not be played. Kierkegaard's discussion of irony indicates the difference between direct and indirect communication. As can be guessed, the difference between direct and indirect communication can at least in part illuminate the distinction between direct and indirect involvement.

So it happens that you make fun of someone doing or saying something you find silly, and that they answer indignantly: "please do not make a joke about it, I meant it seriously." Imagine for example a wife saying to her husband: "If you go on like this, I will divorce you." The husband retorts "Are you kidding?" She answers: "No, I am not kidding, I mean it seriously." We understand exactly what she means by "seriously": she is not joking and she is insulted by her hus-

band's suggestion that she may be. Bluntly, she means what she says and not something else. A friend can tell another friend: "I am in love" or "I have come to understand that the whole of my work is rubbish" or "I have lost my faith"— and when the friend asks "Are you serious?"—the answer will be "Yes, I am serious." In this second type of mini-dialogue, the primary question is not *whether* one means what one says, but *what* one means by saying something, or what the truth of the statement actually entails.

Here, my dear reader, we must look back a little to the discussion of laughing and crying. You have, perhaps, already accepted the hypothesis that the position one takes in laughing is that of the "social a priori"—the position of rationality—although there are very different kinds of rationalities, from common good sense to Reason. There is not a grain of emotion in laughter. In laughing, one keeps one's distance from what one laughs at. One cannot be positively involved in the thing at which one laughs. One can, of course, be positively involved in a character, but in this case we laugh not at the character as a whole person, but at one of his acts, character traits, blunders, or the like. Positive involvement and laughter exclude one another. In daily life, it can happen that one laughs at something one should be positively involved in, and when this happens one becomes ashamed of that laughter. While crying, the position of the "genetic a priori" is taken. Here one is involved, directly involved with oneself or one's fellows. This is an emotional expression. The two related feelings which are characteristic of crying are compassion and pity (compassion for oneself and self-pity always included.) Here we see a total identification with the phenomenon that triggers crying, with no distance at all.

Now I ask my friendly readers to accept, at least as a starting point, the following hypothesis: feeling is always involvement in something; or in another formulation, to feel means to be involved in something. If one takes the position of the genetic a priori and sorrows over the impossibility of clearing the abyss, then one is oneself involved in self-pity and compassion. There is no felt distance between situation and witness. Involvements with something or somebody else, involvements in 'difference' (and also in oneself as different) are not reactions to the impossibility of the human condition; indeed, they are the unceasing attempts to cope with it. Being serious means coping with the human condition, sometimes in general, and sometimes in single cases as they arise. Both kinds of "coping" are direct involvements. In coping, we are involved in something. The affects become differentiated, and they develop into different shades of concrete emotion and in single concrete involvements, in single concrete situations. Let me repeat the hypothesis: Elementary laughter is the rational reaction to the impossibility of the human condition; it is a reaction from a distance, without feelings or emotions. On the other hand, in elementary crying one is involved with oneself, in self-compassion and self-pity. One cannot "work" while laughing or crying; one cannot even speak. Crying, one does not try to build fragile, collapsible bridges; one does not bother vainly leaping over the abyss. In being serious, in thinking about something seriously, in doing something seriously,

one gets emotionally involved in a Sisyphean labor. Just this *is* involvement: it is involvement with others and in the other; in people, tasks and ideas.

Even if my dear readers reject my hypothesis as sheer speculation, they will probably admit that the distinction between cognition and emotion is a vain and philosophically defunct enterprise, and that what we philosophers of sorts are now doing, can be described as 'cognitive involvement in matters of the world'—a world rich in emotion, passion, and feelings of orientation concerning truth and untruth. You, my readers, have already accepted the hypothesis that feelings are involvements in the other. Philosophers are vested in a speculative understanding of questions such as "why is there something rather than nothing," or "how does evil come into the world"; that is, in the so-called 'ultimate' questions. We work on the abyss. The old metaphysicians, each of them, claimed to have found a theoretical solution to the ultimate questions; after each came the next, answering the same questions in another way. After every metaphysical approach to the ultimate questions and answers, another unique way was expounded; taken together, the ways amounted to no way. Postmetaphysicians, our contemporaries, do not make such ambitious claims, but they still continue to work on understanding the human condition and the world, knowing that an ultimate understanding will be in vain. Still, the work itself is not in vain; it remains a passion.

It is time to be reminded again of the love affair between philosophy and tragedy. I briefly try to maintain that tragedy is not the "high genre" of crying, since crying cannot have a high genre at all. Aristotle made this clear in his theory of catharsis. If tragedy purifies the soul of pity and fear, it purifies the soul of exactly the kind of involvements that overwhelm people in elementary crying. Yet tragic heroes are involved in something, and their involvement is not partial, but total. They abandon themselves absolutely to their destiny, with passion and enthusiasm. What philosophers believe they do, and sometimes really do in cognition, usually with less risk, tragic heroes perform in deeds. The sympathy or rather the star-friendship (as Nietzsche calls such relation) that philosophy has with tragedy is easy to understand. Tragic writers generally requite this love, whereas comic writers present philosophy with the gift of a gambling, gaming friendship, without seeing their love requited until late modern times.

Thus when someone says "I am serious, please do not make fun of me" she means, "I am involved in the work of the human condition now; I cannot and will not occupy a position of distance right now; I do not want to be entirely rational, now, for while I am so involved I cannot simultaneously reflect on the thing I am involved in from afar, without any feelings." When the husband asks his wife "Are you kidding?" and she answers "I am serious," she means: "I made a decision; I am unwilling to live with you under certain circumstance; I cannot and will not look at my decision with your eyes. If you think I am crazy, then I will be crazy."

We are generally serious in life. Still, the comic is omnipresent. The dear reader will excuse me if I begin again with the easy question. The comic is om-

nipresent because it is an answer to seriousness. Not to all kinds but to several kinds of seriousness. Since seriousness entails involvement in something, since it is full of certain feelings and emotions and since it is a kind of work on the human condition, it can be trapped by laughter exactly at these points. Not involvement itself, but the type, character, and extent of involvements are the Achilles-heel of earnest concerns, making them the butt of ridicule.

Irrational feelings are always targets of laughter. There are feelings which are irrational in themselves, in the sense of being self-defeating, such as envy or jealousy. There are other emotions which, in themselves, are not self-defeating or irrational, but which can become irrational in certain situations, where they become targets of laughter. Thus almost all kinds of emotions and emotional dispositions can become a laughing stock, such as love and hatred, pity and revengefulness, and also intellectual feelings like credulity, distrust, or curiosity. Human characters obsessed by irrational feelings are butts of laughter. There are emotions which, if overstrained or exaggerated (mostly because of an over iden-tification) become objects of ridicule, and that otherwise are not ridiculous. 'Over identification' is, in fact, a judgment; laughter signals that some identifi-cation is being judged an over identification. The same emotional involvement which is judged by someone to be an over-identification may be valued by someone else as the only proper identification. The first will laugh, the second will not, and will even rebuke those who ridicule something extremely serious. And what is considered proper identification, appropriate behavior, and fitting emotional involvement at one period in time comes to be seen as an over identi-fication to people living in different times. They will find things funny that their ancestors found utterly grave or mundane. This is well known and is exploited in the world of theater and opera. Serious plays or operas are now often staged as comedies, for they work, and work well, only as such.

For the comic to exist, certain things must be serious; they must be meant and done in earnest. It seems that the question which was constantly discussed in all the preceding chapters, namely the problematic identity of characters and authors in comic genres, has something to do with involvement, and with the emotional quality of that involvement. It seems as if over identification must appear in a comic light from the standpoint of the social a priori. The clever reader will shake her head: how can over identification be ridiculous if laughter, according to you (me), takes the standpoint of the social a priori? Why is the social a priori the standpoint of rationality, when after all it only cruelly judges emotional involvements on its own term, that is, vis-à-vis the social a priori?

I invite the reader to make a further distinction or rather to consider the dis-tinctions that have already been made. First: *which* social a priori? Second: *what kind* of involvement? We are thrown into the world by accident. We make a serious effort to harmonize our social and genetic a priories; we are involved in working on ourselves as those who are thrown. But there is not just one world, and there is not just one self. We, normally, do not live in just one world, but in at least two. There is the world of daily life, customs, concrete norms, and rou-tine expectations, and there is the spiritual world, the world of religions, myths,

artworks, and stories, dreams and fantasies. The 'throw' can also split us into two selves, one self which accommodates the daily routines and another which also lives in the spiritual world; further, one self may distance itself from the other, and from the world of the other. There are people who simply assimilate to both worlds as if they were but one, and who identify with themselves and with this narrow world simultaneously. People who are involved in the lofty, spiritual world alone, people of exclusively subtle passions who turn their backs on everyday needs and wants, can cut a comic figure, looking for all the world like aliens unfamiliar with pragmatic acumen or common sense. Yet pragmatic people of common sense who identify themselves entirely with their environment, who do not perceive any difference between things routine and spiritual, cut a comic figure when seen in the light of the non-pragmatic social, cultural, or spiritual viewpoint. Moreover, those who identify themselves entirely with one aspect of a social world without noticing any other also cut a comic figure when viewed or evaluated from the vantage point of any of those other aspects.

Only those who are emotionally involved in the world and who work on the human condition, yet who live in the two worlds at the same time and with awareness, people who can distance themselves on occasion from themselves, yet who also identify with themselves and their destiny, do not cut a comic figure from either the position of common sense or of the world of spirituality and fantasy. As an example, here stands Diderot in his conversation with Rameau's nephew. Socrates, who is ironical and self-ironical, cannot be treated with irony by someone else from the same position, though he can still be treated with humor (as Plato often does), because the position of humorous evaluation (the religious) differs from the position of ironical evaluation (the ethical). These distinctions, borrowed from Kierkegaard with his names for them in parentheses, have been modified here, so that the reader will be at liberty to find them unconvincing or ridiculous.

Our friendly reader will now warn me that I have not yet kept my promise, because I have said nothing about indirect involvement. She is right, but there is still one more thing I must say about direct involvement. I ask her to remain patient for just a few more minutes.

I think that even the most sophisticated reader can accept, at least grudgingly, that without my ever attempting to be consistent, there is much consistency in my hypothesis, more in fact than even I expected. I am still referring to seriousness and to the question of what kinds of earnestness cut a comic face, and what kinds do not tend to become targets of comedy. The person who can occasionally view herself from a distance and can view at the same time her involvements with distance is a person with both a critical mind and a good sense of irony or humor; she is not a good foil for comic presentation. Yet if the distance itself is stabilized and a person cannot always resume a position of seriousness, that situation will change. A mild skeptic is not funny, but a complete skeptic is, because complete skepticism resembles complete credulity, just like two eggs resemble each other, as we would know from Molière if not from our own experience. Comedy, then, can zero in on commitments too rigid to

adapt to changeful situations, and is sensitive to obligations of principle that betoken over identification with some role. Since my readers are impatient and do not want to be drawn into a discussion of more details, I will leave further engagement with earnestness as direct involvement behind, and will turn to the burning issue of indirect involvement.

It is a burning issue, for it is the prevailing question my readers may have about comic genres. The question is as follows. The comic needs seriousness to advance, for what it makes fun of or draws from is seriousness. In comedy, as I have tried to show, reason makes fun of emotion. How is it then that people continue to hold that nothing is more serious than a comedy, a comic novel, or a joke? How can this be true or even acceptable?

All comic genres make us laugh; they make us laugh at things which can generally be described as "irrational" from the position of at least one kind of rational attitude. But no comic genre is composed of sheer laughter. Not even a joke can be absolutely saturated with laughter, for we are supposed to laugh only at the end, at the point or punch line. Not even a caricature or a comic picture is about pure laughter but about something that makes us laugh. Comic genres make us laugh; this is their intention. But this is not their sole intention. They do not intend to make us laugh for laughter's sake alone (only stupid sitcoms do this, and only then to make a buck), but in order to invite us to take their position of assessment, their position of judgment, their evaluation of character, situation, and action. The comic genres invite us to change our regard. They ask us to notice from a distance something in which we may have been too immersed to see, our own follies included. I have already employed the provisional metaphor of a distorting mirror. When we look into an amusement park mirror, we see ourselves as giants or dwarfs, as very thin or very thick, as in a comic novel. But comic genres are not optical mirrors, but poetic ones. To each character belongs his or her own mirror.

What does it really mean to say that comic genres invite us to take the position of one or another kind of rationality? It means that they ask us to suspend our involvements, to alienate things, ideas, actions, and characters in which we are supposed to be constantly involved; they ask us to suspend our emotions. Not only positive but also negative emotions are to be thus suspended. Love is suspended as is hatred. And then, when we burst out into laughter, we laugh at things we love as well as at things we hate; we laugh at our own love and our own hatred. We laugh at our own political friends and also at our enemies; we laugh at ourselves as fathers and as sons, as married or unmarried men or women, as doctors and lawyers; we laugh at our seriousness, our own serious business world included. As long as one really laughs, one is not actively feeling hatred, love, or pity. So one cannot pity oneself.

Thus, while laughing we suspend our emotions, for we suspend our involvements, and we suspend them all. We are not in earnest. One cannot suspend one's involvement in earnest, and this is why we burst out laughing. But one does not laugh during the whole performance of a comic drama or throughout the reading of a comic novel or during the whole time one watches a comic

film. One laughs in waves, from time to time. Where every sentence of an entire play is a "gag," we are not dealing with a work of any high comic genre.

A work of a high comic genre, the only genres at issue in this book, makes us laugh in waves, which means that there are times we are not laughing. We must continue reading or watching or listening, and while we are actually laughing we cannot read, listen, or watch. The actors stop their act while the audience is laughing. With a joke, at which one laughs only when the joke is already 'over,' one laughs precisely when one need no longer pay attention to anything at all. Our emotional involvement, our seriousness, is not entirely suspended during the performance of a comedy (let alone of a novel); it is suspended from time to time. Moreover, this suspension is not necessarily total. If a comedy ridicules one aspect of a character's behavior, it does not make us laugh at the character as a whole, and we can still be involved in the same character positively or negatively; we can love her or dislike her, wish her well or ill. There is no 'happy ending' without positive and negative involvement, without seriousness. True, satirical comedies do not end happily, as for example Gogol's *Revizor*, but in this kind of play, negative involvement cannot be continuously suspended. In a satirical or polemical novel, as in Swift's *Gulliver's Travels*, we do not love a single human being (if we do not count horses among them) but we learn to hate many things more through their comic presentation. Seriousness is thus never entirely, but only partially suspended, insofar as emotional involvement in one or the other character is never entirely or finally suspended. We look at something or someone from a distance, as irrational or ridiculous, yet also with involvement, as someone worth loving, hating, pitying, despising, or empathizing with. Still, something important happens through the alienating regard: with it, we see things we had not seen before, take note of circumstances that have otherwise escaped our notice. My well-informed readers will surely be waiting to make another correction —why do you claim, as though exclusively, that the comic genre has this substantial effect, when such an effect is, after all, the demand of every significant work of art, namely in making us see things we have not noticed before? The attentive readers are again right, and I apologize. I should modify my assertion. The comic genres make us see things and characters in a different light, through altering our involvements themselves. Comedy alters involvements both by making them stronger, weaker, or otherwise different, and by giving us the opportunity to distance ourselves more from certain things. When exposed to waves of laughter, we become accustomed to the switching of attitudes and of involvements, and to taking a more distant perspective on our involvement. The comic genres have an educational effect, not because they present a moral or teach a lesson, as some have argued, but because they loosen the ties of identification, offering a practice of distancing ourselves from something or from ourselves, and of reshaping our emotional ties and relationships.

As an explanation for the dear reader, in the last section I discuss the kind of involvement I termed 'indirect.' The comic novel gets us involved in characters, things, and ideas we have not been caught up in before; it helps to sever our

involvement in characters and things we used to be involved in; and, it strengthens or weakens our involvements through making us, from time to time, involved and uninvolved in the same things. Involvement is altered through indirect experiences and the suspension of direct experiences.

"So far so good," says the sophisticated reader. "I accept that comic works do not just make me see things in a different light, but also change my sense of distance and identification, or the relation between what is called rational thinking and emotional thinking, or egocentric thinking and other-oriented thinking. By telling your story you make a case for the following little conclusion: the effect of the comic is serious, and the quality of its recipient's earnestness is changed by it, or at least, might be changed. But you have not made a very good case for earnestness, in the meanwhile. For comic genres are just veiled fairy tales; they are dreams and fantasies, plays and games, as you yourself admit a few chapters back. You probably remember the place of the reference, since you wrote it. So how deep could the earnestness or seriousness they represent be?"

The sophisticated reader has a point, as always. Though she is actually referring to my remarks specifically about jokes (which followed Kant and Freud in this case), I am still ready to pick up the glove. The sophisticated reader conjures up from under her hat a concept of seriousness different from the one I so far discussed, but she still may be right in confronting me with it. After all, not everyone is obliged to accept my interpretation of earnestness; anyone can come up with another suggestion. If I understand the sophisticated reader well, in her mind, one speaks in earnest whenever one refers to something 'real.' This is too broad a topic to be tackled here. Once in this book—I do not in fact remember where—I hint at some answers to the question of any thing's 'reality.' There, if memory serves me, I say something to the effect that truth and reality can be totally united only in Hegel's philosophy. Not all distorted mirrors are true mirrors, but some of them are. What is truth? The sophisticated reader cannot expect to answer Pilate's question for me, here in my book on the comic, and here at the end of it. Or can she? As the replica of revelation ("I am the truth . . ."), the question of what truth is is different from it; even the question of what comic revelatory truth is, and the truth of revelation are not the same, for one is the revelation of the Unique as the Absolute, whereas the other reveals the unique, which is not at all absolute. The truth of works of art in general can be associated with revelatory truth, and comic works are no exceptions. Their truth, if they are true at all, is revelatory. One can still point to these truths (here, I speak in the plural, because all works are unique but not absolute), and if one answers the question as to their truth with the question "what is truth?" then this answer still remains comic, as would be the question (not asked by Pilate) "what is reality?" Revealed truth can be accepted or rejected, but regarding works of art, this is not a matter of faith but of taste. And this is why I am ready to accept the suggestion of the sophisticated reader that we are dealing here with plays in a double-sense of the word. What must be clarified though, dear sophisticated reader, is that taste is not so entirely unrelated to the person whose taste it is. Taste indicates whether or not a person has, for example, in his disregard or

affection for a comic genre, a good sense of humor. I suppose that the sophisticated reader has a good sense of humor, since otherwise she would have not exposed me to ridicule, by asking such a naïve question, to which, as she surely knew, I could give only a foolish answer.

The impatient reader, who has actually waited quite patiently, is now urging me, with this very point, to write the final words "THE END." To speak in earnest. I have already done so, if only to satisfy him, yet just those words THE END remind me of something I still want to tell you, dear readers. It dawned on me that perhaps I could offer a preliminary answer to that preliminary question: at what do we laugh? Of course, there is no answer to the question, because as we now know, the comic is heterogeneous, and we laugh at so many different things that it would be quite impossible to enumerate only some good portion of them, even in a book twice this size. Yet if I were not afraid of being stigmatized as a holist, or branded a metaphysician or some other kind of untimely comic monster, I would have already dared to come up with a preliminary ANSWER. Courage! In taking courage—with your kind permission or without it—I have erased the words "THE END" (they used to be there, just above) and have decided to enter into a wager.

We are the 'thrown' who will never succeed in bridging the gap between the two a priori conditions of human existence. We laugh and cry from the position of the social a priori and/or the genetic a priori. We laugh or cry at—"For heaven's sake, you repeat yourself, and this is what you call courage or a wager?"—Alright, I will come to the point. It was already obvious throughout the whole book, but we usually do not recognize the obvious. I will forget for the moment about crying. But, to finish my thought, we laugh at something that is common to everything we laugh at, have ever laughed at, and will ever laugh at. The obvious is hidden in the three theories about laughter. "How can the obvious be hidden?" Let me remind you of the three theories of laughter we engage. First, we examine the force/power theory; second, we consider the theory of relief; and third, we analyze the incongruence theory. It now dawns on me that all three theories point to the same thing. I promise to be brief.

Human existence itself is the essential incongruence. That is, incongruence is the essence of human existence. We are born in order to die. Everything we live for or against, all our attempts to leap over the abyss or to cope with it, our cognitions and emotions, the very fact that we are always involved in something, is incongruent with *nothing*. And death (not dying, which is something) is nothing. Kant described the joke as a play of thoughts that suddenly ends in nothingness. Human life is like a joke. It is like a novel or a drama which ends in nothingness; it is a comic novel or drama: the human comedy. And without the gap between the two a prioris, there could be no consciousness of the human comedy. Here reenters the theory of force/power.

When we burst out laughing, we feel our force, we are empowered, and we conquer death, in that moment. Here reenters the theory of relief. Liberation

from the tyranny of the despot (even if only in a comic drama and a joke) makes us feel free in our innermost soul, and thus we can get rid of our fear of death. At the same time, liberation from the internal censor opens us to the task of understanding ourselves as mortals, and of living with the conscious perspective of mortality. All three theories of laughter suggest that we laugh at death every time we laugh.

"I can tell you," says the sophisticated reader, "that you have already lost your wager, since you have gone too far. One cannot laugh at death without a great love of life, and not all comic writers do love life. You yourself discuss the Alceste-type of comic author, and the comic work presented with melancholic regard, which is, as you make clear, one emblematic form at least of comic novels. And do not forget that in existential comedy the melancholic regard becomes eminent." The sophisticated reader has a point, as she always does. But she is also wrong, for I can best support my wager precisely with reference to existential comedy. For in existential comedy the hidden truth is most manifest: death itself is portrayed as comic in Beckett and Ionesco and sometimes even in Kafka. "Forget it," says the sophisticated reader, "a wager does not need to be supported anyway. For if it is, it ceases to be a wager." So take it not as a wager but as a hypothesis. "I will," she says.

Since I cannot get rid of her even now, at the end, I ask the sophisticated reader whether she would support my hypothesis, since I have called it a hypothesis for her sake. "Tell me, which one!?" she retorts, suggesting that I have offered more than one hypothesis. So, it is my final hypothesis that I ask you to support. I will sum it up. Since we are mortals, comedy must be immortal. I hope you will agree that this is a concisely formulated and beautiful hypothesis. Please endorse it.

The sophisticated reader answers: "The formula is silly enough to serve as a summary at the end of a book that has tried to capture the phenomenon of the comic. I endorse it, all right. As long as we remain mortals, comedy will remain immortal."

THE END

Bibliography

I list here only the books I read and used for discussion in particular chapters of this work. Not included here are other works by the same author, not directly addressed or referenced in this work. Nor have I listed writings that are themselves referred to and enumerated in the texts I used, though some are relevant to the topic.

Philosophy, Literary Criticism, Art Criticism, and Psychology Related to the Comic, and Collections of Jokes with Interpretation

Aristotle. *Aristotle's Poetics*. Translated by James Hutton. New York: Norton, 1982.

Attardo, Salvatore. *Linguistic Theories of Humor*. Berlin; New York: Mouton de Gruyter, 1994.

Bakhtin, Mikhail. *Rabelais and His World*. Translated by Helene Iswolsky. Bloomington, IN: Indiana University Press, 1984.

Berger, Peter L. *Redeeming Laughter: The Comic Dimension of Human Experience*. New York: Walter De Gruyter, 1997.

Carrol, Noël. *Beyond Aesthetics: Philosophical Essays*. Cambridge, UK; New York: Cambridge University Press, 2001.

De Sousa, Ronald. "When Is It Wrong to Laugh?" In *The Philosophy of Laughter and Humor*. Edited by John Morreall. Albany, NY: State University of New York Press, 1987.

Dundes, Alan. *Cracking Jokes: Studies of Sick Humor Cycles & Stereotypes*. Berkeley, CA: Ten Speed Press, 1987.

Esslin, Martin. *The Theatre of the Absurd*. Rio de Janeiro: Zahar, 1968.

Freud, Sigmund. *Jokes and Their Relation to the Unconscious*. Translated by James Strachey. New York: Norton, 1960.

Genette, Gerard. *Palimpsests: Literature in the Second Degree*. Lincoln, NE: University of Nebraska Press, 1997.

Grimm, Reinhold, and Jost Hermand. *Laughter Unlimited: Essays on Humor, Satire, and the Comic*. Madison, WI: University of Wisconsin Press, 1991.

Hegel, George Wilhelm Friedrich. *Aesthetics: Lectures on Fine Art*. Translated by T. M. Knox. 2 vols. Oxford: Clarendon Press, 1975.

Hobbes, Thomas. *Leviathan*. Harmondsworth, Middlesex; New York: Penguin Books, 1968.

Howarth, W. D. *Comic Drama: The European Heritage*. New York: St. Martin's Press, 1979.

Jacquart, Emmanuel C. *Le theatre de derision: Beckett, Ionesco, Adamov*. Paris: Gallimard, 1974.

Japp, Uwe. *Theorie der Ironie*. Frankfurt am Main: Klostermann, 1983.

Kant, Immanuel. *Anthropology from a Pragmatic Point of View*. Translated by Mary J. Gregor. The Hague: Nijhoff, 1974.

———. *Critique of Judgment*. Translated by Werner S. Pluhar. Indianapolis, IN: Hackett Publishing Company, 1987.

Kierkegaard, Søren. *The Concept of Irony with Constant Reference to Socrates*. Translated by Lee M. Capel. Princeton, NJ: Princeton University Press, 1989.

———. *Concluding Unscientific Postscript*. Translated by David F. Swenson. Princeton, NJ: Princeton University Press, 1992.

Lessing, Gotthold Ephraim. *Das Theater des Herrn Diderot*. Berlin, 1781.

Morreall, John. "The Laughter Situation." In *The Philosophy of Laughter and Humor*. Edited by John Morreall. Albany, NY: State University of New York Press, 1987.

Plato. *Plato's Phaedrus*. Translated by W. C. Helmbold. Indianapolis, IN: Bobbs-Merrill, 1952.

———. *Plato's Philebus*. Translated by R. Hackforth. Cambridge, UK: Cambridge University Press, 1972.

———. *Plato's Republic*. Translated by Richard W. Sterling and William C. Scott. New York: Modern Library, 1982.

Rohrich, Lutz. *Der Witz: Figuren, Formen, Funktionen*. Stuttgart: J. B. Metzler, 1977.

Rosenkranz, Karl. *Aesthetik des Hasslichen*. Konigsberg: Gebruder Borntrager, 1853.

Schelling, Friedrich Wilhelm Joseph. "On the Essence of Comedy." In *The Philosophy of Art*, by F.W.J. Schelling. Translated by Douglas W. Stott. Minneapolis, MN: University of Minnesota Press, 1989.

Schumacher, Eckhard. *Die Ironie der Unverstandlichkeit*. Frankfurt am Main: Suhrkamp, 2000.

Scruton, Roger. "Laughter." In *The Philosophy of Laughter and Humor*, edited by John Morreall. Albany, NY: State University of New York Press, 1987.

Shaftesbury, Anthony Ashley Cooper. *An Old-Spelling, Critical Edition of Shaftesbury's Letter Concerning Enthusiasm, and, Sensus Communis: An Essay on the Freedom of Wit and Humor*. Edited by R. B. Wolf. New York: Garland, 1988.

Siegel, Lee. *Laughing Matters: Comic Tradition in India*. Chicago: University of Chicago Press, 1987.

Spalding, Henry D. *Encyclopedia of Jewish Humor: From Biblical Times to Modern Age*. New York: Jonathan David Publishers, 1969.

Szondi, Peter. "Friedrich Schlegel and Romantic Irony, with Some Remarks on Tieck's Comedies." In *On Textual Understanding and Other Essays*, by Peter Szondi, 57-73. Minneapolis, MN: University of Minnesota Press, 1986.

Unamuno, Miguel de. *Our Lord Don Quixote: The Life of Don Quixote and Sancho, with Related Essays.* Princeton, NJ: Princeton University Press, 1967.

Westermann, Mariet. *The Amusements of Jan Steen: Comic Painting in the Seventeenth Century.* Zwolle, Holland: Waanders, 1997.

Ziv, Avner. *Personality and Sense of Humor.* New York: Springer Publishing Company, 1984.

Comedies

See all extant works by Aristophanes, Plautus, Terence, Shakespeare, Ben Johnson, Molière, Calderon, Tirso da Molina, Lope de Vega, Lessing, Gogol, Scribe, Shaw, Jarry, Beckett, Ionesco, Durrenmatt and Stoppard.

Novels and novellas

See all works by Rabelais, Bocaccio, Lawrence, Swift, Fielding, Diderot, Voltaire, Gogol, Balzac, Dickens, Joyce, Hasek, Borges, Beckett, Mann, Grass, Garcia Marquez, and Rushdi.

A few works by the authors mentioned above have been thoroughly analyzed; authors whose works I only casually reference do not appear on this list.

Most of the jokes utilized above were borrowed from Rohrich's collection, from Freud's book on jokes, from Dundes' book *Cracking Jokes*, from the *Encyclopedia of Jewish Humor* (ed. Harry D. Spalding), and from *La France qui rit*, French jokes collected by Ernst Kemmner. A few others, which I once heard told, surfaced from my preconscious memory.

 References to the paintings discussed are given in the text, unless I speak of well-known works.

Budapest, 15 July 2003

Agnes Heller

Index

Index